*Impressionism to
Post-Modernism*

MODERN ART

Impressionism to Post-Modernism

Edited by DAVID BRITT

THAMES AND HUDSON

MODERN ART

Chapters 1–7 first published in Great Britain in Dolphin Modern Movements

Reprinted 1990

Printed and bound in Yugoslavia.

Contents

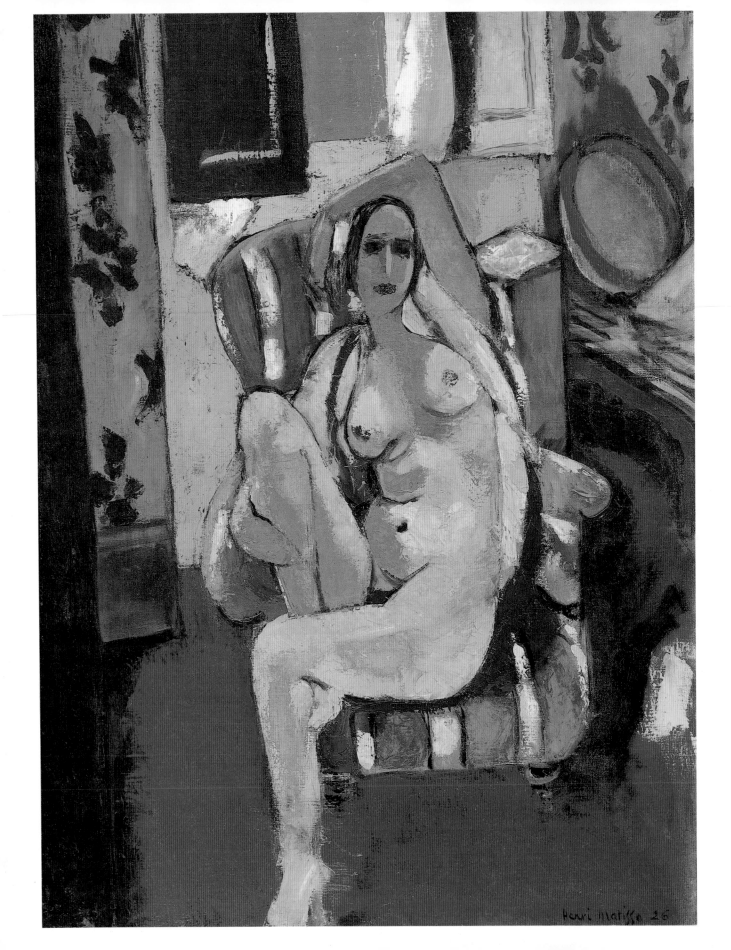

Henri Matisse 26

Preface

DAVID BRITT

Paul Cézanne – an Impressionist from the early days of the movement, in the 1870s – used a word which showed that he had an idea of his own place in an art-historical process. The word was 'primitive'. 'I shall always', he said, 'be the primitive of the path I discovered.' Renaissance painting, in the account given by its sixteenth-century chronicler Giorgio Vasari, evolved as a technique of representing bodies in a structured context of space and light, from the work of a group of pioneers or 'primitives'. Cézanne's hypothesis, a plausible one, was that an analogous process took place in the nineteenth and twentieth centuries, in the course of a massive swing away from what was left of the Renaissance tradition. The pioneers of that process, proud to be called primitives, could hardly realize that Vasari's beautifully simple evolutionary model was not going to apply, and that the modern era in art was to consist of one wave of 'primitives' after another. Six years after Cézanne's death a group of very different artists, the Futurists, were calling themselves 'the primitives of a completely renovated sensibility'. The ten words ending in 'ism' in the titles of the eight essays in this book are ten out of hundreds that have succeeded each other since the birth of Impressionism.

If art from the third quarter of the nineteenth century to the last quarter of the twentieth is an 'era', corresponding in some way to the era inaugurated by the Renaissance, then this modern era is one that contains a confusing multiplicity of visual styles. The affinities between Fragonard and David are visible to us (if not, necessarily, to the artists concerned); but the affinities between Umberto Boccioni and Gilbert and George are not in any sense apparent to the eye. The link in this case is through the idea of 'Modernism' itself, the name of a dimly understood, but manifestly real, historical shift.

Parts of the picture are already clear. The Impressionists gave great offence by showing what was perceived, rather than what the artist knew ought to be there. Seurat and his successors, who included the Fauves and the Futurists, used this vital freedom to show a new kid of *perceived* image: hieratic, dynamic, or transcendental, but always expanding the possible versions of the world of perception. The quasi-scientific idea of a solid world 'out there' – atoms like billiard balls – was something that artists were the first to modify; and the last century and a quarter shows them constantly striving to alter the perceptions of the rest of us. The bafflement that has greeted many of their efforts has much to do with the infinity of alternative universes that they present. 'An object has not one

Henri Matisse
Nude with a Tambourine 1926

absolute form', said the Cubists Gleizes and Metzinger, '. . . it has as many as there are planes in the domain of meaning.' Modernism is a single phenomenon, because of and not in spite of its multiple versions of reality. For every 'plane of meaning', Modernism has a movement. Its multiplicity is its message, and the source of its excitement.

This is a state of affairs that one finds either exhilarating or disturbing; now as in 1874 there are those who are profoundly upset by Modernism in one or all of its forms. There are also those who subscribe to a (rather un-Modernist) linear model, according to which the achievements of the Impressionists and of Cézanne led through a kind of apostolic succession to Cubism and eventually to Abstract Expressionism. Any other 'isms' are marginal, according to this model; if we apply Alastair Mackintosh's entertaining metaphor of a railway station (p. 66) to Modernism as a whole, the 'apostolic' view tends to replace the clatter of trains, passing through a complex junction, with the roar of a six-lane superhighway.

People have been burying Modernism, or describing it as being in a 'late' phase, for at least twenty years; and now, enjoying the ghost of a paradox, they often speak of something called Post-Modernism. Modernism has certainly evolved much faster than its Renaissance predecessor. Marcel Duchamp proved that a work of art was no more than an idea expressed through an object, and that this object might be dispensable, renewable, or even known only by report. As a result, the twentieth century is studded with what look like attempts to produce the ultimate (or last) work of art: from Duchamp's own notorious urinal, through Malevich's black square, to Kosuth's deadpan dictionary. Of course, none of these was the end at all. Modernism is so protean that a new revolution could only replace it with nothing at all; and nothing will come of nothing.

The problem may be sidestepped by turning to pluralism – which is a more convincing way of describing Post-Modernism. From a present-day perspective, the possibilities seem more varied than ever. Figuration is not dead; abstract art is not dead either; Conceptual art and Minimalism are still with us. What does happen next is anybody's guess; but a clue may lie in a wider historical context. The revolutions of which this book speaks have been associated with vast and amazing phases of economic and technological expansion. Western art, in its own way, has reflected that pattern, from the Impressionist response to nineteenth-century urban euphoria, all the way to the postwar psychic brinkmanship of the Abstract Expressionists – or indeed to the affluent understatement of much Minimal art. However, in terms of human society, that expansion now seems to be approaching its end. Sooner or later the growth of consumption will have to be abandoned in favour of a way of life that will depend on renewable resources. What often sounds like a terminal pessimism in much contemporary Modernist work may well be a sign that art – as always – is responding first to a great historical shift. This pessimism, in fact, may not be entirely what it seems. Here and there artists like Anselm Kiefer, who present death in all its horror, are already implying a message of regeneration.

Impressionism to Post-Modernism

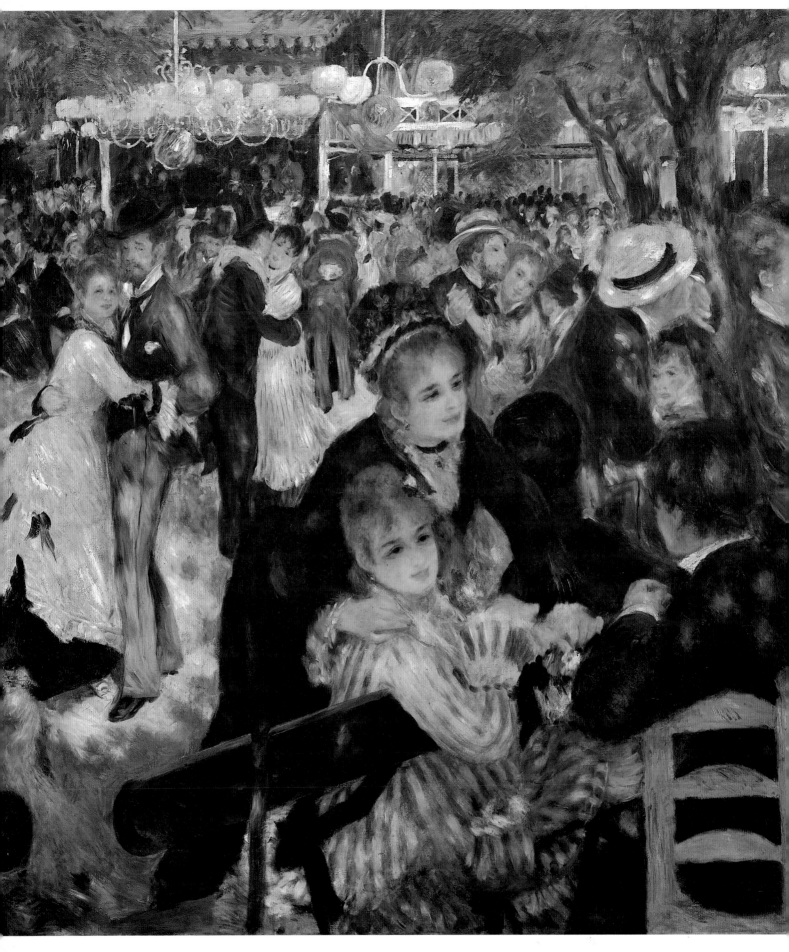

I Impressionism

BERNARD DENVIR

Impressionism is the most important thing that has happened in European art since the Renaissance, the visual modes of which it supplanted. From it virtually all subsequent developments in painting and sculpture have stemmed, and its basic principles have been reflected in many other art forms. For a conceptual approach, based on ideas about the nature of what we see, it substituted a perceptual one, based on actual visual experience. For a supposedly stable reality, it substituted a transient one. Rejecting the idea that there exists a canon of expression for indicating moods, sentiments and arrangements of objects, it gave primacy to the subjective attitude of the artist, emphasizing spontaneity and immediacy of vision and of reaction. Formulating a doctrine of 'realism' which applied as much to subject matter as to technique, it eschewed the anecdotal, the historical, the romantic, concentrating on the life and phenomena of its own epoch. Escaping from the studio, the Impressionists laid great emphasis on painting in the open air, in emotional contact with the subject which was engaging their attention. When painting in this way – and even in the studio, when the necessity to capture the *impression* of the subject they were painting was equally dominant – they evolved a technique dictated partly by the haste demanded, partly by the necessity to achieve perceptual reality. They eliminated black shadows and outlines which do not exist in nature; shadows were painted in a colour complementary to that of the object. They used a rainbow palette and experimented with various techniques of broken colour.

Impressionism was one of the first art movements to be linked with a self-conscious group; its practitioners held a number of exhibitions and intermittently acted in unity. But in fact they were very different in their personalities and in their art; it is dangerous to dramatize their achievements by seeing them merely as idealistic revolutionaries reacting against an artistic establishment. That they seemed occasionally to be so was not integral to their achievement, and has little to do with their status as the first modern artists.

Impressionism was born in a certain social and cultural context, which was responsible for shaping its forms and determining its ideology. Most of its practitioners had grown up under the not so distant shadow of the Revolution and of Napoleon; they themselves lived through '48, the Coup d'Etat, the Second Empire, the Franco-Prussian War and the Commune, dying under the Third Republic. The background to their lives was one of constant political turmoil, with which they were necessarily involved.

Auguste Renoir
Moulin de la Galette 1876 (detail)

Mostly they were committed, with varying degrees of intensity (Pissarro was probably the most politically aware, and he was more of an anarchist than anything else), to the left. But whether they wanted to or not, the temper of the times identified them with it: to be a revolutionary in art was to be a revolutionary in everything, and the denigratory adjectives which their enemies chose to describe their work showed that this was taken to include morality as well as politics.

The enemies of the Académie were inevitably enemies of the Establishment, and though none of them professed the bellicose sentiments of Courbet, they were all suspect. By the middle of the century an implicit alliance had been established between Bohemia and the Left – an alliance which, as the events of 1968 proved, subsists into the late twentieth century. Those who fail to comprehend a new art style see in it a threat not only to society, but also to the inner certainties of the ego.

There was not much that was subversive in the personal lives of the Impressionists; on the whole they were pillars of domestic rectitude. And it would be entirely wrong to visualize them, even in their purely professional context, as indolent dependents on the whims of creativity or the fluctuations of inspiration. Their output was prolific – sometimes even unfortunately so. They rose early and set off, their easels on their backs, through the countryside, along the banks of the Seine, or through the streets of Paris, looking for suitable sites, likely landscapes, appropriate scenes. Or they laboured in their studios as long as the light lasted.

They were sensitive to public reaction and did all they could to manipulate it in their favour. They were, almost without exception, anxious to be successful, in the most traditional, conventional way.

They grew up in the Paris of Balzac and came to maturity in the Paris of Zola, seeing its transformation under the guidance of Baron Haussmann from an archaic tangle of great palaces and untidy warrens into the luminous city of broad boulevards, luxurious hotels and verdant parks which, by choosing them so frequently as the subject matter of their paintings, they were to immortalize. For, despite the obvious evils of the nineteenth century, its latter half saw an immense improvement in the amenities of life, and nowhere was this more apparent than in the French capital. Life was easier for a large number of people than ever it had been. Social intercourse was more relaxed, and though cafés, for instance, had always played some part in the cultural life of Paris, in the nineteenth century they assumed a significance which they have never since lost. They provided an invaluable meeting-place for men of similar ideas, where the most fruitful and significant forms of contact could be established, theories propounded, programmes worked out. Cafés were of seminal importance in the creation of artistic groups – and it must not be forgotten that such groups were a comparatively new phenomenon in art, peculiar to the nineteenth century (but not of course to France, as the Nazarenes and the Pre-Raphaelites prove). The history of French art during most of the nineteenth century could be written in terms of cafés: the Brasserie Andler, where Courbet used to preside; the Café Fleurus, with panels decorated by Corot and others; the Café Taranne, patronized by Fantin-Latour and Flaubert; the Nouvelle-Athènes, where Manet, Degas, Forain and Lamy were often to be found; the Café Guerbois,

which more than any other place could claim to have been the birthplace of Impressionism.

These changes in the landscape of French and especially Parisian life were closely linked to social changes. The industrial revolution generally, and in particular the real-estate boom in Paris consequent upon the policies of Napoleon III, had created an immense amount of new wealth, most of it possessed by newcomers to affluence. Unversed in the older traditions of patronage, it was they who were largely responsible for the sudden emergence in the nineteenth century of the art dealer. Till then art dealing had been a haphazard business, more highly developed, for historical reasons, in Holland than elsewhere. But by the 1860s a new breed had emerged in all the European capitals. Housed in prestigious premises, able, and indeed eager, to advise and direct both artists and customers, acting as impresario, accountant and public relations officer combined, the dealer provided a new and significant service. He liberated artists from their dependence on the annual offical Salon; he opened up new outlets; without him the avant garde would never have existed. This effective influence was especially true for Impressionism, which owes an incalculable debt to the perspicacity, good sense and loyalty of Paul Durand-Ruel and Ambroise Vollard, the movement's main dealers.

The art market was, in fact, expanding at an unprecedented rate – not only because there was more money about. Education was improving; the application of the steam engine to the printing press led to a proliferation of cheap books, and to the emergence of a multiplicity of journals and newspapers. The invention of lithography, the production of cheap chromo-lithographic prints, advances in the techniques of producing line blocks – leading eventually to the application of photographic processes – all produced a growth of visual sophistication and of knowledge not only about the art of the past, but about that of the present. An inevitable concomitant was that much more was written about art than ever before. The art historian and the critic emerged as figures of significance. The latter, of course, was especially important in the context of contemporary art. The public was hungry for guidance, and it is probable that current exhibitions in the Paris of the 1870s received more coverage than they did in Paris of the 1970s. Even hostile criticism was probably better than none, though it is now becoming increasingly apparent that hostility to the Impressionists was by no means universal. The support of Zola, even though based at times on erroneous assumptions, was invaluable.

Further, Impressionism also owed its historical validity to the fact that it reflected the profound changes taking place in the whole of European culture. The colour theories of the polymath chemist Eugène Chevreul (1786–1889) had been published before the Impressionists began to paint, though it would seem that they did not really begin to apply them until the 1880s, in conjunction with associated discoveries made by Helmholtz and Rood. The more significant point is that the scientists and the artists were moving in the same direction, towards a realization that colours were not, as Leonardo and Alberti had believed, immutable realities but depended on individual perception, that they were part of the universe of light, one of the elementary dimensions of nature. Unlike the traditionalists in both fields, the new breed of scientists and artists could

Auguste Renoir
Ambroise Vollard 1902

no longer believe in the existence of a permanent, independent, unchangeable reality which could be controlled by perspective or Newtonian physics – a hypothesis which had done much to allay the anxieties of Western man since the Renaissance.

Unconsciously, they were moving towards a concept of the nature of matter which was to find expression half a century later in the discoveries of Einstein. In this context their concern with time – this is, of course, especially true of Monet, who eventually endeavoured to relate light, time and place in a sequence of serialized images of cathedrals and lily ponds – is especially significant. The advent of the machine, with its fixed temporal rhythms and the demands it made on its users to comply with them, had fostered an obsessive concern with time, symbolized by the vast proliferation of clocks in public places which took place after about 1840, by the emergence of history as a dominant discipline, and by the appearance of systems such as the Darwinian and the Marxist which were essentially time-orientated.

But if time and light were one series of preoccupations which affected the nature of Impressionism, speed, the combination of time and space, was another. Till the popularization of the railway engine in the 1830s and 1840s, nobody had experienced travelling at more than about 15 miles an hour. To see objects and landscapes from a train travelling at 50 or 60 miles an hour emphasized still further the subjective nature of visual experience, underlying the transitory, blurring the precise outlines to which post-Renaissance perspectival art had accustomed the artist's eye, and unfolding a larger, less confined view of landscape. Even the increased ease of transport was significant. The Impressionists opened up the South of France as a source of inspiration; they travelled more extensively than any other group of artists had been able to in the past; their work was nourished by a greater variety of landscape.

There were other technological discoveries of their time which influenced them. Chemistry was extending the range and improving the quality of pigments available to the artist (chemical pigments are purer and more stable than their organic equivalents); paper and other materials were cheaper and generally better. Most important of all, however, was the influence of what had originally been called 'the pencil of nature' – the camera. Its impact on art generally, and on Impressionism specifically, was enormous.

In the first place, the camera then had none of the pejorative 'mechanical' associations with which it was later to be endowed. In 1859 the Salon included a photographic section, and in 1862, after a prolonged legal battle, the courts declared photography an art-form – much to the chagrin of Ingres. His reaction was understandable: the camera was to abrogate one of the, admittedly minor, functions with which artists – especially of his type – had always been entrusted: as documenters of events and appearances; the result, of which the Impressionists must have been half-consciously aware, was to allow painting to be itself, to emancipate it from the necessity of referring to a concept of external reality as an inescapable criterion. Art had achieved a self-sufficiency.

But the Impressionists – and in this they were not unique: many of their more academic contemporaries had come to the same realization –

were aware that photography had made an important contribution to the painter's technical armoury. It enabled him to get a steadier and more continuous look at appearances; it permitted analyses of the nature of structure, and of movement, of a kind which had never been possible before. Photography and the new art were natural allies: the first Impressionist exhibition was held in the premises just vacated by Nadar (Félix Tournachon), photographer, cartoonist, writer and balloonist. Much of Eadweard Muybridge's work in the photographic analysis of movement was carried out in France, where he had worked in collaboration with the painter Meissonier, and it was widely known and discussed in artistic circles. Himself an ardent photographer, Degas saw the publication of Muybridge's instantaneous photographs in *La Nature* in 1878, and thereafter followed his work closely (A. Scharf, 'Painting, Photography and the Image of Movement' in *The Burlington Magazine*, CIV 1962, pp. 186–95), not only being influenced by it in a general way, but making drawings and sculptures from some of the plates in Muybridge's *Animal Locomotion*.

In his work on *Degas, Manet, Morisot*, Paul Valéry summed up some of the perceptual consequences of this new technical 'eye': 'Muybridge's photographs revealed all the mistakes which painters and sculptors had made in depicting, for instance, the movements of a horse. They showed how creative the eye is, elaborating on the data which it receives. Between the state of vision as mere *patches of colour* and as *things* or *objects*, a whole series of mysterious processes take place, imposing order on the jumbled incoherence of mere perception, resolving contradictions, reflecting prejudices which have been formed in us since infancy, imposing continuity, connection, and the systems of change which we classify as *space, time, matter*, and *movement*. That is why the horse was supposed to move in the way the eye seemed to see it, and it might be, if that old-fashioned method of representation was studied with enough percipience, we might be able to discover the *law* of unconscious falsification which enabled people to picture the positions of a bird in flight or a horse galloping, as if they could be studied at leisure.'

Implicit in Valéry's notions are many of the aims and preoccupations of the Impressionists. Moreover, the vision of the camera incorporated that very element of immediate spontaneity which had become such a desideratum. It froze gestures, immobilized a movement in a street, fixed for ever a dancer's pirouette. It conveyed a form of truth: it was real, and the Impressionists were above all else Realists – not only in their choice of subjects from everyday, ordinary life and everyday, ordinary people, but in their determination to be visually sincere, not to vamp up the things they saw, not to paint them as they *thought* they were, but as they actually were. Zola, writing in 1868 about Monet, Bazille and Renoir in his *Salon*, called them *Actualistes*: 'Painters who love their own times from the bottom of their artistic minds and hearts. . . . They interpret their era as men who feel it live within them, who are possessed by it, and happy to be so. Their works are alive because they have taken them from life, and they have painted them with all the love they feel for modern subjects.'

The vision of the camera was an enormous incentive in this direction. And it influenced not only the Impressionists' attitudes but their style.

Time and time again the composition of their paintings imitates, or is influenced by, the arbitrary, unselective, partly random finality of the photograph. No longer is there the academic insistence that the subject should be coherent, complete and seen from a compositionally convenient viewpoint. The unity is now in the painting, and in the elements which compose it. Figures may be truncated, poses awkward and ungainly, movements arrested. Chance has entered into painting, to be controlled, manipulated, but still to retain a dominance which it can never lose.

It would, of course, be absurd to see Impressionism purely as the by-product of social, scientific and historical factors. It was rooted firmly in the stylistic evolution of art. Always we are tempted to over-dramatize history, and though Impressionism was indeed the nucleus of the new and the revolutionary, we see it now as more closely related to the art of its own time than the simplifications of criticism once seemed to demand. The Pre-Raphaelites, for instance, though they adopted a different technique, were equally concerned with visual and social realism; the cult of 'sincerity' was widespread, and had been formulated by Ruskin; the academic Meissonier's light, nervous brush-stroke was not unlike the *facture* of many of the Impressionists in the later 1860s, and round about this period Millet's paintings began to palpitate with a hitherto unfamiliar light.

Though they rejected official art, the Impressionists owed an allegiance to some of their immediate predecessors. Manet's teacher Thomas Couture, though apt to paint pictures of decadent Romans, suggested that artists of the future might find as appropriate themes workers, scaffolding, railways (*Méthodes et entretiens d'atelier*, Paris, 1867, p. 254) and there was a whole tradition – of what might be called potential avant-garde painters – which contributed significantly to the techniques and ideology of Impressionism. Delacroix, with his romantic fervour and liberated attitude towards colour, was an obvious idol. So too was Courbet, who once said 'Realism is Democracy in art', and whose life-style as well as his actual work had a very marked influence, especially on Pissarro and Cézanne.

The real achievement of the Impressionists is that they gave coherence and form to tendencies which had for some considerable time been latent in European art. Turner and Constable, for instance, whose influence is discussed later, had been concerned with many of the same problems about light, colour and the approach to a 'realistic' interpretation of landscape. The whole of the Barbizon school had been painting out of doors (*au plein air*) since the 1840s, even though they usually completed their paintings in the studio. Narcisse-Virgile Diaz (1807–76) had been one of the most forthright opponents of 'the black line' in painting, and his exercises in capturing the effects of sunshine coming through the dark greens of the forest, all expressed in a heavy impasto, contained obvious elements of Impressionism. It was he who, meeting Renoir painting in Fontainebleau, said, 'Why the devil do you paint so black?' – a remark which had an immediate effect on the younger artist's palette – and who, incidentally, allowed Renoir to buy painting materials on his account. Théodore Rousseau (1812–67), who expressed the ideal 'always to keep in mind the virgin impression of nature', carried an interest in the rendering

of atmospheric effects to a point where it came close to Monet. The sense of poetry, the compulsion to reproduce scrupulously what he saw, and the light silvery tonality of Corot (1796–1875) had an obvious impact, and the luminous Northern seascapes of Eugène Boudin (1824–98), with their vivacious directness, their creamy impasto and their radiance, made it almost inevitable that, though not an 'official' Impressionist, he should participate in their first group show.

There were other artists outside of France who anticipated Impressionism, or followed similar lines of approach. Outstanding among these are the Germans Adalbert Stifter (1805–68), who was also a poet and stumbled almost accidentally on those qualities of visual sincerity and spontaneity typical of the movement, and Adolf Menzel (1815–1905), whose mastery of light was only appreciated after his death. The Dutchman Johan Jongkind (1819–91) was virtually a Parisian, and though he did not practise *plein-air* painting, he was obsessed with representing in his works not what he knew about the subject, but what appeared to him under certain atmospheric conditions. It is interesting that in an article in *L'Artiste* in 1863, the critic Castagnary said of him: 'I find him a genuine and rare sensibility. In his works everything lies in the *impression* [my italics].'

The art of the past was revealed to painters of the mid-nineteenth century in a way which would have been impossible before. Till the 1840s museums and art galleries were few and far between, but between then and the end of the century they proliferated at an extraordinary rate. Sisley, Monet and Pissarro saw the works of Turner, Constable and others in London's National Gallery, which was then only a few decades old. Every provincial city of importance acquired its cultural institutions, and, in ever-increasing numbers, works of art which had once belonged to private collectors found their way into public collections, where they were described and analysed by critics as perspicacious as the painter Eugène Fromentin and others. It was through these innovations that the Impressionists became conscious of, and reacted to, a whole range of old masters, from the early Renaissance painters to Dutch landscapists such as Ruysdael, all of whom gave sanction to their visual explorations and enlarged their range. The Louvre, of course, had been in existence for some time as a public gallery, and its treasures had been greatly enlarged by Napoleon. But even here an important innovation took place in the 1830s, under the reign of Louis-Philippe, when in consequence of that monarch's dynastic preoccupations with Spain, the gallery acquired an important collection of paintings by hitherto little-known artists such as Velázquez, Ribera and Zurbarán, all of whom were to have an enormous impact on the painters of the 1870s. In 1851 Napoleon III reopened the newly rearranged galleries, which had been enhanced by the addition of the Rubens *Medici* cycle. Despite the contrary image of him which has grown up, Napoleon III's administration of the governmental Beaux-Arts department was far more enlightened and progressive than anything else of the same nature in Europe. Special copying facilities were provided at the Louvre, the Palais du Luxembourg was given over to contemporary art, and it was, after all the Emperor himself who initiated the Salon des Refusés in 1863.

Another new set of influences came from outside Europe. As far back as 1856 Japanese art had started to infiltrate into Paris, and six years later Madame Soye, who had lived in Japan, opened a shop, 'La Porte Chinoise', in the Rue de Rivoli; the simple colours and summary treatment of light and shade which were to be seen in the prints of Hokusai and others began to have their effect on a number of artists including Whistler, Rousseau, Degas, and later Van Gogh and Gauguin.

Edouard Manet (1832–83), too, was intrigued and influenced by this revelation from the East, but that is not surprising, for though the accidents of history forced on him the role of the great innovator, and the *maître d'école* of Impressionism, few painters have paid more attention to the art of the past and of their own time. His most famous painting, *Le Déjeuner sur l'herbe* (d'Orsay) of 1863, which when it was exhibited at the Salon des Refusés aroused a storm of ridicule and controversy (which effect may not have been entirely foreign to his intentions), was based on a Giorgione and on a Renaissance print of a painting by Raphael; the equally controversial *Olympia* (d'Orsay) was clearly painted under the direct influence of Titian, and many of his compositional themes were borrowed from his contemporaries, especially Monet and Berthe Morisot. Popular prints also provided for him a frequent repertory of imagery, and the kind of subject he so often chose, rag-pickers, barmaids, actors, crowds enjoying concerts, were the staple of many illustrated magazines of the period. He was an assiduous frequenter of museums in the Low Countries, Austria, Germany and Italy as well as France and Spain, and it was the influence of Velázquez and Goya which informed those of his early paintings – often with the appropriate Hispanic theme – such as *Lola de Valence* (d'Orsay) which had a modest popular success, based on the same wave of public interest in the peninsula which Bizet so successfully exploited in *Carmen*.

Almost in spite of himself, Manet had become to the young artists of the Café Guerbois and the Atelier Gleyre a symbol of revolt, a Robespierre of art. It was his subject matter which appealed at least as much as his free and inventive technique. *Music at the Tuileries*, painted at about the same time as *Le Déjeuner*, emphasized the quality of direct observation of an ordinary urban event, packed though it is with portraits of the painter's friends, and related though it probably is to an engraving of a military band recital which appeared in the magazine *L'Illustration*.

Towards the end of the 1860s, however, Manet began to paint in the open air, and he transferred his attention from exploiting to exploring the effects of light and colour. But he was never entirely to lose the sharp contrasts of light and shade, the sensuous brushwork, the feeling of drama, the flattened volumes which he had derived from the Spaniards, and which are to be seen so vividly present in the *Eva Gonzalès Painting* (National Gallery, London). His sense of the discipline of art persisted despite the freedom which his painting acquired as he came into closer contact with the work of his admirers (he did not participate in the Impressionist exhibitions), especially Monet and Renoir, to whom, paradoxically, he owed so much. This contact was most fruitful between 1874 and 1876 when he worked with them at Argenteuil, where he

Edouard Manet
Le Déjeuner sur l'herbe 1863

Edouard Manet
Olympia 1863

Edouard Manet
Music at the Tuileries 1862

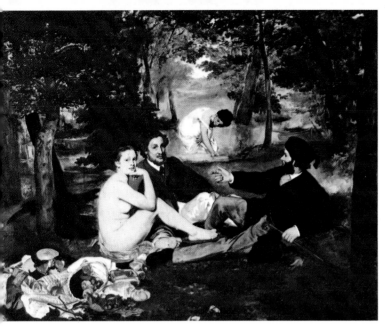

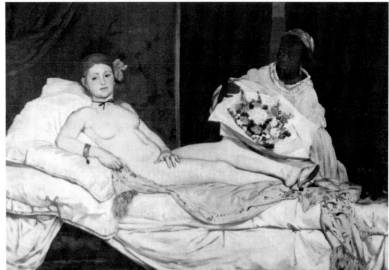

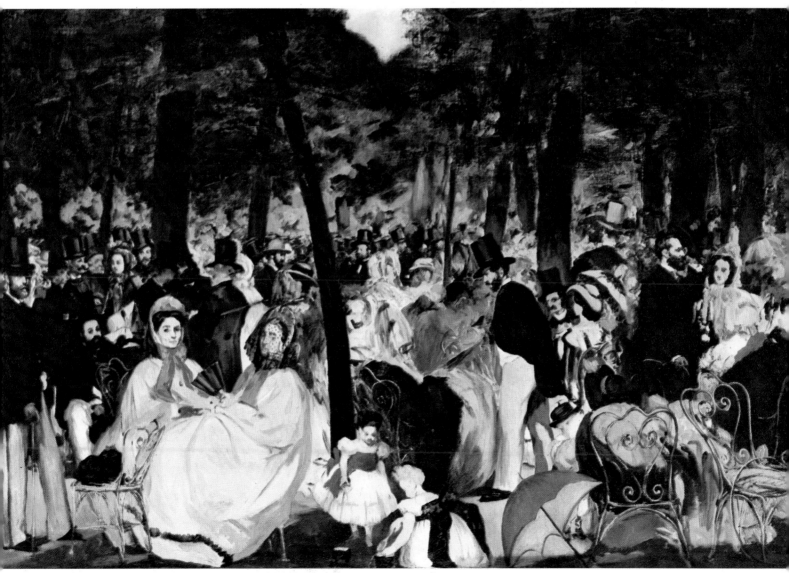

painted, among many other similar themes, the *Boating*, now in the
Metropolitan Museum, New York. Here, despite the limpid colour, the
free handling and sense of spacious luminosity, there is a sense of linear
control, a complex handling of the compositional elements. Here, and in
the *Waitress* of 1878, the structure is intellectual, the handling
instinctive. The same is true of the *Bar at the Folies-Bergère*, painted a year
before he died and at a period when he was already suffering from the
locomotor ataxia which killed him. The complexity of the subject matter,
the manner in which it is composed, the sense of space and volume, the
ingenuity of the perspectival effects, recall *Music at the Tuileries*, but here
there is an added richness, a magisterial certainty and richness of vision
lacking in the earlier work.

The vibration of colour, the nature of light, the ability to capture at the
moment anonymous figures, trapped between reality and its shadows – all
these were Manet's constant concern, and he brought to their realization
techniques which were very much his own. The light passages in his
works were the dominant ones, brushed in with flowing, 'fat' paint; into
this paint, while it was still wet, were worked the darks and the half-
tones. In a way it almost simulated the fresco techniques of the early
Italians, producing just that sense of limpid freshness which they share

Edouard Manet
Waitress Serving Bocks c. 1878–79

Edouard Manet
Eva Gonzalès 1870

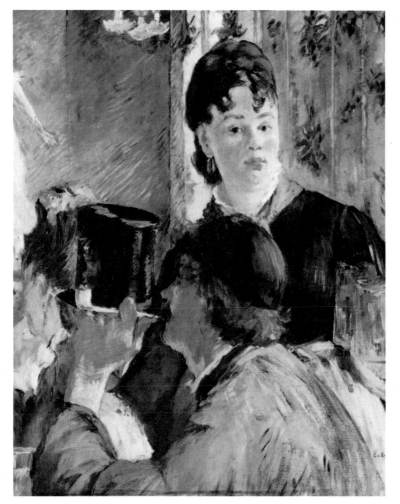

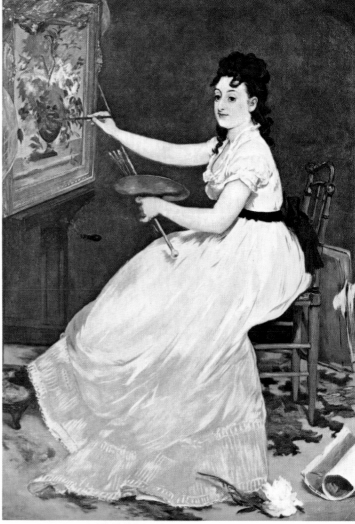

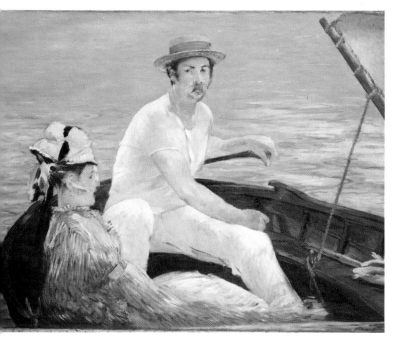

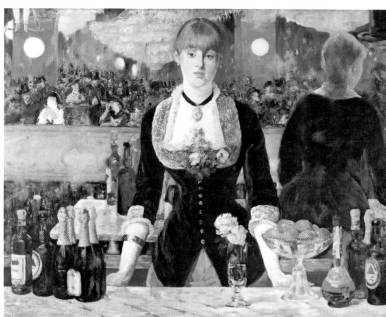

Edouard Manet
Boating 1874

Edouard Manet
A Bar at the Folies-Bergère 1882

with Manet. He was the most revolutionary of traditionalists, the most traditional of revolutionaries.

The relationship between Manet and Berthe Morisot (1841–95) was close, and a good deal more complex than is often surmised. The great-granddaughter of Fragonard, she was born into an affluent banking family, and her mother created one of those cultural salons so typical of the Second Empire. Berthe Morisot began to study painting at the age of fifteen under Joseph-Benoît Guichard, and then under Corot, one of the habitués of her mother's salon. She worked with Corot until 1868, when she first met Manet, who had been very much taken by a painting, *Paris Seen from the Trocadéro* (Ryerson Collection, Chicago), which she had exhibited at the 1867 Salon. Not only did Manet praise its freshness and delicacy, its low-toned Whistlerian harmonies; he carried flattery to the point of imitation by using the theme and many of the compositional elements which it contained in the *View of the Paris World's Fair* (Nasjonalgalerie, Oslo) which he painted in the same year. It was inevitable that an artist with Morisot's particular sensibilities should have fallen under Manet's influence, and for several years she worked in his studio, as his pupil and his model (she eventually married his brother Eugène). His most famous portrait of her is in *The Balcony* (d'Orsay), of 1869, in which her dark, smouldering, almost Pre-Raphaelite, intensity provides a piquant foil to the pert attractiveness of the violinist Jenny Claus.

In the first Impressionist exhibition of 1874 Morisot showed *The Cradle* (d'Orsay), in which the visual drama of the composition – with its strong counterpoint – emphasizes the delicacy of the paint and the lyricism of the subject matter, even though the main element, the baby, is technically unconvincing. A comparison with the portrait of her mother and younger sister Edma, painted some four years earlier (National Gallery of Art, Washington), shows how far she had moved towards a greater lightness, a keener sense of tonal recession, a crisp delicacy of

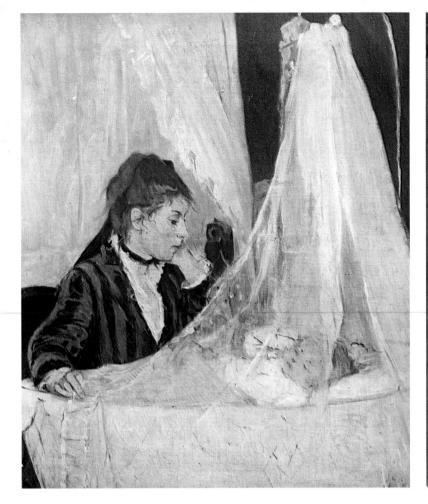

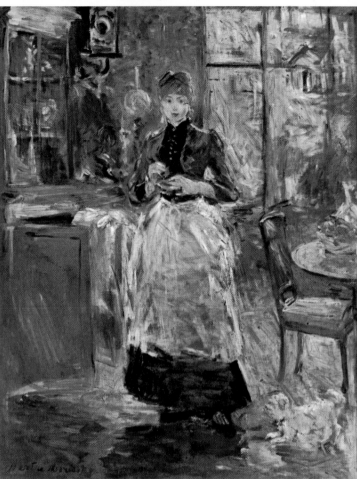

touch. More consistently than any other of his students, she preserved Corot's silvery iridescence, and it was this quality, allied to an almost uninhibited and uncontrolled distribution of brush-strokes, which created her personal style and explains the undoubted influence she was to have on Manet, exorcizing the darkness and chromatic inhibitions which characterized his work after the early 1870s. In her *In the Dining Room* (National Gallery of Art, Washington) of 1884, for instance, the strokes which make up the door of the cupboard, the maid's apron, the floor and the glass in the window are virtually free gestures, visual abstractions, through which shapes and forms emerge as from a mist.

Both as a person and as a painter Claude Monet (1840–1926) was very different from Manet. Less detached, less diffident, he was committed by his nature, by economic necessity – and by a kind of professionalism which, one feels, Manet would have disdained as being not quite *comme il faut* – to vigorous exploration of the substance and nature of his art. Perhaps this is what Zola meant: 'He's the only real man in a crowd of eunuchs' (though that remark, like so many things Zola said about art, was not really true, even though compelling). A provincial, born in Le Havre, with ferociously precocious talents, Monet eventually became more peripatetic than any of his colleagues, and his subject matter covers a remarkably wide range of places and themes. Boudin and Jongkind had

Berthe Morisot
The Cradle 1873

Berthe Morisot
In the Dining-room 1886

been early influences on him, and though he deferred to Courbet, he did not imitate him. At the studio of Charles Gleyre he met Bazille, Renoir and Sisley, and he subsequently underwent the virtually obligatory experience of Fontainebleau. But though he had produced by this time some three hundred paintings, and had been accepted in the Salon, he was plagued by economic and psychological stress, and at the age of twenty-six tried to commit suicide (the psychological disturbance common to many of the Impressionists has not received the attention it perhaps merits).

It was not, however, until Monet came to London in 1870 that his art really jelled. Although he professed to dislike Turner's 'exuberant romanticism', and denied in later life that Turner had any influence on him, it is impossible not to see in his use of aerial perspective, his treatment of wide reaches of landscape and of sea, even his concern with the transient, amorphous effects of fog, steam and clouds, something of the influence of the English landscape artists. Then there was the actual quality of London's light, which had so intrigued Whistler: mist on the Thames, with the great buildings and bridges swimming out of it; the green reaches of the parks; the constant mutations of atmosphere.

Pissarro explained it well some thirty years later in a letter to Wynford Dewhurst, who was writing a book, published in London in 1904, *Impressionist Painting*: 'Monet and I were very enthusiastic over London landscapes. Monet worked in the parks, whilst I, living at Lower Norwood, at that time a charming suburb, studied the effect of fog, snow and springtime. We worked from Nature, and later on in London Monet painted some superb studies of mist. We also visited the museums. The

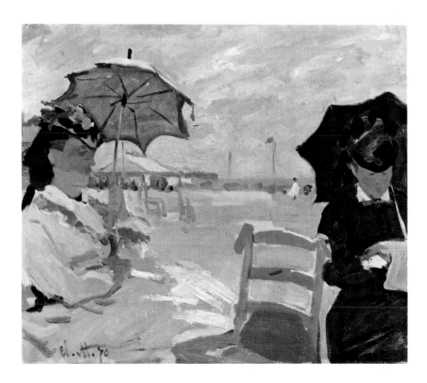

Left:

Edouard Manet
Berthe Morisot 1872

Right:

Claude Monet
On the Beach, Trouville 1870

watercolours and paintings of Turner and Constable, the canvases of Old Crome, have certainly had an influence on us. We admired Gainsborough, Reynolds, Lawrence etc., but we were struck chiefly by the landscape painters, who shared more in our aim with regard to *plein air*, light, and fugitive effects. Watts and Rossetti strongly interested us among the modern men. About this time we had the idea of sending our studies to the Royal Academy. Naturally we were rejected' (pp. 31–32).

A visit to Holland, itself part-ancestor of the English tradition, confirmed Monet in his already obvious concern with light and transience, and some encouragement had come from the fact that Durand-Ruel bought his *On the Beach: Trouville*. A fruitful stay at Argenteuil brought him into closer contact with Manet and Renoir, confirming his instinctive belief that Impressionism provided the appropriate framework for his creative intentions. To the exhibition of

Claude Monet
Women in the Garden 1866–67

Claude Monet
Wild Poppies 1873 (detail)

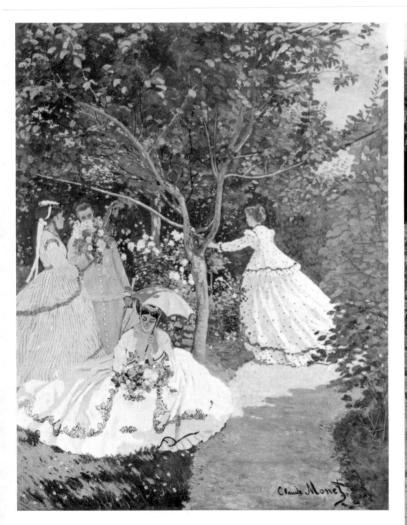

1874, which owed a great deal to his initiative, he sent five paintings – including *Autumn at Argenteuil* and *Bridge at Argenteuil* – and seven pastel sketches. He continued his association with the movement until the fifth exhibition, to which he refused to send anything. In 1876 he began a series of paintings of the Gare Saint-Lazare which, in their subject matter, their luminous treatment of the effects of atmosphere and steam, their lightly adumbrated but unifying structures, may well be thought of as the most 'typical' of all Impressionist paintings.

A steady, persistent worker, independent of the necessity of waiting on 'inspiration', agonizing over every picture he started, Monet found a prop for creativity in serialism, the creation of sets of works all using the same motif; and so virtually stumbled on one of his most original contributions to the language of contemporary art. Quite apart from the technical use of the system, which has been of such value to later painters, he proved

Claude Monet
Autumn at Argenteuil 1873 (detail)

Claude Monet
The Bridge at Argenteuil 1874 (detail)

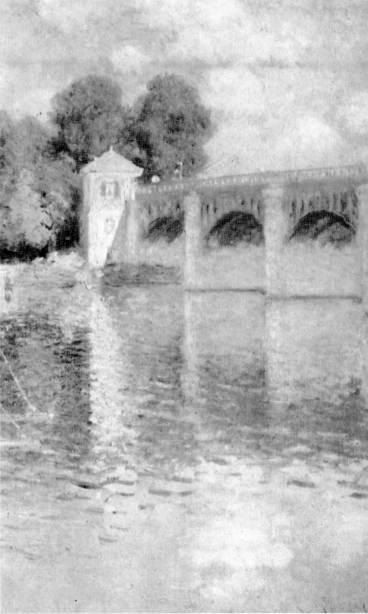

and emphasized that a whole range of equally 'real' paintings could be made of the same subject, each varying according to the quality of the light and the time of day. At first rather haphazard – as in the *Gare Saint-Lazare* series, and the views of Westminster Bridge – they became more purposeful with the *Poplar* series and that devoted to the façade of Rouen cathedral, culminating in the *Nymphéas* series, the most remarkable attempt art had ever made to paint the passage of time.

Unlike Manet, he paid little attention to the old masters, being influenced rather by his contemporaries. In *Women in the Garden* (1866–67), and even more in later works, he evolved a method of depicting form by accumulating a mass of brush-strokes which are reconstructed and completed by the spectator to produce the effect he is suggesting. This again was a vital new element in art: the realization that the viewer has to participate, that he has to build his understanding of a painting, just as he 'reads' a landscape. This attitude was essential to the future of art. It

Claude Monet
Poplars on the Epte 1891

Claude Monet
Water-lilies: Sunset 1914–18 (detail)

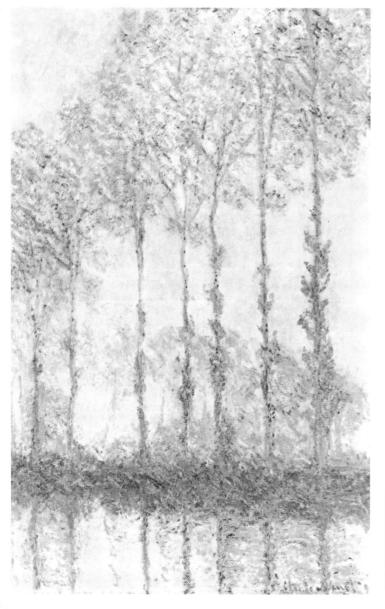
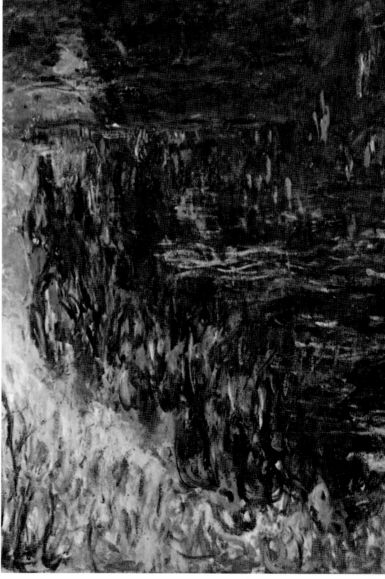

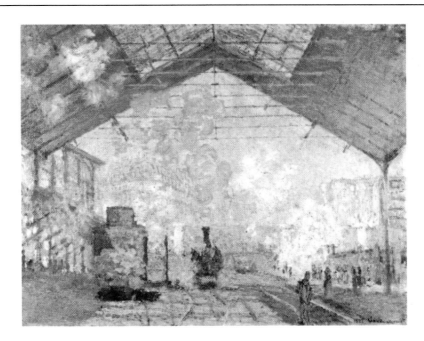

Claude Monet
Gare Saint-Lazare 1877

was only because Monet destroyed the old limited, arbitrary concept of immutable form that the painters of the twentieth century were able to build new visual structures.

Of Alfred Sisley's contributions to the seventh Impressionist exhibition of 1882 Eugène Manet said that they were the most consistently coherent of the whole group, and it would be difficult to pick on a painter more typical of the movement as a whole. Born in Paris of wealthy English parents, Sisley's (1839–99) career was socially and economically almost the exact reverse of that of his colleagues. Encouraged to become a painter by his father, he began his career cushioned by affluence, and his appearance at Gleyre's studio was that of a young dandy. Leaving there in 1863, at the same time as Bazille, Monet and Renoir, he worked with them, exploring the landscape of the forest of Fontainebleau and, like them, concerned himself with the shimmer of light on leaves and the analysis of shadow, painting, with similar fervour, the glades which had bewitched Daubigny and Courbet in the 1850s.

This was to be his familiar, beloved landscape; short visits to Brittany and England (*Molesey Weir*) were the only occasions when he left the Ile-de-France. Nor did he – unlike Renoir – go far beyond a dedication to landscape, nor yet, unlike Monet, concern himself with the transformations effected by time. The figures (as in the magical *Misty Morning*) are perfunctory. These limitations were self-imposed, but their rigour was probably reinforced by his lack of success. Although he succeeded in getting a painting into the Salon of 1866, Sisley was subsequently rejected, a situation compounded in difficulty by the economic ruin of his father as a consequence of the Franco-Prussian war. Poverty was to be his constant irritant; his outstanding virtue, modesty, he cultivated almost to the point of converting it into a vice. Yet he was

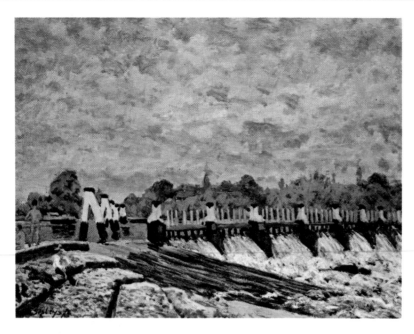

Alfred Sisley
Molesey Weir, Hampton Court c. 1874

singularly dedicated to achieving his own, admittedly limited, form of perfection, and his paintings, at their best, have a clarity, a brilliance and a sense of aesthetic honesty which are infinitely compelling. Nobody could better him in achieving the balance between form and the light which irradiates it, so that the one is never dissolved in the other. The transition between water, trees, building and cloud-flecked sky in *Floods at Port-Marly* is symptomatic of his consistent tonal mastery, and the way in which he conveys a sense of almost palpable atmosphere. Remarkable rather for the delicacy of his perception than for the dynamism of his imagination, Sisley frequently manifests a certain dullness of composition, as evinced for instance in the *Canal Saint-Martin*, where the great weight of the barges grouped at the intersection of the horizontal and vertical extreme and mean ratios is mechanically balanced by the two masts accentuating the gap between the distant houses. But the treatment of the

Alfred Sisley
Floods at Port-Marly 1876

Alfred Sisley
Canal Saint-Martin, Paris 1870

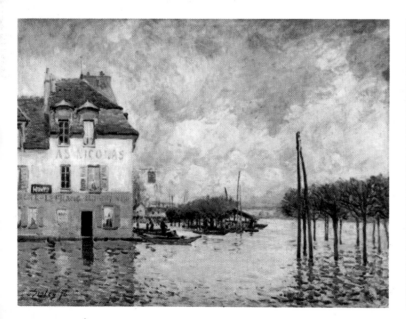

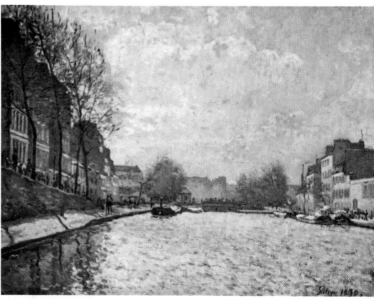

Alfred Sisley
Misty Morning 1874

surfaces, the movement of the water, the radiance on the distant roof-
tops, and the texture of the canal wall are all rendered exquisitely. Sisley's
was a kindred spirit to Corot's in the previous generation. The worst that
can be said of him is that his pictorial reticence has been taken as a
prototype by innumerable lesser talents, whose amateur enthusiasms
have found in his paintings the justification for their own creative
inanity.

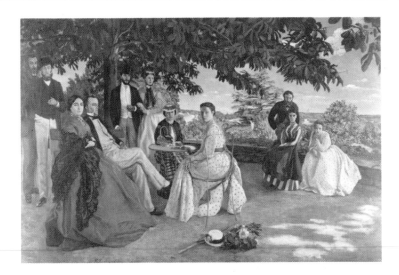

Frédéric Bazille
Family Reunion 1876

Over the work of another member of the Gleyre quartet hangs the
enigma of premature death. Frédéric Bazille (1841–70), arriving in Paris
from Montpelier in 1861, was supposed to divide his time between
studying medicine and studying art, but it was the latter which obsessed
him, and he became entirely committed to the emergent principles of
Impressionism. With Monet and the rest he painted at Chailly in the
forest of Fontainebleau, and also spent some time in that other habitat of
young painters, the Normandy coast. From a letter which he wrote to his
parents at this time we can get some idea of the atmosphere of the time:
'As soon as we arrived at Honfleur we started to look for suitable
landscape subjects. They were easy to find, for the country here is heaven.
It would be impossible to find anywhere richer meadows or more
beautiful trees. The sea – or rather the Seine, as it broadens out –
provides a marvellous horizon to the masses of green. We are staying in
Honfleur itself at a baker's, but we eat at a farm on the cliffs above the
town, and it's there that we do our painting. I get up every morning at
five, and paint all day till eight in the evening. However, you mustn't
expect me to bring back a lot of good work. I'm making progress; that's
all I want. I hope to be satisfied with myself after three or four years of
painting. Soon I'll have to go back to Paris and apply myself to medicine,
a thing which I abhor' (G. Poulain, *Bazille et ses amis*, Paris, 1932, p. 40).
Progress he did make, despite some hesitancy (a weakness which always
seems to affect artists whose economic circumstances absolve them from
complete dependence on their work) and an inability to free himself from
those Ingres-like conventions of academic precision which had
characterized his training. They are apparent in *The Family Reunion*,
painted on the terrace of the Bazille home at Montpellier. But other
things are also evident in this moving work: a clarity of vision, a
simplicity of conception heightened by the bright, luminous colours, and
a spontaneity, which are characteristic of youth. Three years after
painting this picture, and shortly after his famous group portrait of 1870
painted in his studio (the figure of himself in it was painted by Manet)

had been rejected by the Salon, he was killed in action at Beaune-la-Rolande.

Bazille had been a great help to his friends, providing not only admiration – even hero-worship – but also money. In 1869, when Monet was experiencing more than his usual difficulties, for instance, Bazille bought his *Women in the Garden* for the obviously philanthropic price of 2,500 francs. In both these respects his place in the group was taken by Gustave Caillebotte (1848–94), an engineer specializing in boat-building, who had met Monet at Argenteuil, where they were neighbours. A simple, intelligent, warm-hearted bachelor, Caillebotte was already an amateur painter, but the work of his new friends came to him with the force of a revelation, and by 1876 he was exhibiting at their group exhibitions. His talents were not enormous, but they were real, and though his portraits betray the influence of Degas, there was something very personal about his views of Paris and the villages of the Ile-de-France, and even more so about his paintings of working-class life and activities (*Workmen Planing a Floor*, d'Orsay).

But Caillebotte's importance cannot be estimated purely in terms of his work. He was above all a friend, *un bon copain*, helping to the utmost of his resources Monet, Renoir, Sisley and the rest, acting as an adviser and an organizer, and taking upon himself most of the responsibility for arranging at least three of the group exhibitions. At the age of 27 he made his will, naming Renoir as his executor and stipulating that enough money should be taken from his estate 'to arrange under the best possible conditions, an exhibition of the painters who are called *Les Intransigeants* or *Les Impressionnistes*'. In the event this was not necessary, for by 1894 the Impressionists had secured a fair degree of recognition. And yet, although he left his collection of 65 paintings by the Impressionists to the State, it was only after three years of agitation that the authorities consented to accept 38, and these did not enter the Louvre till 1928. It is typical of Caillebotte's nature that he consistently bought from his friends those paintings which they found most difficulty in disposing of. And it is those pictures which, of course, now are often recognized as their most important.

Camille Jacob Pissarro (1830–1903) was a movement in himself, and though he was by no means the greatest of the Impressionists, the movement as such owes more to him than to any other of its members. An able and coherent theorizer, a persistent stylistic explorer, a born teacher – his pupil Mary Cassatt said that he could have taught the stones to draw correctly – he was friend and counsellor to his associates; even the usually uncommunicative Cézanne once confessed, 'He was like a father to me. He was the sort of man you could consult about anything – a sort of God the Father.' He digested the discoveries of others; he expressed them in an understandable and engaging, but seldom very dramatic, style; he ensured the transmission of the Impressionist legacy to its inheritors; and Gauguin was to acknowledge, 'He was one of my masters, and I shall never deny the fact.' At those moments when the very existence of the group seemed threatened by the actual or imminent defection of members, Pissarro held it together; he contributed to all eight exhibitions, and accepted with equanimity the condescension, or even

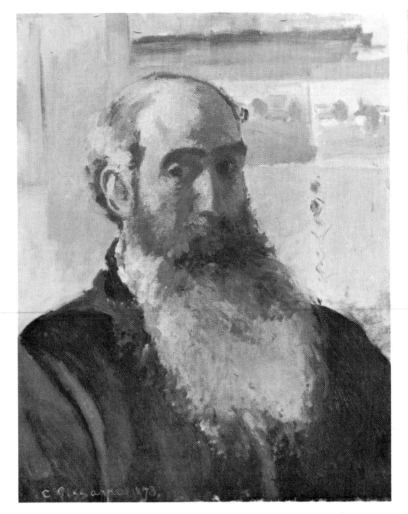

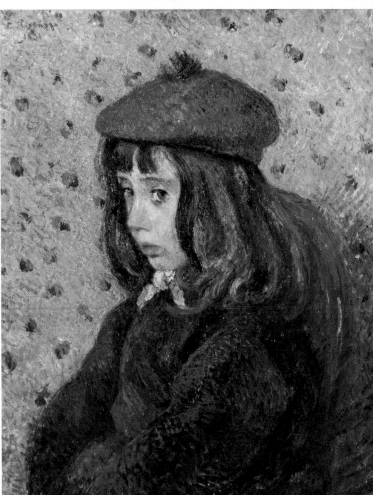

contempt, with which some of his contemporaries regarded him once they had tasted the fruits of success.

Born in the Virgin Islands, where his father, a Frenchman of Portuguese-Jewish descent, was a successful trader, he came to Paris in 1855, determined to become a painter. He admired Delacroix, took lessons from Corot, who was to be a major influence on his early work, and became a pupil at the Académie Suisse, an establishment opened by a former model, where students could draw and paint from the life without any formal tuition. There his work – combining at this time something of Courbet's sense of compositional drama with the limpid luminosity of Corot – greatly impressed the young Monet. For the next two decades their careers were to be closely intertwined, and together they moved towards the techniques and attitudes of Impressionism. On the outbreak of war in 1870 they both moved to England, to which Pissarro was to return at regular intervals. They found London and its neighbourhood a rich source of subject matter, and, even more to the point, it was there that they met Durand-Ruel, who was to become the 'guardian angel' of Impressionism.

On his return to Paris Pissarro discovered that most of his 1,500 canvases (this gives some idea of his output) left at his studio at

Camille Pissarro
Self-portrait 1873

Camille Pissarro
Portrait of Felix 1883

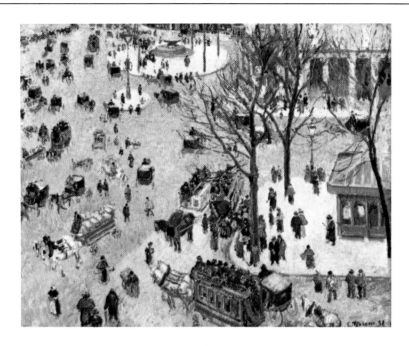

Camille Pissarro
Place du Théâtre Français 1898

Camille Pissarro
Place de la République, Rouen 1886

Louveciennes had been destroyed, though one interesting survivor is the painting of that district which he must have painted shortly before leaving. Despite – or perhaps because of – near-poverty and despite failing eyesight, he painted with prodigious energy, torn often enough between what to him were the conflicting claims of mass and luminosity, sometimes close in feeling to Monet, sometimes inclining to the plastic preoccupations of Cézanne, and in doing so influencing both. By the 1880s, however, he was becoming increasingly aware of the structural problems which Impressionism seemed to sidetrack and, seduced by all the talk going on in studios about the theories of light and colour propounded by Rood, Helmholtz and Chevreul, he fell under the influence of Seurat with his belief in 'scientific' painting and his fond hope that he had discovered a technique for representing visual truth. For some five years Pissarro produced a series of Pointillist paintings based on the divisionist technique of tiny dots of pure colour, but he found this too rigid in the long run, and by 1890 had returned to his earlier style.

In 1892 he held a very successful one-man exhibition at Durand-Ruel's; he had found himself. He divided his time between Paris and Eragny, which had provided the subject matter for most of his Pointillist landscapes. In the city he concentrated mostly on fairly large urban views – such as the *Place du Théâtre Français* of 1898 – usually painted with an aerial perspective, in which he showed a remarkable ability to control complex subject matter, relate figures to their environment, maintain a sense of movement, and yet preserve a technical vivacity as convincing as that which informed the landscapes of his youth. Complementary to these, and usually painted in the country, were the landscapes, interiors, portraits and the like which expressed the *intimiste* side of his personality. In the 1880s he painted tender portraits of his son Félix, and of another

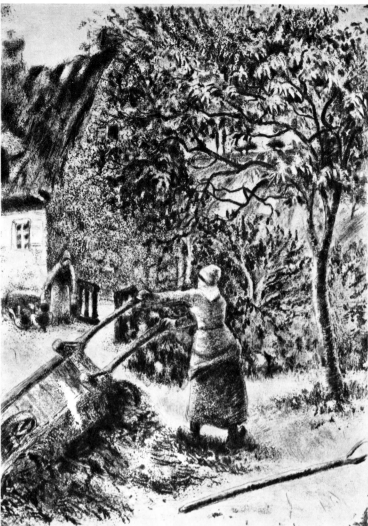

Camille Pissarro
The Little Country Maid 1882

Camille Pissarro
Woman Emptying a Wheelbarrow 1880

son sitting with *The Little Country Maid*. A *catalogue raisonné* of his works, compiled in 1939 by his son Lucien, lists some 1,664 paintings, and when one adds to these those destroyed in 1870 it is possible to get some notion of his output.

Probably today the most popular of all the Impressionists – though in fact he was by no means one of the most doctrinally committed – Pierre Auguste Renoir (1841–1919) displayed consistently in his works that sense of visual hedonism, that naturalness, that delight in spontaneous feeling which tend invariably to be associated with the movement. Devoid of dogmatic commitments, presenting himself as a creature of instinct, he once attributed to his generative organ the source of his creative powers. But this bit of braggadocio is balanced, if not explained, by a suggestion of melancholy, a certain appearance of anxiety which characterize the photographs and portraits of him which still exist.

The son of a tailor, Renoir made his first venture into art as a painter of flowers on porcelain, and it is difficult to disregard the theory that this influenced his subsequent development. Throughout most of his career his work possessed a decorative quality which allies him to those artists of the

eighteenth century, such as Boucher, whose main activities were directed towards the provision of objects for the luxury trade. Indeed, the current prices paid for his works suggest that even today his appeal to the devotees of conspicuous expenditure is a powerful one.

While working in the studio of Gleyre Renoir came into contact with Monet, Bazille and Sisley, and by the later 1860s had started producing works which, though clearly influenced by both Courbet and Manet, still showed an intensely personal idiom. Many of these earlier works were street scenes, or interiors such as the very complex *Sisley and his Wife*. He was already concerned with the creative qualities of light, with the solidity of shapes and with the ambiguities of colour. But it was not until he spent some time with Monet at Bougival between 1867 and 1869 that he really began to experiment with these qualities in a free and dynamic way. His paintings of La Grenouillère, a popular bathing resort on the Seine, are exercises in the representation of light, reflections and movements on water, expressed in rapid, freely applied brush-strokes.

Auguste Renoir
The Box 1874

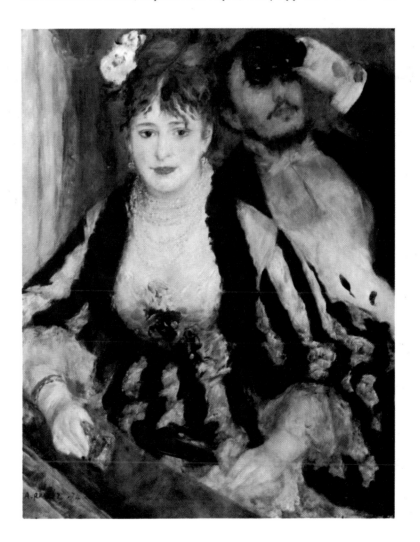

Renoir always, however, had a nagging preoccupation with the human figure, and his concern was largely with employing in its interpretation that chromatic analysis and luminous transfiguration which could so much more easily be applied to landscape. That he achieved this transference was, in effect, his greatest personal contribution to Impressionism, and it was already becoming apparent in works such as the *Odalisque* which he exhibited at the Salon in 1870. Economic necessity impelled him to constant activity, and to any outlet, though after renting a studio in Montparnasse in 1872, where he produced more Parisian street scenes and landscapes of the Ile-de-France, he was taken up by Durand-Ruel. He was largely responsible for the hanging of the Impressionist exhibition of 1874, at which he exhibited seven canvases, including *The Box*, one of his most brilliant transfigurations of the human presence, and *The Ballet Dancer*.

Auguste Renoir
Moulin de la Galette 1876 (detail)

Auguste Renoir
The Country Dance 1890

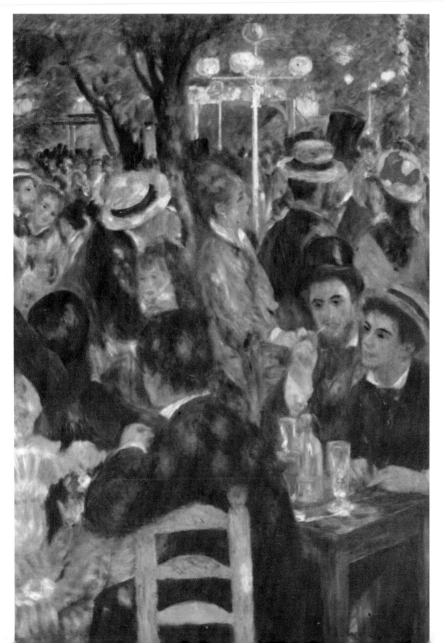

This exhibition was his major break-through, and during the next few years he produced some of his most memorable paintings, in which his own particular feeling for the play of light on people and objects was linked to a remarkable sureness of composition and feeling for the plastic qualities of the human form. Mostly he concerned himself with urban pleasures, with the life of the people, with the diffused Parisian gaiety of what future generations would remember wistfully (and perhaps inaccurately) as *la belle époque*. Typical of this phase was *Moulin de la Galette*, which was exhibited at the third Impressionist exhibition in 1877. The glowing Chinese lanterns, the opalescent distances, the sense of vivacity seem to illuminate the canvas from within itself. But more remarkable even than the Watteauesque fervour of the handling is the way in which a vast and intricate composition including scores of people (several of them were portraits of his friends, Frank-Lamy, Lhôte, Cordey and Rivière), and an infinity of poses and directions, has been welded, partly by light, partly by structure, into an ingeniously convincing unity.

But all the while Renoir's instincts were pulling him in a different direction. Above all else a professional, he was not uninterested in official recognition, and though this may not have been the determining factor in the change which started to take place in his art in the late 1870s, it must have had something to do with it; in any case it led him away from the group as such, and he only once again participated in one of their exhibitions, and that at the request of Durand-Ruel. It is significant that his portrait of Madame Charpentier and her daughters, painted in 1878, had a great success in the Salon of the following year. 'Renoir has had a big success at the Salon; I think he is now really launched, which is a good thing, as poverty is hard,' wrote Pissarro with his usual generosity.

Auguste Renoir
Madame Charpentier and her Children 1876

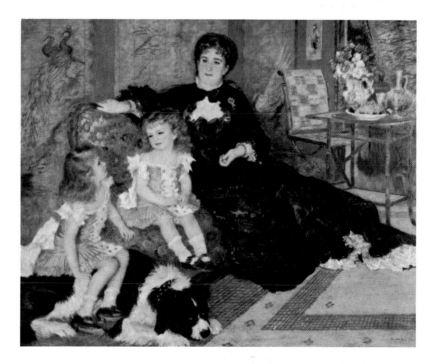

The simple triangular composition of the main figures, balanced by the table and chair at one corner, the prostrate dog at the other, bespeaks a more ordered spontaneity than had hitherto been apparent in his work, and these intimations of a new austerity are reinforced by a certain chromatic rigour.

In 1881 Renoir visited Algiers, and in the following year Italy, where he discovered in the works of Raphael intellectual precedents for continuing in the direction along which his painterly instincts led. Still using light as the unifying element in his paintings, he now began to prefer an Ingres-like definition of outline, a more static and overtly geometric form of composition, a less spontaneous brush-stroke, and a colder palette. At the same time, however – although by now he seemed to have become incapable of escaping from a stereotyping of faces – his conception of the subjects which he painted was amazingly fresh and vivid. Nothing could display this more convincingly than the street scene in the National Gallery, London, entitled *The Umbrellas*. This work seems snapped, as it were, in a moment of time, full of delicious trepidations; and its elements of conscious contrivance, the blueish tonality, and the series of parallel lines which govern its composition, do nothing to impair its documentary vivacity. This is all the more remarkable in that a careful analysis of the painting shows that it was painted over a considerable period and was extensively recast. The two little girls and the lady behind them show strong indications of Renoir's earlier style, and are slightly out of harmony with the general feeling of the whole painting. Indeed, there is evidence of extensive retouching, and the portions of the canvas turned over the stretcher show that the original composition was a good deal larger (see Martin Davies, *National Gallery Catalogue: French School*, London, 1946, no. 3268), and contains elements of a girl's purplish skirt, a gloved hand and the lay-in of part of a face.

This painting seems to mark a withdrawal into a cerebral as opposed to a sensuous style (in Renaissance terms, a move away from Venetian towards Florentine affiliations). But this tendency was soon reversed – as if it had been his deliberate intention to *reculer pour mieux sauter* – and at the point at which he started to emerge from it he produced *The Large Bathers* (Philadelphia), which may be considered the last great exercise in the Renaissance tradition, tempered, nevertheless, by those perceptual sensibilities which the Impressionists were exploiting with such vigour.

Now gradually becoming more and more successful – and, as a consequence of this and the increasing felicity of his family life, more relaxed – Renoir was able to devote more attention to painting for pleasure. He had always tended to choose popular subjects, and by the late 1880s was concentrating more and more on *intimiste* subjects – portraits of his wife and children, vases of flowers, the delights of domesticity, the diffused hedonism of the good life – and hinting too – especially in the series of paintings of Gabrielle, a servant-girl who became an integral part of his iconography – at the pleasures of the bed as well as of the table and the fireside.

His *facture* became progressively looser, large surfaces of the canvas being dissolved in swirling maelstroms of iridescence, through which the forms emerge modelled in white highlights, silver greys and coppery reds.

Though he was to transfer much of his interest in volume to his sculpture, it never vanished in his paintings, where it always provided a centre of interest and point of visual reference. His late works, like *Shepherd Boy*, glow constantly with an almost unbearable ruddiness; they seem on fire, and the whole of this last phase of his *oeuvre* is patient of many explanations. The two most obvious are that age and growing infirmity (he suffered from rheumatoid arthritis) weakened the control his hands could exercise over his brush, and that those changes in sight which come with senescence – and which influenced other great colourists such as Turner – impaired his chromatic sensibilities. There is also the fact that he spent more time in the South of France, painting in its sun-drenched roseate landscape. But whatever the cause, and however slight and evanescent some of these works may be, their freedom, their 'coarseness', their dependence upon the gesture of the hand, help to explain how some see in them the antecedents of the Abstract Expressionism of the 1940s and 1950s.

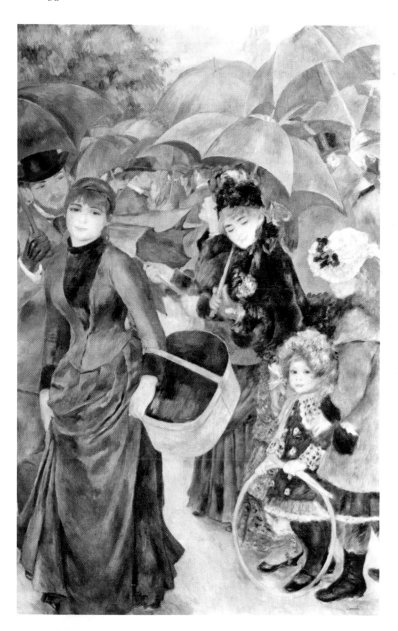

Auguste Renoir
The Umbrellas c. 1884

Auguste Renoir
Shepherd Boy 1911

Auguste Renoir
Gabrielle with Roses 1911

To describe Degas and Cézanne as the mavericks of Impressionism is to give the movement a consistent aesthetic dogma which it never possessed. After all, Manet was its leader in spite of himself, and throughout most of his career he was closer stylistically to Degas than to most of his colleagues who practised the more overt mannerisms which the movement was supposed to sanction. Cézanne, who according to one reading of art history finally destroyed Impressionism, exhibited at two of its group exhibitions (and would probably have liked to have done so at more); Degas, who was, according to the judgments of the time, a 'better' painter, exhibited at seven. They were in fact poles apart, and it was almost one of the accidents of history that they appeared to subscribe to a common allegiance.

Hilaire-Germain-Edgar Degas (1834–1917) was by instinct, by upbringing and by choice, a Baudelairean dandy, in his life as well as his art. Throughout his career his paintings, drawings and sculpture were marked by a kind of detached, almost masochistic, purity. He is the uninvolved spectator who describes young Spartans at exercise (National Gallery, London, 1860) and a bored, disillusioned couple sitting moodily over their absinthe (d'Orsay, 1876) with the same dispassionate eye. The subjects, of course, are widely different: the one looks back to David, the other forward to Toulouse-Lautrec. The styles are dissimilar: the one has the clear outlines of a Florentine painting, the other the free, spontaneous handling of one who has experienced, even though he has not been swept

away by, the discoveries of Impressionism. But both are cool, in our
contemporary sense.

Like Berthe Morisot the member of a banking family, Degas started off
at the Ecole des Beaux-Arts, and had an early and rewarding experience
of Italy, where he made meticulous copies of works by Leonardo,
Pontormo and others. It was during this time that he acquired his
remarkable gifts as a draughtsman in the classic tradition, gifts which
were to characterize all his later work and were the sources of his
greatness and of his weakness. It is an interesting comment on his attitude
towards the art of his time that he saw nothing inconsistent in exhibiting
one of the major products of this period of his development, the young
Spartans (the National Gallery title, *Young Spartans Exercising*, is a little
coy; Degas called it *Petites filles spartiates provoquant des garçons*), at the Fifth

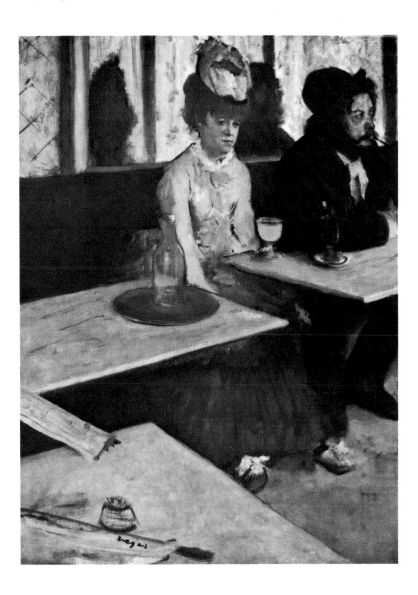

Edgar Degas
Absinthe 1876

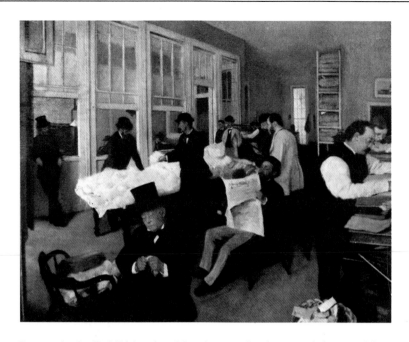

Edgar Degas
The Cotton Exchange in New Orleans 1873

Impressionist Exhibition in 1880. Appropriately enough he met Manet
while copying a Velázquez in the Louvre. They became close friends,
artistic allies. Degas went in the following year for a short visit to the
United States, where he painted *The Cotton Exchange in New Orleans*
(Musée des Beaux-Arts, Pau) which embodied the qualities his painting
had acquired at the moment when he made contact with Impressionism.
Many of them already exemplified characteristics which the group was
already elevating into doctrines: the sense of actuality; the social realism
of the subject matter; the instantaneity of the moment at which the
brokers are 'snapped' (the camera was to have a more definitive influence
on Degas than on any other of the group); the sharpness of the
underlying draughtsmanship; the way in which an apparently haphazard
grouping of figures masks a sophisticated and ingenious composition. The
painterly technique is still basically traditional, close in fact to the early
Manet, but under no circumstances could this have been mistaken for an
'academic' painting.

The perspective angle is unusual and emphasizes the compositional
motif of the diagonal wedge of figures which vanishes away into the
distant corner of the room. This delight in the difficult was always to
remain one of the main characteristics of Degas's work. An even more
impressive example, of the same period, is *At the Races* (d'Orsay), painted
between 1869 an 1872; here the angle from which he sees the horses, the
course and the stand involves such technical expertise that one is
immediately reminded of those Renaissance masters such as Uccello and
Mantegna, who also set themselves perspectival problems of dazzling
complexity. In this work another of his favourite devices is apparent – the
pushing to the edges of the canvas of large sections of the composition, so
that they are occasionally cut off, as in a photograph, and the spectator's
imagination becomes engaged in visualizing their continuance into his

own spatial ambience. Degas canonized the casual, conferring on the moment of observation a sense of perpetuity which it had never known in art before. At the same time he was the greatest portraitist that the movement produced. Renoir, for instance, was a facial mannerist who made everybody look vaguely alike. Perhaps this effect arose because portraits demand a certain structural emphasis if they are to be anything more than a pretext for the exercise of certain painterly preoccupations – the sitter being no more intrinsic to the totality of the painting than an apple to Cézanne, or a guitar to a Cubist. But Degas was a living camera, noting and recording, sometimes with insouciance, sometimes with tenderness, as in the *Head of a Young Woman* (d'Orsay, 1867), sometimes with deep psychological insight.

Edgar Degas
At the Races 1869–72

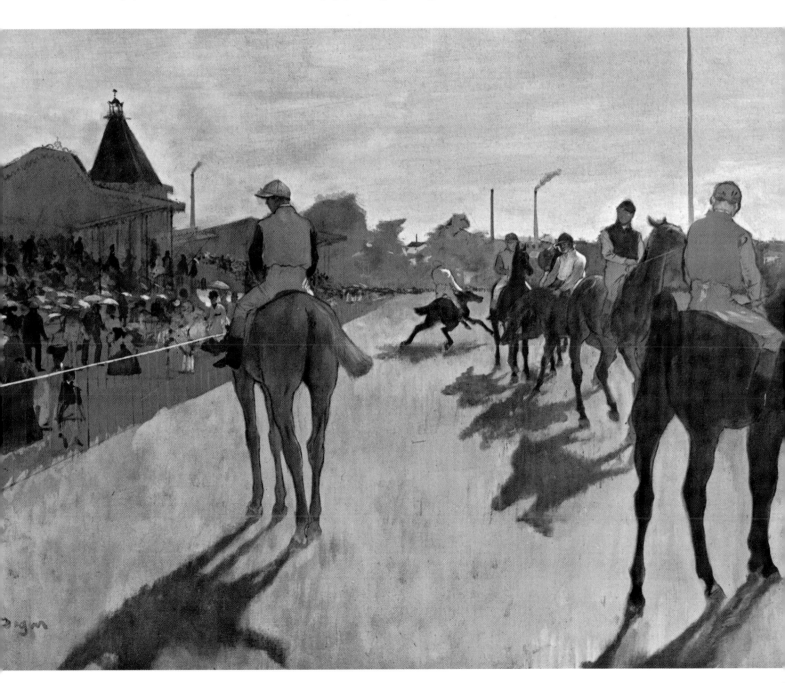

Linda Nochlin has suggested this most convincingly in relation to *The Bellelli Family* of 1860–62: 'While Bazille, in his representation of the upper middle class, has firmly rejected the aura of sentimentality or nostalgia that sometimes seems inherent in the theme of the family, transforming his subject into a motif modern in both emotional tone and pictorial structure, Degas has gone one step further, making his family portrait *The Bellelli Family* an occasion for the dispassionate and objective recording of subtle psychological tensions and internal divisions in the representation of a refined group from the Italian minor aristocracy. Once again the implications are built into the pictorial structure; there is no meaningful anecdote to serve as the "purpose" of the picture as there is in most contemporary English work representing a family of a similar class in a situation of overt external and internal disruption.'

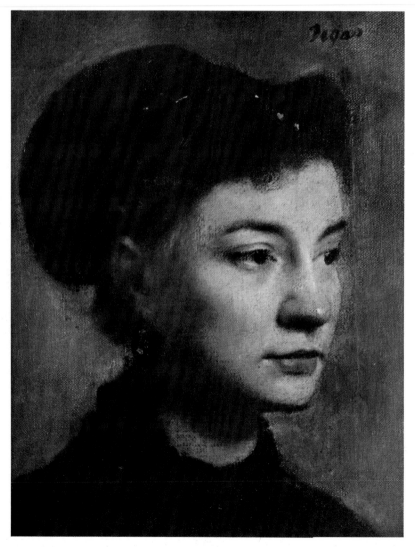

Edgar Degas
Head of a Young Woman 1867

Right, above:

Edgar Degas
The Bellelli Family 1860–62

Right, below:

Edgar Degas
The Dance Foyer at the Opéra 1872

Far right:

Edgar Degas
The Dance Foyer at the Opéra 1872 (detail)

Few artists have had a keener sense of pictorial structure than Degas. The spontaneity of his works is an illusion – albeit an infinitely satisfying one. Their compositional logic is absolute, and his treatment of reality is always subordinate to the need for total representation. It was here that he parted most decisively from Impressionism, and most clearly showed himself to be a classicist working within a romantic framework. To the first Impressionist exhibition he sent ten paintings, including *The Dance Foyer* (d'Orsay), and continued to show at all the subsequent exhibitions. Impressionism had contributed much to his technical armoury. He had come to it as one dependent, in the tradition of Ingres, on a linear perfection which had been hammered out in his drawing sketchbooks. It gave him a new sense of the value of light as a means of adding volume, vibration and the suggestion of a dimension more profound than that

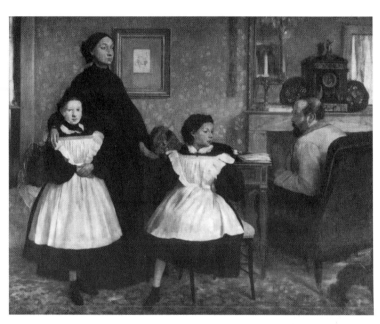

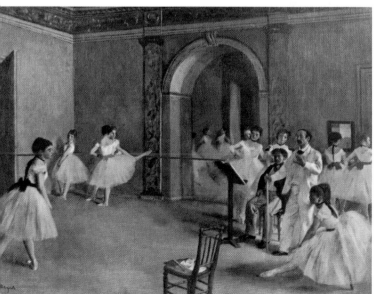

provided by traditional perspective. His paint was always thin; it never had the crusty quality which characterized the technique of Monet or Pissarro. His forms were never dissolved in light; they were accentuated and moulded by it.

Apart from portraiture, the subject matter of Degas's work is of considerable interest and significance. The early classical themes were succeeded by a series devoted to race-courses, ballet, opera, theatre (*The Rehearsal*) – the favourite relaxations of polite society, as opposed, for instance, to the more plebeian entertainments which Renoir chose to depict. In the 1880s, however – at a period when he was increasingly coming to rely on pastel as a medium to provide just those elements of spontaneity and vibrancy which he so relished – Degas turned his attention to the intimacies of womanhood, with an almost revengeful acuity of observation, delighting in the most apparently graceless poses and undignified actions. But, unlike the boudoir paintings of the previous century, they were entirely without salacity, and they were the harbingers of one of the dominant themes of late nineteenth-century art. They were inspired partly by that late Romantic fascination with the sordid – the

Edgar Degas
The Rehearsal c. 1877

Edgar Degas
Admiration c. 1880

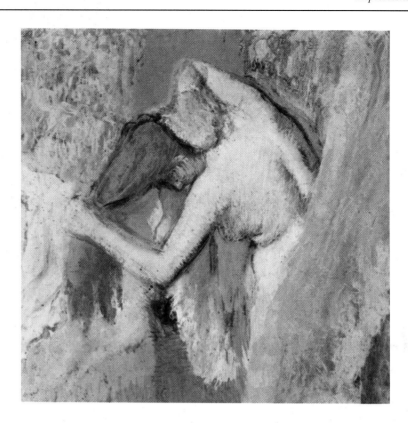

Edgar Degas
Woman Combing her Hair c. 1887–90

nostalgie de la boue – which Baudelaire had first brought out into the open; but to a much greater extent they were a by-product of attitudes which characterized the whole Impressionist ideology. They were sincere, they were real, and above all else they were totally alien to anything artists had done before, so that they could be approached by eyes innocent of accepted conventions. They had no precedents and were therefore endowed with a visual honesty which had become indispensable to living art: a work such as *Woman Combing her Hair* is a genuinely fresh departure.

Another recruit to Impressionism from the world of banking was Mary Cassatt (1845–1926) who was born in Pittsburgh, of French descent. Trained at the Pennsylvania Academy of the Fine Arts in Philadelphia, she came to Europe when she was twenty-one and imposed on herself the same rigorous study of the masters of drawing – especially Correggio and Ingres – which Degas had undergone. Perhaps this is why he was so impressed by one of her paintings at the Salon of 1874, and from that moment a close bond was established between them. Although she was never actually his pupil, her work was influenced by his in very much the same way that Berthe Morisot's was by Manet. But Mary Cassatt had an individuality of her own, cultivating intimate domestic themes with a sensitivity and charm which allow one to accept the analogies drawn between her and Henry James. She came into her own as a maker of prints – a medium with which most of the Impressionists, especially Degas and Pissarro, toyed at one time or another – being especially successful with soft-ground etching, and showing very clear evidence of the

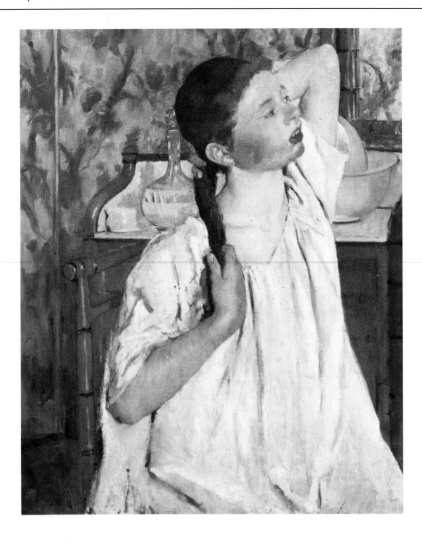

Mary Cassatt
Girl Arranging her Hair 1886

influence which Japanese art exerted on her. Of some importance was the extent to which she was responsible for transmitting Impressionism to the United States, thereby not only opening up a new and avid market, but also influencing the work of painters such as Theodore Robinson, Ernest Lawson and Arthur Clifton Goodwin.

Paul Cézanne, like Degas, reacted significantly to and against Impressionism; and there was something complementary in their reactions. Whereas the one turned to linear structuralism, extended and diffused by the interplay of light and shade, the other introduced into his work a light which is reinforced by chromatic masses and itself enhances them. Both were concerned with new concepts of space, which were eventually to revolutionize European art, but Cézanne went a good deal further in this direction than Degas by controlling perspective in several directions, and so opening up an entirely new synthesis of visual expression. As he himself once said, 'I shall always be the primitive of the path I discovered.'

Cézanne (1839–1906) was born and died in Aix-en-Provence (he was another Impressionist from a banking family) and had the advantage of having Zola for a schoolfellow. In 1861 he persuaded his family to let him come to Paris, where he worked intermittently for a while at the Académie Suisse, but there he was discontented, aggressive, moody, finding little to admire either in the work of his contemporaries or in his own. He had a passion for violent, erotic painting, in muddy colours, which owed more to Delacroix than anyone else, though there were suggestions of the influence of Courbet. He seemed constantly at this time to oscillate between strangely adolescent dreams – *A Modern Olympia* of 1870, which could be seen either as a snide comment on Manet or as a sexual fantasy, is typical – and half-hearted essays in direct observation. It was not that he was out of contact. In the course of his intermittent visits to Paris he haunted the Café Guerbois. He had had work in the Salon des Refusés, and submitted regularly, but unsuccessfully, to the Salon. He picked up ideas from the Impressionists, but his adherence to them sprang rather from a generalized feeling of revolt against the system, than from any deep feeling of allegiance.

When he was thirty-three, however, a change took place which may well be connected with the fact that he achieved a large degree of emotional security through the stabilization of his relationship with Marie-Hortense Fiquet, a young model, who bore him a son in that year. Of more immediate relevance was his settling for two years in Auvers-sur-Oise, where he worked with Pissarro. This was precisely the kind of experience he needed. Instead of the confused and sometimes contradictory titbits of doctrine and theory which he had picked up from the cafés of Paris, he was presented, in a suitable environment, with the practical demonstrations of an artist who not only knew what Impressionism was about, but had reduced it to a coherent, transmissible formula. The effect on Cézanne was immediate. He began to observe directly from nature; he began to achieve that optical fusion of tones which was one of the emancipating discoveries of the movement. His palette lightened, and though his paintings were never to reach out for that documentary quality which Pissarro, Monet, Renoir and Degas often achieved, they were to be free from their earlier iconography of violence.

During the next four years his relationship with official Impressionism (if the phrase is not self-contradictory) was to be close, and he exhibited at the exhibitions of 1874 and 1877. To the former he contributed three works including *Man with Straw Hat*, in which he realized his objective of an almost palpable solidity of form, achieved through compositional simplicity, the colour reinforcing and complementing the unity of the painting rather than being a mere gloss on its form. Whereas with most other Impressionists the forms seem to swim towards the spectator through a mist of light, with Cézanne, even at this stage, the light seems to emerge from the forms; and, when he said 'Light devours form; it eats up colour', it was almost a complaint. He possessed that sense of innocence when confronted with his subject matter which a painter like Degas could only achieve by the most complicated means. What Cézanne always represented was his own personal reaction to what he saw – a kind of psychological realism.

But all the time something else was fretting him: the oft-repeated desire to create a synthesis of Renaissance discipline and Impressionist truth – to 'redo Poussin after nature', and 'make Impressionism something solid and durable like the Old Masters'. What he really wanted was to organize into a solid structural role all those visual elements which could be rendered truthfully only by Impressionist techniques. A lot of nonsense has been written on this score, and Clement Greenberg's warning is especially relevant: 'The Impressionists, as consistent in their naturalism as they knew how to be, had let nature dictate the over-all design and unity of the picture, along with its component parts, refusing in theory to interfere consciously with their optical impressions. For all that, their pictures did not lack structure; insofar as any single Impressionist picture was successful it achieved an appropriate and satisfying unity, as must any successful work of art. (The over-estimation by Roger Fry and others of Cézanne's success in doing exactly what he said he wanted to do is responsible for the cant about the Impressionists' lack of structure; in its stead the Impressionists achieved structure by the accentuation and modulation of points and areas of colour and value, a kind of

Paul Cézanne
Portrait of Chocquet 1875–77

Paul Cézanne
The Man with a Straw Hat 1870–71

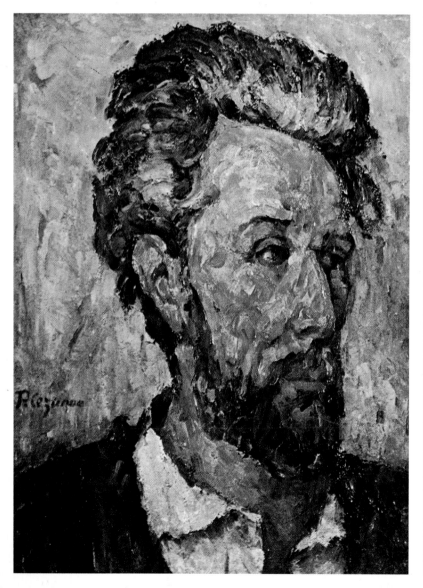

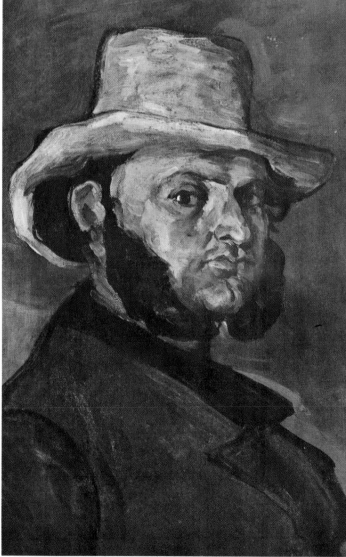

'composition' which is not inherently inferior to or less 'structural' than
the other kind.) . . . Cézanne still felt that [the motif] could not of its
own accord provide a sufficient basis for pictorial unity; what he wanted
had to be more emphatic, more tangible in its articulation and therefore,
supposedly, more 'permanent'. And it had to be *read* into nature' (*Art and
Culture*, London, 1973, p. 51).

The changes which his art underwent during the next twenty years,
and which were to link the world of the Impressionists with the world of
Braque, Léger and Ozenfant, were all motivated by his passionate desire
to create a new classical syntax with the vocabulary of Impressionism.
Sometimes external factors intervened – especially in regard to his
landscapes. The change of locale from the small cosy villages of Pontoise
to the larger, exaggerated reaches of the South, with its strong all-
pervasive light, its great distances apparent to the eye, its chequered fields
and intersected mountains, pushed him even farther into a more ruthless
investigation of the mechanics of composition than any of his
contemporaries had undertaken. He followed two different approaches,
which coincide exactly with those Cubism was to use in the first two
decades of the twentieth century. In paintings such as *Chestnut Trees at the
Jas de Bouffan* (1883) or the *Mont Sainte-Victoire* of the same year, a process
of synthesis is adopted: large and small cubes of form and colour are
massed together to create the image. In others – and here again the
persistent preoccupation with Mont Sainte-Victoire serves as a touchstone
– an analytical approach predominates: forms are extracted from what is
seen, volume is dissociated at certain dramatic points around which a
new structure is formed. The whole canvas is in movement as the tesserae
of paint flicker between their surface impression and the image they

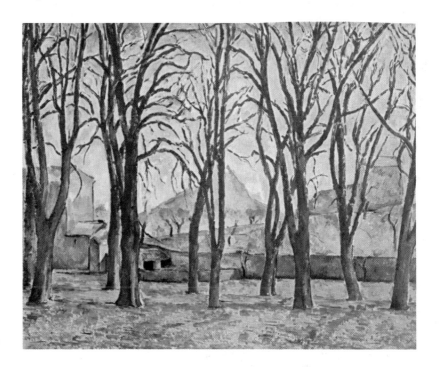

Paul Cézanne
Chestnut Trees at the Jas de Bouffan 1885–87

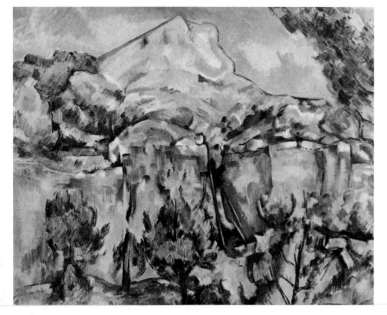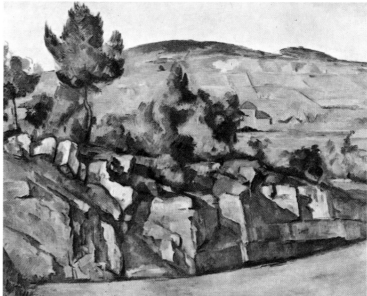

create. In all his landscapes the sense of space is emotive rather than descriptive, so that at the great distances at which he sometimes paints Mont Sainte-Victoire, one can sense, though one cannot see, the intervening areas.

The organization of volumes around a culminating point is very evident in Cézanne's portraits too, such as that of Chocquet (1877), where each part of the sitter is divided into units of coloured volumes which are put together to create the totality of the image. Later, however, especially in the series of *Card Players*, he seemed almost to extend his volumetric passion to Euclidean proportions: each part of each figure is expressed in terms of cylinders or cubes, but the process is never pushed

Paul Cézanne
Quarry and Mont Sainte-Victoire 1898–1900

Paul Cézanne
Mountains in Provence 1886–90

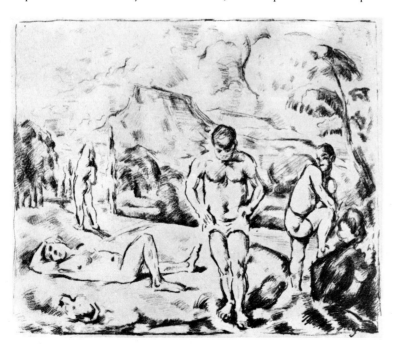

Paul Cézanne
Four Men Bathing

to its logical limits, and the pleats in the clothes, the pipes, the faces, the background have a Courbet-like lusciousness which counteracts the stringency of the modelling. 'If you paint you can't help drawing as you do it', he once said to Emile Bernard, and it is difficult at times not to feel that the whole of his creative outlook was orientated to the still-life, a world which lent itself perfectly to displaying that solidity, that rotundity which so enraptured him. His fruit has the eternal quality of the vegetation in a seventeenth-century nature poem by Herrick or Traherne; but this is because his paintings are autonomous objects, and the elements which constitute them are valid for no reason other than that they are in

Paul Cézanne
The Card Players c. 1885–90

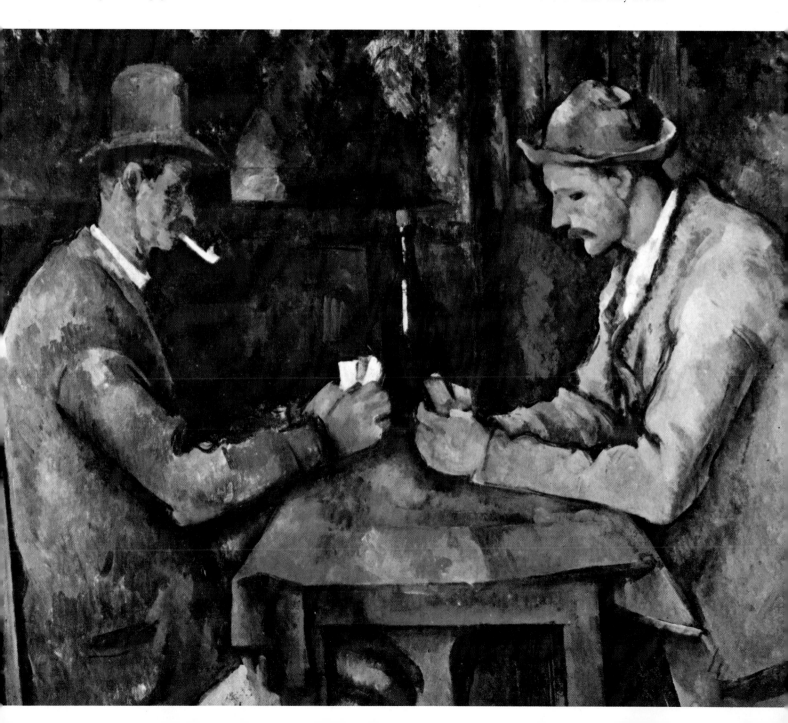

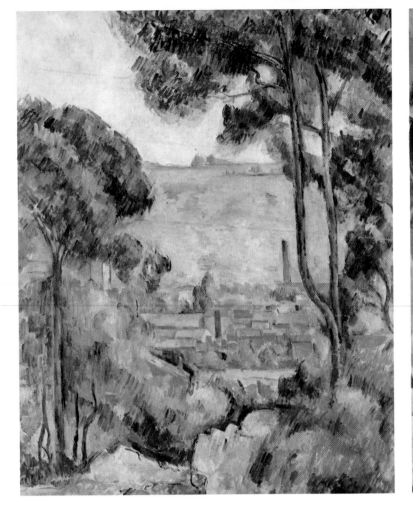

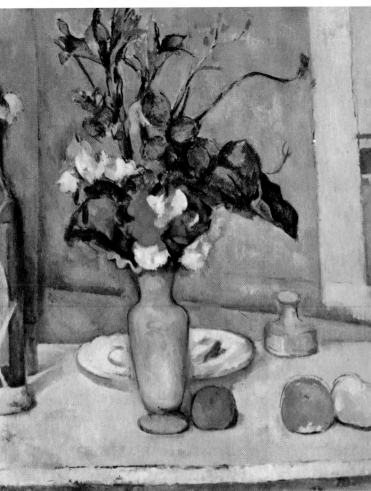

them. The apples and oranges are in the painting; the painting is the apples and oranges.

It was Cézanne more than anybody else who transmuted Impressionism into a mode of vision and a technique which would reach far beyond the limits of the nineteenth century, a fact which has led to a good deal of near-hysterical and certainly uncritical adulation, for, ironically enough, his art has also spawned a vast amount of flaccid academicism quite alien to his own ideas.

Monet neatly summed up the later development of Impressionism in 1880 when he said that what had once been a church was now a school, and as a school it spread rapidly, becoming, in each country it reached, first a suspect revolutionary art form, and then after a few decades a moribund official idiom. And in all cases it was the earliest protagonists of the style who were the most vital. In Germany Max Liebermann (1847–1935) and Max Slevogt (1868–1932); in what is now Yugoslavia Ivan Grohar (1867–1911) and Matej Sternen (1870–1949) were typical of a generation which adapted Impressionist techniques and attitudes to a national style. Whole groups grew up – in Amsterdam, for instance – dedicated to the propagation of the new gospel. With England the links had always been close: there were the influence of Whistler who had been marginally connected with the movement, the writings of George Moore

Paul Cézanne
L'Estaque 1885

Paul Cézanne
The Blue Vase 1883–87

and above all else the fact that from 1865 till 1892 Alphonse Legros –
who although not himself an Impressionist, had been a friend of Manet,
and in close contact with the influences which created the movement –
taught first at what is now the Royal College, and then at the Slade. It
was the latter institution which spawned the New English Art Club,
whose leaders, Steer, Tonks, Orpen, McEvoy and John, were all indebted
to Impressionism for that liberating impulse.

Impressionism in fact had revolutionized art, and indeed the word was
used, admittedly rather loosely, to describe literary and musical
movements. But it was its developers rather than its imitators who were
most vital, and Cézanne was not alone. In 1884 there was founded in
Paris a *Société des artistes indépendants*, most of whose members were self-
consciously dedicated to renovating Impressionism by adding to it the
systematic qualities which they thought it lacked. They set out to provide
a doctrinal framework for future developments which would give light a
structure based on small points of pure colour, applied in such a way as to
fuse when perceived by the beholder. The outstanding figure of
Pointillism was Georges Seurat (1859–91) who had, significantly, studied
under Henri Lehmann, the pupil of Ingres. Always intent on returning to
those schemata which orthodox Impressionism had set out to destroy, he
even went on in the later stages of his career to attempt to devise modes
for expressing emotion and feeling, very much in the same way as the
Carracci had some centuries earlier. His subject matter was resolutely in
the Impressionist tradition – landscapes and popular entertainment – and
his paintings radiate a lyricism which has little apparent connection with
the austere aesthetic ideology they are supposed to exemplify.

It was inevitable that so beguiling a doctrine should attract disciples; in
France Seurat's ideas were followed by artists such as Paul Signac (1863–

Paul Signac
Debilly Footbridge c. 1926

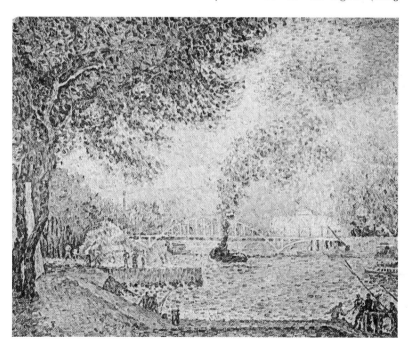

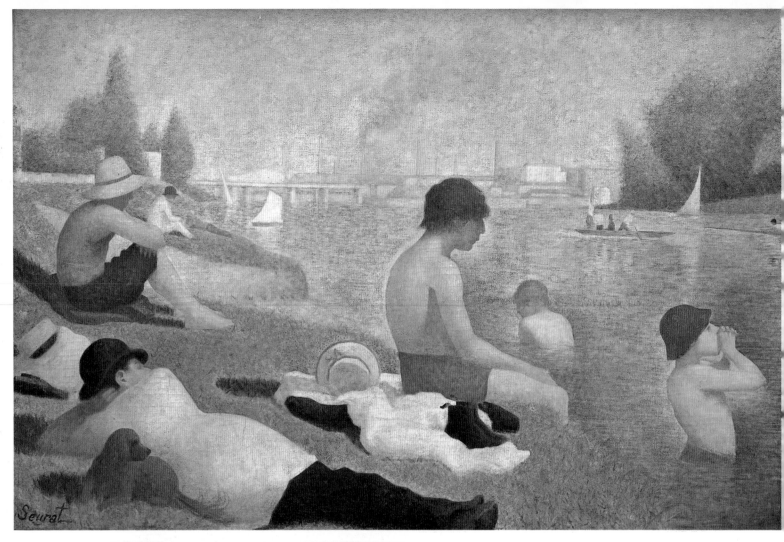

Georges Seurat
Bathing at Asnières 1883–84

1935) Henri-Edmond Cross (1856–1910) and Maximilien Luce (1858–1941); outside France it was especially effective in Belgium, where through Theo van Rysselberghe (1862–1926) and Henry van de Velde (1863–1957) it not only created a new group, 'The Society of Twenty', but also contributed a great deal of stamina and inspiration to the rather eclectic manifestations of Art Nouveau. In Italy too, where Impressionism itself had had little effect, it was enthusiastically received, though given a literary and naturalistic colouring, in the works of Giovanni Segantini (1859–99) and Gaetano Previati (1852–1920), who transmitted its attitudes to the Futurists.

Neo-Impressionism is clearly the ancestor of most subsequent hard-edge art from Braque to Stella, and in this sense it represents one of the dominant voices in the dialogue of painting. But the other, the 'soft', also stemmed from Impressionism. The importance of creative sincerity, the ability to express emotional reactions freely, to surrender to the instinct of the hand, and a realization of the emotive as well as the descriptive and analytical use of colour – all these are qualities which led through Van Gogh, on whom the works of the Impressionists had a liberating and crucial effect, to the Fauves and on to the Abstract Expressionists.

Far left:

Georges Seurat
Seated Nude: Study for 'Bathing at Asnières'
1883–88

Left:

Georges Seurat
Bridge at Courbevoie 1886–87 (detail)

Right:

Vincent van Gogh
Dr Gachet's Garden, Auvers 1890

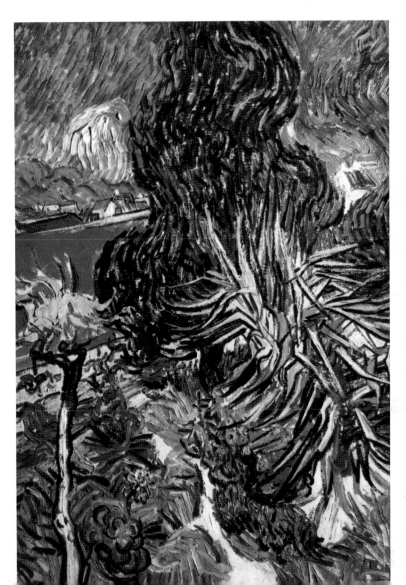

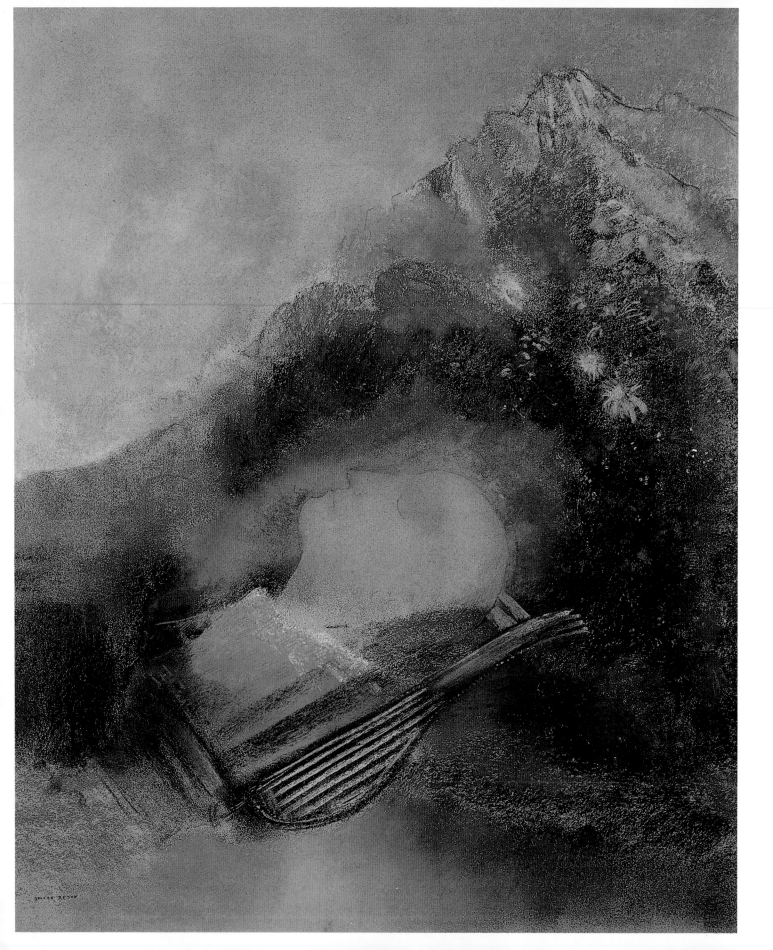

2 Symbolism and Art Nouveau

ALASTAIR MACKINTOSH

'There is some fascination to be derived from watching a change in artistic taste, or at any rate an artistic revival, taking place – so to speak – under one's very eyes. Hidden qualities are discovered in pictures hitherto despised or ignored; commercial pressures are applied by the dealers, and speculative buying begins "as in investment"; a cult that was once "camp" soon seems to be merely eccentric and then rather dashing; scholarly articles are written because there is nothing new to be said about established favourites; colour supplements spread the good news to a wider public. From some combination of these and other factors a new taste develops.' (Francis Haskell in *New York Review of Books*, July 1969).

In the passage quoted above Mr Haskell, one of the best historians of artistic taste we have, was discussing French academic painting, but the point that he makes applies to an even greater extent to the subjects of this chapter. In the 1960s an inexpensive book directed at the broad mass of art lovers might have been written about Cubism, Surrealism or Impressionism, but never Symbolism or Art Nouveau. The last-named was considered to be the over-aesthetic last gasp of Victorian vulgarity, while Symbolism was not even well enough known to be dismissed. Clearly a huge shift of taste took place which allowed this chapter to be written.

It can easily be forgotten by the person who is interested in art, visits exhibitions and reads books on the subject that the history of art is not absolute but fluid. Although there are independent-minded people who make their own expeditions into the past, most take their lead from the historians who write the books and organize the exhibitions. The public may influence them by showing a preference for a certain type of art, in this case for a decorative and sensual one, but it will be the historians and the dealers who decide where the next revival is coming from.

Because historians very naturally want to make a name for themselves by rediscovering a new period, and dealers are interested in selling as many works as possible, a revival will usually lead to high claims being made for the art revived. This is certainly true of Symbolism; from being a forgotten or ridiculed style it has swiftly risen to being 'an alternative tradition of modern art', as Alan Bowness put it in the catalogue of the large exhibition which finally accorded Symbolism the accolade of historical respectability: 'French Symbolist Painters' at the Hayward Gallery, London, in 1972. Other writers, such as Phillipe Jullian, go even further and place the Symbolists above the established masters of the birth of modernism.

Odilon Redon
Orpheus c. 1913–16

The 'league of excellence' game is clearly not profitable in any terms of common sense. Art is not a competitive activity, and questions of promotion and relegation are hardly relevant to enjoyment. In the opinion of this writer certain artists are 'better' than others because they more consistently produce work of complexity and emotional depth, but one style is not necessarily any better than any other. It is natural that there has been a reaction against the somewhat clinical approach of the Cubists and other geometrical artists, and it is healthy that we should turn the searchlights of history into previously dim corners, as long as we retain some balance of judgment.

Revivals of past art usually mirror contemporary trends. Abstract Expressionism in the 1950s led to a revaluation of late Monet, and even Turner was hailed as a 'proto-Abstract Expressionist'! It is doubtful if the Art Nouveau revival of the mid-1960s would have occurred without Pop Art, which rehabilitated exuberant colour and linear decoration. In addition, Pop frequently derived from artifacts of the past rather than from 'high art', and, as we shall see, the main impetus of Art Nouveau was in the field of applied rather than pure art. Minimal Art, so fashionable at the end of the 1960s, may have affected the revival of interest in the Neoclassicism of David; and the reaction against that Minimalism, a type of art too new to have been classified but which is often termed 'funky', is clearly related to the revival of Symbolism: both have an aesthetic of deliberate vulgarity.

One final factor must be considered in the revivals under consideration, and that is the influence of drugs. The last twenty years have seen a remarkable increase of drug-taking, especially of mind-expanding drugs such as hashish and LSD, and particularly among the young. The qualities of the drugs have affected the popular art of today, the strip cartoons, the rock posters and underground magazines. Designers looking for a style that offered a visual equivalent to their drug-induced experiences found it in Art Nouveau and later in certain aspects of Symbolism. The connection of these styles to a world-wide movement unconnected with art led to a far wider dispersal of imagery than is common in most artistic revivals. The Art Nouveau style became, for a period, standard right across the Western world as a common language of the young. For once, control over our view of the past slipped out of the hands of the experts and dealers, and in this particular area they have not entirely regained it.

As a result of this, and also because of the speed of the revival, Symbolism, and to a lesser extent Art Nouveau, are still disputed territory. Against the claims of their defenders, there are many experts who dismiss certain of the painters illustrated here as artistically absurd; but at present it is enough to describe their work and the conditions in which it developed. If this introduction indulges in an occasional value judgment, then the reader must check it against the work for himself and make up his own mind.

Although Symbolism and Art Nouveau are directly related, they are not the same thing. Indeed very few apologists agree on which artists can be included under either heading. There is a school of thought that says only French artists of the 1880s and 1890s can properly be called

'Symbolist', and another that excludes the English Arts and Crafts movement from any discussion of Art Nouveau. Such art historical nitpicking is a fruitless activity. Generic names given to movements such as Symbolism, Cubism and so on usually appear after the movement is well under way and are often no more than a convenient form of labelling. Common sense and the use of the eyes show that in the last two decades of the nineteenth century and the first of the twentieth there were common ideas and visual styles circulating in Europe and America. These styles were united only in their opposition to the main currents of art at the time: academicism and Impressionism. To understand Symbolism and Art Nouveau, we must therefore go back in time and see how these two influences affected them. The two streams had their origins in two painters: Ingres and Delacroix.

In Ingres we see for the first time the emergence of public eroticism, which was to find its apotheosis in some Symbolist art. The paintings were 'ideal', and thus catered to the view that high art should raise human aspirations to a lofty plane; but their subject matter was not the noble life of the Romans, as with David, but more often than not naked women. The settings were usually exotic, frequently Middle Eastern, which made them respectable and remote, but the technique was so realistic as to make the smooth-skinned, soft-eyed beauties who inhabited them easily available for fantasy. The new public, the emergent bourgeoisie, in accepting Ingres had found the perfect method for eating their cake and having it, for deriving erotic satisfaction from the most respectable high art.

Delacroix, on the other hand, was not interested in how the mind ought to conceive reality. He was far more interested in the eye. With Delacroix we find for the first time the idea that the eye can act independently of the mind, and that art can trace the actual process of seeing. He was the first painter to examine the play of light across objects in terms of its constituent parts. Instead of mixing colours on the palette, he put down a far wider range of colours separately on to the canvas and let the eye mix them there. He also began the process of excluding black and grey as means to depict shadow, using complementary colours instead: for the shadow of a red object, he would introduce green, and so on. Compared to later painters such as Seurat, his approach was still largely instinctive, but he was beginning the process of formulating theories of how light and colour actually work.

From these two sources two ways of thinking about painting emerged and as the century progressed gradually grew further and further apart. By the 1850s the opposition of the two schools was quite clear. The style based on Ingres had become the established 'official art' of the day, seen in the huge Salons and much sought after by the rich patrons of the time, while the line of development from Delacroix had gone underground.

That these two streams of artistic development should have diverged to such a degree in terms of public context is something that is difficult to understand from the twentieth-century viewpoint. It seems obvious to us that the academic art of the nineteenth century had little if any merit, and that Impressionism, deriving from Delacroix through Courbet, was the natural line of artistic development; and it seems extraordinary that

paintings by Monet or Renoir should have been met with savage hostility when we appreciate them for their charm and understatement. But savaged they were, and to understand why will help considerably in placing movements such as Symbolism and Art Nouveau in perspective.

Academic art takes as its canons of judgment the ideals of the past. It is a static concept which holds that the summit of artistic achievement has already been conquered and that new art must be judged by its adherence to already established principles. Reference should not be to the real world but to the history of culture, which is seen as being unaffected by the trivialities of everyday life. The Impressionists were seen as devaluing the status of art by negating this reference to the culture of the past.

It is, though, an ironic truth that the moment when art claims to be 'above' contemporary life is always the moment when it becomes controlled by it. A man could exploit his workers to make a personal fortune and then spend it on 'high art' which made no reference to the reality of his and their situation. The combination of cultural respectability and high prices made the Salon virtually impregnable.

The Impressionists took as their criteria not those of culture but of its great rival, science. The Impressionists were painters of this new technological age: Monet painting steam from railway engines, Degas making use of the camera, Renoir depicting the emergent middle class at play; but the last thing the beneficiaries of this new materialism wanted was to be reminded of it. They required culture.

It was not only the subject matter of the Impressionists that made them unacceptable, but also their methods. They used their eyes like cameras and noted down what they perceived. This neutral method of working led to a discovery that science was not to reach until the early years of the present century, and which was in no way acceptable to the contemporary 'art patron'. This was that light, and by implication everything else, was a continuous phenomenon. Light was seen to penetrate everything equally and continuously. Furthermore, as Monet demonstrated in front of Rouen Cathedral, it was not static. Form itself changed with the change of light.

To deal with this observation, a new style of painting was necessary. If the eye shows that forms are not separate from each other in reality, a technique such as the smooth realism of academicism will be of no use. Thus through the middle and end of the nineteenth century we can observe the atomization of the brush-stroke, which gets smaller and more regular until this approach reaches its logical conclusion in the dots of pure unmixed colour which make up the paintings of Georges Seurat.

For Seurat, science was all. 'They see poetry in what I have done. No, I apply my methods and that is all there is to it,' he said; and no more rigorous statement of the scientific method has ever been made by an artist. The Impressionists could rely on their eyes, but for Seurat this was too haphazard. Unfortunately, the eye cannot see the atomic structure of the world, so it is necessary to postulate a theory. So Seurat in his moment of complete scientific neutrality found himself taking art straight back into the realms of 'idea'. Only his particular sensibility enabled him to steer the narrow path between what he observed and what he

suspected he observed; and with his premature death the stream of art
that had started with Delacroix and led through the Impressionists ran
into a serious impasse which it could in no way have avoided.

The problem for those Symbolist artists, such as Gauguin, who
approached their take-off point along the runway of Impressionism, was
to find a new subject matter without losing the lessons learned along the
way. The Impressionists had shown that a precise observation of nature
led to what is now known as a 'field theory', the idea that all things are
part of the field of observation of the observer and carry equal weight
within it. Furthermore, the observer himself is part of this field. The
Impressionists had not drawn this last conclusion because they were
committed to the idea of the impartial observer; but the implication
lurked in their work. The years from 1880 to 1910 were to see the first
attempt to deal with this implication.

Aware that to continue neutral observation of nature could only lead to
the pure scientism of Seurat, Symbolist painters turned in the only
direction available to them, inwards. The problem was how to depict the
world of the subconscious, of the archetype, without falling into an
academic rendering of myth. The answer as we shall see was to retain the
external world as subject matter, but to paint in a way that reflected not
what the dispassionate eye saw but what the observer felt. If one accepts
that the observer and the observed are part of the same whole, then it
becomes possible to describe one through the other. The feelings of the
artist could be shown by a reworking of observed reality.

This idea was both difficult to grasp and a huge step in a new
direction. Even in the work of hallucinatory painters such as Goya, we
feel we are being shown something that was as real to the artist as

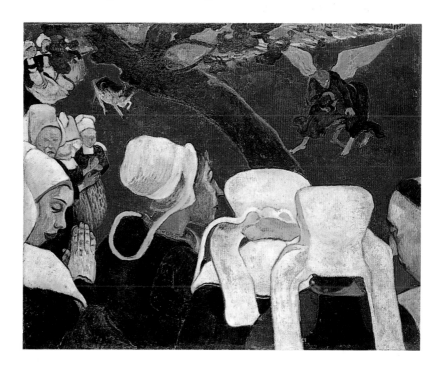

Paul Gauguin
*Vision after the Sermon (Jacob Wrestling with
the Angel)* 1888

everyday life, not a deliberate attempt to describe internal feelings and states of consciousness by recreating the external world to mirror the internal. It is not surprising that few if any of Gauguin's followers were able to understand this point, and that, to begin with at any rate, his influence was principally stylistic.

The first entirely successful painting in the new style, Gauguin's *Vision after the Sermon*, is very much concerned with problems of symbolic landscape and the relationship between the observer and the observed. A group of Breton women have heard a sermon on the text of Jacob wrestling with the Angel, and after the service apparently participate in a communal vision. The problem for Gauguin was how to show the nature of this vision. He could hardly show it naturalistically because visions are not natural phenomena, so an Impressionist technique would not do. Equally, an academic technique would be too clear-cut and idealized to express the strong emotions involved.

Given the state of confusion in thinking about the question of showing the internal world at that time, Gauguin's solution is astonishingly precise and complete. Instead of painting a 'real' landscape, he paints an emotional one. The figures of Jacob and the Angel inhabit a flat red ground of considerable spatial ambiguity. The bright colour not only has strong emotional associations but also pushes the figures forward, contradicting their size, so that it becomes impossible to say exactly where they are. The tree leaning across the picture strengthens this effect by seeming to grow out of the picture plane into the space in front of the surface. The women grouped along the bottom of the painting have the effect of cutting the viewer off from the action, making it clear that it is their vision that is being depicted and that it is their state of mind that governs the emotional landscape. If one looks at the women carefully, it will be seen that very few are looking directly at the wrestling figures; in fact most appear to have their eyes closed and to be directing their attention to a spot some distance to the left of the apparition. This underlines the point that the figures are part of their state of mind rather than independently observed, and indeed the whole painting has a unity about it which implies that it is impossible to separate the painting into subject and object, observer and observed.

Gauguin was the first artist to attempt to live like his art. The Impressionists were typical bourgeois Frenchmen who did not seek to be involved in scandal or to live differently from the general public; the academicians were of course successful members of high society. Gauguin, on the other hand, after he had come to the point of view that his art could be about his life, realized that this inexorably meant that his life had to be about his art. He therefore, and at times his actions seem oddly deliberate, set about creating a character for himself, Gauguin the painter, the martyr, the iconoclast, the wild man of the avant-garde. It was a role he relished.

It is in this determination not to separate art and life that we can see the clearest connection between Gauguin and other Symbolist painters of quite different styles. A glance through the illustrations of this chapter will show that we are not considering a style but an attitude of mind, which affected artists of differing training and aesthetic intention.

Painters brought up in the academic tradition also faced a dilemma, albeit a less sophisticated one than that faced by followers of Impressionism. The academic style had by the 1870s run out of the little steam that it ever had, and the classical subject matter was seen to hold no more surprises. Painters who did not wish to enter the matter-of-fact world of the Impressionists, and who also lacked the vision and courage of a Gauguin, were forced to look further afield for images which would still have some power and mystery. They were helped in this by the rising interest in the occult, typified by the exotic speculations of Eliphas Levi, and in Eastern thought, made fashionable by the arrival in society of Madame Blavatsky. As one might expect it was the cruder and more spectacular elements that appealed to most of the artists. These interests coincided with a fashion for drug-taking, usually laudanum or hashish, based upon the experiments of Baudelaire and Gautier some years earlier.

It was an easy and attractive method of escaping the triviality of everyday technological life. Gauguin who used his own mind for his source material, needed only to 'become himself' to fulfil his role; the occultists, not quite capable of comprehending the subtlety of Gauguin's role and unable to find a ready-made occult society to live in, had to create one of their own. The result was the Salon de la Rose + Croix, headed by one of the most preposterous figures in the history of art, the self-styled Sâr Peladan.

Peladan would have been a familiar enough figure in the 1970s, guru of a small band of beaded and bearded followers publishing incomprehensible underground magazines. But in the Paris of the 1880s, already reeling under the onslaught of Wagner and anxious for anything that would break the stifling monotony of life, he was hailed, by some, as a saviour. His books, including an erotic novel of almost total obscurity entitled *Le Vice suprême*, were avidly read, and young painters and writers flocked to him. He was exactly what they needed, a man with a complete system that did away with the boring business of having to find their own. All you had to do was wear robes, take part in the odd minor rite and paint the most cryptic and sensational pictures you could.

However the Salon de la Rose + Croix was not entirely ridiculous, in spite of its leader. The idea on which its art was based had already attracted many painters of talent, Gauguin included, and in the field of literature Stéphane Mallarmé, Paul Verlaine and, a lesser figure, J. K. Huysmans. The idea was that the function of art is not to define the obvious but to evoke the indefinable. The feeling that art should concern itself with ideas rather than with everyday life, but with ideas that had a basis in the human imagination rather than in the moribund dreams of the academy, was to be the strongest single impulse in the art of the period: and its consequences have conditioned much of the 'difficulty' of twentieth-century art.

Clearly, the methods of Gauguin were too private and those of Peladan too exotic to appeal to the public at large, so the time was soon ripe for a more widely-based style to emerge which would allow the art-loving public to feel that it could be involved without having to change its way of life. It follows from this that the new style would not be of painting or sculpture but of applied art, so that the public could incorporate the idea

into its life-style. The relationship between a man and the picture he owns is essentially a static one which requires time and patience to enter. How much more satisfactory then actually to *use* the work of art, whether in the form of printed material, books, china or glass. And so because many Symbolists were concerned less with problems of picture-making than with evolving a life-style, it was logical that the next development should be concerned with the application of art to life. In this sense Art Nouveau was both the natural child of Symbolism, in that it continued the earlier movement's preoccupation with style, and a reaction against it, in that it shifted the emphasis from the private to the public world.

Gauguin and Symbolism

Writers on Symbolism, faced with the daunting prospect of giving shape to such a many-sided movement, are prone to the invention of massive similes. Philippe Jullian, the movement's principal apologist, has described it as a walk through a huge forest, with each glade and path representing a different aspect of the movement, or, more convincingly, as a visit to a museum, with various groups of rooms opening off each other. My suggestion is that one might think about it as a huge and somewhat exotic railway station. The lines converge towards it from all parts of the art landscape, some of them terminating here, while others pass through towards stations further down the line called Expressionism, Abstraction and Surrealism. The two stations of Symbolism and Art Nouveau are separate but so close as to be virtually joined. Each platform is subtly different from the next. The Gauguin platform is flooded with sunlight, but not very crowded; the Rose + Croix platform is in deep shadow and the seats on the train are covered in red velvet, alchemical brews are offered in the buffet car and the price of the tickets is your good taste. A few passengers are changing to this train from the one standing on the academic platform, where everybody seems to wear top hats and the Légion d'Honneur, although neither train ever seems to go any great distance. Between them, the Pre-Raphaelite train is pulling in from England, with an Arts and Crafts coach, booked through Art Nouveau, stuck on the end. At the extreme north edge of the station Munch sits gloomily by himself waiting for Strindberg, who, as usual, is late.

Whatever metaphor one uses, the important thing is that it should contain the idea of many separate and diverse strands if not coming together, then at least running parallel for a period of time. Only in this way will one avoid the problem of having to reconcile Symbolism's many different styles or to chart a central course through its tangled lines of development.

In describing the movement's artists and their interrelationships one can start almost anywhere; but the work of Gauguin is as good a place to begin as any, although it postdates some of the other work illustrated here; his was the most consistent and subtle mind to be affected by the Symbolist idea.

In 1883 Gauguin had given up his job as a bank clerk to become a full-time artist, a decision that led eventually to the break-up of his marriage two years later. He had been a Sunday painter until then, using the

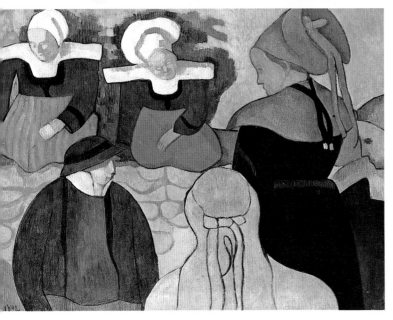

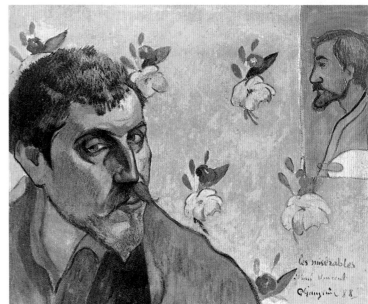

Emile Bernard
Breton Women on a Wall 1892

Paul Gauguin
Self-portrait: Les Misérables 1888

Impressionist style to which he had been introduced by his friend Camille Pissarro. Once he had made his decision, his commitment to art was total, and he soon began to find that Impressionism was not a style that could easily contain such a full-blooded approach. It was not until 1888, after a visit to Martinique which had given him a taste for bright colour, that he found the solution to his problem. Aware that the painting of everyday life was too tame an undertaking for a man of his voracious appetite for experience, and unwilling to enter the moribund world of classical myth that was practised in the Academy, Gauguin deliberately turned his back on 'civilization' and set out to find the most primitive area of France. For artists to look to the primitive is now such a commonplace idea that it is easy to forget how radical it was at that time. The Pre-Raphaelites in England had turned to the past for inspiration, but because they found it more exquisitely beautiful than the present. Gauguin was not interested in beauty as much as power. He needed to find some culture where ideas were still felt emotionally rather than played with intellectually, and he found it in Brittany, a part of France that still retained a sense of Celtic otherness.

In Pont-Aven, on the Brittany coast, Gauguin found a temporary haven. He took with him the young painter Emile Bernard, who had originally suggested that he look in that part of France for his answer. Between them they evolved a new style of painting, which they called Synthesism. A few years later, after the two painters had quarrelled (throughout his life Gauguin was quite incapable of retaining friends for longer than two or three years), Bernard insisted that it was he that had been the first to paint in the new style and that Gauguin had merely copied him. But whoever was the first to execute the first painting, there is little doubt that it was Gauguin who provided the theoretical basis. Compared to *The Vision after the Sermon*, Bernard's Brittany paintings are decorative but unsophisticated. He grasped the visual essentials of the new style, but its aesthetic and philosophical implications were beyond him. Nevertheless, Gauguin obviously benefited from the younger

painter's presence. He enjoyed the cut and thrust of argument and was always open to new ideas. It was this urge to test his theories against other painters whom he admired that led him to Vincent van Gogh, with ultimately tragic results. It is an indication of the accuracy of Gauguin's eye that he, almost alone, understood the value of what Van Gogh was doing.

The two wrote to each other frequently, Gauguin expounding his theories with relish and exuberance and Van Gogh painfully trying to explain his more personal methods. He was aware that he might be susceptible to Gauguin's more powerful personality, and on one occasion let himself be persuaded to paint a picture from his imagination rather than from life. It was the nearest Van Gogh got to Symbolism, and he quickly rejected it. Although the Dutch painter's work has in common the use of 'real' landscape distorted to reflect the emotions of the painter, it lacked the other essential ingredient of Symbolism: the existence of an independent Idea. Van Gogh's paintings are always direct descriptions, while Gauguin's employ the idea of symbolic reference to something other than the ostensible subject.

This can be seen in the portrait Gauguin painted of himself, to send to Van Gogh, which is inscribed *Les Misérables*, a reference to Victor Hugo's novel of an alienated man pursued relentlessly by society. Gauguin's attitude to painting and to himself as a painter is revealed in a letter written to Bernard describing the work: 'I believe it is one of my best efforts, so abstract as to be totally incomprehensible. . . . First the head of a brigand, a Jean Valjean [the hero of *Les Misérables*], personifying a disreputable Impressionist painter likewise burdened forever with the chains of the world. The drawing is altogether peculiar, being complete abstraction. The eyes, the mouth, the nose are like flowers on a Persian carpet, thus personifying the symbolic side. The colour is remote from nature, imagine a confused collection of pottery all twisted by the furnace! All the reds and violets streaked by flames, like a furnace burning fiercely, radiating from the eyes, the seat of the painter's mental struggles. The whole on a chrome background sprinkled with childish nosegays. Chamber of a pure young girl. The Impressionist is such a one, not yet sullied by the filthy kiss of the Académie des Beaux-Arts.'

Gauguin referred to himself as an Impressionist because, although he was reacting against Impressionism, there was still no word to describe his style. None of the Impressionists themselves would have accepted such a romantic and alienated description of the painter's role. The description is also illuminating in showing how Gauguin thought about symbols. Colours and visual emblems are used for their associative value rather than as direct reference. Not many of us nowadays would associate the background wallpaper with the 'chamber of a pure young girl', but we would accept that it does have a certain innocence about it. Gauguin was wise enough not to ram the symbols down our throats by making them too specific, and it is this psychological subtlety that raises him above most other practitioners of Symbolism.

As one might expect, a man of such force of personality and novelty of thought had a considerable effect on those painters who were drawn to him. These included Bernard, Maurice Denis, Paul Sérusier and Charles

Filiger, all of whom passed through a 'Breton' period. Denis and Bernard were attracted by the simple way of life in Brittany, and, using it as subject matter, managed to simplify their own paintings. They took as their method Gauguin's use of flat colour, and at times seem to venture further into the area of decorative abstraction than their master. But neither painter managed to incorporate the philosophical content that was the basis of much of Gauguin's art. Where he succeeded in capturing some of the intensity of the religious feeling native to that part of France, they could only show the colourful patterns of Breton life.

Filiger, on the other hand, was more successful in portraying the piety of the peasants. Intensely religious himself, suffering from guilt about his homosexuality, he found it far easier than his more sophisticated friends. But where they lacked Gauguin's psychological insight, Filiger lacked his aesthetic boldness. Rather than invent a new method of painting, Filiger

Maurice Denis
Breton Dance 1891

Charles Filiger
Breton Cow-herd

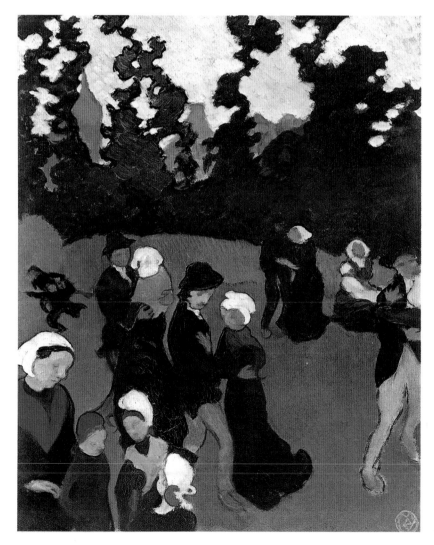

Paul Sérusier
Landscape: the Bois d'Amour (The Talisman)
1888

preferred to refurbish the old ones. In this he bears some similarity to the Pre-Raphaelites, in that he also returned to pre-Renaissance sources for inspiration, in his case to Giotto and the Sienese.

Gauguin's most direct disciple was Paul Sérusier, who was a theorist and writer as well as a painter. Sérusier's career shows that he was highly susceptible to influences and picked up theories like blotting paper. His writings are thus more important than his paintings, with one odd exception. This is a work called *The Talisman*, painted on a cigar-box and glowing with rich colour. It was executed in curious circumstances, with Gauguin standing literally at the painter's right hand telling him what to do. 'What colour is that tree?' Gauguin would ask. 'Yellow,' replied Sérusier. 'Then put down yellow.' So Sérusier would apply yellow straight from the tube. The result of this practical lesson he took back with him to Paris and showed all his friends, slightly uncertain whether

he was showing them a work by himself or Gauguin. There seems to be no doubt that Sérusier actually painted the picture, but as he never again achieved anything near its quality, the credit for the work should really go to Gauguin, and is another indication of the extraordinary power of the man.

With Gauguin's departure, his followers, as one might expect, were left in disarray. Some stayed on in Brittany, and were forgotten, others returned to Paris to find other umbrellas to shelter under, the Nabi movement being the principal of these. This was a theoretically high-minded ('Nabi' means prophet in Hebrew) but loose grouping of artists including Maurice Denis, Sérusier, Pierre Bonnard, Edouard Vuillard and Paul Ranson, and as one might expect of such an aesthetically diverse body, never produced a style unique to itself. The carefully observed bourgeois interiors of Vuillard have little to do with paintings such as *April* by Maurice Denis.

April is an interesting work because it shows how a painter like Denis, whose sympathies, where subject matter was concerned, were with the main body of the Symbolists but who had learned too much from Gauguin to use their methods, embarked on a path that led towards Art Nouveau. The strongest part of the painting is the organization of the various arabesques that curve across the surface, from the path to the vegetation in the foreground. Denis has attempted to counter this fluidity

Maurice Denis
April 1892

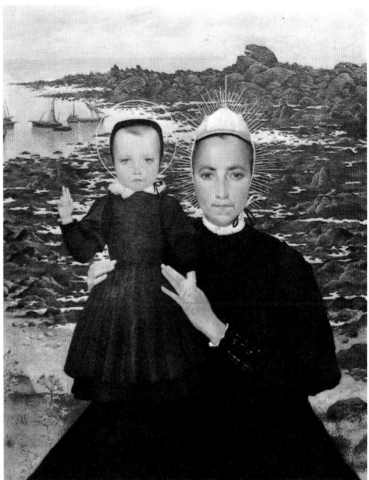

Lucien Lévy-Dhurmer
Our Lady of Penmarc'h 1896

Eugène Grasset
Spring 1884

with a straight fence drawn half way up the painting, but the effect is
awkward. The emotional content of the work is no more than a
suggestion of mood. The next generation followed illustrators and
designers such as Eugène Grasset in retaining the decorative flow of line
while rejecting the Symbolist content.

Before we finally leave Brittany for the more civilized decadence of
Paris, one curious work demands attention. This is *Our Lady of Penmarc'h*
by Lévy-Dhurmer, an artist who painted in various Symbolist styles. The
almost *faux-naïf* placing of the figures, and the disturbing degree of
realism he brings to the faces, make it a work that could have been
painted at any time in the last hundred years, and yet is quite unlike

anything else. That a minor painter can produce one work of such
startling freshness of vision is perhaps indicative of the character of
Symbolism; like its successor, Surrealism, it created the sort of cultural
climate where such flowers could be encouraged to bloom. The same
cannot be said for any of the more systematic approaches to art. Lévy-
Dhurmer was able to experiment in many different Symbolist styles,
bringing to each an eclectic professionalism. His decorative panels of
marsh-birds show a quite different approach to paint from the Breton
picture, the shimmering veils of colour reminding one of Whistler or even
late Monet. If Wagner was the principal musical inspiration of
Symbolism, this work corresponds to Scriabin's chromatic landscapes.

Meanwhile Gauguin himself was pursuing his quest for the primitive to
its logical conclusion. In 1891, just as his stylistic innovations were
beginning to be absorbed and imitated on a wider scale, he left France for
the South Seas. He had understood the central problem of Symbolism,
which was that it was impossible to infuse a painting with mystery and
archetypal meaning if you are carrying around in your luggage the
traditions of French nineteenth-century painting, or, as a later poet put
it, 'You cannot light a match on a crumbling wall,' and in spite of the
time he had spent in Brittany he still felt hemmed in by civilization.

When he finally reached Tahiti, Gauguin found that Western colonial
civilization had already destroyed most of the old culture of the islands,
and that the ease of living he had anticipated was not to be found. It was
only the role he had taken upon himself that kept him going and enabled
him to paint the paradise which he had expected to find, and which, as
he now realized, existed only in his imagination.

His method of painting remained essentially the same as it had been in
Brittany. The painting *Manao Tupapau* is typical of the period. The title
means 'Thinking of the Spirit of the Dead', and it shows a ghostly figure

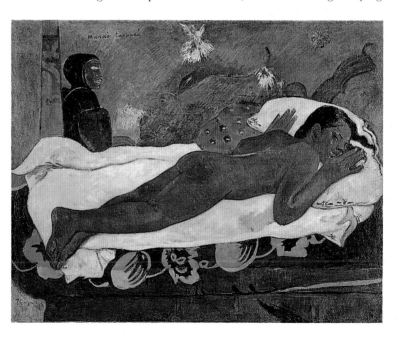

Paul Gauguin
Spirit of the Dead Watching (Manao Tupapau)
1892

appearing to a young girl. In his description of the work Gauguin makes it clear that the apparition is in the imagination of the girl and not a literal event.

Having made this point, he continues: 'She rests on a bed which is draped with a blue pareu and a cloth of chrome yellow. The reddish violet background is strewn with flowers resembling electric sparks and a rather strange figure stands beside the bed. As the pareu plays such an important part in a native woman's life, I use it as the bottom sheet. The cloth has to be yellow both because the colour comes as a surprise to the viewer and because it creates an illusion of a scene lit by a lamp, thus rendering it unnecessary to simulate lamplight. The background must seem a little frightening, for which reason the perfect colour is violet. Thus the musical part of the picture is complete.'

Gauguin's use of the word 'musical' is interesting. Poets such as Verlaine and Mallarmé had pushed literature towards music, because they saw that only by liberating it from the normal use of words could they make it truly symbolic of a state of mind. Most of the Symbolist painters, as we shall see, did not manage an equivalent liberation of visual language. Gauguin on the other hand realized that by freeing colour and form from their descriptive roles he could achieve a result very similar to Symbolist verse. Instead of being pictures *of* symbols, the pictures *were* symbols.

Gauguin's life in Tahiti went from bad to worse. He lived in a state of poverty, and by the mid-1890s had contracted syphilis. His quarrels with the other French residents had left him in near isolation, so he moved to a more primitive island, Papeete, but found things no better there. He even considered returning to France, but his friends there warned that it was the exoticism of his subject matter that was bringing him the occasional sale, and that a move to France would dry up even that meagre market. In 1897 he attempted suicide, but, as always in practical affairs, failed.

Just before the attempt on his life, he painted his largest painting, which he saw as his testament. Entitled *Where do we come from? What are we? Where are we going?*, the work is the masterpiece of Symbolism, if the movement is considered from any sort of broad perspective. It is designed to be read from right to left, starting with the two women in the bottom right-hand corner, representing pure joy in living, moving through the man picking fruit (the Tree of Knowledge) to the idol representing man's pursuit of the unknown. All stages of human life are shown, from the baby to the old man. The symbolism of the work is not overt, as Gauguin had long known that to make a symbol too obvious rendered it impotent, and so the painting can be considered on many levels. It is a pessimistic work in that it offers no easy answer to the questions it asks, and optimistic in its rich colour and form. One might say that, just as Gauguin had anticipated twentieth-century field theory in his earlier work, here he demonstrated the point that Wittgenstein was to reach forty years later, that the question *is* the answer, that the way the painting is realized is the solution to the problem posed.

Gauguin was almost alone in his time in so successfully marrying content and form. In this he was untypical of Symbolism, and nowadays it is the discordance between the two elements that we recognize as being

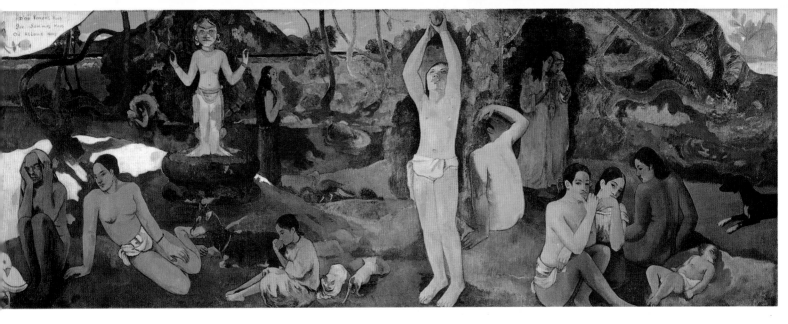

Paul Gauguin
Where do we come from? What are we? Where are we going? 1897

the most consistent aspect of the style. Yet although Gauguin is isolated by his genius, he had much in common with many other painters in the movement. We have seen how he had a strong effect on the artists grouped round him in Brittany, but it is also true that some painters had an influence on him. Chief amongst these was Puvis de Chavannes.

Puvis is probably the least sympathetic of the Symbolists to our modern tastes. The uniform greyness of his compositions, the deliberate lack of excitement and the unending classically draped maidens (if anyone ever painted 'maidens' rather than girls, it was Puvis) make it difficult for us to understand the revered position he held in the eyes of many painters of the time. Artists as diverse as Gauguin, Seurat and Aristide Maillol paid homage to him, and the Nabis adopted him as their godfather.

But it is in the neutrality of the works, the very factor which makes them difficult to appreciate, that Puvis's claim to fame lies. We are accustomed in these days of Minimal art to an aesthetic of neutrality and Hard-Edge painting has demonstrated the effect of treating all parts of the canvas with the same level of intensity. In the 1870s, when Puvis arrived at his mature style, such an aesthetic was revolutionary. Academic painting was usually concerned with the attempted highlighting of a single moment, and dramatic lighting would usually be employed, rather as in a certain brand of Hollywood epic. The Impressionists had been led to an 'all-over' aesthetic where each part of a painting carried equal weight, but their discoveries could not be applied to anything other than a small easel painting: they depended too much on the painter being able to set down his canvas in front of the subject.

Puvis was not interested in imitating nature; his concern was with large-scale decorative schemes. His solution was to use large essentially flat areas of equal colour. This enabled him to create a general mood rather than to illustrate a specific moment. Thus almost all Puvis's paintings show figures in a state of rest or minimal movement. St Genevieve, subject of a large decorative scheme for the Panthéon, is seen standing on a balcony looking out over the city of Paris, of which she is the patron saint. Where other painters might have shown an incident in

the life of the saint, Puvis shows the broader aspect of her relationship with the city. One might call it abstract figurative painting.

Occasionally Puvis would attempt a more emotionally charged scene as in *The Poor Fisherman*, a painting much admired by Seurat who adopted its tonality in many of his works. It makes no concessions whatever to the pleasure principle: the tonality is uniformly grey, and there is no story for us to grasp. Yet the painting is a disturbing one. J.K. Huysmans, a frequent defender of Symbolism, wrote: 'It is dry, hard, and as usual, of an affected naive stiffness. I shrug my shoulders in front of this canvas, annoyed by this travesty of biblical grandeur achieved by sacrificing colour to line. But despite this disgust which wells up in me when I stand in front of the painting, I cannot help being drawn to it when I am away from it.'

One can sympathize with Huysmans' predicament. There is an awkwardness to the painting that makes it strangely affecting. The sloping lines of the shore and mast have the disconcerting effect of making the whole landscape seen unstable and menacing, while the flat solidity of

Pierre Puvis de Chavannes
St Genevieve Watching over Paris 1886

Pierre Puvis de Chavannes
The Poor Fisherman 1881

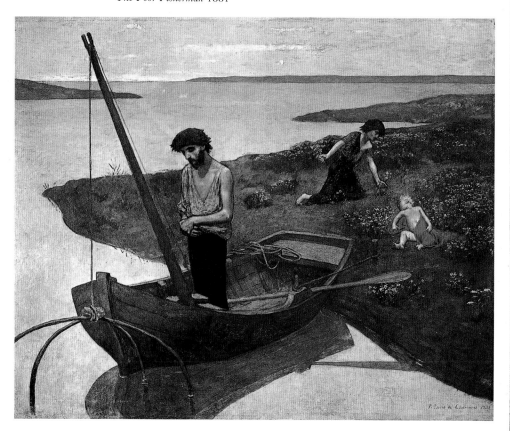

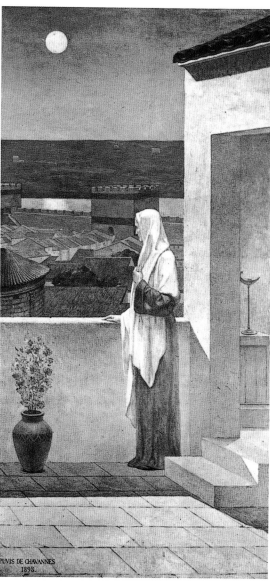

the paint surface brings it forward to add a touch of claustrophobia. The figures seem to be both immovable and in states of awkward imbalance. It seems to be a very general painting, in that no specific event is taking place, yet the girl in the background is clearly in motion. All in all it is one of the most disturbing paintings to come out of a movement whose intent frequently was to disturb, but the effect is brought off without the paraphernalia that characterizes so much Symbolist work.

Like his paintings, the influence of Puvis was general rather than specific. One can see it in Seurat, who lies outside the scope of this book; in Gauguin, who borrowed Puvis's use of flat paint, although with a more ambitious palette; in Maurice Denis, whose *April* uses figures of girls dressed in white as a method of ordering the composition, a device surely learnt from Puvis. In the Swiss painter Ferdinand Hodler one can detect an influence in the rather flat use of paint in large decorative schemes. Hodler was known both for figure compositions, which are often strongly reminiscent of Puvis, and for paintings of mountains. The Alps of course had long been a favourite subject of painters, but they were usually treated dramatically, with thin shafts of sunlight spotlighting the mountains. Hodler used a more neutral technique, and tended to give equal weight to all parts of the painting. The result is light and airy, but without focus. As a result one realizes that the subject of the painting is not the light effects in the mountains, as it usually was with other painters, but the mountains themselves. The very neutrality of the treatment imbues the subject with a metaphysical quality.

Moreau and Redon

In complete antithesis to Puvis, the other great father figure of Symbolism, Gustave Moreau, plunged into rich and vibrant colour. His career had started in the orthodox fashion, in the Salon, where he was known for paintings such as *Oedipus and the Sphinx*, which combined Ingres' style of painting figures with a tonality not far removed from Puvis. Like Puvis, Moreau wished to break way from the anecdotal aspect of academicism, and so he tended to show his figures at the moment of confrontation rather than action. In *Hercules and the Hydra of Lerna*, the hero is shown facing the monster across a sea of bodies prior to battle. The result is a tense stillness rare in academic painting. But the preparatory sketch for the painting shows that Moreau's interests were elsewhere. Already the paint is beginning to break up, and it is becoming difficult to tell where one element stops and another starts.

In 1870, when his official career seemed set for success, Moreau withdrew from public exhibition. 'He is a hermit who knows the train timetables', said Degas, somewhat cattily, and it is true that Moreau kept himself fully informed of all new developments in painting. His open-mindedness made him the best teacher in Paris, and painters as ultimately diverse as Henri Matisse, Albert Marquet and Georges Rouault studied with him, all excepting him from their contempt for art teaching at the time.

During the period of his absence from the Salon, Moreau concentrated on watercolours and oil sketches. Like Gauguin, he realized the necessity for a new visual language, and in many ways his solution was even more startling than Gauguin's and still remains controversial today. Instead of a flat and systematic use of colour for composition, Moreau began to investigate the paint surface itself. He was a great admirer of Baudelaire and Mallarmé, and wished to find a method of painting equivalent to their rich and evocative use of metaphor. His painting style became looser, the pigment being laid on thickly and allowed to create accidents of colour. One could say with some justification that Moreau discovered the principles of Abstract Expressionism, and that by the end of his life he was painting what he called 'colour studies' that rival the best works by Willem De Kooning and Franz Kline, albeit on a far smaller scale.

When he returned to showing his work in public, the change was obvious. Where before the paint had been smooth and the details impeccably painted, now the surface was thick and crusted with colour, brushmarks clearly visible. The paintings caused a sensation, but surprisingly were not vilified like those of the Impressionists, whose style was often more restrained. The public could see that Moreau's work was still Art by its subject matter: *Jacob Wrestling with the Angel*, *David Meditating*, and, endlessly, *Salome*. Salome had become, both for Moreau and for writers such as Mallarmé and Huysmans, the central symbol of the age. Evil and innocent at the same time, exotic and sensual, alluring but dangerous, she exemplified the Symbolist view of women, a view which had become a literary cliché in Romantic poetry. Moreau returned to the subject again and again, showing her dancing before Herod almost naked in a dimly lit temple.

In 1886 Huysmans used Moreau's paintings of Salome to set the scene for his novel *A Rebours*. His hero, a tedious aesthete named Des Esseintes, surrounds himself with 'evocative works of art which would transport him to some unfamiliar world, point out the way to new possibilities and shake up his nervous system by means of erudite fancies, complicated nightmares and suave and sinister visions'. Pride of place in his collection of works by Moreau, Redon and Rodolphe Bresdin goes to Moreau's *Salome*. Huysmans devotes considerable space to a description of this work, and the following should give a flavour of his style:

'With a withdrawn, solemn, almost august expression on her face she begins the lascivious dance which is to rouse the aged Herod's dormant senses; her breasts rise and fall, the nipples hardening at the touch of her whirling necklaces, the strings of diamonds glitter against her moist flesh; her bracelets, her belts, her rings all spit out fiery sparks; and across her triumphal robe, sewn with pearls and patterned with silver, spangled with gold, the jewelled cuirass of which every chain is a precious stone, seems to be ablaze with little snakes of fire, swarming over the matt flesh, over the tea-rose skin, like gorgeous insects with dazzling shards, mottled with carmine, spotted with pale yellow, speckled with steel blue, striped with peacock green.'

This passage, and the use to which Huysmans puts such paintings in his book, gives an idea of the essentially literary interpretation of art common in Symbolist circles. Although Huysmans captures some of the richness of

the painting, he adds too many of this own theories and prejudices to be an accurate critic, and his discovery of erotic nightmares in the *Salome* seems to me ridiculous. Moreau's paintings, however much they may try to locate the subconscious levels of myth – and it is doubtful if the painter thought that way at all – remain essentially charming and innocent. His figures evoke characters from a medieval romance rather than chimaeras from the realms of sleep, and the all-over use of colour in continuous arabesques piled one on top of each other implies a positive energy-filled world rather than the negative and decadent end of a culture that Huysmans describes.

Moreau's work remains paradoxical, and in the final analysis, compared to artists such as Gauguin, unsatisfactory. The figures of nubile young girls Moreau was so fond of never quite fit into the almost abstract

Gustave Moreau
Hercules and the Hydra of Lerna c. 1870

Gustave Moreau
Salome Dancing before Herod (Tattooed Salome)
1876 (detail)

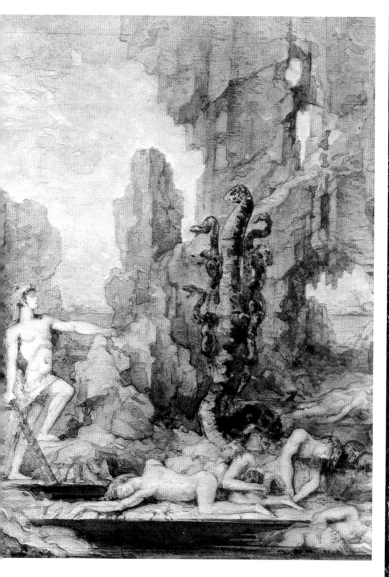

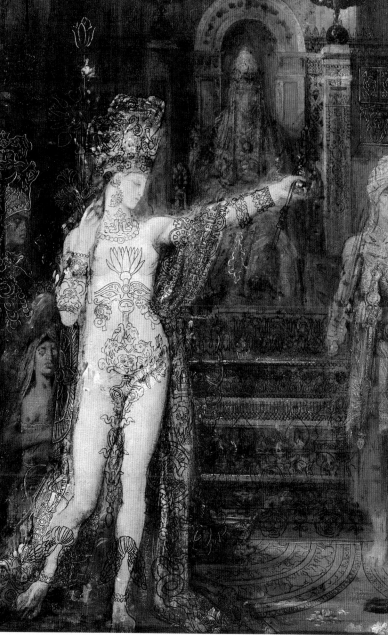

Gustave Moreau
Voice of Evening

background; it is as if he had discovered the tool of abstraction and then did not know what to do with it. His instincts as a painter were those of an Impressionist, but his aspirations as a man of culture were towards the Salon and the by then empty pool of myth. At his best, as in the *Salome* paintings, the two parts of his art came together to produce works of startling beauty. But his art is a useful touchstone; through it we can see how painters such as Gauguin achieved a new synthesis which was

beyond Moreau, but we can also see how much closer he got to a satisfactory solution than many of the painters of the Salon de la Rose + Croix.

The other Symbolist artist with a claim to greatness was Odilon Redon. Like Moreau, he was something of a recluse, and although he was lionized by younger painters after Gauguin's departure for Tahiti had left the movement bereft of a hero, he always remained independent. His vision was too private and personal to have any significant influence.

Redon was one of those fortunate men who make the right connections at the right time. At the moment when he decided to devote his life to art he met two men who were to have a profound influence on him. These were a botanist, Clavand, whose particular speciality was microscopic work and Rodolphe Bresdin, an important precursor of Symbolism in general. Bresdin was a master printmaker in both engraving and

Rodolphe Bresdin
The Good Samaritan 1861

lithography, whose entire *oeuvre* is in black and white. It is indicative of his influence on the younger artist that Redon did not touch colour for the first twenty years of his working life. Bresdin's work combined an eye for detail, and this influence, coupled with the even more curious sights he saw down Clavand's microscope, started Redon on his course as an imaginative artist.

Redon's *oeuvre* can be divided into two parts: the early black and white works in the form either of drawings or lithographs, and the later work using colour. For many years it was by the later work that he was chiefly known, while recently the tendency has been to consider the earlier work more important. The coloured paintings are often extremely beautiful, reminiscent in their loose paint and treatment of figures of the work of Moreau. Redon's *Pandora* shows the same free use of thick paint and rich colour coupled with a carefully drawn figure, although the nude is more classically derived than Moreau's medieval figures. The use of flowers is also typical of Redon's later work, underlining his continued interest in the natural world. The painting is charming and airy, but lacks the punch of his early work.

Perhaps the most interesting of Redon's paintings is the *Portrait of Gauguin*, done as a memorial (in 1904). The profile of the artist is idealized and given a sumptuous setting in which flower forms rest on a more abstract background. Redon had long been an admirer of Gauguin and had corresponded frequently with him. Why he chose this particular form for the portrait is made clearer by his own comment on Gauguin's work: 'Above all else I love his sumptuous, regal ceramics; it was here that he created truly new art forms. I always compare them to flowers discovered in a new place where every one seems to belong to a different species, leaving the artists who follow the task of categorizing these flowers into their respective families.' The portrait can then best be read as a portrait of Gauguin the ceramicist, and its glowing colours do remind one of the glazes on pottery.

But it is in his earlier black and white work that Redon's particular genius emerges. He seems to have had an open line to his subconscious, and his images entirely lack the literalism, the deliberate and rather forced peversity, of much Symbolist art. Flowers with faces, spiders with leering grins, skeletons that are somehow also trees; his subjects come directly from the world of dreams, and his masterly technique enables him to transfer them directly on to paper. Yet there is nothing uncontrolled about his work; the effect is deliberate and preconceived. Often a title is added which is like a small poem running parallel to the visual impact: *The eye floats towards infinity like some weird balloon*; *The breath of wind which supports human beings also inhabits the spheres*; or *His weak wings could not lift the animal in those black spaces*. Like all Symbolist poetry, these titles are not easy to translate because the words are used for their evocative sound as much as for their meaning. The last mentioned reads in French: *L'aile impuissante n'éleva point la bête en ces noires espaces*.

Typical of his works in black and white is that entitled *The Marsh Flower, a Sad and Human Head*. As so often in Redon's work, the background is impenetrably dark. The head hanging from the plant seems to create its own light and illuminates only a small area. There is

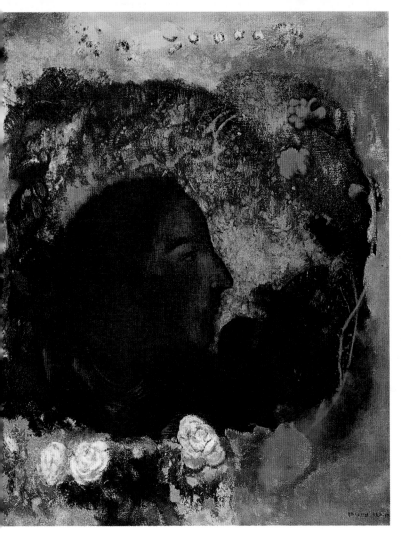

Odilon Redon
Portrait of Gauguin 1904

Odilon Redon
The Marsh Flower, a Sad and Human Head
1885

no explanation for the image, no literal meaning beyond the cryptic title. Mallarmé, who much admired the work, wrote to Redon about it: 'This head of a dream, this flower of the swamp, reveals with a clarity which it alone knows and which will never be talked about, all the tragic fallacies of ordinary existence. I love too your caption which, although created from a few words, correctly shows how far you penetrate into the heart of your subject.'

Huysmans included work by Redon in the same context as work by Moreau; and yet significantly, while he was able to write the purplest of passages about Moreau's work, he found that Redon's works would not really yield to verbal description. They are not too self-contained and purely visual, and as such are not typical of much Symbolist work.

The Rose + Croix painters

Gauguin, Moreau and Redon are all manifestly artists of originality and quality, and like all great artists they pursued their own visions even when it led them into isolation. The main body of Symbolist work was neither obviously good nor original and tended to be executed to a

formula. In the case of artists discussed so far one feels that the visual is
inseparable from the aesthetic issues; while with most Symbolists one feels
that the idea came first and the vision followed. The most notorious of
Symbolist groups, the Salon de la Rose + Croix, took as their bible the
works of Edgar Allan Poe. Poe said of poetry: 'Its sole arbiter is Taste.
With the Intellect or with the Conscience, it has only collateral relations.
Unless incidentally, it has no concern whatever either with Duty or with
Truth.' When Poe refers to Taste he does not necessarily mean the word
in terms of good or bad taste: the meaning is that a work of art should be
judged by its aesthetic qualities (including its power to stimulate the
imagination) rather than its moral content. The French Symbolists were
much drawn to Poe's own subject matter, with its haunted castles and
necrophiliac heroes; and, like Poe, they often showed woman as beautiful
but corrupt, an immaculate and pure skin enclosing a fetid swamp.

 To Poe were added Wagner, with his technique of building up passages
of augmented triads until the nerves are at breaking point, Baudelaire,
Mallarmé and Verlaine, who had begun to investigate these areas in
poetry. In painting they drew largely on the academic styles, although
artists such as Arnold Böcklin influenced their choice of subject matter.
Böcklin's allegories of life and death were immensely popular, and there
was a time when an engraving of his *Isle of the Dead* was as *de rigueur* in a
fashionable house as a Hockney would be today. His subdued tonality
and the classical quality of his figures were a little insipid for the painters
of the Rose + Croix, who were aiming at headier brews, but there is little
doubt that Böcklin prepared a good deal of the way.

Arnold Böcklin
Isle of the Dead 1886

The English Pre-Raphaelites also had their effect. We shall return to them later; at the moment it is sufficient to point out the similarity between the religious ecstasies depicted by Rossetti and the almost orgasmic self-absorption of many figures in French Symbolist painting. On both sides of the Channel artists were trying to find methods of showing ideas rather than actual events.

Typical of the most extreme elements of the Rose + Croix is the work of Jean Delville, whose paintings usually have a strong Satanic element. Delville had a phenomenal drawing technique and an imagination quite devoid of the usual restraints that an artist imposes on himself. His work often approaches the erotic with a determination that even the most liberated painters of today might balk at. A drawing, *The Idol of Perversity*, of an almost naked figure seen from about the height of the groin, is idealized in that the breasts have a tautness and fullness unobservable in reality and the lips are unbelievably full; it is a fantasy, and its modern equivalent in terms of style is Vargas, the American pin-up artist, although his creations are far cosier.

Satan's Treasures, a large oil painting, also shows Delville's skill in achieving a visual effect. The precision of the drawing is combined with a red so strong that it creates a vibration across the centre of the painting; it is like looking into a fire and half-seeing figures writhing inside it. The arabesque of Satan's wings, if that is what they are, is an effect as

Jean Delville
The Idol of Perversity 1891

Jean Delville
Satan's Treasures 1895

overstated as the quality of the red, and sweeps the eye into a disturbing vortex. It is impossible to look at the work without in some way being affected by it.

Writers on nineteenth-century art differ wildly in their opinions on the quality of paintings such as this. It is obvious that in terms of the central development of art over the last hundred years, this type of Symbolism is quite unrelated to the standards we normally use to judge art. We cannot say it is 'bad', as we might say that André Derain's later work was 'bad' compared to his earlier work, because the intentions of Symbolism are so different from those of the mainstream of modern art. Delville was not interested in making points about the objective nature of art; he wanted to arouse a strong reaction in the viewer. Our own reactions will, of course, be very different from those of the public of the 1890s, for we bring to the paintings an awareness and enjoyment of the discrepancy between intention and effect, which makes it even more difficult to make up our minds.

Many paintings of French Symbolism strike us as absurd, or at least incongruous. Both Point's *The Siren* and Séon's *The Chimaera's Despair* combine a sophisticated approach to colour and brushwork with a ridiculous central figure. In itself, Séon's painting is skilfully composed, with the strong vertical of the cliff giving a curiously unstable effect to the painting, while the cold colours create an intense emotional landscape. Unfortunately the figure of the Chimaera presents more difficult problems which Séon could not resolve. Poets of the time repeatedly referred to Chimaeras, but they could allow the unsettling poetry of the word itself to carry their medium. But the painter has to show what the poet has only to describe, and this desire to follow the poets into essentially literary fields was the undoing of many a Symbolist masterpiece. Séon's Chimaera seems to have strayed out of a literary tea party, and looks more as if she is complaining about the cucumber sandwiches than singing a universal song of archetypal despair.

But Symbolism was nothing if not ambitious, and the artists of the movement were continuously looking for that one stunning image, a metaphor that would illuminate the human condition. Léon Frédéric's *The Lake – The Sleeping Water* comes very close to bringing off an unlikely effect. At first sight the image seems merely sentimental; but the more it is examined the more disturbing it becomes. The sleeping children are drawn with great accuracy of observation, and the swans really seem to be floating over them. The lack of central focus makes the painting seem specific and general at the same time.

Absolute self-confidence was a necessary aspect of the movement in its more public forms such as the Rose + Croix. The doubt and hesitation one finds so often in the work of really great artists had no place in such a deliberate assault on conventional life in the name of hidden truth. It was an inevitable part of the aesthetic of this area of Symbolism that the paintings should exhibit no trace of the self-searchings that appear in the work of Gauguin or even Moreau. This led to a quality which we might call 'synthetic', in the way that Miss World is a 'synthetic' rather than a real woman. The product must show no evidence of hard work or struggle; it must seem effortless and as if it arrived complete.

Alexandre Séon
The Chimaera's Despair 1890

This aspect of Symbolism is at its clearest in the more religiously inclined painters. Satanism and perversity provided one kind of thrill for painters like Delville, but the sicklier aspects of Roman Catholicism offered images of equal emotional weight with the added benefit conferred on sales by respectable sentimentality. Carlos Schwabe was one artist associated with the Rose + Croix who made this area his speciality. His paintings were executed with meticulous regard to detail, and one can often detect the influence of the English Pre-Raphaelites in the early Renaissance quality of his work. His painting of detail is usually far superior to the over-all ordering of the work, as can be seen in the *Virgin of the Lilies*, where the lilies are beautifully observed and then used in a compositional device that looks more like a celestial escalator than anything else. The literalness of the image destroys it. The same can be said of his *Death and the Gravedigger*. The painting very nearly comes off;

Armand Point
The Siren 1897

Léon Frédéric
The Lake – Sleeping Water 1897–98

the use of vertically hanging branches of willow skilfully expresses the mood of the picture, the colour of the angel is finely judged, and the curve of her wings around the old man is an oddly touching idea. But then Schwabe has to show the reaction of the gravedigger, a real man suddenly confronted with an unreal situation, and the picture breaks down. His reaction is too unsubtle, too much in the traditions of Grand Guignol to carry conviction, and now it is a different type of pleasure that takes over, pleasure in the discrepancy between the intention and the realization, a 'camp' pleasure. Such is the fate of many Symbolist paintings.

Carlos Schwabe
The Virgin of the Lilies 1899

Carlos Schwabe
Death and the Gravedigger 1895–1900

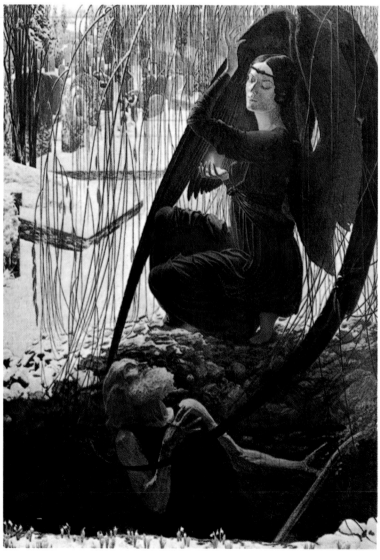

European Symbolism

Whether one can call painters such as the Belgian James Ensor and the Norwegian Edvard Munch Symbolists is debatable, but their work is part of the same impetus and climate that gave rise to Symbolism and shows the same use of dream-like images and distortions. Ensor, although his violent brushwork was entirely original, perhaps might not have found it so easy to draw on his own imagination had not Gauguin and Redon prepared the ground.

Ensor's visions of the world at times came close to the psychopathic. He combined a rich, almost sweet, range of colour, applied thickly, with images of alienation where all faces become masks and all roads lead to hell. His *Self-Portrait with Masks* shows the artist hemmed in by a sea of grinning faces, his eyes the only ones which are not blankly void. When he painted entirely from his imagination he chose subjects like *The Fall of the Rebel Angels* and showed the hellfire as thick and almost liquid. 'No light but rather darkness visible', said Milton, describing his version of hell, an observation that Ensor would have well understood (*see also* pp. 125–28).

Ensor tackled his nightmare head-on; the other great northern painter of the period approached his vision more gradually, although when he reached it, it was, if anything, still more powerful. Munch's work is discussed in the next chapter, in the context of Expressionism (*see* pp. 122–24).

Other artists who are usually considered separately from any account of Symbolism because their main contributions are outside that field, should be mentioned in passing. Because the movement was not a stylistic one, but a general state of mind that affected artists, musicians and writers, many painters and sculptors were influenced by some of the Symbolist ideas. Auguste Rodin, for instance, surely owes something to

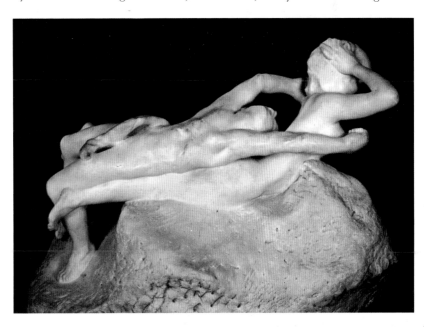

Auguste Rodin
Fugit Amor 1885–87

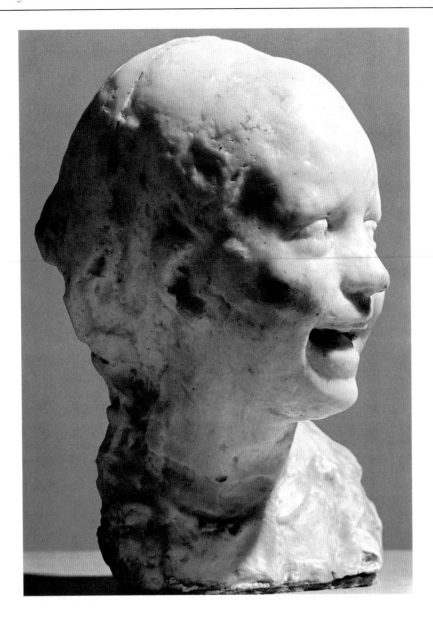

Medardo Rosso
Infant Laughing 1890

Symbolism in his more erotic works. The way the figures emerge from the 'background' of stone until they are precisely articulated reminds one of Moreau's or even Delville's figures. The smooth perfection of the skin of Rodin's nudes is the opposite of 'realistic' description, and the long curving lines of the bodies are reminiscent of Debussy or Verlaine. There is also a case for considering the Italian sculptor Medardo Rosso as a Symbolist. His works are often made of wax which seems to be melting in front of us. The route that led Rosso to this technique is surely the same as that which led Moreau to his disintegrating paint surface, with the same implication of a world of continuous flux.

In Italy the Symbolist style was softened and used for decorative purposes. The work of Segantini does not strive for the *coup de théâtre* as does so much French Symbolism; he still used the languid ladies so common in art of the period, but we are not asked to believe in them or to take them particularly seriously. The emphasis on the flowing line looks forward to Art Nouveau and is not so far in feeling from the work of the Swiss artist Augusto Giacometti. Both are using the draped female form in essentially decorative work; Giacometti's painting uses the flat areas of colour typical of Art Nouveau, while Segantini is still modelling form in space.

Symbolism, as it has been so far discussed, was very much a Continental phenomenon. Exoticism as a way of life never took root in Britain. When Symbolist ideas crossed the Channel they were pruned of

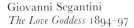

Giovanni Segantini
The Love Goddess 1894–97

their worst excesses and given a certain refinement. Even when the Aesthetic Movement was at its peak in the last two decades of the century, the best England could offer to compare with the decadent cavorting of the Salon de la Rose + Croix was Oscar Wilde and his white lily. But, when one considers Wilde's fate at the hands of his fellow countrymen, it is perhaps not surprising that artists tended to restrain their less orthodox points of view.

In talking about Symbolism in terms of English art we are on dangerous ground: there are those who think that such a term should not be applied to any English painter. Nevertheless one can point to certain ideas held in common on both sides of the Channel, and it is interesting to note that although these ideas usually reached their ultimate development in France, they were often first conceived in England.

The best example of this is the work of the Pre-Raphaelite Brotherhood, a loose grouping of artists in many ways similar in intention to the later Salon de la Rose + Croix. Both groups were concerned with finding an alternative to the choice between academicism and naturalism, both groups tended to look into myth and fairy tale for their subject matter as well as showing an interest in religious themes. Both groups tended to use their subject matter to express a state of mind rather than to describe an event. Here, however, it becomes more difficult to draw comparisons because neither group was consistent within itself.

The Pre-Raphaelites can be divided into three camps. The first, historically speaking, consisted primarily of the leaders of the Pre–Raphaelite Brotherhood of 1848: Dante Gabriel Rossetti, John Everett Millais, William Holman Hunt and (not officially a member) Ford Madox Brown. Its aim was to cleanse art of the complicated and painterly qualities that had accrued since the Renaissance and to return to it a purity of vision based on the styles of the early Renaissance painters. Parallel to this was a younger group centring on William Morris, which included Edward Burne-Jones the painter and William de Morgan the ceramicist. Morris shared Rossetti's distaste for post-Renaissance art, but because his character drew him as much to social issues as to aesthetic ones, he concentrated on the fields of decoration and applied art which he saw as a fundamental aspect of civilization. His influence in these fields was enormous.

The third group was more of a regrouping than a separate school, and consisted primarily of Rossetti and Burne-Jones. Rossetti had rejected the meticulous Pre-Raphaelite style proper, with its intensely observed detail, in favour of a more luminous and visionary type of painting which is at times reminiscent of certain aspects of French Symbolism. The painting of the Annunciation, *Ecce Ancilla Domini*, demonstrates this well. But where a painter such as Schwabe was interested in showing a general idea, Rossetti is interested in the psychology of the moment: we become involved in a way that never happens with the products of the Rose + Croix.

Rossetti was a mystic whose painting is a reflection of the interior world he experienced and attempted to transcribe. Like Redon, or Ensor, he projects a variety of experience which is entirely his own and which cannot be separated from the method he used to portray it.

Dante Gabriel Rossetti
Ecce Ancilla Domini (The Annunciation) 1850

Yet there is a bloodlessness in Rossetti's work, as if he could not face
the true nature of his inspiration; at times this makes for a suppressed
tension, almost sexual in nature. The figures in his painting seem uneasy
in their bodies, as if the dualism between spirit and flesh were pulling
them apart. Twenty years later the French painters were to have no such
qualms, but their work only rarely attains the psychological vitality that
Rossetti's best works show. The English have never been very good at

dealing with the physical facts of life in their art, which perhaps explains the delicate awkwardness found in so much of Rossetti.

Burne-Jones, on the other hand, although he too had his vision, was a more earthbound character who had to work hard to bring his painting into line with his imagination. He was also a craftsman, in a sense that Rossetti never claimed to be, and took great delight in experimenting with media such as stained glass, pottery, and book illustration. This professionalism, coupled with a wide knowledge of the history of art, made it difficult for him to find his own voice.

Like the French Symbolists, Burne-Jones turned to myth for his subject matter, but unlike them he was not interested in exotic gods from the east or chimaeras from the murkier aspects of classical myth. His real subject matter took a long time to emerge, but when it did it was a very strange one: sleep. His two masterpieces, the *Briar Rose* series on the legend of the Sleeping Beauty, and *Arthur in Avalon*, both show the principal characters asleep, and many figures from other paintings have the look of somnambulists. Yet these sleeping figures are frequently surrounded by nature in excess and by richly ornamented objects and materials. World-weariness, a favourite theme of the French, had no place in Burne-Jones's scheme; the feeling is rather of imminence – that something will happen rather than that something has happened. The clarity of observation he inherited from the founder members of the Brotherhood, with its resultant three-dimensional depiction of objects and plants, adds to the sense of

Edward Burne-Jones
The Sleeping Beauty 1870–90

beginning and is quite opposite to the sense of dissolution and decay that pervades so much French Symbolism. One has the feeling that the French painters saw themselves as the end of art, the final hectic rhapsody before brute civilization finally takes over, and their works often have an 'end of the world' feeling about them. Burne-Jones's work has none of that sense of doom; perhaps he would have considered it extravagant.

Right:

Edward Burne-Jones
The Golden Stairs 1880

Below:

Edward Burne-Jones
The Beguiling of Merlin 1874

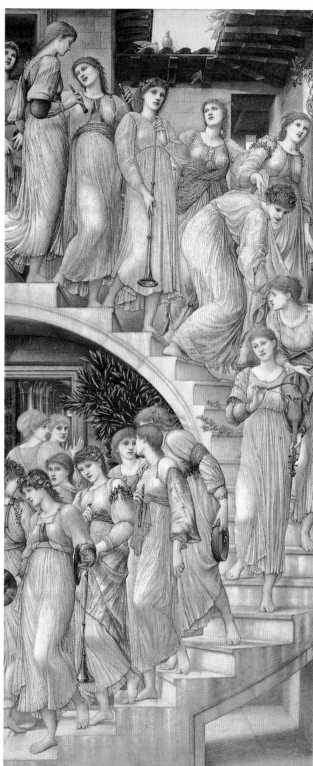

Art Nouveau

The English have never approved of excess, particularly of the gloomy variety; and so it was perhaps inevitable that Art Nouveau, which was partly a reaction against the more portentous elements of Symbolism, should have originated in England with the Arts and Crafts Movement. This was principally inspired by William Morris, who like the other Pre-Raphaelites had been attracted to medieval art. Unlike them, however, he was not content merely to paint pictures influenced by such art; his social concerns led him to a position where he could consider the re-creation of the best aspects of medieval society in the present. One of the fundamental parts of this vision concerned the role of the artist. Morris did not see the artist as an individual standing aloof from society, but as someone emerging naturally from it. He considered that the moment that art lost its decorative and functional basis and became independent of other disciplines, it lost its central purpose of enriching society and became the plaything of rich patrons.

Accordingly Morris concentrated on reviving the idea of applied art. His own speciality was fabric and wallpaper design, but he also acted as a focal point for many other craftsmen and artists. He knew the work of A. H. Mackmurdo and his disciple C. A. Voysey, although neither artist could be said to be directly under his influence.

The achievement of this group of designers was radically to rethink the concept of pattern. Before Morris, fabric design had tended to be three-dimensional and illusionistic in character. Large bunches of cabbage roses would be drawn with some perspective and shading, an effect that tended to be fussy and negate the inescapable two-dimensionality of a floor or a wall. Morris flattened out the design, removing any attempt to show flowers or birds realistically. The emphasis was switched from the subject matter to colour and line of great richness and complexity.

For inspiration Morris looked at any part of the history of art that struck him as useful, to medieval tapestry, to Jacobean hangings and to Oriental design. This eclectic method was picked up by those around him: for instance, William de Morgan, the group's ceramicist, studied Islamic and Hispano–Moresque pottery and as a result rediscovered lustre techniques that had been largely forgotten.

By the 1880s a growing body of connoisseurs was buying the products of the Arts and Crafts Movement. Fashionable houses were entirely papered and hung with Morris designs, and pots by De Morgan and paintings by Burne-Jones would be bought to complete the whole. Even Pre-Raphaelite styles of dress were copied as the idea of living aesthetically caught on. Because the art was applied, it needed to be used to fulfil its role, and this enabled non-artists to take part in the movement. The same process can be seen in the emergence of Pop styles in the mid-1960s.

This way of looking at art as part of the fabric of living meant that artists could apply themselves to a wide choice of media. Where before an artist was someone who painted pictures or made sculpture, now he could design wallpaper, make pottery or illustrate books. This enabled artists such as Aubrey Beardsley to find their true role.

William de Morgan
Twin-handled amphora in Persian colouring, 1888–97

Above, left:

Arthur Mackmurdo
Textile design, 1884

Above, right:

Charles Voysey
Tulip and Bird wallpaper, 1896

William Morris
Daffodil chintz, 1891

Aubrey Beardsley
Isolde c. 1895

Beardsley was a graphic artist who needed to work on a small scale. His technique of combining large areas of flat colour with fine line work was perfectly suited for printing techniques, with the result that his images were widely disseminated through books and publications. His subject matter was similar to that of French Symbolism, with its emphasis on the less sunlit areas of history and myth, but he brought to it a satirical and cruel eye. Where the French painters often seemed to take their subjects too seriously, Beardsley would always be careful to let his public know that his attitude was, in a sense, a pose. This enabled him to relate his work to contemporary mores and avoid the remoteness of much of the work of the Salon de la Rose + Croix. Perhaps only Félicien Rops, on the Continent, brought a similarly jaundiced flavour to Symbolism. But both the Arts and Crafts Movement round Morris, and the Aesthetic Movement round Beardsley looked to the past for their sources. A new idea was needed, something not dependent on eclecticism. And when the idea came, it manifested itself in the most unlikely of countries: Scotland.

Charles Rennie Mackintosh was a native of Glasgow and his most important work was done in that city. As one might expect, the English totally ignored his work. It was left to the Austrians to take up his ideas and disseminate them through Europe. His main claim to fame is as an architect, and is therefore outside the scope of this chapter, but his ideas and methods had an effect on all the arts. Mackintosh introduced the idea that design should be something that sprang naturally from function, rather than being an arbitrarily imposed cosmetic. This meant that he designed buildings from the inside out, letting the form grow naturally from the function, and where he needed a style of design, for details and decoration, he turned to the most natural of styles: the organic.

Organic structures were not new to art. Much 'primitive' art reflects the patterns of natural growth, but since the Renaissance art had largely been seen in terms of subject matter and representational style, and it was not until the turn of this century that artists again looked at the natural patterns of organic growth.

What they found was a method of working that solved the problems of 'style' that had beset the Symbolists. Instead of thinking of an idea and then finding a suitable style in which to express it, artists and designers could apply the organic style to literally anything. It was a radical idea and appropriately called Art Nouveau.

The glass doors for the Willow Tea Rooms in Glasgow are a good example of Mackintosh's style. They lead into a room entirely designed

Charles Rennie Mackintosh
Door to the 'Room de luxe' of the Willow
Tea-Rooms, 1904

by the artist, so there is a unity to the whole conception. The doors are reminiscent of Celtic art, which also drew on plant forms, and like Celtic art they are abstract. Instead of representing something through an image, they function entirely in terms of colour, light and line, and the sheer beauty of the design is enough to create the mood desired. Certain motifs appear which are typical of Mackintosh: the stylized rose form and the long stem-like rods of metal. Clients entering the 'Room de luxe' through these doors could feel that they were becoming part of an aesthetic experience that in no way interfered with taking tea.

The decorative ease of Mackintosh's work must have seemed a great relief after the gloomy exoticism of the Symbolists, and very quickly the style spread to Vienna where it influenced the Secession group, and then to Holland which was itself already evolving an Art Nouveau style. In Vienna, Mackintosh's use of pure pattern influenced the painter Gustav Klimt who combined fairly straightforward figures with areas of almost abstract pattern. In *The Kiss* it is the robe of the man that is the subject of the painting, and the psychological element is nearly absent, while in *Danaë* the awkward placing of the nude makes us read the picture as a flat pattern. The face of the girl still has that look of erotic self-absorption so beloved of the Symbolists, but it is almost incidental to the impact of the patterns. We tend to read the painting as a flat surface pierced by shallow depressions, two dimensions juxtaposed with three.

As one might suspect from the appearance of Klimt's work, he saw himself primarily as a mural painter. The flat quality of the Art Nouveau style is particularly applicable to decorative schemes, but more difficult to apply to the easel painting. In fact there are very few Art Nouveau paintings as such; objects or decorative schemes dominate.

Gustav Klimt
The Kiss 1909

Gustav Klimt
Danaë 1907–08

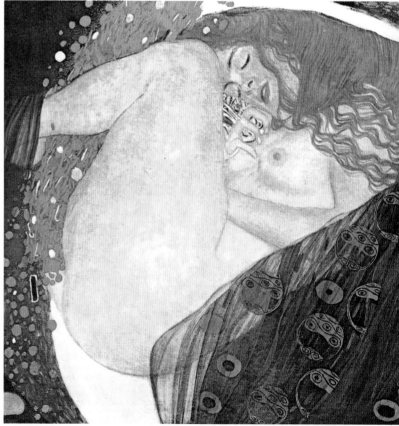

In Holland, however, painters did apply themselves to the problems of the Art Nouveau painting. Dutch artists evolved a style independently of the French and Austrian schools, and may even have influenced Mackintosh. They combined the subject matter of Symbolism, which was sacramental and mystical, with the flat arabesques of Art Nouveau. Bonding this mixture was the influence of Java, at that time a part of Holland's empire, and one can easily detect the use of Javanese stick puppets in the work of Jan Toorop.

Toorop had been brought up in Java; and, whereas the exoticism of French Symbolism is usually obviously borrowed, Toorop's was inherent in his background. His masterpiece, *The Three Brides*, is a genuinely disturbing painting because it is so un-European; although its subject is very much in the Western tradition, its style and philosophy are not.

The painting shows three aspects of woman at the same ceremonial moment of marriage. On the right is the Bride as courtesan, on the left the Bride of Christ, and in the middle the 'human' Bride. But the two Brides at each side are not necessarily meant to be read as Good and Evil, the standard Western interpretation of such dualities; if one reverses the painting and looks at it from the inside out, then the figure at the left hand of the Human Bride can be seen as representing the Left Hand Path of Tantric Hinduism, and that on the right the Right Hand Path. The Left Hand Path was usually associated with the goddess Kali, who like the figure in Toorop's painting is conventionally shown wearing a necklace of skulls. She represents not evil but achievement through eroticism and a close knowledge of the links between birth and death. The Right Hand Path is the path of meditation and of transcending the body. Tantric thought does not say that one path is better than another.

John Thorn Prikker
The Bride 1892–93

Jan Toorop
The Three Brides 1893

Toorop has tried to show the nature of the difference between them, both in his treatment of the figures and in the background. The patterns in the air above the Kali figure are strong and decisive; those above the Bride of Christ are fluid and natural in form. The figure in the centre represents the middle way, but, because it is a product of the two poles of experience rather than something that exists in its own right, it is veiled.

Similar imagery can be found in paintings by the other well known Dutch painter of the time, Johan Thorn Prikker. His painting of *The Bride* shows a similar use of flat linear design, but it is less hieratic and *faux-naïf* in execution. Thorn Prikker was influenced by French painting and particularly by the Pont-Aven school around Gauguin. His forms are given more body than Toorop's, and the brushwork is more 'painterly'. The result is an almost abstract style held together by strong curving lines. The imagery is more overtly Christian than Toorop's and does not attempt to draw the philosophical lines of distinction that appear in *The Three Brides*.

But Art Nouveau is at its purest and is most successful when applied to a purpose other than the easel painting. It was a style that lent itself very well to graphic reproduction because areas of flat colour are the essence of lithographic technique. And, as posters are functional by their very nature, Art Nouveau artists found themselves designing advertisements.

It is this aspect of the movement, more than any other, that characterizes Art Nouveau as being the first movement of the twentieth

Jan Toorop
Delftsche Slaolie before 1897

Henri de Toulouse-Lautrec
Divan Japonais 1893

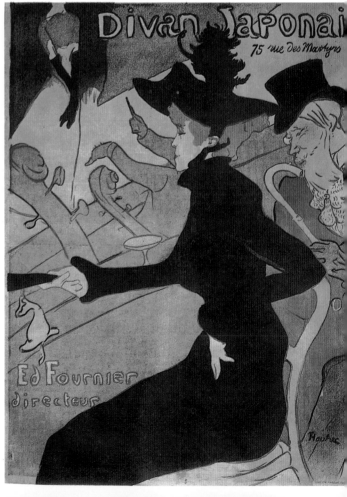

century rather than the last of the nineteenth. One of the central issues of modern art has been the erosion of the idea that art is something separate from life. Art now takes place in the streets as well as the art gallery, and the first manifestation of this idea was the advertisement. Toorop felt no difficulty designing an advertisement for salad oil, because he was allowed a free hand. He was able to experiment with subtle combinations of colours and linear style, and the result is both a beautiful work of art and a sophisticated piece of sales promotion. And it is indicative of the degree to which Art Nouveau styles had penetrated normal life that the manufacturers should have considered this type of advertisement useful.

Although Toorop's sources were Javanese, the art of the poster looked primarily to Japan for inspiration. The Japanese print had become widely fashionable in the second half of the century, and had influenced almost all artists working at the time. From the work of Hokusai and Hiroshige, European artists learnt how to organize a flat surface, distorting perspective where necessary and balancing areas of flat colour with line. Henri de Toulouse-Lautrec shows the influence very clearly in his *Divan Japonais* poster with its curiously steep perspective.

Posters became the principal Art Nouveau medium in all the countries of the Western world, and each country evolved its own style. French posters often show the lingering influence of Symbolism; the figures in Alphonse Mucha's posters still show traces of that country's obsession with the idea of Woman the Temptress. And perhaps because of the

Alphonse Mucha
Gismonda 1894

Georges de Feure
Le Journal des ventes 1897

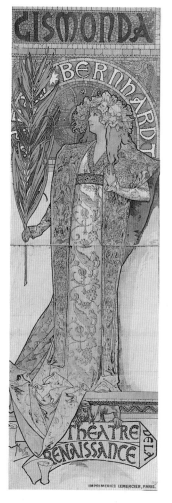

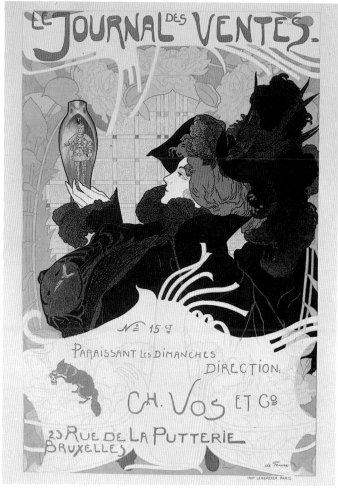

country's long history of painting, artists there found it more difficult to adapt to the discipline of lithographic techniques. Neither Mucha nor Georges de Feure uses the flatness of lithography as much as their Austrian or Dutch counterparts; they still tend to draw in three dimensions, and so their graphic work is more complicated than other contemporary work. The Dutch designers, led by Henry van de Velde, specialized in very linear, frequently abstract, designs with much emphasis on lettering. They were particularly skilful at juxtaposing colour to produce a slight vibration. The influence of this type of design spread to Germany and can be seen in Bernhard Pankok's exquisite design for the 1900 World's Fair catalogue. Colour and form have been released from any descriptive role, and the artist is free to achieve pure abstract beauty.

In Germany the style was called 'Jugendstil', after the magazine *Jugend* ('youth'), and was split between those who, like Pankok, were influenced by the delicate abstract style of the Dutch, and those who leant towards the more robust style of the Vienna Secession. Sattler's *Pan* is typical of the latter style, with its deliberate imagery and use of blocks of rich colour.

In England, the Beggarstaff Brothers (William Nicholson and James Pryde) evolved a style that left large areas of the picture bare of any ink,

Below:

Henry van de Velde
Tropon 1898

Bernhard Pankok
Endpaper design for the catalogue of the German Empire exhibit at the Paris World's Fair, 1900

Opposite:

Ludwig von Zumbusch
Cover for *Jugend* (No. 40), 1897

Josef Sattler
Pan 1895

Beggarstaff Brothers (William Nicholson and James Pryde)
Girl on a Sofa 1895

William Bradley
The Chap Book 1894

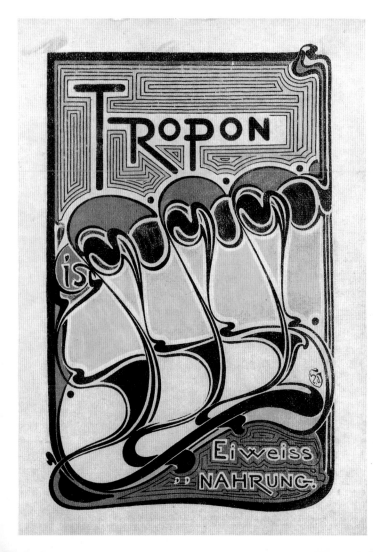

a trick they learned from Toulouse-Lautrec and Bonnard, and the style even reached America with the work of William Bradley who adapted it to the flavour of that country.

Art Nouveau never produced a school of sculptors as such; but in applying the ideas of Art Nouveau to objects, designers were able to retain the idea of function while investigating sculptural possibilities. The art of Emile Gallé was restricted to the making of vases, usually of polychrome glass, but it is really the true sculpture of Art Nouveau. In Nancy he inspired a school of designers and glass-workers whose work is often almost indistinguishable from his own. Typical of the Nancy style is the tulip-like vase illustrated here; formal aspects are kept to the minimum, enhancing the effect of the meticulously considered surface, with its mother-of-pearl iridescence. The influence of Japanese ceramics is evident in the maker's willingness to let accident play a part in the design, juxtaposing rich glaze effects with simple shapes.

The same cannot be said for Louis Comfort Tiffany, the other great maker of glassware of the period. Where Gallé was designing for a few French connoisseurs, Tiffany's clients were rich Americans who came to

René Wiener
Portfolio for engravings, 1894

Daum, after Bussière
Glass vase, *c.* 1900

Louis Comfort Tiffany
Glass vase, *c.* 1900

René Lalique
Decorated cup

his shop in New York to buy decorations for their town apartments. His work is altogether more flamboyant, and the iridescent effects used more openly. Tiffany never achieved the purity of the Nancy style, but his immensely popular work has, at its best, a ponderous beauty.

Jewellery also proved an excellent medium for Art Nouveau and produced one master of the art. This was Lalique, who worked principally with silver baroque pearls and semi-precious stones. The regularity of cut stones such as diamonds or rubies did not appeal to him, but with stones such as moonstone and opal he made luminous pieces of great delicacy using stylized representations of animals and plants.

Being such a widely based movement, Art Nouveau was susceptible to changes in fashion. Unlike many art movements, which seem to be jealously guarded secrets, Art Nouveau found its public almost immediately. It was good form in fashionable circles to have your vases by Gallé, as it had been in Britain to have wallpaper by Morris. And being a fashion, the style changed, so when Serge Diaghilev arrived in town with his Ballet Russes, the linear aspect of Art Nouveau was put to the service of Oriental exoticism. And because it was so firmly based in society, Art Nouveau disappeared with the destruction of the old ways in 1914.

Now Gallé vases fetch even higher prices than they did in 1900, and Morris wallpapers are seen everywhere. Even the more ridiculous Symbolist paintings are breaking records in the salerooms, and no doubt many more 'minor masters' will be discovered to fill gaps in the supply to the market. How to react to these exotic blooms, every man must decide for himself, but it is certain that without Symbolism's heady attempt on the citadel of Mystery, and without Art Nouveau's wilful decorative elegance, the history of art would be safer but duller territory.

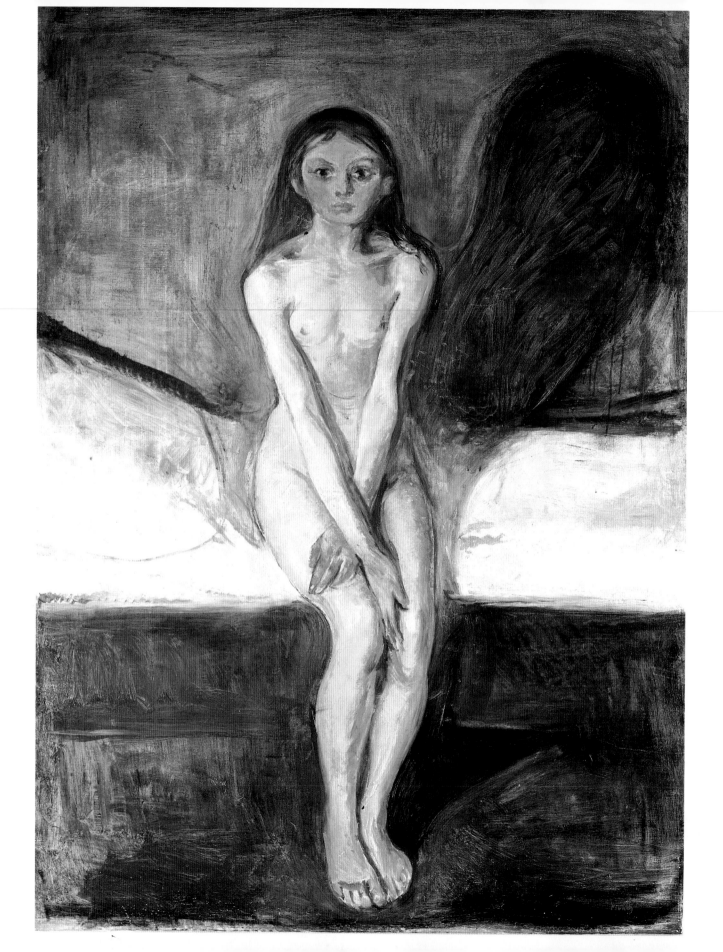

3 Fauvism and Expressionism

BERNARD DENVIR

Expressionism is one of those words, like romanticism, which have a general and a specific meaning in their function of defining cultural phenomena. In its wider sense it is taken to describe works of art in which feeling is given greater prominence than thought; in which the artist uses his medium not to describe situations, but to express emotions, and allows it to be manipulated beyond currently accepted aesthetic conventions for that purpose. Further to enhance the effect on the spectator, the artist may choose a subject which in itself evokes strong feelings, usually of repulsion – death, anguish, torture, suffering. In a stylistic context, expressionism in painting often implies an emphasis on colour at the expense of line, largely because the effects of colour are less patient of a rational explanation than are the effects of line.

Expressionism in this sense is one of the constituent elements in the dialectic between thought and feeling which powers so much creative activity, and it is to be found, with varying degrees of intensity, in all periods and most cultures. The thirteenth-century Byzantine murals in the church of San Zan Degolà in Venice, Giotto's *The Mourning over Christ*, in the Capella dell'Arena in Padua, Rembrandt's self-portraits, the etchings of Goya, and Delacroix's *Dante and Virgil in Hell*, are all symptomatic of its spirit.

In a more specific sense, however, Expressionism refers to the works of a large number of painters (among whom there were many varieties of style, and some of whom were absorbed into other movements), who during the late nineteenth and early twentieth centuries translated the general principles of expressionism into a specific doctrine. In so doing they effected a transformation of the nature of art which made possible the traumatic revolution which it has experienced during the last three-quarters of a century. Expressionism in this sense involved ecstatic use of colour and emotive distortion of form, reducing dependence on objective reality, as recorded in terms of Renaissance perspective, to an absolute minimum, or dispensing with it entirely. Above all else, it emphasized the absolute validity of the personal vision, going beyond the Impressionists' accent on personal perception to project the artist's inner experiences – aggressive, mystical, anguished or lyrical – on to the spectator. Though this is to define Expressionism in terms of the visual arts, it was as powerful in music, literature and the cinema as it was in painting.

The revolt against rationalism, and the accompanying cultivation of the sensibilities, had been proceeding apace since the beginnings of the Romantic movement. But in the nineteenth and early twentieth century

Edvard Munch
Puberty 1895

it had received support from a variety of sources. The revolutionary mysticism of Kierkegaard, the existentialism of Heidegger, the tortured social preoccupations of Ibsen and Strindberg, the febrile anguish of Swinburne and Whitman, the aggressive Dionysian myths of Nietzsche, all created a climate of intellectual violence which intoxicated the young. The discoveries of Darwin reduced the status of man in the scale of life, and emphasized his relationship to other, more instinctual creatures. The theories of Marx suggested that he was the toy of history rather than its master. The researches of Freud, which made their impact felt most clearly in those countries where Expressionism flourished, suggested that our actions are not motivated by those processes of conscious thought on which we had placed such reliance. Bergson stressed the subjective nature of perception, and the flow and flux between nature and the mind of man. In developing humanism, Western man had begun to alter his notions of humanity.

The romantic stereotype of the artist as an anguished creator, tormented into creativity by his finely attuned sensitivities, had become accepted by the 1870s, and it is not without significance that among those artists involved in Expressionism, at least six, Van Gogh, Munch, Ensor, Kirchner, Beckmann and Grosz, experienced psychotic as well as neurotic episodes. Nor was the situation helped by the temper of the times. Most of the Expressionists were young men when the Great War broke out, and old men when the horrors of Hitler's extermination camps were unveiled. Events provided them with as much anguish as they needed, and their involvement with the more macabre aspects of history is reflected in such coincidences as that the leading Expressionist magazine in Berlin was entitled *Der Sturm*, foreshadowing the Stormtroopers of a later decade.

There were recent precedents for the Expressionists' hunger for sensation. In the 1880s and 1890s the so-called Decadents and the Symbolists had explored sex, drugs, religion, mysticism, magic and alcohol as paths to creativity, and in so doing had helped to cast the artist in the role of archetypal rebel against society and the establishment. The Expressionists were to go further in this respect than the socialists of the Arts and Crafts Movement, such as William Morris and Walter Crane; and the same individualism which led them to reject the conventions of official art led them to a profound concern with human suffering and deprivation which found expression in Anarchism or Communism. Indeed, the relationship between Expressionism and Communism still survives on both sides of the Iron Curtain.

In one of the most popular books of the *fin de siècle*, *Là- bas*, J. K. Huysmans describes Grünewald's Karlsruhe *Crucifixion* thus: 'Dislocated, almost dragged from their sockets, the arms of Christ seemed pinioned from shoulder to wrist by the cords of the twisted muscles. . . . The flesh was swollen, stained and blackened, spotted with flea-bites. Decomposition had set in. A thicker stream poured from the open wound on the side, flooding the hip with blood that matched deep mulberry juice. . . . The feet, spongy and clotted, were horrible; the swollen flesh rising above the head of the nail, the clenched toes, contradicting the imploring gestures of the hands, seemed cursing as they clawed at the ochreous earth.'

This expressionist prose, replete with horror, highly personal, full of chromatic adjectives, describes the work of a rediscovered artist who himself was one of the most significant forerunners of Expressionism. The movement was in fact greatly nurtured by the work of art historians such as Friedländer, whose exhaustive study of Grünewald appeared in 1907, of Mayer whose monograph on El Greco was published in 1911, and of others who at this period wrote about Hogarth, Bosch, Goya and Bruegel, all of whom represented elements in the expressionist tradition. At the same time, too, new precedents were provided by the discovery of irrational, 'primitive' art, of popular art, which owed nothing to cultured sensibilities, and of the traditions of caricature, which had always distorted objective reality to convey a message or sensation.

Fauvism

Expressionism, in the sense in which I have described it, has always been regarded as a Teutonic and Nordic phenomenon; but its appearance in modern painting is the result of a liberation of colour and form which took place in France, and which culminated in the short-lived but seminal style known as Fauvism.

When in 1906 the group which had gathered round Henri Matisse exhibited together as the Salon des Indépendants, it is little wonder that in terms of current conventional sensibilities, the art critic Louis Vauxcelles (who had a gift for assessing art historians of the future; he also coined the word 'Cubists') should have described them as *fauves* – wild beasts. As a coherent group it was remarkably short-lived, and virtually ended a year after its birth; most of its members went on to other styles, and of those who retained the original Fauve inspiration many became embedded in its mannerisms. But it represented the birth of the School of Paris, and shared (with Expressionism proper) the responsibility for creating the art of the twentieth century.

France was special. Since at least the time of Louis XIV, the arts there had been fostered by the State on a formidable scale, discussed by the intelligentsia with passion, explored by their practitioners with a vigour never consistently attained in any other European country. French painting, marked in the eighteenth century by elegance and visual sophistication, was characterized in the nineteenth by an evolutionary dynamism. Stimulated by the special social and cultural atmosphere of Paris, with its museums and galleries, its art schools, still working on the traditional *atelier* system, its closely-knit community of artists in constant social contact through the network of cafés, French painting evolved with a remarkable speed and diversity, establishing a dialogue which lasted for more than a century between the romantic and the classical, the hard and the soft, the emotional and the intellectual. The pattern which had been established in the contrast between Ingres and Delacroix persisted under many different guises.

The Impressionists in the 1870s had made the most spectacular contribution to what might be called the perceptual revolution, creating a new form of visual humanism by vindicating the primacy of the individual sensibility. As a result, Impressionism was never consistent or

homogeneous. Tensions between thought and feeling, between line and colour, between analysis and synthesis, were there all the time, expressed not only in the difference between, say, Sisley and Pissarro, but between phases in the work of single artists, such as Manet and Renoir.

The hunger for ordered structure was the most apparent of the disruptive elements, producing the Pointillism or Divisionism of Seurat and Signac, with its hieratic rigidity of structure and its dogmatic use of dots of pure complementary colours, and those architectural explorations of form which led eventually from Cézanne to Cubism. But its complementary antithesis was also very much present. The current was flowing strongly in the direction of emotional sensibility, in France as elsewhere. A generation which looked up to Baudelaire could not but be aware of the fact, and towards the last quarter of the century the desire to wring the last drop of sensation took the same shapes in Paris as it did all over Europe. Beneath the surface of conventional life there existed an 'underground' as active in its explorations as any which exists today. Drugs were endowed with a cultural cachet by readers of Poe, Coleridge and Baudelaire; alcoholism was as widespread in Montmartre and Montparnasse as it was in the deprived rural areas of France. There was a hunger for unmentionable vices and strange experiences; there was even a not unfamiliar passion for anarchism. An important Fauvist painter, Maurice de Vlaminck, once wrote: 'Painting was an abscess which drained off all the evil in me. Without a gift for painting I would have gone to the bad. What I could have achieved in a social context only by throwing a bomb, which would have led me to the guillotine, I have tried to express in art, in painting, by using pure colours straight from the tube. Thus I have been able to use my destructive instincts in order to recreate a sensitive, living and free world.'

This romantic agony, as it took shape in the context of French culture, touched a wide range of artists. The music of Debussy and of Fauré throbbed with new excitements, and the theme of Salome as expressed in Oscar Wilde's verse drama attracted not only Aubrey Beardsley but Gustave Moreau, too often described as a traditional salon painter. 'Nature itself is of little importance; it is merely a pretext for artistic expression. Art is the relentless pursuit of the expression of inward feeling by means of simple plasticity.' These sentiments were the basis of Moreau's teaching, and his pupil Henri Matisse was to find them 'profoundly troubling'; they were to be the unavowed credo of Fauvism.

There were more apparent precedents. Vincent van Gogh had never made any pretence that his art was other than the expression of inward feeling. 'I don't know if I can paint the postman *as I feel him,*' he once wrote to his brother Theo; and the fervour of his colour, the emotive violence of his forms, were having an impact which was emphasized by the first retrospective held at Bernheim-Jeune's gallery in 1901, at which Matisse was introduced to Vlaminck by another painter, André Derain.

In 1889 Paul Gauguin, staying at Pont-Aven in Brittany, had been moving towards a style which would combine spontaneity, mysticism and a complete disregard for 'truth to nature' with the use of non-descriptive colours, as exemplified in *The Yellow Christ*. The motivation may well have been literary and Symbolist; 'I find everything *poetic,* and it is in the

Vincent van Gogh
Self-portrait with Pipe and Bandaged Ear 1889

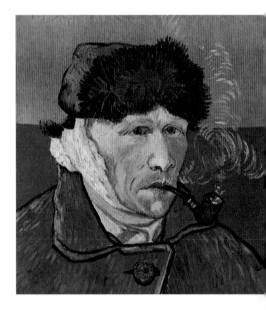

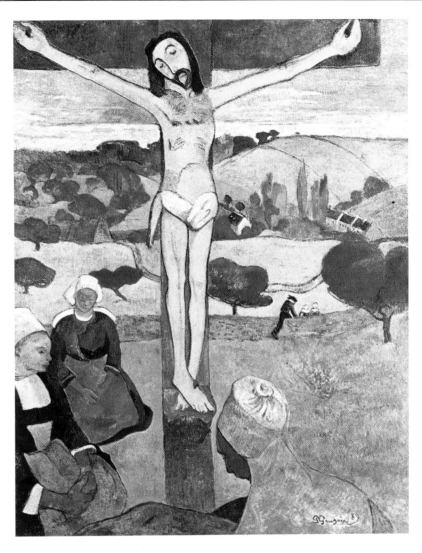

Paul Gauguin
The Yellow Christ 1889

dark corners of my heart, which are sometimes mysterious, that I perceive poetry,' he wrote to Van Gogh at this time. The stylistic origins lay in Japanese and primitive art, but the total effect was one of emotional excitation of the 'dark corners of the heart', implying as time went by (*Contes Barbares* of 1902) a total independence of the artist from any terms of reference except those of his own sensibilities.

The technical revolution which was under way was Expressionist in perhaps the purest sense of the word: it had no exclusive connection with any particular kind of subject matter, but was concerned with the direct use of colour and form, not to suggest but to express. It was a necessary step in the emancipation of art from literal depiction. The essence of what came to be known as Fauvism, which every painter interpreted in his own way, lay in the uninhibited use of colour to define form and express feeling. In Matisse's *Nude in the Studio* of 1898, the purity, the violence of the colour conveys a sense of audacity that disguises the resolute quest for

formal coherence, inherited from Cézanne, which he was never to abandon. There was clearly something in the air at the moment which transcended personal contacts and coteries, for in Barcelona, for instance, nineteen-year-old Pablo Picasso was painting pictures such as *The Window* which showed the same tendency for forms to dissolve in, and be moulded by, evocative colour; in Picasso's case they were less pure, less adventurous, echoing the palette of Manet rather than venturing into new chromatic dimensions.

Personal contacts, however, were the flashpoint which ignited Fauvism. The common experiences of Moreau's studio were extended in 1899 at the Académie Carrière, where Matisse met two painters from the Paris suburb of Chatou, André Derain and the self-taught Maurice de Vlaminck, both of whom were making adventurous visual experiments in

Pablo Picasso
The Window 1900

Maurice de Vlaminck
The Bar Counter 1900

Henri Matisse
Nude in the Studio 1898

the same direction under the influence of Van Gogh. Vlaminck, an explosive, naturally gifted, physically vital man, an anarchist and a champion cyclist, who once said that he loved Van Gogh more than his own father, obviously owed something to his Flemish ancestry. Consumed with a passion for brutal truth, he crucified his sitters with something approaching relish, handling paint with a Chardin-like verve.

Matisse was to build his subsequent career on his experiences and discoveries during this period, in which he produced some of his most spectacular works. The continuing evolution of colour and its emancipation from accepted perceptual conventions led to an increasing concern with what he called 'pictorial mechanism', which owed a lot to the disciplines of Seurat's Pointillism: its structural purity and use of dots of pure colour. Abandoning realism, he kept a tangential hold on reality;

and even in a painting such as *Luxury I* he not only retained spatial depth, but arranged the figures in a composition which would not have been unfamiliar to an artist of the Renaissance. They are simplified, stylized, but not distorted for any emotive reason. At the same time, however, they convey perfectly the resonances of the title.

Among Matisse's associates in the early 1900s, the closest to him was Albert Marquet. From a style close to the bold formalism of Edouard Vuillard and the other members of the Nabi group of the 1890s, Marquet migrated to one which, though expressive in form and technique, eschewed the pure brilliant colours of Vlaminck or Matisse, and kept much closer to figurative sources. In *Matisse Painting a Nude*, for instance, the colour appears rather as a background than as an integral part of the whole composition; the figure is defined by a line, and not modelled by the surrounding areas of colour. There is also apparent Marquet's growing concern with a subdued palette, and with the potentialities of a luminous black; in many ways he reverted to a Manet-like approach to painting, and his draughtmanship was such that Matisse once described him, with some pertinence, as 'the French Hokusai'.

André Derain brought to the Fauves something of the same vigour and panache as his friend Vlaminck; he too used colour directly from the tube, applied in broken lines with quick impetuous brush-strokes; but

Henri Matisse
The Green Stripe 1905

Henri Matisse
Luxury I 1907

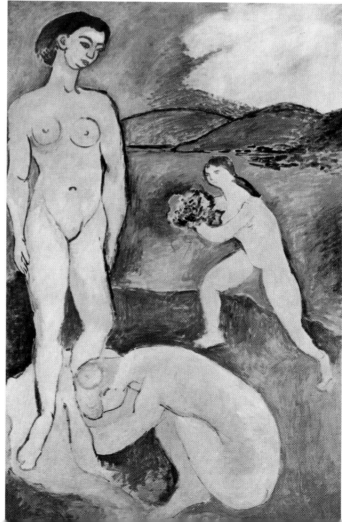

Albert Marquet
*Matisse Painting a Nude in Henri Manguin's
Studio* 1904–05

even in his youthful works he was more lucid, more thoughtful, more graceful. Conscious of the past, his discovery of the emotive use of colour owed as much to the Pointillists as it did to Van Gogh, and his forms were influenced by a variety of precedents: *Images d'Epinal*, those simple folk-images which had so appealed to Courbet and Gauguin; Byzantine art; and the simplified planes of African sculpture. In 1905, the year in which he visited London and painted scenes on the Thames, he produced views of the Seine in which Seurat's Pointillist technique is allied to Van Gogh's hatched brush-strokes to produce works of organized lucidity, remarkable for their emotional coherence.

Face to face with a living model, however, Derain's work took on greater immediacy; and in *Lady in a Chemise* he came close to the impetuous vehemence which was at the heart of Fauvism. The

multiplicity of colours and tones, the flickering flame-like brushwork, the exaggeration of the face and eyes, the heavily pendulous and slightly distorted left hand, the partial use of a contour line to define those parts of the figure which play a dominant part in the composition, create an impression of adventurousness which in the long run turned out to be alien to his talent.

'How, with what I have here, can I succeed in rendering, not what I see, but what is, what has an existence for me, *my reality*, then set to work drawing, taking from nature what suits my needs? I drew the contours of each object in black mixed with white, each time leaving in the middle of the paper a blank space which I then coloured in with a specific and quite intense tone. What did I have? Blue, green, ochre, not many colours. But the result surprised me. I had discovered what I was really looking for.' The description which Raoul Dufy gave, many years later, of his conversion to the ideas of Fauvism, describes as well as anything the sense of elated emancipation which so many of his contemporaries felt, and it is immediately apparent in his paintings of this period; they have a chunky vitality which his later, more graceful and sophisticated works

André Derain
Banks of the Seine at Pecq 1905 (detail)

André Derain
Lady in a Chemise 1906

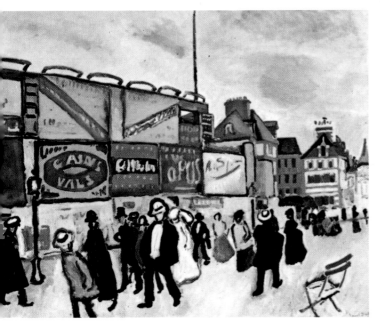

Raoul Dufy
Placards at Trouville 1906

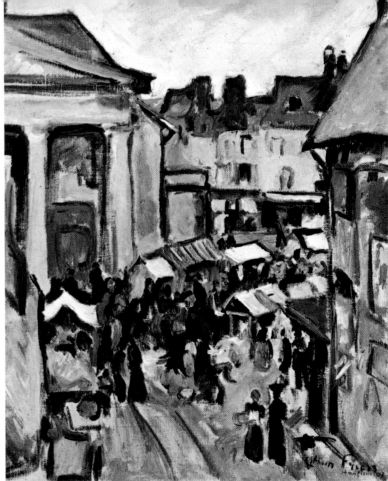

Othon Friesz
Sunday at Honfleur 1907

were to lose completely. *Placards at Trouville*, with its movement, its bold simplified outlines, its areas of bright colour, each emitting an air of joyous sensationalism, conveys perfectly the sense of seaside holiday-making in fresh sparkling air. Born at Le Havre, Othon Friesz studied at school under the same teachers as Dufy, and he too was fascinated by seaside subjects. His *Sunday at Honfleur*, painted a year after Dufy's exercise at Trouville, emphasizes the differences between them. The composition is more static, the colour less adventurous, the lines heavier, more dominant; the desire to charge the canvas with some kind of lyrical emotion is more apparent, and therefore less successful. Friesz's thirst for visual eloquence was to lead him eventually to a baroque exuberance which verged on the hysterical.

The Fauve experience was for many artists a period of liberation, marking the moment at which they escaped from the conventions of realism and the confines of the conventional palette to achieve a realization, on which their future careers would be built, that the artist was concerned with the primacy of his own personal vision, and with creating a world which he himself controlled. This is especially evident in the case of Georges Braque, who was, like Friesz, a native of Le Havre. It was Friesz who first introduced him to what the Fauves were doing; and for some three years, between 1904 and 1907, he produced a series of works which, though vivid in colour and exuberant in line, are thoughtful

in composition, velvety in texture, and more deliberate in execution than
the general run of paintings his friends were producing. Already there was
implicit in them a concern with construction, a tendency to flatness of
composition, which foreshadowed the emergence of Cubism. But artists
such as Robert Delaunay, who themselves were never Fauves, and who
went on to Cubism, Futurism or any of the other subsequent movements
which the Fauve revolt had made possible, always retained strong
evidence of its influence in their works, paying unconscious tribute to its
liberating force, and to the new significance which it had given to colour.

This was even more true of those artists whom one might define as
unconscious Fauves, of whom the most outstanding example was
Georges Rouault. A pupil of Moreau, and at one time marginally
connected with Matisse's group, Rouault never really felt in sympathy
with the movement, although he was equally concerned with wringing
anguish from his colours, and using art as a means of expressing a
personal, anti-realist viewpoint. The two dominant elements in his
creative make-up were his early experiences as an apprentice to a maker
of stained glass, and his friendship with two prominent figures in the
Catholic revival which had such an important influence in the cultural
life of the early twentieth century: J. K. Huysmans, a convert who united
the fervours of belief with the recently shed languors of decadence, and
Léon Bloy, one of the new school of writers who combined a radical

Georges Rouault
Bal Tabarin (Dancing the Chahut) 1905

Georges Rouault
Versailles: the Fountain 1905

concern about social justice with an almost excessive passion for the traditional values which he saw enshrined in Christianity. From these combined sources Rouault built up a style which varied little throughout the whole of his career. From his religious and social preoccupations he evolved an iconography which dealt with religious subjects, with whores and clowns, with all that involved the grandeurs and miseries of *la condition humaine*, and a passion tinged with bitter irony, even pessimism. From his feeling for the translucent beauty of stained glass he evolved a style characterized by its craftsmanship, its Byzantine simplicity, its luminous colours. But, in spite of these personal mannerisms, Rouault was still at heart a Fauve. The sense of stylistic passion, the savage slashes of colour, the need for vehemence, become more apparent when, as in *Versailles: The Fountain*, the subject matter is not overtly Expressionistic.

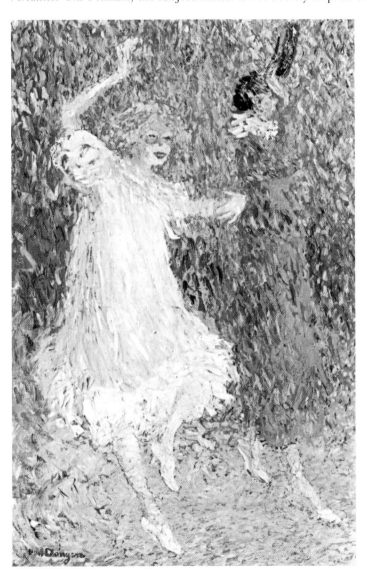

Kees van Dongen
The Speech 1904–05

The extent of Rouault's Fauvism can be assessed by comparing his work with that of the happy, extroverted Kees van Dongen, an instinctive, archetypal Bohemian, who also had a penchant for painting clowns and the demi-monde, and whose finest work has an exuberant panache, an evocative passion, which seduce rather than convince. His momentary strengths and his eventual weaknesses sprang from the fact that he was a natural painter. A member of the Fauves, he later went on to join the German group Die Brücke (*see* p. 132), and in this context demonstrated the gulf which existed between those artists to whom passion in painting was a matter of style and those for whom it was a way of life.

A Northern Episode

The almost irresistible urge to identify the genius of Expressionism with that of Nordic cultures – and to relate its degrees of intensity to the distance which separated its practitioners from the shores of the Mediterranean and the influences of Catholicism – receives its most cogent support from the work and personality of Edvard Munch, whose paintings have become the very archetypes of all that the movement implied. A Norwegian, he was nourished in the same traditions which produced the guilt-tinged work of Ibsen and Strindberg (who wrote a catalogue entry to his *The Kiss*). Profoundly neurotic, his childhood was spent in the most inauspicious circumstances: his mother died when he was five, and one of his sisters when he was thirteen; his father was a doctor who practised in a poverty-ridden area of Löiten. He grew up in an atmosphere dominated by the ideas of death, disease and anxiety, and the images of this period of his life were always to remain with him. In the *Madonna* of 1895–1902, for instance, the typically 'decadent' concept of the subject as a nearly nude, whore-like figure is reinforced by a painted border of spermatozoa, which lead to an embryo in the lower left-hand corner, derived from an illustration in a German anatomical text-book published in the middle of the century, and presumably forming part of his father's library.

Significantly enough, Aubrey Beardsley made use of the identical figure in several of his drawings; which underlines the fact that many artists who came to creative maturity in the later nineteenth century were obsessed with the same symbols, the same preoccupations. The concept of the *femme fatale*, using the phrase in its literal sense, to indicate the idea of woman as a malevolent, destructive and seductive siren, played a vital part in the work of Munch. Time and time again he reverts to the theme of woman as vampire, as the fatal temptress, and even in his *Madonnas* he seems intent on destroying utterly the icon which in the past had done so much to idealize femininity.

No less was he seduced by the idea of death and disease. In part this may have been due to the circumstances of his childhood; death struggles, sick rooms and the paraphernalia of mortality intrigued him as much as the themes of classical mythology had obsessed Poussin. But there was more to it than that. The idea of eventual personal annihilation has always been emotive, and the nineteenth century was more than half in love with

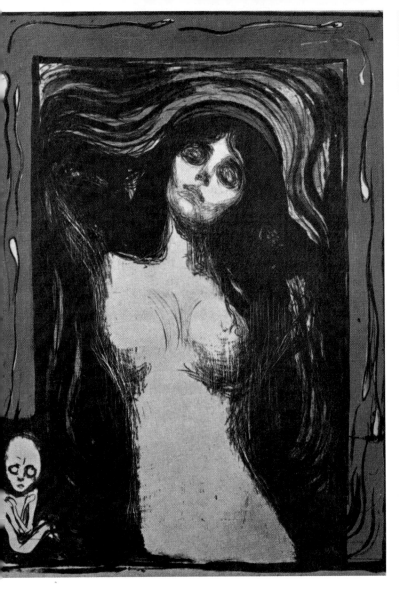

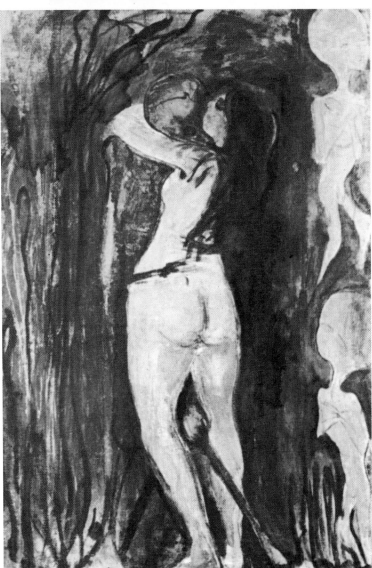

Edvard Munch
Madonna 1895–1902

Edvard Munch
Death and the Maiden 1893

easeful death. Queen Victoria was as susceptible to the idea as Munch, and in some curious way – partly at least explained by Mario Praz – it had become intermingled with sexuality. Keats, Schubert, Schiller and many others had underlined the connection in the early part of the century; the Belgian Antoine Wiertz (1806–65) devoted his whole artistic career to the theme, and bequeathed to an ungrateful posterity a museum commemorating the fact. But nowhere – because he bent his technique to underlining his image – has the idea been better elaborated than in Munch's *Death and the Maiden* of 1893. On the left of the picture wriggle the spermatozoic shapes; on the right is a frieze composed of two foetus-like creatures. Death himself is no traditional Gothic-horror skeleton, though the black branch-like lines which echo his shape suggest the anatomical: he is a semi-human shape, full of amorphous ambiguities, the sense of horror emphasized by the wooden leg-stump which emerges through the girl's thigh. She, on the other hand, is characterized by an exuberant sensuality, underlined in a formal sense by the heaviness of her

thighs, the solidity of her buttocks, the bluntness of her face, and the exaggeration of the line which runs from her left armpit to her knee.

That Munch had personality problems more pressing than those which beset the generality of mankind is obvious, and it would be ridiculous to disregard them in assessing the nature of his work. His neuroses are apparent in such a way that the work is often the graphic expression of actual experience. He was conscious of this, and in his diary he records the experience which created one of his most symptomatic subjects, *The Scream*. 'I was walking along the road with two friends. The sun was setting, and I began to be afflicted with a sense of melancholy. Suddenly the sky became blood-red. I stopped and leaned against a fence, feeling dead-tired, and stared at the flaming clouds that hung, like blood and a sword, over the blue-black fjord and the city. My friends walked on. I stood riveted, trembling with fright. And I heard (felt) a loud, unending scream piercing nature.'

The experience, then, although psychological in origin, was as real to him as to a mystic. But many have had similar sensations; what was in a sense unique about Munch was that within the traditional framework of the European artistic tradition, he forged a remarkably expressive – the adjective is inescapable – visual technique, combining the curved whiplash line of Art Nouveau with colours which range from the acidulous to the sentimental in a frenzy of compositional vigour which is often strongly reminiscent of Van Gogh. Nor is the stylistic affinity accidental. In 1889 Munch had travelled to Paris on a state scholarship and had come into contact with Van Gogh and Gauguin – the latter, as usual with younger artists, exerting a strong influence on him. In 1892 he was invited to exhibit at the Verein der Berliner Künstler, where, after a great deal of controversy which helped to impress Munch on the German artistic awareness, and led to the foundation of the Berlin Secession, the leaders of the society closed the exhibition in which he was participating. But it was in the German capital that he came into fruitful contact with the poet Richard Dehmel, the critic and historian Julius Meier-Graefe, the enlightened industrialist Walter Rathenau (who first bought a Munch painting in 1893) and Strindberg. By 1895 he was back in Paris again, and for the next few years lived a cosmopolitan existence, though forced to spend occasional periods in a sanatorium. In 1908 he suffered a complete collapse and spent a year in Dr Daniel Jacobson's hospital in Copenhagen. In 1909 he returned to Norway and passed the rest of his life there in relative seclusion.

Like his literary compatriots, Munch was preoccupied with feelings rather than objects, and above all else with their effects on people and their relationships. In this latter respect he was unusual among the Expressionists. This is apparent especially in the contrast between his work and that of his Belgian contemporary James Ensor, with whom, in other respects, he has many affinities. Both were ecstatic in their approach; both concerned themselves with the dark underside of life; and yet both drew support and nourishment from the traditional elements of art – though this was more apparent with Ensor, whose affinities with Turner, and even with Chardin, need no underlining. Even physically they were rather alike. But the style is almost invariably the man, and

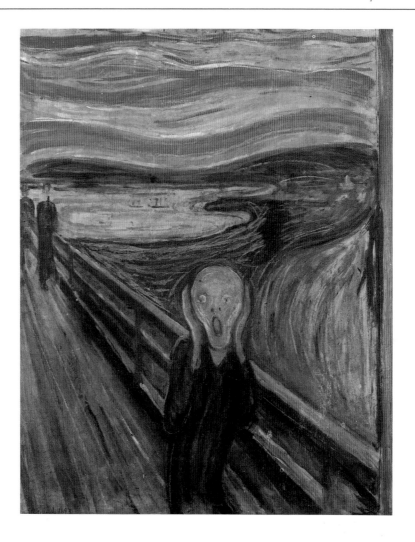

Edvard Munch
The Scream 1893

Ensor seems through his Flemish mother to have established instinctive contact with the cultural tradition which she represented. It was derived not from the Italianate episodes of the seventeenth century as represented by Rubens, nor from the French-orientated style of the Walloons, but from a stream of uninhibited visual fantasy, interlaced with bucolic folklore, which, stretching back to the Middle Ages, had found its supreme expression in the works of Pieter Bruegel, and which, continuing into the twentieth century, has helped (largely through Belgian artists such as Magritte and Delvaux) to link Expressionism with Surrealism. Ensor marks, more clearly than any other artist the line of continuity between the so-called 'Nibelungen Expressionists' – Hieronymous Bosch, Urs Graf, Hans Baldung Grien – and the artists of the late nineteenth and early twentieth century.

Satirical, compassionate, acerbic and whimsical, Ensor created a universe of his own, peopled with absurd, tawdry, moving, shocking figures which grip the imagination, stimulate the fancy and by their very

vehemence produce just that shock to the susceptibilities of the spectator which is the prime goal of Expressionism. *Skeletons Warming Themselves at a Stove* might well be an epitome of the whole movement: the macabre theme, the sinister whimsicality of the scattered skulls grouped grotesquely in a clumsy pyramid around the stove, the minatory figure in the right-hand corner of the composition. But despite the subject matter – and this is a consistent element in Ensor's work – the colouring has a light, sensuous quality, which verges on the lyrical, and underlines his debt to the Impressionists. It was only in his early phase that his technique verged on the sombre, and even then it had a delicate, velvety texture.

 Skeletons Warming Themselves at a Stove looks almost as though it might be an illustration of some pungent, folksy proverb, and though Ensor was capable of painting such pictures as *The Ray* which have no meaning other than that conveyed by the form and colour, there are always literary and social implications in his major works. They are commentaries, even though the precise nature of the moral is never clearly indicated. This is especially true of the *Entry of Christ into Brussels*, which packs into one massive composition (250 × 434 cm) a whole host of satirical, grotesque episodes and situations. A great mass of ugly, distorted faces; Christ mounted on an ass; a broad banner with the inscription *Vive la Sociale*: the whole thing is like some mad *kermesse*

James Ensor
The Singular Masks 1891

James Ensor
Skeletons Warming Themselves at a Stove 1889

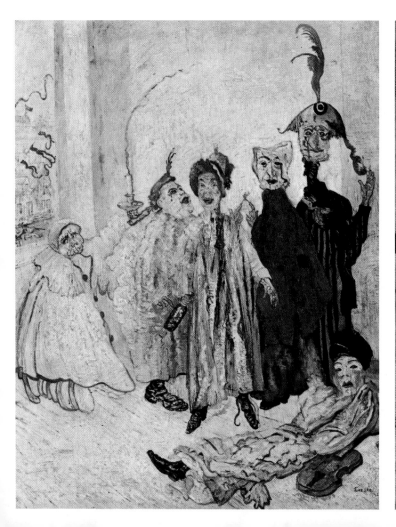

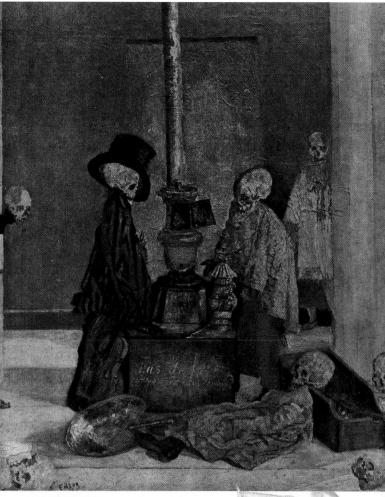

portrayed in a manner which hints at a parody of a historical *grande machine* by a Baroque artist. Again, the colours are light, lyrical, but emphatically dissonant; and the substructure of drawing is marked by a deliberate coarseness – vulgarity would not be too strong a word – which underlines one of Ensor's greatest contributions to the vocabulary of Expressionism, the use of line to create an emotive effect independently of colour. It was this quality which especially endeared him to Paul Klee, and to Emil Nolde, both of whom derived a great deal from his influence. It is important to remember that Ensor produced his most significant work in the last twenty years of the nineteenth century – *The Entry of Christ into Brussels* was painted in 1889 – and that, more forcibly than Gauguin, and even than Van Gogh, he assailed the primacy of the representational element in art, deriving his inspiration largely from that one area in which it had never played an important part – caricature. At the same time too his exploration of the incongruous and the irrational anticipated developments which would not become apparent in the mainstream of art until the second decade of the twentieth century. Life, death, the absurd grandeur of the human condition, were themes which obsessed him, whatever the changes which took place in a style which showed at times the influence of Turner, of Constable and of Rowlandson (in the Royal Museum at Antwerp there are copies by him of works by all three of these). An assiduous student of the great printmakers and

James Ensor
The Entry of Christ into Brussels 1889

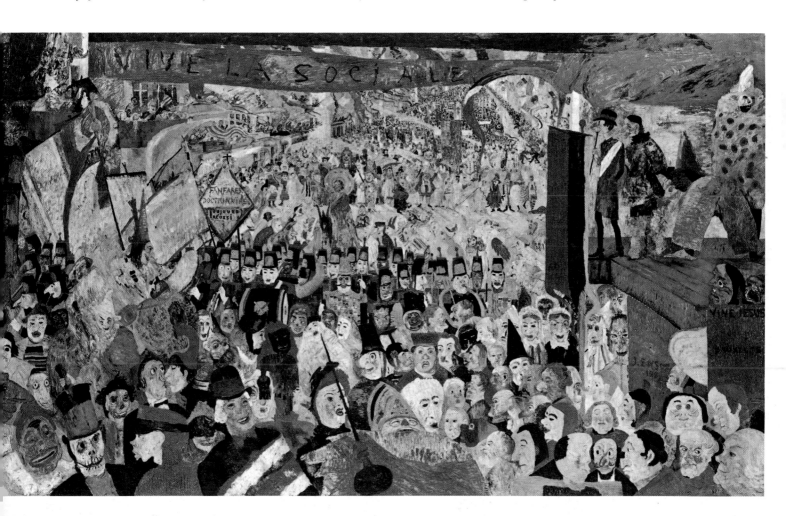

etchers (Rembrandt, Callot, Daumier and Forain were his favourites), he produced, especially in the 1880s, a great number of etchings and other monochrome works in which Goyaesque fantasy illumines disciplined skill.

He was subject to the ambiguities of his time, and though public recognition came late, he could well be claimed as a precursor by Fauves, Expressionists and Surrealists alike; while, equally, the Symbolists might have observed in his work strong elements of their own preoccupation with metaphysical references. He was, after all, the compatriot and largely the contemporary of Emile Verhaeren and Maurice Maeterlinck. His iconography with its strong allusive qualities would have been acceptable to artists who eschewed the violence of his technique, and his preoccupation with those imaginative resonances which were the concern of painters as disparate as Redon and Klimt is suggested by his concern with masks – as in the famous *Self-portrait with Masks*. The autobiographical source of these (as well as of his concern with shells and Chinese porcelain) was doubtless the stall which his mother used to run on the front at Ostend. But they came to possess for him an abiding significance, reflecting at once the psychic anomalies of his own life and the baffling enigmas of interpersonal relationships. Masked figures were almost a cliché of Symbolist art, but Ensor was the first to raise them to the status of independent entities, suggestive question-marks in the carnival of life.

Although he was a co-founder of the avant-garde group Les XX, which exhibited Seurat's *A Sunday Afternoon at the Island of La Grande Jatte* in 1887, Ensor did not start to receive real recognition until the 1920s, by which time he had long done his best work. But he did play a significant part in forming the considerable tradition of Belgian Expressionism, itself a vital link in the transmission of all that the movement implied to later generations.

The links between Paris and Brussels had always been close, and a typical transitional figure was Rik Wouters, who, commencing as a self-taught artist, visited Paris, where he came under the influence of Degas and Cézanne, to whom, superficially, his style owes a great deal. But in his case what might have been little more than a kind of derivative Post-Impressionism was transformed, partly through the influence of Ensor, partly through the consuming passion which he felt for his wife Nel, into something much more dynamic, broad in handling, lyrically emotive in colouring, with passages of rich vibrancy which suggest the basic grammar of pure Expressionism.

For him there was never any precise moment of conversion; perhaps his life was too short for that, and a more typical figure was Gust de Smet, whose career illuminates the way in which the dormant inclination to Expressionism which was inherent in Flemish art could be triggered off by external stimuli into something closer to our conception of an international style. When in Holland he broke away from the luminist tradition which he had derived from the Impressionists, and, largely through the magazine *Das Kunstblatt*, became familiar with what was happening in Germany. His art became wilder, more tragic, the brushwork quick, nervous, ecstatic, with sombre earthen colours, and he chose for his subjects those emotion-laden themes – prostitutes, circus

people, peasants – which had come to be accepted as the accredited icons of twentieth-century romanticism. After flirting for a while with the structural dynamics of Cubism, he reverted in the 1930s to paintings in which the sonorous play of light and colour within a clearly defined outline evokes a sense of passionate sensuality.

If Bruegel was Flemish, so too was Rubens, and the particular brand of Expressionism which dominated Flanders for the first quarter of this century was on the whole humane rather than violent, lyrical rather than vehement; an Expressionism of the brush rather than of the heart. This was as true of De Smet as it was of his friend and contemporary Constant Permeke, who also started off his artistic career in the Impressionist-inclined artists' colony of Sint-Matens-Latem, and then developed an emotive monumentality which retained Ensor's sense of near-abstraction and visual violence. Objects ceased to be clearly visible, and were discernible rather than apparent; there was a largeness of treatment, an air of the cosmic about both his figures and his landscapes. Wounded in the war, Permeke lived for five years in considerable poverty among the farmers of Devonshire, an experience which confirmed in him that penchant for a kind of rural mysticism which was one of the minor

Rik Wouters
Nel Wouters 1912

Gust de Smet
The Striped Skirt 1941

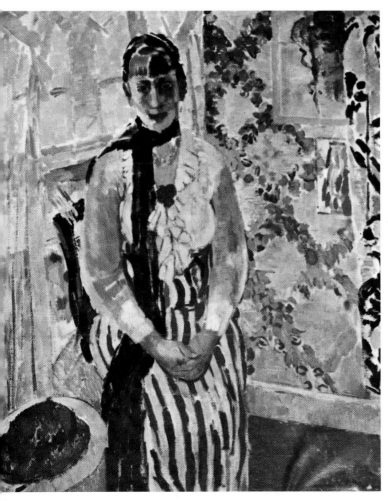

Leon Spilliaert
Tall Trees 1921

strands in the Expressionist tradition, deriving its sanction from both Van Gogh and the Pont Aven school. The sense of lyrical rapture infuses his paintings with a Turneresque quality which may have been consciously acquired in England, but more directly it permits the unification of a whole variety of disparate objects – trees, houses, windmills – which assume a limpid plasticity within an all-embracing light.

Léon Spilliaert, although self-taught, was formally more sophisticated, his art more elusive. Untouched by Ensor, but owing much to Munch, his earliest works have strong Symbolist characteristics, the linear arabesques which dominate them suggesting an impassioned Art Nouveau with emotional undercurrents alien to that more purely decorative style. But

from the very beginning, his paintings had an unreal, hallucinatory quality, and certain images obsessed him – girls by the seaside, human beings confronting and being absorbed by nature. Trees came to play an increasingly dominant role in his imagery, and he observed them with a frenzied intensity which converts them from inanimate phenomena into brooding totems, transforming their surroundings into landscapes of the mind heavy with hidden significances. More clearly than any of his contemporaries, he shows the intricacy of the network which linked Symbolism, Expressionism and Surrealism.

Germany: Die Brücke

A good deal of the impetus which Expressionism in Belgium received came from the presence there during the Great War of a number of German artists, most of them working in a medical unit. Erich Heckel, for instance, was stationed in Ostend, came into contact with Ensor, and painted his lost *Ostend Madonna* in 1915 on the canvas of an army tent. This underlines the fact that although Expressionism was a European phenomenon, it was in Germany that it achieved hegemony. It was there that it became almost a way of life, and it was there that it assumed its most radical and influential forms. The reasons for this cannot be restricted to mere stylistic evolution or changing aesthetic credos. Dangerous though it may be to make generalizations about the pattern of national cultures, it seems impossible to evade the realization that of all European peoples, the German-speaking have been the most apt to emphasize feeling, to prefer the world of the imagination to that of fact, to be seduced by the concept of storm and stress, to toy with the ideas of darkness and cruelty. This was no new thing. The sadistic iconography of Grünewald, the violence of popular German art, especially in the field of graphic reproduction; the fact that, for instance, of the seven 'horrid' novels Jane Austen mentions in *Northanger Abbey* two are actual translations from the German, and four others are set in Germany; the popularity of stories such as that of *Struwwelpeter* all point to a continuity of interest in the macabre. John Willett, in his lively history of Expressionism, makes the point that the poet Johannes Becher, a leading figure in literary Expressionism, could quote with approval this passage from the seventeenth-century poet Andreas Gryphius:

Oh the cry!
Murder! Death! Misery! Torments! Cross! Rack!
 Worms! Fear!
Pitch! Torture! Hangman! Flame! Stink! Cold!
 Ghosts! Despair!
O! Pass by!
Deep and high!
Sea! Hills! Mountains! Cliff! Pain no man can bear!
Engulf, engulf, abyss! those endless cries you hear.

It could well be a catalogue of Expressionist iconography.

Reinforced by its self-imposed function as the guardian of the West against the Slavonic hordes, nourished by the horrors of the Thirty Years

War, the German spirit alternated between apocalyptic idealism and intellectual masochism. The patterns of history did little to relieve these tensions. Between its beginnings as a united nation in 1870, and the advent of Hitler some sixty years later, it endured the hysterical imperialism of the Hohenzollerns, the privations of the Great War, the miseries of inflation, the tragedies of the Weimar experiment. Catastrophe or the millennium seemed always to be on the horizons of German experience. The music of Wagner and of Richard Strauss; the writings of Nietzsche and Heinrich Mann; the plays of Strindberg (which were very popular in Germany) and Wedekind, all nourished that sense of revolutionary emotional turbulence which drove the artists of Berlin, Munich, Dresden and Vienna far beyond the limits reached by their more restrained contemporaries west of the Rhine. In Germany, to an extent unknown in any other country, Expressionism dominated painting and sculpture, literature, the theatre and the cinema.

Unlike France, with its strong traditions of unified political history and centralization, Germany still retained that regionalism which the creation of the Empire under Prussian rule had hidden rather than destroyed. Although the first stirring of a new movement in the arts was nourished by the presence in Germany during the 1890s of Munch who had a *succès de scandale* at the exhibition of the Verein der Berliner Künstler (a dominantly Impressionist body) in 1892, and by the steadily widening influence of Gauguin and of Van Gogh, its final realization was regional rather than national.

Die Brücke ('The Bridge'), which has justly been described as commencing more like a revolutionary cell than an art movement, was founded in 1905 by four refugees from the school of architecture at Dresden, the capital of Saxony. They had no experience of painting, but they saw in it a means of liberation, a medium for expressing a social message. In the programme which one of them, Ernst Ludwig Kirchner, composed and engraved on wood for the group in 1906, he wrote:

'Believing as we do in growth, and in a new generation, both of those who create and those who enjoy, we call all young people together, and as young people, who carry the future in us, we want to wrest freedom for our actions and our lives from the older, comfortably established forces. We claim as our own everyone who reproduces directly, and without falsification, whatever it is that drives him to create.' Influenced by Van Gogh, by medieval German woodcuts, and by African and Oceanic sculpture, Kirchner was concerned with exploiting every technical and compositional technique which could convey a sense of immediate vivid sensation, mixing petrol into his oil paints so that they dried quickly with a matt finish, excelling in watercolour, often in conjunction with other media, applying bright local colour with small brush-strokes. His chromatic inventiveness was, within his own context, remarkably revolutionary: he would harmonize reds and blues, black and purple, yellow and ochre, brown and cobalt blue. Indeed all his earlier works show the self-education of an artist untrammelled by formal education.

By 1911, therefore, when he and his friends decided to move to the more metropolitan atmosphere of Berlin, Kirchner had acquired considerable technical skills, designed for his own purpose, but had not

Ernst Kirchner
Programme of *Die Brücke* 1905

yet lost a certain innocence of visual approach. All this is summed up in *Semi-nude Woman with Hat*, painted in that year. Broad and simple in conception, parsimonious almost in its range of colours, it is a simple dynamic composition, depending on the use of contrasting and complementary arcs. One series starts with the top of the hat and is continued through the shoulders and arms. Another commences with the brim of the hat, is half-echoed in the chin, doubled in the breasts, and concludes with the lines of the blouse. As a counterpoint to this theme is another, consisting of triangles; the first in the lower section of the hat where it reveals the woman's forehead, the second, inverted at the throat, is echoed in the armpits and the fingers of her left hand. The broadly brushed-in background serves as a counterfoil to the figure, whose face, while it suggests the influence of primitive sculpture, is also marked by a kind of suggestive eroticism. The Expressionists as a whole were to be enamoured of the Brechtian underworld of Berlin, with its whores, pimps and gangsters who contrasted so strongly with the apparent simple purity of their own dreamworld. How powerful the effect was on Kirchner is especially apparent in works such as *Five Women in the Street*, in which the ominous black figures, with their sinister, elongated bodies and fantastic hats, are sited against a virulent green background, which, though it retains a few elements of figurative observation, is virtually abstract and of considerable compositional complexity. Sculptural influences are again apparent; but the whole painting is massively dedicated to representing the artist's own sense of projected sin, Puritan in intention, passionate in expression. Significantly, five years later, when on the verge of physical and mental collapse, he wrote; 'I stagger to work, but all my work is in

Ernst Kirchner
Figures on Stones (Fehmarn) 1912–13

Ernst Kirchner
Semi-nude Woman with Hat 1911

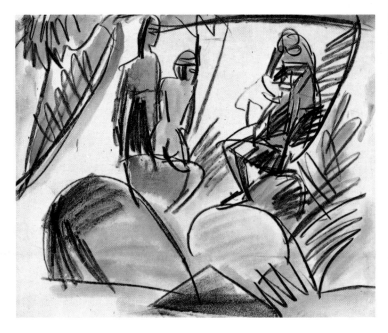

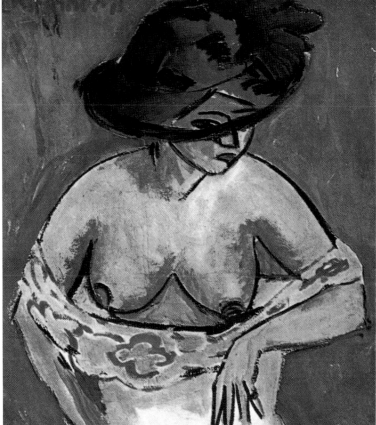

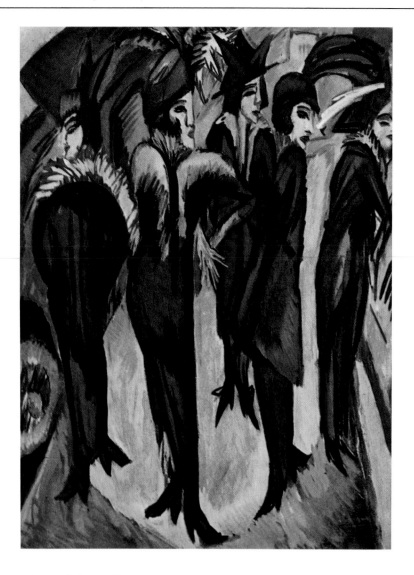

Ernst Kirchner
Five Women in the Street 1913

vain, and the mediocre tears everything down in its onslaught. I'm now
like the whores I used to paint.'

After his breakdown he went to Switzerland, and there found
annealing but less emotive themes in the contemplation of landscape, and
in the idealization of those peasants of Davos whose staple industry for the
last century seems to have been the inspiration of neurasthenic
Northerners. Though still showing a certain violent grandeur of
conception, his post-war works never really lived up to the earlier works,
with their overriding sense of passionate apprehension.

Erich Heckel was in some ways more restrained than the other
members of Die Brücke, even though his technique was occasionally more
adventurous. His first paintings have the uncontrolled vehemence of the
newcomer overwhelmed by the freedom which art gives him, intoxicated
by the sense of apparently limitless power which it seems to confer on its

practitioners. *Brickworks* of 1907, for instance, has been painted by squeezing oil out of the tubes straight on to the canvas, and using the brush only to tidy up the total effect. Colours and forms swirl together in a kind of pictorial storm. The visual impact – an extremely moving one – has nothing to do with the actual theme; it is created entirely by the medium, which has a life and movement all of its own. The pure, undiluted pigment has the same vehemence as in some of Van Gogh's paintings.

There was something touchingly idealistic – and German – in Heckel's devotion to the concept of the group to which he belonged at this period – reminiscent both of the ideals of the nineteenth-century Romantic religious painters, the Nazarenes, and of the less admirable duelling clubs. It was he who procured their communal studios and organized their first exhibition and their shared holidays on the Moritzburg lakes. In 1909 Heckel travelled extensively in Italy, was impressed by Etruscan art, fascinated by the idea of light, and set out to express in his work those qualities of formal coherence which he had discovered south of the Alps. The first fruit of this new inclination, and possibly his finest painting, is the *Nude on a Sofa*, in which the singing colours and gently hedonistic image are set off by the vigour of the composition and the nervous, ecstatic brushwork. At first glance it is closer to the Fauves than to their German Expressionist contemporaries, but no Frenchman would have been quite so peremptory in his treatment of the feet, nor so emotive in the handling of the walls and window. In a sense, *Nude on a Sofa* exemplifies perfectly Kirchner's clarification of the original Brücke declaration: 'Painting is the art which represents a phenomenon of feeling on a plane surface. The medium employed in painting, for both background and line, is colour. The painter transforms a concept derived from his own experiences into a work of art. He learns to make use of his medium through continuous practice. There are no fixed rules for this. The rules for any given work grow during its actual execution, through the personality of the creator, his methods and technique, and the message he is conveying. The perceptible joy in the object seen is, from the beginning, the origin of all representational art. Today photography

Erich Heckel
Brickworks 1907

Erich Heckel
Nude on a Sofa 1909

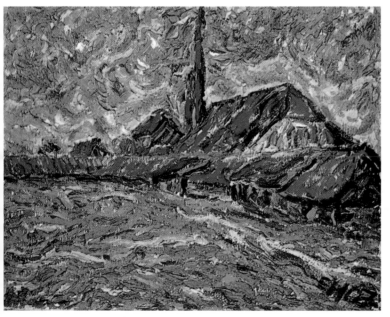

reproduces an object exactly. Painting, liberated from the need to do so, regains freedom of action. Instinctive transfiguration of form, at the very instant of feeling, is put down on the flat surface on impulse. The work of art is born from the total translation of personal ideas in the execution.'

In fact, in becoming more surface-orientated, Heckel's work, with its geometricized transcriptions of light and form, its sharp, angular contours and its figurative stylization, became the virtual standard of the Brücke contribution to the art of the twentieth century. It is nevertheless exceptional in possessing strong human sympathies, which have nothing to do with social protest, and an interest in narrative which secured him a considerable degree of popular success long before his fellow members achieved it.

Karl Schmidt-Rottluff, the third member of Die Brücke, and the one who invented the name for the group – the implication was that it provided a link which held the group together, and led into the future – was in some ways more single-minded than either of the other two. For several years figures hardly ever appeared in his paintings. Introverted and reserved, often in a state of latent hostility to some of his fellow-members, his bold vigorous handling, vehement at times to the point of coarseness, his heavily saturated colours and large undefined compositional areas, brought him to the brink of pure abstraction. He was impassioned by the sea, and a determinant influence on his art was the landscape of Norway, which he visited frequently. Emil Nolde (*see below*), whom he introduced to the group, had helped him to achieve that transition from Impressionism which was an almost essential episode in the development of any Expressionist, but it was the move to Berlin, with its wider horizons, its more explicit literary interests, which led him away from landscapes to figures and still-lifes, to a more precise definition of the subject matter, to a more fragmented and complex form of composition, with the landscape reduced to a series of two-dimensional symbols (as in *Summer*) against which the human figures appear as almost primeval statues.

After the war Schmidt-Rottluff's work became more lyrical, less vibrant, and he took refuge in religious transcendentalism from the barbarism of his age, moving to a kind of Symbolism with strong literary and theological undercurrents. This was a common enough pattern at the time. Similar conversions had affected the Decadents and other writers and artists, who, relying initially too much on the absolute validity of their own sensations, had tended to react violently in the opposite direction when the inevitable disillusionment came. Forbidden to paint by the Nazis, who confiscated his works, he was appointed in 1946 to a professorship at the Berlin Hochschule für Bildende Kunst.

Emil Hansen, who in 1901, at the age of thirty-four, changed his name to Nolde, was both the outsider and the professional of Die Brücke. In 1898, while a drawing teacher at St Gallen in Switzerland, he decided to become a full-time painter, and went to study with Adolf Hölzel at a small village near Munich which bore the still-innocent name of Dachau. A Czech by birth, Hölzel was, through his teachings and writings, a figure of seminal significance in the evolution of contemporary art. Deeply interested in problems of colour harmony, preoccupied with using

Karl Schmidt-Rottluff
Summer 1913

Karl Schmidt-Rottluff
Lady with Fruit-dish 1909

natural forms as the basis of a visual vocabulary, his writings had a strong
social bias, and he was one of the main contributors to the significantly
titled magazine *Die Kunst für Alle* ('Art for All'), which was widely read
throughout Europe.

After his contact with Hölzel, Nolde spent some time in Paris, where he
was greatly impressed by the works of Daumier and Manet. Gradually his
Impressionistic technique widened under the combined influence of
Gauguin, Van Gogh and Munch, and by 1904 he was using brilliant
colours, laid on with an ecstatic disregard for the conventional techniques
of brushwork. These paintings inevitably attracted the attention of the
much younger artists of Die Brücke, who asked him to join them, and he
took part in the group exhibitions of 1906 and 1907. But he felt that the
group was too confined, too inhibiting, and tried to start a rival
association, more broadly based, and including Christian Rohlfs, Munch,
Matisse, Max Beckmann and Schmidt-Rottluff. This was abortive, and
equally unsuccessful was his attempt to take over the leadership of the
Neue Sezession in Berlin in 1911. Some forty years later he wrote:
'Munch's work led to the founding of the Berlin Secession, my work to its

splitting and dissolution. Much sound and fury, both at the beginning and the end. But all these irrelevancies soon pass; the essential alone remains, the core – art itself.'

It is difficult to understand Nolde's artistic career without paying attention to the deep pietistic side of his character. Sprung from a simple farming background, he was in full accord with that religious undercurrent which influenced men as disparate as Van Gogh and Bloy; and once he confessed to his friend Friedrich Fehr; 'When I was a child, eight or ten years old, I made a solemn promise to God that, when I grew up, I would write a hymn for the prayer book. The vow has never been fulfilled. But I have painted a large number of pictures, and there must be more than thirty religious ones. I wonder if they will do instead.'

It was mainly to religious themes that he turned when he reverted to figure painting in about 1909, having rejected it at the point of his conversion from Impressionism. But though in works such as *The Last Supper* of 1909 his figures are realistic in appearance, by the following year they are translated in *The Dance Round the Golden Calf* into hieroglyphs of Dionysiac ecstasy, violent in colour, jagged in shape, dominating the landscape which retains the abstract qualities of his first excursions into the Expressionist idiom. The outlines of the forms are defined by the edges of the areas of colour, so helping to build up an air of almost uncontrolled hysteria. Believing absolutely in the validity of the instinctive reaction, the personal vision, Nolde's own aesthetic credo expressed perfectly the romantic egocentricity of the Expressionist stance: 'None of the free imaginative pictures that I painted at this time [*c*.1910], or later, had any kind of model, or even a clearly conceived idea. It was quite easy for me to imagine a work right down to its smallest details, and in fact my preconceptions were usually far more beautiful than the painted outcome; I became the copyist of the idea. Therefore I liked to avoid thinking about a picture beforehand. All I needed was a vague idea about the sort of light arrangement and colour I wanted. The painting then developed of its own volition under my hands.'

Emil Nolde
The Dance Round the Golden Calf 1910

Emil Nolde
Tropical Sun 1914

Emil Nolde
The Prophet 1912

Nolde was probably more deeply concerned with the implications and significance of primitive art forms than were his younger contemporaries. He began work on a book, *Kunstäusserungen der Naturvölker* ('Artistic Expressions of Primitive Peoples'), and in 1913 was invited to join an official expedition to the German colonies in the Pacific, including New Guinea. From this experience he not only derived new sanctions for his expression of what he described as 'the intense, often grotesque expressions of force and life in the most basic form', but came into contact with landscapes and climatic conditions more violent than any he could have seen in Europe. *Tropical Sun* of 1914, which comes close to the kind of work Wassily Kandinsky was producing at about the same time, combines the sharp impact of intensely disturbing colours with forms which have a suggestive, cosmic, almost primeval vehemence.

After the outbreak of war, Nolde withdrew very largely from the contemporary art scene, and the first big exhibition of his work took place in 1927, when he was sixty, with Paul Klee providing the introduction to the catalogue. In this he wrote: 'Abstract artists, far removed from this world, or fugitives from it, sometimes forget that Nolde exists. Not so I. No matter how far I may fly away from it I always manage to find my way back to earth, to find security in its solidity. Nolde is more than of the earth; he is its guardian spirit. No matter where one may be, one is always aware of one's kinship with him, a kinship based on deep immutable things.'

Nolde too suffered greatly under the Nazis, but received some degree of official rehabilitation by receiving the prize for painting at the 1952 Venice Biennale, four years before his death.

Max Pechstein had been an extremely successful student of decorative art before he joined Die Brücke in 1906, and in the following year he was awarded the Rome prize for painting by the Kingdom of Saxony. He was above all else a professional, resolved, for economic and psychological reasons, to make a success of his chosen occupation. No innovator, comparatively untouched by the wilder waves of aesthetic passion which

Max Pechstein
Nude in a Tent 1911

buffeted his contemporaries, he used their discoveries to evolve a style of
painting which combined brightness of palette, freedom of line, and
freshness of approach with decorative decorum. And this was no bad
thing. Every art movement needs men such as Pechstein who can mould
its discoveries and innovations into an acceptable visual syntax; Raphael
did something of the sort for the Renaissance, just as Pissarro did for the
Impressionists, and Dufy and Van Dongen for the Fauves. Like Nolde,
Pechstein went on a trip to the Pacific, but it neither exacerbated his
sensitivities nor inflamed his emotions. Paintings such as *Nude in a Tent*,
one of the many he produced in the course of his yearly summer holidays
on the Baltic, suggest the elegance of his line, the delicacy of his colour.
His motivations were too trouble-free for him ever to have achieved the
agonized vulnerability of his colleagues. 'I want to express my desire for
happiness. I do not want to be ever regretting missed opportunities. Art is
. . . the part of my life which has brought me the greatest joy.'

Otto Mueller
Two Girls in the Grass

Otto Mueller, like Nolde, was older and more experienced in the arts when he joined Die Brücke than were Kirchner, Schmidt-Rottluff or Heckel. Supposedly of partly gypsy extraction (Romany themes were to have a special attraction for him), he commenced as a lithographer, and then studied painting at the Dresden Academy. The most important formative influence on him during his early years was that of the writers Carl and Gerhart Hauptmann, whose works had close affinities with literary Expressionism, and with whom he travelled extensively in Italy and elsewhere. He was also greatly attracted by the paintings of the Swiss artist Arnold Böcklin, whose dream-like fantasies, replete with strange emotional undertones, had an important influence on all those artists who effected the transition between nineteenth-century empiricism and twentieth-century subjectivism. Kirchner wrote in his journal: 'If one now traces Böcklin's work in Basle from its beginnings, one finds such a pure line of artistic development that one cannot but acknowledge his great talent. It progresses confidently, without divergence or hesitation, straight from value painting to coloured two-dimensionalism. It is the same path that Rembrandt took, and the moderns such as Nolde or Kokoschka, and it is probably the only right path in painting.'

Mueller's own works during this period – he later destroyed most of them – seem to have been predominantly Symbolist in content, if not in form, and he was very conscious of Egyptian influences. In 1910, he joined Die Brücke at the age of thirty-six. By then his style had become more or less fixed. His favourite theme was the female nude, which he treated without a great deal of distortion; his colouring was subdued, almost at times monochromatic, and this feeling of nostalgic reticence was enhanced by his concern with securing a fresco-like effect, mainly by the use of coarse canvas and various combinations of oil paint, gouache and glue. On the whole Mueller's work has much of the decorative nature of Pechstein's, and he played a similar role in disseminating the visual discoveries of artists more radical than himself.

Germany: Der Blaue Reiter

By comparison with Die Brücke, the other important group of German Expressionists, Der Blaue Reiter ('The Blue Rider') was larger, more amorphous, more changing in its membership, but more ideological in its approach, more concerned with exploring man's relationship to his world; and so in the long run its members tended to have greater influence in the avant-garde. Several of them – Klee and Kandinsky are the obvious examples – went on to explore new visual territories and open up new dimensions of experience. The name of the group originated in a conversation between two of its founders. In 1930 Wassily Kandinsky recalled: 'Franz Marc and I chose this name as we were having coffee one day on the shady terrace of Sindelsdorf. Both of us liked blue, Marc for horses, I for riders. So the name came by itself.'

It is hard to disentangle all the manoeuvrings and dissensions among the young artists of Munich which led to the foundation of the group. Kandinsky had been painting and teaching in that city since 1896, and had been the main driving force in the creation of various progressive

groups, but when in 1911 one of these rejected his *Last Judgment*, he and Marc founded Der Blaue Reiter, which held a series of exhibitions in Munich and Berlin and published an 'almanac' or year book, *Der Blaue Reiter*, whose one and only issue included essays and reviews about all the arts, and numbered among its contributors Schönberg, Webern and Berg, and among its illustrations, folk art, children's drawings and works by Cézanne, Matisse, Douanier Rousseau, the Brücke group, Van Gogh and Delaunay. Indeed, Der Blaue Reiter was cosmopolitan in its membership and affiliations, including in one or other of these categories Russians such as Mikhail Larionov and Natalia Goncharova; Frenchmen such as Braque, Derain, Picasso and Robert Delaunay; and the Swiss Louis-René Moilliet and Henry Bloè Niestlé.

But, whatever stylistic allegiances Der Blaue Reiter commanded, and however divergent the paths which its members later followed, it was in its conception and short life – the group dispersed in 1914 – essentially German in origin, Expressionist in nature. In the *Prospectus* to the catalogue of the first exhibition at the Thannhauser gallery in Munich we find another statement of those familiar ideals: 'To give expression to inner impulses in every form which provokes an intimate personal reaction in the beholder. We seek today, behind the veil of external appearances, the hidden things which seem to us more important than the discoveries of the Impressionists. We search out and elaborate this hidden side of ourselves not from caprice nor for the sake of being different, but because this is the side we see.'

But by and large, the members of Der Blaue Reiter were more rigorous and more searching in their attitudes than were most of their contemporaries. They investigated colour theories, became concerned with problems of perception, flirted fruitfully with the physical sciences (Kandinsky owed much to the microscope), explored imaginary space and declared their independence of the boundaries of the visible world. Deeply influenced by the philosophical speculations of Wilhelm Worringer, whose *Abstraktion und Einfühling* ('Abstraction and Empathy') was published in 1907, several of them wrote persuasively in creative forms. Their approach to art was interdisciplinary in a way which had not been seen since the Renaissance.

Wassily Kandinsky was born and educated in Russia, and having in 1895 been converted to art by seeing an exhibition of the French Impressionists in Moscow, came to Munich, to devote himself entirely to painting, at a time when that city was the centre of the so-called New Style of art in Germany. He expressed himself in a wide variety of media (forecasting in his concern with the decorative arts his future involvement with the Bauhaus), designing clothing, tapestries and handbags. His painting was at this point predominantly Art Nouveau with Symbolist undercurrents, but already possessing allusive, emotive qualities. Travelling extensively, he was widely recognized, and he received medals in Paris in 1904 and 1905, was elected to the jury of the Salon d'Automne, and won a Grand Prix in 1906.

But during this period stronger, more vital impulses began to be apparent in his work. He digested the influence of Cézanne, Matisse and Picasso; he began to understand the value of Bavarian folk art; his colours

began to sing; visible shapes began to lose their descriptive qualities. In paintings such as *On the Outskirts of the City* of 1908 the actual subject matter is of slight importance; indeed, it is positively irrelevant. What matters is the sense of dynamism which controls the cumulus-like groups of strongly contrasting colours; 'Houses and trees made hardly any impression on my thoughts. I used the palette knife to spread lines and splashes of paint on the canvas, and make them sing as loudly as I could. My eyes were filled with the strong saturated colours of the light and air of Munich, and the deep thunder of its shadows.'

This was a crucial moment in the history of modern art. The Dionysiac freedom of Expressionism was being suffused with another element, the metaphysical tradition of Russian Byzantinism, with its strong anti-naturalistic, hieratic tendencies. From 1910 onwards Kandinsky continued painting pictures in which representational elements were still discernible; but side by side with these were works such as the *Large Study* of 1914, in which forms as well as colours have taken off into a world of their own, owing little to any recognizable visual phenomena – even though he did find some difficulty in creating an entirely abstract iconography. In the famous apologia which he published in 1910, *Über das Geistige in der Kunst*, ('Concerning the Spiritual in Art'), he used the word

Wassily Kandinsky
On the Outskirts of the City 1908

Wassily Kandinsky
Large Study 1914

geistig, usually translated as 'spiritual', to describe the unreal elements in his paintings; perhaps today we would incline towards translating it by some adjective involving a suggestion of the psychological. These whirling shapes move across the canvas like dancing Dervishes, suggesting impulses deeper than those 'emotional' impulses which powered the main stream of Expressionism. His subsequent career indicated the extent to which he was constantly motivated by the desire to achieve a synthesis of thought and feeling, science and art, logic and intuition.

All his achievements were rooted in the original liberating experience of Expressionism, but there were others, less cosmopolitan in their upbringing, less vigorous in their empiricism, who never shook off their early dependence on a framework of naturalistic references. Whether this would have been true of Franz Marc it is impossible to say; he was killed at Verdun in his mid thirties, at a moment when he seemed to be reaching a point of evolution which his friend Kandinsky had arrived at a few years earlier. There was a strongly obsessive quality about his imagination, perhaps not unconnected with his religious preoccupations. He had started off as a theology student before turning to painting, which he looked upon as a spiritual rather than a worldly activity. Bowled over by Impressionism, he devoted himself for several years to the study of animal anatomy, and even gave lessons on the subject. Although these studies were undertaken primarily to evolve general principles of form from the close examination of the particular, they assumed a special emotional significance for him in his devotion to the horse – that symbol so loved by advertising agents and adolescent girls. To him animals came to represent a sort of primeval purity, each signifying some admirable strength or desirable virtue: the deer fragile agility, the tiger restrained, latent strength. Although at first he painted animals in the foreground of

Franz Marc
Deer in Wood II 1913–14

Franz Marc
Tiger 1912

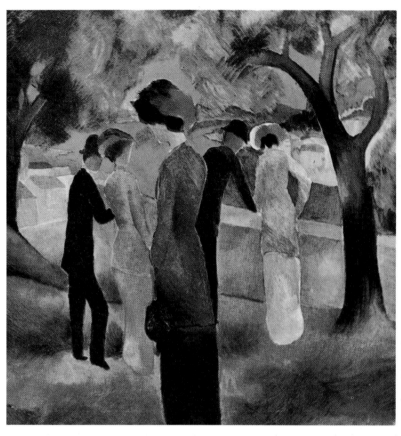

August Macke
Lady in a Green Jacket 1913

his pictures, later they became integrated with the landscape, as though he were seeking a complete identification of both.

Having secured expressive forms, he went on, under the influence of his friend August Macke, another member of Der Blaue Reiter, who of all the group came closest to the Fauves, to explore the emotional potentials of colour. 'If you mix red and yellow to make orange, you turn passive yellow into a Fury, with a sensual force that again makes cool spiritual blue indispensable. In fact blue always finds its place inevitably at the side of orange. The colours love each other. Blue and orange make a thoroughly festive sound.'

The sexual undertones, the rather childish symbolism, the strong sense of personalization – all are typical of Marc, and of his generation. His colour experiments were leading to a dissolution of form similar to that being achieved by Kandinsky, when his death cut them short.

Like Kandinsky a Russian by birth, Alexei von Jawlensky was closely associated with Der Blaue Reiter, but did not participate in any of their joint exhibitions. Though he was later to grow close to Nolde, the formative influences on his work up to about 1912 were those of Gauguin, Matisse and Van Dongen. His warm and passionate painting depended largely on simplification, brilliant colours held within dark contours, and a bounding sinuous line, which gives a hieratic unity to the whole composition. The impact of the war led to an exaggeration of that taste

Alexei von Jawlensky
Girl with Peonies 1909

for religious mysticism which he shared with Marc and others. 'Art' he
said 'is nostalgia for God', and after 1917 the bulk of his work consisted of
têtes mystiques – abstract head forms.

 Although Expressionism in general, and the Blaue Reiter (in whose
exhibitions he participated) were of great importance in the development
of the art of Paul Klee, his approach to both was tentative, marked by
that sense of hesitation which characterized the whole of his early career.
Right from the beginning he had been, by instinct as it were, a linear
Expressionist, producing graphic forms which paid little attention to
naturalistic conventions, and which were bent or distorted to convey a
sense of whimsical irony, even of gentle sadism – emphasizing the debt
which non-realist art owed to the traditions of caricature. Line for him

was an independent structural element which he deployed to express strong sensations. But his contacts with Der Blaue Reiter led him to assume enough courage to explore the potentials of colour. He took the final step in 1914 when on a trip to Tunisia with Macke and Moilliet. It was the outcome of a long process rather than a moment of sudden conversion. In effect, he was an introvert who schooled himself to become an extrovert, a classicist who turned to romanticism (he always confessed to preferring Cézanne to Van Gogh). But, even so, it was in the compromise medium of watercolour that he was happiest, and that he made the most advances. In works such as *The Föhn Wind in the Marcs' Garden* of 1915, perfunctory gestures to perspectival space can still be seen, and he was never completely to renounce references to objective reality; he regarded it as a source of materials from which to create a personal imagery rather than as a model to be copied. Complex, subtle and lyrical, the picture is composed of roughly geometric sections each containing its

Paul Klee
The Föhn Wind in the Marcs' Garden 1915

Alfred Kubin
One-eyed Monster

own colour, the different shapes forming a contrapuntal flat pattern which moves up and across the surface of the paper.

At the opposite pole of Expressionism, but within the same milieu, Alfred Kubin represented a tradition very different from the delicate happy fantasies of Klee. Mainly an illustrator, his imagination was nurtured on the morbid, and he gave shape to the nightmares of anxiety in a style which owed something to Beardsley, something to Goya, and a good deal to Odilon Redon. The author of a strange novel, *Die andere Seite* ('The Other Side'), he reasserted in the twentieth century the 'Gothic' traditions of the early nineteenth.

Der Sturm: Berlin and Vienna

It would be wrong, of course, to think of the experiments of Die Brücke and the Blaue Reiter as the sole manifestations of the new visual romanticism which was sweeping through the German-speaking countries. In both Berlin and Vienna powerful Secession movements – anti-academies, beset by schisms – gathered the progressive elements in the arts into an uneasy alliance. Not all of these elements, even within the

Opposite:

Max Beckmann
Self-portrait with a Red Scarf 1917

Lyonel Feininger
Zirchow V 1916 (detail)

Expressionist idiom, would have subscribed to the radical theories of Kandinsky or Marc, and within the pages of art journals such as Herwarth Walden's *Der Sturm* (which was largely responsible for publicizing the notion of Expressionism as a movement) bitter controversies raged about the extent to which traditional attitudes should be accepted or rejected. A typical figure in this context was that of Max Beckmann, who commenced as an instinctual Expressionist working in a style which owed a good deal to Munch and even to Delacroix, and taking as his themes subjects such as his mother's deathbed, the Messina earthquake of 1910, or the sinking of the *Titanic*. He emphasized, especially in the course of a lengthy controversy with Marc, which appeared in the magazine *Pan* in 1912, the traditional qualities of paint: 'Appreciation for the peach-coloured sheen of skin, the glint of a nail, for what is artistically sensual; for those things such as the softness of flesh, the gradations of space, which lie not only on the surface of a picture, but in its depths. Appreciation too for the attraction of the material. The rich gloss of oil paint which we find in Rembrandt, in Cézanne; the inspired brushwork of Frans Hals.'

A conversion which no aesthetic dialectics could bring about was effected by his traumatic experiences as a medical orderly – experiences which not only caused him to have a nervous breakdown, but also made his style into a medium appropriate for expressing their bitter content. The tormented anguish of the *Self-portrait with a Red Scarf* of 1917 is expressed not only in the appearance of the face and in the pose, but in the cramped space, the acrid colours, the dryness of handling – far removed from his earlier delight in quality of pigment and sensuality of texture. Producing for the rest of his career mainly figure paintings, including many self-portraits, he presented them as symbols of pure despair, essays in existentialist agony.

Lyonel Feininger and Oscar Kokoschka presented differing but complementary antitheses to Beckmann's pessimistic passion; the one was inventive in style, the other predominantly traditionalist; both were much more joyous in content. Feininger, who rejected groups and never participated in a manifesto, openly declared himself an Expressionist: 'Every work I do serves as an expression of my most personal state of mind at that particular moment, and of the inescapable, imperative need for release by means of an appropriate act of creation, in the rhythm, form, colour and mood of the picture.'

In fact, his inspiration derived mainly from the Cubists, and to a lesser degree from the Futurists; it was the first two qualities, rhythm and form, which were most apparent in his work. Geometric in construction, with metamorphosized figurative elements, his works are sharper than those of Robert Delaunay, with which they have considerable affinities. The colour is brooding, the subject matter larger in scale than the average French Cubist would have attempted; the analysis into geometric units is complete and thorough, taking in every element in the painting – including even the light in the sky. It was light which contributed the major Expressionist element to his works, wrapping them in a sense of mystery and drama, making them, despite the austerity of the style, emotionally disturbing.

More self-confident in its hedonistic cosmopolitanism than Berlin, the capital of the Austro-Hungarian empire had experienced in the closing decades of the nineteenth century a Secession movement dominated by the Byzantine sensuality of Gustav Klimt's paintings. The emotionally liberated principles which underlay the movement were disseminated throughout Europe in the pages of the magazine *Ver sacrum* which greatly influenced Die Brücke.

Stylistically Egon Schiele, one of Klimt's pupils, who was briefly imprisoned for producing what were described as 'pornographic' drawings, depended very much on the luscious linear vitality of Klimt's art, but he added to it a pungent morbidity of his own which is heightened by elegant formal distortions. Even his oil paintings have something of the quality of watercolour, and he found special pleasure in this medium, using it originally for subjects with a marked erotic appeal, but later – especially in those works which he produced in prison – expressing a tormented anguish of spirit.

A good deal is often made of the fact that Kokoschka grew up in the Vienna of Sigmund Freud, and his concern with portraiture – rare in the avant-garde of the twentieth century – is often related to his desire to penetrate beneath the disguise of appearance to the sitter's inner

Egon Schiele
Portrait of the Painter Paris von Gütersloh 1918

Egon Schiele
For My Art and for My Loved Ones I Will Gladly Endure to the End! 25 April 1912

Oskar Kokoschka
The Bride of the Wind (The Tempest) 1914

Max Ernst
The Bride of the Wind 1926–27

personality. But the effects which critics tend to attribute to psychological penetration are more likely to have been determined by the stylistic attitudes which he formed in the period between 1910 and 1914 when his thin, tortuous linear patterns were reinforced by a passion for rich, heavy impasto through which figures emerge, and by means of which they are defined. In one of his more famous works of this period, *The Bride of the Wind (Die Windsbraut)*, all the qualities which have made his work so popular and so significant are immediately apparent: an immense capacity for visual rhetoric, which can at times descend to pomposity; an ability to contain within a single composition the most disparate elements; and a sense of Baroque vitality. The historical analogy is significant; for throughout his career Kokoschka basically worked within the framework of traditional Renaissance and post-Renaissance conventions, even favouring the same kind of scale. In *The Bride of the Wind* there are obvious references to El Greco and to Delacroix; the size conforms to that of the *grandes machines* of Rubens or Poussin (it is 181 × 220 cm), and there are no striking innovations in form or construction. What is special to Kokoschka's generation and the Expressionist tradition of art is the apocalyptic treatment of the theme, the morbidity of the colour, and the adaptation of the actual handling of the medium to create a mood.

It is interesting in this connection to compare Kokoschka's painting with one of several which his younger contemporary Max Ernst produced on the same theme – significantly, the Germans use the word *Windsbraut* to mean 'Storm Wind' – in the 1920s. Expressionism had been the force which initially liberated Ernst, and his early works before the war were well within its idiom. But after his encounter with the Nihilism of Dada he turned to the Surrealist liberation of unconscious imagery.

In his *Bride of the Wind* the sense of violence, aggression and disquiet is expressed formally in a style which contains all the basic elements of the Expressionists – emotive colour, turbulent shapes distorted to provoke strong reactions in the spectator – and added to them is a whole series of sexual metaphors, involving the sense of rape, the whole effect heightened by the contrast with the placid lunar circle.

Ernst Barlach
Manifestations of God: The Cathedrals 1922

After the Great War

The political ferment which characterized the post-war years in Germany gave aesthetic allegiances even stronger political undertones than those they had already expressed. Powerful though the appeals of Dada and Futurism were, it was Expressionism which commanded the big aesthetic battalions, and which became identified most clearly with all the progressive elements in the tragedy of the Weimar republic. Even the older painters were inspired by its fervour; and Lovis Corinth, whose vigorous Impressionism had inspired Nolde and Macke, now abandoned this for a charged, violent emotional style – with strong social undercurrents – closer to that of his disciples than to that of his predecessors.

Lovis Corinth
The Painter Bernd Grönvold 1923

The temper of the times also gave fresh impetus to the interest which the Expressionists had always shown in graphic media – with their propaganda potential being transferred from aesthetic to political ends. The reasons for this interest were many and complex. The stylistic innovations pioneered by Crane and William Morris; the growing popularity of illustrated books; the impact of Beardsley, of Gauguin and of Lucien Pissarro, each of whom in his own way had extended the range of prints and engravings, was reinforced by a contemporary interest in the tradition of the popular German woodcut of the late Middle Ages, with its strong democratic appeal. It was this influence which led artists such as Nolde, Heckel and Ernst Barlach (1870–1938) to produce works in black and white, simple in composition, urgent in emotional appeal, with perspectival effects created by the interrelation of planes, and arrogantly devoid of any attempt to please or charm.

The desire to rape rather than to seduce the spectator's sensibilities, which was inherent in many Expressionist works, seemed especially relevant in the 1920s; and it was seen at its most compelling in an artist who, though belonging at one point to the Berlin Dadaists, was at heart committed to the stylistic manners of the Expressionists, using visual violence to excoriate the establishment and propagate his own democratic

ideas. George Grosz recorded, with a bitter brilliance which has never been excelled, the unacceptable face of capitalism. He produced a flood of lithographs, prints and paintings which document post-war Germany with the same virulent accuracy with which Daumier portrayed the France of Louis-Philippe. But his strength was his weakness, and though his colour could often be gently lyrical, he could never seem to overcome a basic distaste for humanity, despite the democratic ideals which informed his work. He was always best at his most sadistic, and he exemplifies, in an exaggerated form, the strong streak of Puritanical venom which frequently powers the Expressionist imagination.

The Expressionists had led the last attack on the ramparts of rationality, and had breached them. They gave to instinct a standing in the visual arts which the Romantics had never succeeded in establishing; they declared their independence of the visible world, and gave the

George Grosz
Market Scene with Fruits 1934

George Grosz
Gold Diggers 1920

Matthew Smith
Nude, Fitzroy Street, No. 1 1916

subconscious a new significance in the act of creation. The actual
techniques which they had evolved were used by many artists to achieve
effects not dissimilar from those which they themselves sought. The strong
simple colours and passionate vision which characterize the works of a
basically Fauve painter such as Matthew Smith (1879–1959) represent
one aspect of a tradition which complements the more personal emotional
vehemence of an artist such as Jack Yeats, whose concern with a semi-
private mythology echoes through thick layers of luminous paint applied
with a vigorous, whirling brush stroke. Nor would any member of Die
Brücke or Der Blaue Reiter see in the sun-drenched, fiercely expressed
imagery of the Australian Arthur Boyd anything very different from what
he himself had been trying to achieve.

The passion for violence, the search for ultimates in sensation and
feeling which could yet be confined within the traditional framework of
painting are yet another aspect of the legacy of Expressionism, and the
resemblances between Francis Bacon's *Study of Red Pope* and Chaim
Soutine's *Pageboy at Maxim's* are more than fortuitous. Both are motivated
by the desire to express in the resonances of colour, in the deformation of

lines, in the exaggeration of physical characteristics, a sensational impact experienced by the artist, impressed on the spectator.

At the same time, too, as painters had been moving towards a mode of creativity based on the creative significance of passion, so the aestheticians and the critics were providing new theoretical bases for establishing that infallibility of the *id* which was one of the tacit assumptions of the Expressionist approach. John Russell, for instance, sets out to explain (and in a sense to vindicate) Bacon's multi-planed distorted imagery in terms of the notion of 'unconscious scanning' which Anton Ehrenzweig formulated in *The Hidden Order of Art* (1967), and which is a continuation of an Expressionist theory of creativity first formulated by Worringer fifty years earlier. Rationalization, control, restraint, analysis, are converted into psychological sins; spontaneity, the

Chaim Soutine
Pageboy at Maxim's (Le Chasseur d'Hôtel)
1927

rejection of conscious vision, 'the chaos of the subconscious', the
undifferentiated structure of subliminal perception, are virtues.

The moralistic undertones are obvious, and this was to be emphasized
by the fact that when, with the advent of the New York school of
Abstract Expressionism, the critic Clement Greenberg set out to provide
it with a rationale, he did so virtually in terms of the notion that, because
of the absolute spontaneity of works dictated by pure gestural chance,
they achieve a kind of liberating truth which is at once virtuous and
therapeutic. And this notion has gone far, spilling over into the conduct
of life as 'doing your own thing' and making possible the cult of
contemporary culture-heroes such as Joseph Beuys.

Nor are the earlier formal impulses of Expressionism yet exhausted.
The *art brut* of a painter such as Jean Dubuffet shows a conscious
intention to assault the eye, and he himself has said about the *Corps de
Dame* series: 'I have always delighted (and I think this delight is constant

Francis Bacon
Study from Innocent X 1962

Willem De Kooning
Woman and Bicycle 1952–53

in all my paintings) in contrasting in these feminine bodies the extremely general and the extremely particular; the metaphysical and the grotesquely trivial.' Willem De Kooning is one of those who, turning their backs on the earlier purely abstract phases of their careers, have reverted to inspirations which would not have been alien to the early Expressionists.

But to limit the contemporary significance of Expressionism to the occasional survival of its stylistic mannerisms would be to underrate it. More than any other single episode in the history of art during the last century it has emancipated painting, extended the boundaries of form, line and colour, made possible the impossible. Nothing in art that has happened since its beginnings has been untouched by its liberating effect.

4 Cubism, Futurism and Constructivism

J.M. NASH

Cubism, Futurism and Constructivism were the three most important movements in early twentieth-century art. They developed in different places and at different times – Cubism grew up in Paris between 1907 and 1914, Futurism was announced in a manifesto from Milan on 20 February 1909, and Constructivism first flourished in Moscow after the Revolution of 1917 – but there were many links between them. The Futurist painters visited the studios of the Cubists in Paris in 1911 and what they saw there profoundly influenced their style. The Constructivists learned from both earlier movements. Almost all the major artists of the first half of this century were active in one or more of the movements. Between them they created modern art. They created new forms, experimented with new procedures and propounded theories of art that still affect our ideas about the purpose and value of art. But in many ways the movements were strongly opposed to each other. It was not simply that the Cubists dismissed the Futurists as Italian plagiarists – as they did – or that the Italians called Cubism a 'sort of masked academicism' and said their own art was the only truly modern, *dynamic* art, or that, later, the Constructivists wrote that the 'attempts of the Cubists and Futurists to lift the visual arts from the bogs of the past have led only to new delusions'. No doubt much of this abuse sprang from the modern need to appear to be totally original. But it is clear that despite their various similarities, and despite their mutual interest in and indebtedness to each other, the three movements did stand for quite different values, and these values were moral and social as much as aesthetic.

Cubism

Modern art, it has often been said, began with Cubism. Cubism has been called a revolution in the visual arts as great as that which took place in the early Renaissance. Futurism and Constructivism owed it a debt that they disliked having to acknowledge. But unlike Futurism and Constructivism, true Cubism was not conceived as a movement at all. Whatever its other virtues, a movement in art, like a political movement, sets out to confront the larger public. It depends on organized demonstrations for its existence. True Cubism, was, on the contrary, a deliberately private, essentially esoteric art, created by two painters for themselves and for a small circle of intimates.

These painters were Pablo Picasso, who was Spanish, and Georges Braque, who was French. Their circle of friends included a number of

Pablo Picasso
The Three Dancers 1925

avant-garde writers, Max Jacob, Guillaume Apollinaire, André Salmon, and the wealthy American Gertrude Stein. The only other painter within the circle was André Derain. Most of these friends lived in Montmartre, the village on the hill overlooking Paris that in the late nineteenth century had become the centre of Parisian nightlife. The ramshackle slum where Picasso and Max Jacob lived had earlier housed artists and writers of Gauguin's generation and had been visited by Gauguin himself. The group self-consciously inhabited Bohemia, the world of art. To the larger world it was indifferent: art, as the neglected careers of Cézanne and Van Gogh had proved, was necessarily incomprehensible to the majority. In their memoirs the writers recalled their poverty with affection: 'We all lived badly. The wonderful thing was to live at all,' wrote Max Jacob. The writers took jobs or wrote journalism. One or two discerning picture dealers visited the artists' studios and bought their works. But the group could survive largely because one of its members was also wealthy. Gertrude Stein probably bought more of Picasso's works produced before 1906 even than Ambroise Vollard the dealer.

It was a small circle that gloried in its exclusiveness. 'We invented an artificial world with countless jokes and rites and expressions that were quite unintelligible to others,' wrote André Salmon later. Max Jacob called the studios in which he and Picasso lived the Bateau Lavoir, the floating laundry, presumably because it was on a hillside and was filthy. At the centre of the circle was Picasso. The friends visited his studio almost daily; its doorway was inscribed *au rendez-vous des poètes*. The group as they visited the bars and cafés of Montmartre were known as *la bande à Picasso*, the Picasso gang.

Gertrude Stein described them: 'They began to spend their days up there and they all always ate together at a little restaurant opposite, and Picasso was more than ever . . . the little bullfighter followed by his squadron of four . . . Napoleon followed by his four enormous grenadiers. Derain and Braque were great big men, so was Guillaume [Apollinaire] a heavy set man and Salmon was not small. Picasso was every inch a chief.'

For his friends Picasso was unique: a compelling, unpredictable, enigmatic genius. He had been an infant prodigy in Barcelona and had had his first exhibition in Paris when he was only nineteen, in 1901, at the Vollard gallery. Apollinaire described him as he was at twenty-four: 'an adolescent with restless eyes whose face recalled at once those of Raphael or Forain. . . . His blue workman's overalls, his sometimes cruel jokes, and the strangeness of his art were known all over Montmartre. His studio, cluttered with paintings of mystical harlequins, with drawings that people walked on and that anyone could take home if he wished, was the meeting-place of all the young artists, all the young poets.' In 1911 Picasso's friend André Salmon gave his version of Picasso receiving visitors to his studio. 'Welcoming and quizzical, dressed like an aviator, indifferent to praise as he is to criticism, at length Picasso shows the much sought-after canvases he has the coquetry not to exhibit at any salon.'

Salmon's account – and Apollinaire's – emphasize Picasso's idiosyncrasies, his manner, his blue denim uniform, his total indifference to public recognition. But they are, it must be recognized, carefully promoting Picasso's image. These descriptions were pieces of journalism

written to establish Picasso's originality when other lesser artists were beginning to attract attention with their versions of Cubism. 'There has been some talk about a bizarre manifestation of Cubism, . . .' wrote Apollinaire in 1910; 'it is simply a listless and servile imitation of certain works that were not included in the Salon and that were painted by an artist who is endowed with a strong personality and who, furthermore, has revealed his secrets to no one. The name of this great artist is Pablo Picasso.'

Because the ones who ought to know, Apollinaire, Salmon and Gertrude Stein, ignored or belittled Braque's role in the genesis of Cubism, he was believed to have been one among a number of Picasso's followers. Apollinaire, who was a good friend of André Derain, in an article in *Le Temps* in 1912, first proposed that Derain and Picasso had created Cubism together. Apollinaire preferred to call Braque 'the verifier': 'He has verified all the innovations of modern art.' It was only in 1917, after he and Braque had suffered similar wounds in the War, while Picasso sat in Paris and jeered, that Apollinaire wrote to the papers to assert Braque's equal contribution and to insist that Cubism was not Spanish, but Franco-Spanish or, more simply, Latin.

Despite this belated attempt to make amends to Braque, the accepted version of the relationship was repeated much later by Gertrude Stein. In Gertrude Stein's *The Autobiography of Alice B. Toklas*, 'Miss Toklas' recalls seeing two paintings at the Salon des Indépendants 'that looked quite alike but not altogether alike. One is a Braque and one is a Derain, explained Gertrude Stein. They were strange pictures of strangely formed rather wooden blocked figures.'

Later, Gertrude Stein took Alice B. Toklas to Picasso's studio in the Bateau Lavoir. After they had left, 'What did you think of what you saw, asked Miss Stein. Well I did see something. Sure you did, she said, but did you see what it had to do with those two pictures you sat in front of so long. . . . Only that Picassos were rather awful and the others were not. Sure, she said, as Pablo once remarked, when you make a thing, it is so complicated making it that it is bound to be ugly, but those that do it after you they don't have to worry about making it and they can make it pretty, and so everybody can like it when the others make it.'

Among the awful pictures Alice B. Toklas and Gertrude Stein saw in Picasso's studio must have been the now famous *Demoiselles d'Avignon*. This great canvas filled by five enormous naked and half-naked women is now widely recognized as the beginning of Cubism. Various explanations for its ugliness have been put forward. Most of these explanations echo that given by Gertrude Stein: it is ugly because it is new. John Berger is one writer who has recognized the inadequacy of this approach. In *The Success and Failure of Picasso* he wrote: 'Blunted by the insolence of so much recent art, we probably tend to underestimate the brutality of the *Demoiselles d'Avignon* . . . it was meant to shock. . . . The dislocations in this picture are the result of aggression not aesthetics: it is the nearest you can get in a painting to an outrage.'

This was what André Salmon hinted at when he wrote his 'Anecdotal History of Cubism' in 1912. He must have been there when Picasso first revealed the *Demoiselles* to a group of friends. 'Nudes came into being,

whose deformation caused little surprise – we had been prepared for it by Picasso himself, by Matisse, Derain, Braque . . . and even earlier by Cézanne and Gauguin. It was the ugliness of the faces that froze with horror the half-converted.' The Medusa-masks, he says, shocked because they affronted the Renaissance canons of female beauty.

But Salmon does not explain why Picasso should make this attack. On the contrary, he stresses the gratuity of the act. 'Picasso', he says, 'at that time was leading a wonderful life. Never had the blossoming of his free genius been so radiant . . . he consented to be led by an imagination quivering with excitement. . . . He had no ground for hoping that some different effort would bring him more praise or make his fortune sooner, for his canvases were beginning to be competed for. And yet Picasso felt uneasy. He turned his pictures to the wall and threw down his brushes. Through long days – and nights as well – he drew.'

The reason for Picasso's unease can only be guessed at. A possible source can be discovered within that small circle of friends that revolved around him. The circle was all-important: not only was it the sole source of outside acclaim that he could value, but without two of its members, Gertrude Stein and her brother Leo, he might starve again as he had before they had discovered him. He was, however, not the Stein's only protegé. In his copy of the catalogue of the Salon des Indépendants held in March 1906, Apollinaire scribbled: 'at the moment [Leo] Stein swears only by two painters, Matisse and Picasso.'

Henri Matisse was thirty-six in 1906, twelve years older than Picasso and the doyen of the avant-garde. The previous year his paintings had been displayed at the Salon d'Automne with those of several friends and they had caused a sensation. Their colouring was improbably bright, daubed straight from the tube in strokes a child could have made, in the view of most critics and visitors to the exhibition. A critic, Louis Vauxcelles, dubbed the group 'Les Fauves', the wild beasts. As the other painters in the group, André Derain, Maurice de Vlaminck, Albert Marquet, and Kees van Dongen among them, were all younger than Matisse, he was called 'the king of the beasts'.

Picasso was a regular visitor at the apartment at 27 rue de Fleurus where his new patrons lived; and each Saturday, when he went to dinner, he would see these advanced and admired paintings and often would meet Matisse himself. When, later in 1906, he began making studies for a large and unconventional painting of female nudes, he must have realized it would be at once compared with Matisse's works, and with two canvases in particular: *The Happiness of Living* (*Le Bonheur de vivre*), owned by the Steins, and the *Luxury, Calm and Delight* (*Luxe, calme et volupté*) that had been the centrepiece of the Salon d'Automne of 1905. The latter, painted in the Pointillist technique, with prismatically bright spots of colour, represented a group of naked and half-naked women bathing and picnicking on the seashore. The *Bonheur de vivre* was even more outrageously bold. In colour and general effect it was more like a Persian carpet than a traditional European oil painting. Its drawing was as free as its colouring and suggested eighteenth-century Japanese woodcuts.

In these two ambitious paintings, Matisse had undertaken the strangest subject of nineteenth-century painting: the grand composition of female

nudes. In Paris, in the nineteenth century, in the great exhibition halls of the annual Salons, to which bourgeois families flocked in thousands each weekend, the nude composition flourished in an astounding way. Venus, Galatea, Diana, minor inhabitants of Olympus, nymphs, and many other subjects were given as titles, but it was clear that the subject was becoming less and less important. But when it was stripped even of its subject matter, the nakedness of the nude composition became more problematic. If the critic's general impression was that it was 'acceptable', it was praised for its execution, the excellence of its draughtsmanship, the delicacy of its colouring, and also for the beauty of its subject. If not, drawing, colouring and the ugliness of the model might be criticized, but it was probable that the picture would be finally condemned as objectionable, vulgar or indecent.

There were two artists of the nineteenth century who, by 1906, were at once heroic in their genius and inevitably associated with compositions of nudes. The one whose influence on Cubism is unmistakable is Paul Cézanne. His late paintings of women bathing, often thought to be the climax of his career, have been taken to be important influences on Picasso when he was creating the *Demoiselles*. Cézanne died in 1906, and his achievement was recognized as the greatest in contemporary art.

The other painter of the nude was the old master, Jean-Dominique Ingres, 'the great painter, the artful adorer of Raphael' as his contemporary Charles Baudelaire had called him in 1845. Among his many paintings of the female nude, one was unprecedented. This was the *Turkish Bath* (*Le Bain turc*) of 1863, finished when he was eighty-two. This

Pablo Picasso
Study for *Les Demoiselles d'Avignon* 1907

Pablo Picasso
Les Demoiselles d'Avignon 1907

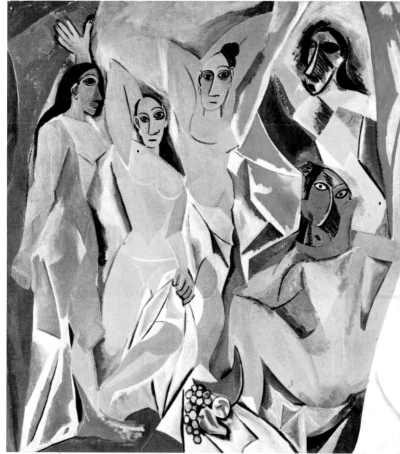

circular composition of an interior filled with naked women is astounding in its blatant sensuousness. It is not excused or disguised in any way. Ingres had abandoned the goddesses of Olympus. Instead he had offered the Parisian public the concubines of a Turkish harem, stripped in their communal bath.

Picasso's friends testify to the importance of Ingres for Cubism. Salmon's list of influences on the Cubists – 'Cézanne, the Negroes, Douanier Rousseau, El Greco, Ingres, Seurat' – might, except for Seurat, be applied directly to the *Demoiselles d'Avignon*.

Picasso painted two versions of a harem scene in the summer of 1906. The more complete version, in Cleveland, shows an unmistakable debt to Ingres, both in subject and in style. The first studies for the *Demoiselles d'Avignon* show that it was intended to be a brothel scene. A clothed sailor sits among five naked women and another clothed man enters from the left. The brothel is the sordid Western alternative to the harem. It had been the chosen subject of another nineteenth-century artist, Picasso's first hero, Toulouse-Lautrec.

In the prolonged sequence of preliminary drawings Picasso made for the *Demoiselles*, the two men quickly disappeared. Historians have explained this by suggesting that Picasso abandoned his original idea and became engrossed in the purely pictorial problems he was exploring. This explanation suggests that Picasso worked like a scientist making experiments. But this seems quite untypical of Picasso's character. 'In my opinion to search means nothing in painting. To find is the thing', he said in 1923. Rather, by removing the sailors from within the composition, Picasso has turned the focus of the picture outwards. The figure on the left, which had been a man entering the room, becomes a woman, partly covered by a peignoir, drawing back a curtain to reveal the two central figures who pose *for the spectator*. The spectator was now placed as he had often been placed previously at the annual Salons; with one difference. There, he had been confronted by a scene to which a sexual response would be normal and asked to contemplate it for its artistic excellence or for its ideal beauty. Picasso has made this impossible.

The artists he emulates are men who, in 1906, were widely believed to have had little or no skill: the medieval painters of Catalonia; a Spanish painter who was considered bizarre, El Greco; a naive French painter befriended and celebrated by Picasso's circle, the Douanier Rousseau; and, most shocking of all, 'the Negroes'.

African carving was collected by most of Matisse's circle, though Picasso denied having seen Negro masks until after he had completed the *Demoiselles*. Yet the two faces on the right, the most shocking in the painting – almost certainly the faces Salmon had in mind when he recalled the horror with which the painting had been received – do strongly resemble African masks. This cannot be wholly a coincidence.

The squatting figure on the right of the final canvas is the embodiment of Picasso's most extreme innovation. In addition to the grotesque, mask-like head, the body is curiously distorted. 'It is as if the painter had moved freely around his subject, gathering information from various angles and viewpoints. This dismissal of a system of perspective which had conditioned Western painting since the Renaissance marks . . . the

beginning of a new era in the history of art,' wrote John Golding in his influential book *Cubism*. This figure is there from the very first composition sketch, and there she has a specific role. While the other prostitutes stand casually about, she squats facing the sailor - the client – who sits in the centre of the scene. She is unmistakably offering herself to him, with her thighs splayed apart. She is as accessible as the melon that lies split open on the table between them. But in the canvas itself the sailor has gone. The squatting Demoiselle has swivelled her head, owl-like, to stare out of the canvas. The bowl of fruit is now in the front of the canvas, between the spectator and the harlots.

Picasso has not turned his squatting figure round to display her explicitly to the spectator. Instead her whole position is ambiguous. It is clear from drawings for the painting, that Picasso was intrigued by ambiguous silhouettes: outlines that could be read as front or back views. In an oil sketch for the *Demoiselles*, her face is turned towards the spectator, but her body is a totally ambiguous outline, with conical breasts sprouting under her armpits. It is impossible to decide whether she is exposing her back or her belly.

This is the problematic torso on which Picasso abruptly placed the terrifyingly inhuman 'African-primitive' mask. There are two drawings of this time that might be studies for this head – or for a torso. Picasso has traced one face over the outline of a back. The eyes are created out of the shoulder-blades, the nose is the curving line of the spine, and the chin is

Pablo Picasso
Study for *Les Demoiselles d'Avignon* 1907

Pablo Picasso
Study for *Les Demoiselles d'Avignon* 1907

one foreshortened thigh. The other sketch shows the same contour modified first into a front view of a torso, then into another similar face, but this time the eyes are the breasts and the mouth is equated with the female genitals. It is an equation that occurred in several of Goya's *Caprichos*.

This is the Medusa mask that 'froze with horror the half-converted', as Salmon observed. It is an aesthetic indecency that metaphorically transfers the obscene display, originally made to the sailor, directly to the spectator. The painting did not lose its original subject. Salmon says that it was at once named *The Philosophical Brothel*; he named it after the Carrer d'Avinyò, a street in the Barcelona red-light area.

If Picasso's canvas was a response to Matisse's *Happiness of Living* – a modern version of Ingres' *Turkish Bath* – it was a cruel one. The only explanation given by anyone likely to know is that given by Salmon, who simply said that Picasso took savage artists as his mentors because 'his logic led him to think that their aim had been the genuine representation of a being, not the realization of the idea we have of it'. He has taken Ingres's dream of houris, swooning languorously in an Oriental bathhouse, and given it the *realistic* savagery of a 'truly' primitive style.

Matisse and Leo Stein were very angry when they saw the *Demoiselles*. They laughed and said Picasso was trying to create fourth dimension. It was at this time that Georges Braque was brought on his first visit to the Bateau Lavoir. When he saw the *Demoiselles* he too was shocked. He said to Picasso: 'Despite all your explanations, you paint as if you wanted us to eat rope-ends or to drink petrol.'

Braque was only six months younger than Picasso, but he was not a prodigy. It was at the Salon des Indépendants held in March 1907 (when Picasso was already at work on the *Demoiselles*) that he had his first professional success. He sold all six pictures he was exhibiting. His work was noticed by a young German dealer, Daniel-Henry Kahnweiler, who had just opened a gallery in Paris. That October, he signed a contract to buy Braque's entire production. He also introduced him to Apollinaire. Apollinaire naturally introduced him to Picasso.

Whatever Braque thought of the *Demoiselles* when he first saw it, it must have made a profound impression on him. The paintings with which he had been so successful at the Salon des Indépendants that Spring had been Fauve, but soon after his visit to Picasso's studio he began to work on a quite different subject and kind of painting. This was a medium-sized painting of a nude which occupied him for the following six months. Everything about this painting suggests that after seeing the *Demoiselles* he set out deliberately to transform his way of painting.

The influence of the *Demoiselles* can be seen in many features of Braque's *Nude*. Most striking is the empty-eyed mask which is turned to stare blankly at the spectator over a shoulder. The vigorous outlines, too, suggest the *Demoiselles*' effect. Like the *Demoiselles*, it is placed against drapery that is sculpted into hard, angular folds. And just as in Picasso's invention, the spatial orientation is obscure. The Demoiselle in the pink peignoir draws back a brown curtain to reveal a milky blue sky which is itself a curtain parted to reveal another darker interior. The Demoiselle with one arm raised was, in the earliest drawings, sitting on a chair. Now

she appears to stand, or rather to slide to one side; her pose is almost the same as that of the famous Venus painted in sixteenth-century Venice by Giorgione, that now known as the Dresden Venus, except that Giorgione's Venus is lying down. Braque's nude looks most uncomfortably balanced on the toes of her right foot, but appears much more at ease as if she is seen lying down, shown from above. Nothing allows the spectator to make a decision between these possibilities.

Despite its striking kinship with the *Demoiselles*, Braque's *Nude* marks the beginning of Cubism in a way that Picasso's picture does not. For much of 1908, Picasso followed the implications of his inventions of 1906. His preoccupations were with solid, sculptural forms and bold shapes. This time has been called his 'Negro' period, and even the works which do not resemble African art are *primitive* in their harshness and crudity. Braque, on the other hand, developed from his *Nude* in a different direction. Throughout 1908, he showed, more and more strikingly, the influence of Cézanne. It was Braque's work of 1908 that was first called 'Cubist'. This was by Matisse, who was one of the jury that rejected all the new paintings Braque submitted to the Salon d'Automne of that year. Despite this, these canvases were shown, at Kahnweiler's gallery, that October. Louis Vauxcelles noted that Braque reduced everything to cubes.

Perhaps it was from that time that Picasso began to regard Braque's work seriously. Certainly it was from then that Cubism began to grow.

Georges Braque
Nude 1907–08

Georges Braque
Landscape at L'Estaque 1908

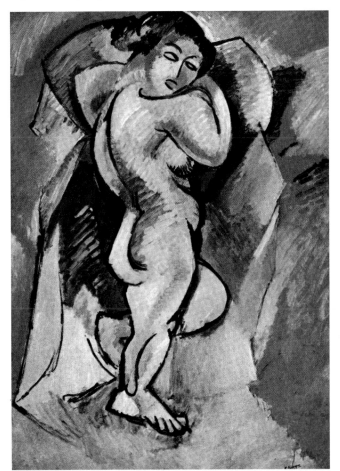

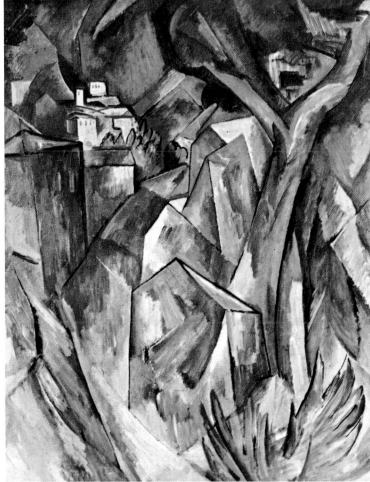

Between then and 1914, the work of Picasso and Braque passed through several transformations, and in retrospect these developments look inevitable, even logical. But true Cubism, this painting of Picasso and Braque, was not the result of a programme, a project. It flourished out of the friendship and rivalry of these two. Braque described the following years: 'We lived in Montmartre, we saw each other every day, we talked. During those years Picasso and I discussed things which nobody will ever discuss again, which nobody else would know how to discuss, which nobody else would know how to understand.' In his memorable phrase, he and Picasso were like 'two mountaineers roped together'. There came a moment when they had difficulty in distinguishing between their paintings. They valued this similarity and abandoned signing their works on the front, leaving it to the assistant of their dealer, Kahnweiler, to identify the work on the back only.

Braque, in the landscapes painted at L'Estaque in 1908, crystallized the essential qualities of Cubism. From Cézanne, Braque learned a good deal. He learned, first of all, to avoid strong diagonals, foreshortening and other perspectival devices that would give clear indications of depth in the traditional way of Western painting. He learned to see or invent patterns in which objects in quite different planes in three dimensions could be balanced two-dimensionally. For example, a tree rising on the right of a canvas will be balanced by a path on the left, and these two curved shapes will between them bracket the landscape. A third device that Braque adapted from Cézanne was to avoid closed contours, to leave gaps in outlines: this allowed objects in quite different planes to melt into each other as they were juxtaposed in the pictorial composition; and it also emphasized the independence of the outline as a pictorial element.

Braque's landscapes were quite unlike those of Cézanne in two significant ways. Cézanne learned from the Impressionists, and his canvases glowed with sunlight; Braque's palette was almost monochromatic (perhaps in reaction against his Fauve days), and he often used a neutral grey. Cézanne's outline was quivering, tentative; Braque drew with an aggressive, bold stroke. Cézanne seemed to contemplate the world, searching for its significance; Braque remade the world as his art demanded it.

From early in 1909, the differences between Picasso's 'Negro' style and Braque's post-Cézanne style diminished and disappeared. They created an art which was, as critics had said of Matisse's Fauvism, theoretical and artificial, but which, unlike Fauve painting, seemed to be about the *substance* of things. Much later, Braque was explicit about his interest in abandoning traditional perspective: 'It was too mechanical to allow one to take full possession of things.' It is a paradox of much Cubist painting, and especially that of Braque, that though it is often hard to know *what* is represented, or even *where* it is meant to be, that unknown, uncertain object is undeniably tangible.

There is no mystery about this. It is the result of the Cubist use of the *facet* as the basic element of painting. This had been Picasso's fundamental technical innovation in the *Demoiselles d'Avignon*. The facet, not the cube, is the key to this art. The facet may vary in size, but its basic features survive from 1908 to 1913. It is a small area bordered by

straight or curved lines, two adjacent edges defined with a light tone and two opposite edges with a dark tone, and the area between modulating between these extremes. The tonal effect would suggest a strongly convex or concave surface, but this is denied by the edges of the facet.

The facets are composed according to three principles. First, they are almost always painted as if at a slight angle to the vertical surface of the canvas; that is to say, they are like louvres of a window that are usually ajar, but never fully opened at right-angles to the frame. Secondly, although the facets overlap and cast shadows on each other, the shadows and overlappings are inconsistent; it would be impossible to construct a relief model of a Cubist painting. Thirdly, the edges of facets dissolve, allowing their contents to leak into each other in the manner the Cubists had learnt from Cézanne.

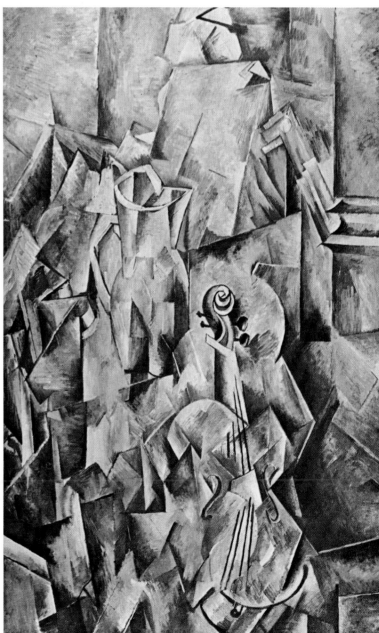

Georges Braque
Still-life with Herrings (Still-life with Fish)
c. 1909–11

Georges Braque
Still-life with Violin and Pitcher 1909–10

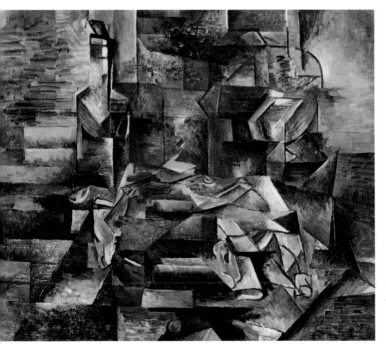

Thus these facets, apparently in low relief, painted in traditional chiaroscuro, and so tangible, real, are structured in a baffling paradoxical system that defies immediate identification. Nevertheless, they do represent very real, commonplace objects, pipes, bottles, musical instruments, the possessions of the artists' lives – or are even portraits of their friends and mistresses.

The first phase of Cubism was that created by the fusion of Picasso's primitivism with Braque's post-Cézanne forms. This was the time of bold simplifications into heavy blocks of form. Its monumentality was lightened by the ambiguity of the shapes and by avoidance of the foreshortening that would have given the objects a convincing three-dimensional existence.

Out of this sculptural imagery grew the paradoxical figures of 1910. In this phase unmistakably solid objects were represented in spaces that often appeared profound. But the dimensions of objects and spaces are uncertain, even elusive. In the Tate Gallery, London, are two paintings from this time, a *Seated Nude* by Picasso and *Still-life with Herrings* by Braque. Each painting conveys a strong sense of deep space, of the shifting light and shade of a gloomy studio interior; but each is obscure in

Pablo Picasso
Seated Nude 1909–10

Pablo Picasso
Girl with Mandoline 1910

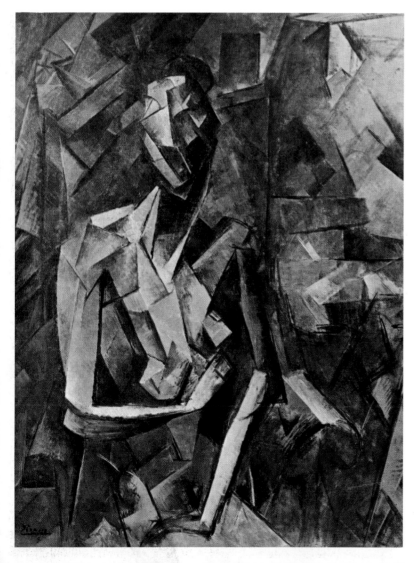

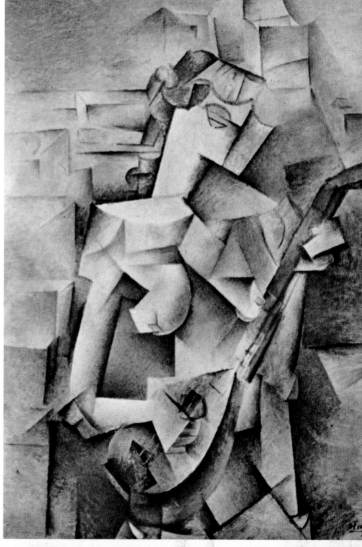

other ways. Braque's still-life might, at first sight, be a landscape with factory chimneys. Certainly the herrings of the title are hard to identify immediately. Some major forms in the painting never resolve themselves, are irresoluble. But the space in which these objects are suspended, the light that flows about them like a sluggish, ebbing tide – *these* are pictorial forms compelling in their presence.

Picasso's *Seated Nude* of 1910 is enigmatic in another way. The canvas is covered with intersecting diagonals of lighter and darker paint of sombre tones. The surface is homogeneous and yet it is not difficult to identify the figure sitting in a chair and, beyond her shoulder, the distant clutter of a studio. The chair, like the table on which Braque's *Still-life with Herrings* is placed, is drawn in conventional perspective. But the torso framed by its arms is harshly defined, as if assembled perfunctorily from old picture frames and the discarded wooden stretchers of old canvases. It is the head that is totally ambiguous: is it raised to stare out beyond the spectator's left shoulder, or lowered in reverie?

By this time, Picasso and Braque had developed an alternative process of representation that was as flexible and expressive as that of the schools. This may be seen by comparing the Tate Gallery *Seated Nude* with

Pablo Picasso
Ambroise Vollard 1909–10

Pablo Picasso
Daniel-Henry Kahnweiler 1910

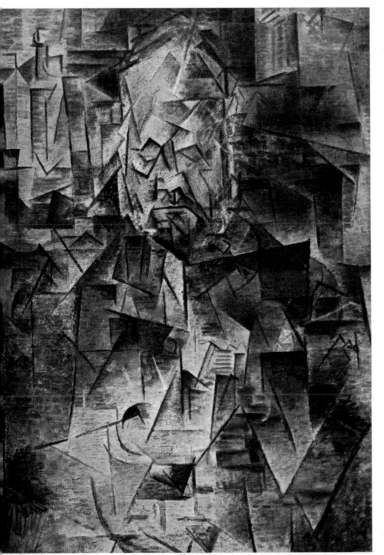
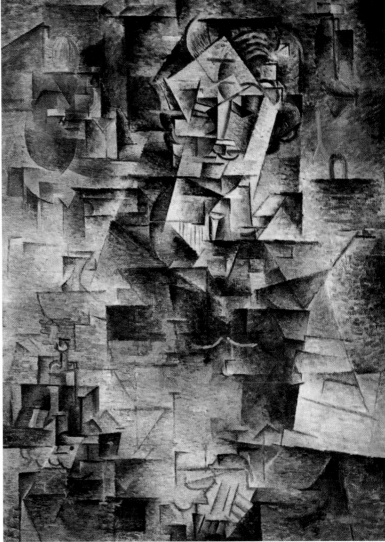

another by Picasso, *Girl with a Mandoline*, in a private collection in New York. The Tate painting is an emblem of brooding melancholy, whereas in contrast the New York nude is far more sensuous. Again, look at Picasso's portrait of his dealer, Ambroise Vollard. It is an excellent likeness. The bull-dog muzzle clamped shut is firmly defined. The dome of the skull, though, has been offered as several alternative outlines. This time the language is used to suggest the process by which the artist, fascinated by those clenched, immovable jaws, found that his perception of the top of the head shifted with each successive glance.

Within a few months, the process developed further. In Picasso's portrait of Kahnweiler, the dealer and the objects around him, pictures, books, bottles, are reduced to facets that, like cards overlapping, flutter across the canvas surface. The facets themselves dissolve in a flux of light and dark. In the paintings that follow, the object represented is almost lost within the crystalline faceting that dominates the picture surface. The paint is often applied in regular small dabs, something like bricks placed horizontally but loosely across a firmer grid of lines, vertical, horizontal and in diagonals of 60° and 30°. In these structures the eye could wander as if in a maze. First one set of shapes drifts to the surface; then, by a sleight of perception, it sinks back and an alternative conformation replaces it. But at this point the painter inserts a clue: an eye blinks out among the parallelograms, two sagging lines become a watch-chain, or a series of black studs become the pegs of a mandoline. The title becomes crucial as a key to the mystery. First Braque, then Picasso, uses lettering to clarify his meaning.

This is the extreme phase of true Cubism that has been called 'hermetic', the ultimate 'analysis' of the object. It is, rather, the most extreme refinement of representational obliquity. In a still-life that after contemplation resolves into a newspaper and glass on a café table, Braque uses the unpainted canvas to represent all the *objects* in his still-life and uses a heavy impasto to create the airy intervals around them.

Although Braque followed Picasso's example, and (after showing two pictures at the juryless Salon des Indépendants in Spring 1909) did not exhibit publicly in Paris until after the First World War, Cubism was becoming known. Other painters visited their studios, and in the Salon d'Automne of 1910 there were enough works painted under the influence of Picasso's and Braque's new style to attract critical attention. These painters included Jean Metzinger, Henri Le Fauconnier, Robert Delaunay, Albert Gleizes and Fernand Léger. This group organized itself to take over the hanging committee of the Salon des Indépendants the following Spring and so transformed the esoteric achievement of Picasso and Braque into an Art Movement.

The response of *la bande à Picasso* to the new Cubists may be deduced from Gertrude Stein's description of Robert Delaunay. He was, she wrote, 'the founder of the first of the many vulgarizations of the cubist idea, the painting of houses out of plumb, what was called the catastrophic school. . . . He was fairly able and inordinately ambitious. He was always asking how old Picasso had been when he had painted a certain picture. When he was told he always said, oh I am not as old as that yet. I will do as much when I am that age.'

But for the general public, the Cubism of these followers was the only Cubism to be seen. In 1911, the Cubist Movement exhibited at the Indépendants in Spring, at the Société des Artistes Indépendants in Brussels in June, and at the Salon d'Automne in October. These *bizzareries cubiques*, as Vauxcelles called them, attracted attention and called for explanation. The following year, 1912, a spate of articles and pamphlets were published to explain what Cubism was about. The explanations were various but there was general agreement on one thing: that the Cubists were realists; they did want to paint representational pictures, but believed that traditional methods of representation were false. Olivier-Hourcade, a writer best known for his defence of Cubism, explained: 'The ruling preoccupaton of the [new] artists is with cutting into the essential TRUTH of the thing they wish to represent, and not merely the external and passing aspect of this truth.' Hourcade invoked the German philosophers Kant and Schopenhauer to insist on the distinction between 'that which appears and that which is . . . between the thing and us there is always the intelligence'. Then he gave a crucial example. 'The painter, when he has to draw a round cup, knows very well that the opening of the cup is a circle. When he draws an ellipse, therefore, he is not sincere, he is making a concession to the lies of optics and perspective, he is telling a deliberate lie.'

In 1912 a quite different explanation and theory was offered in a book written by two painters, Albert Gleizes and Jean Metzinger, who had become, by this time, leaders of the Cubist Movement. Like other interpreters, Gleizes and Metzinger said that Cubism was concerned with reality, and like others they said that 'the visible world only becomes the real world by the operation of thought'. But whereas those others argued that the reality sought by painters was the eternal truth – the thing-in-itself – that lay behind the partial images revealed by our senses, Gleizes and Metzinger denied this. 'According to (certain other critics),' they wrote, 'the object possesses an absolute form, an essential form, and, in order to uncover it, we should suppress chiaroscuro and traditional pespective. What naivety! An object has not one absolute form, it has several; it has as many as there are planes in the domain of meaning.' 'To the eyes of most people the external world is amorphous. To discern a form is to verify it against a pre-existing idea, an act that no one, save the man we call an artist, can accomplish without external assistance.'

The artist, they argue, imposes his vision of the world on the rest of humanity. Therefore whenever an artist with a new vision appears his work is at first rejected as false because the crowd remains a slave to earlier painted images and 'persists in seeing the world only through the already adopted sign'.

By comparison with the theories of outsiders and followers, Picasso and Braque have given little explanation of their interests or the subject matter of those long, incomprehensible conversations that Braque remembered so nostalgically. Braque did make a number of brief statements throughout his life, the earliest being to an American interviewer in 1908. His views remained remarkably consistent. His concern was with reality; but it was a reality of the mind, not of the senses. 'There is no certainty except in what the mind conceives.' And

reality must be represented not by imitating appearances, but by an intuitive exploration of the medium.

Picasso did not commit himself on his art until 1923. Then he emphasized the artificiality of art. 'Art is a lie that makes us realize the truth. . . . They speak of naturalism in opposition to modern painting. I would like to know if anyone has ever seen a natural work of art.' Velázquez and Rubens both painted Philip IV of Spain, said Picasso, but we believe only in the Philip of Velázquez. 'He convinces us of his right by might.'

In short, while the sympathetic onlookers, from Olivier-Hourcade to Kahnweiler, claimed that Cubism was concerned with the eternal truth hidden by appearances, and evoked the name of Kant to give substance to their explanation, those on the inside, from Gleizes and Metzinger to Picasso, said with varying degrees of firmness that there was no eternal truth. Truth, they said, was illusion imposed by the strong on the multitude of the weak. In this they were themselves influenced by another German philosopher, Friedrich Nietzsche. He is the only philosopher mentioned by name by Apollinaire, Salmon and Braque when discussing Cubism. (Picasso's view of art seems a direct adaptation of Nietzsche's words: 'art, in which precisely the *lie* is sanctified and the will to deception has a good conscience'.)

But though Nietszche, the creator of Zarathustra and the Superman, author of *The Will to Power*, was certainly read and admired by the circle round Picasso, his influence probably worked most powerfully indirectly, through the character and writing of another acquaintance of the group, the writer Alfred Jarry. Jarry first became notorious at the age of twenty-three, with his play *Ubu roi*, a grotesque burlesque fantasy. Soon, Jarry himself became a scandal, living a fantasy life of absurd extremism. His novel *Le Surmâle*, the Supermale, of 1902, which was an outrageous combination of science-fiction and pornography, had a hero who demonstrated that a man could do everything he decided he wanted to do – physical limitations were a fiction of conventional social values. *Le Surmâle* was Nietzsche's superman made comic.

It is hard to insist that a serious art is also deliberately absurd: clearly the Cubism of Picasso and Braque was much else besides. But it would be quite wrong to ignore the high value placed on the comic, on playfulness, on wit, in Picasso's circle. The regard for Jarry speaks for this, and Gertrude Stein's description of Picasso and Braque together is at once comical and revealing. She describes them visiting the dealer Wilhelm Uhde. 'He kept a kind of private art shop. It was here that Braque and Picasso went to see him in their newest and roughest clothes and in their best cirque Medrano fashion kept up a constant fire of introducing each other to him and asking each other to introduce each other.'

It was a double act in which each partner was raised to greater brilliance by the rivalry than either could ever achieve alone. Certainly, neither Picasso nor Braque ever painted better than in the Cubist years.

They were creating an *alternative* art, just as Jarry created alternative worlds in his absurd fantasies. It cannot have been mere coincidence that these two abandoned what has been called 'Analytical Cubism' in 1912, just when versions and explanations of it were becoming commonplace.

This was when they began to use collage, a 'synthetic' method, sticking objects on to their canvases instead of painting them. This has been explained in various ways: Braque himself said that he used shapes cut from paper to give his shapes a kind of factualness, a kind of certainty. And yet this is not quite the impression created by the works themselves.

First, by using scraps of newspaper, old cigarette-packets and the flimsy detritus of modern life, they made these new works hard to take. The public which had learned to admire the obscurity of Analytical Cubism had to reverse its values to like this crude pasting-together of rubbish.

Then again, the objects stuck on to their pictures did not inevitably make them more real. On the contrary, the first time Picasso stuck anything on a picture it was a piece of oilcloth printed by the manufacturer to resemble chair caning. Both he and Braque delighted in fake textures and surfaces.

And finally, Picasso delighted in the humour that collage made possible. He stuck the conventionally realistic apples and pears from a horticultural catalogue on to a fruit dish cut out of newspaper. In general, he exploited collage to tease and amuse his spectator with witty transformations of familiar images.

Cubism was a self-consciously esoteric, difficult art. The value of Apollinaire to Cubism, Braque said rather unkindly, was that his book on Cubism, far from enlightening people, only succeeded in bamboozling them. And much later, after attempting to explain a little of Cubism, he added: 'but the only value of all this is that it should remain a mystery'.

Gleizes and Metzinger ended their book on Cubism with a few sentences that are usually ignored: 'For the partial liberties conquered by Courbet, Manet, Cézanne and the Impressionists, Cubism substitutes an indefinite liberty. Henceforth, objective knowledge at last regarded as chimerical, and all that the crowd understands by natural form proven to be convention, the painter will know no other laws than those of Taste [In the depths of science] one finds nothing but love and desire. A realist, [the artist] will fashion the real in the image of his mind, for there is only one truth, ours, when we impose it on everyone. And it is the faith in Beauty which provides the necessary strength.'

It is a statement that bridges Nietzsche and the Surrealists. It will serve to remind us that Picasso's last great Cubist work, the *Three Dancers* of 1925, is also one of the masterpieces of Surrealism.

I have confined myself to the achievement of Picasso and Braque, and I believe that my reasons for doing so will be clear by now. There were, however, a considerable number of painters who painted Cubist works during the period between 1908 and the First World War. The majority of these were the painters who took part in the Cubist Movement, exhibiting together at the Salon des Indépendants, the Salon d'Automne and elsewhere. There were, in 1912, no fewer than three different groups of Cubists: that formed by Robert Delaunay; the nucleus of the original group centred around Gleizes and Metzinger who now called themselves 'Les Artistes de Passy'; and a group that called itself 'La Section d'Or' and was based in the suburb of Puteaux in the studios of three brothers, Jacques Villon, Marcel Duchamp and Raymond Duchamp-Villon. It seems probable that these groups became militantly Cubist in response to

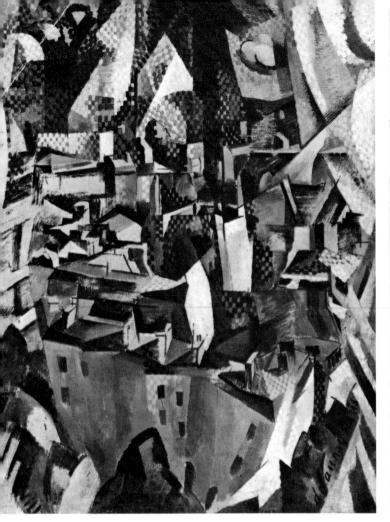

the exhibition and demonstration of Futurist art held in Paris in February 1912.

The majority were minor talents, and had they not taken part in the movement would seldom be remembered. These include Gleizes, Metzinger, Herbin, Le Fauconnier, Lhote, Marcoussis and other even lesser figures. There were also artists of real stature who were young enough to pass through Cubism as a form of adolescence before discovering their own styles. The most important of these were Robert Delaunay, Marcel Duchamp and Fernand Léger, though innumerable painters of all nationalities, artists as different as Chagall and Klee, also felt the influence of Cubism.

This leaves André Derain and Juan Gris. Derain had been a powerful innovator among the Fauves. He was one of Picasso's circle, and there is no doubt that in 1907 he looked a daring and original artist. However, though he painted a number of works which show the influence of Cézanne, he never painted anything that might properly be called Cubist. As I have suggested earlier, it was Apollinaire who out of friendship suggested that Derain had played a major role in the creation of Cubism. Juan Gris, a Spaniard six years younger than Picasso, has

Robert Delaunay
The City, no. 2 1910

Fernand Léger
Contrasts of Forms 1913

Juan Gris
Sunblind 1914

Juan Gris
Still-life with Fruit and Bottle of Water 1914

been called the third of the true Cubists, but in my view this is
unwarranted. He did know Picasso well, he lived in the Bateau Lavoir,
and he was certainly talented: he was a better Cubist than any other
follower. Between 1913 and 1915, he painted works incorporating collage
that could be placed beside the most brilliant of Picasso's works of those
years. But his later works became mannered and repetitive, reducing the
spontaneity and wit that had been the heart of true Cubism to elegant
decoration.

Futurism

Futurism was a movement: it lived on publicity. It was announced in a
manifesto published in French on the front page of the Paris newspaper
Le Figaro on 20 February 1909, while hundreds of copies in Italian were
sent to leading figures all over Italy. Between then and the outbreak of
the First World War, over a dozen further manifestos were published and
were accompanied by countless articles in the press. During the same
period, there were Futurist demonstrations and exhibitions in theatres
and galleries at towns throughout Italy and in Paris, London, Berlin,

Umberto Boccioni
Futurist Evening in Milan 1911

Brussels, Amsterdam, Munich, Rotterdam, Moscow and Petrograd.

It was an international movement conceived by an Italian, Filippo Tommaso Marinetti. Marinetti had a strange history. His father settled in Egypt and made a fortune speculating and advising the Khedive of Alexandria. In 1893, Filippo Tommaso Marinetti went to Paris and studied at the Sorbonne. He soon became known in the Symbolist circles of Paris. Much later he remembered himself and Alfred Jarry, 'the most threadbare genius in the world', in the ornate salon of Mme Périer, where 'I toss off my ode on the speed of cars and Jarry his metamorphosis of a bus into an elephant'. Marinetti's play *Le Roi Bombance* was unmistakably influenced by Jarry's *Ubu roi*; both were staged in Paris by Lugné-Poë, and both were greeted by a riot. From Paris Marinetti went, in 1895, first to Pavia and then to Genoa to study law. However, his elder brother, his mother and his father all died within a few years, and Marinetti inherited a considerable fortune. He settled in Milan and set about the renovation of Italian letters. In 1905 he founded his own periodical, *Poesia*. But, as Apollinaire wrote rather tartly in 1912, 'to awaken Italy from its torpor, he has taken France as his model because France is the leader in the arts and in literature'.

The 1909 'Founding and First Manifesto of Futurism' is best known for its eleven principles which glorify action and violence and vilify tradition of every kind. 'The essential elements of our poetry will be courage, audacity, and revolt. We wish to exalt too aggressive movement, feverish insomnia, running, the perilous leap, the cuff, the blow.' This cult of violence, the belief that 'there is no more beauty except in struggle' (axiom 7), culminated in the notorious axioms 9 and 10:

'We will glorify war – the world's only hygiene – militarism, patriotism, the destructive gesture of the Anarchist, the beautiful ideas that kill, contempt for woman.

'We will destroy museums and libraries, and fight against moralism, feminism, and all utilitarian cowardice.'

The past was past, museums were cemeteries. 'We declare that the splendour of the world has been enriched by a new form of beauty, the beauty of speed. A racing-car adorned with great pipes like serpents with explosive breath – a roaring racing-car that seems to run on shrapnel, is more beautiful than the *Victory of Samothrace*.'

More revealing even than the eleven points of the Manifesto is Marinetti's way of presenting them. He describes the events which led to the moment of their proclamation. 'We had been up all night, my friends and I, under the Oriental lamps with their pierced copper domes starred like our souls – for from them too burst the trapped lightning of an electric heart. . . . An immense pride swelled our chests because we felt ourselves alone at that hour . . . confronting the army of enemy stars staring down from their heavenly encampments. Alone with the stokers working before the infernal fires of the great ships; alone with the black phantoms that poke into the red-hot bellies of locomotives launched at mad speed; alone with the drunks reeling with their uncertain flapping of wings around city walls.'

This is very similar to the feeling of *difference*, of the artist's superiority, prevailing in nineteenth-century Romantic writing, typical of Edgar Allan Poe or Théophile Gautier. But, where Gautier uses similar images to present his account of smoking opium, Marinetti is using the ethic of Romanticism to attack Romantic values. He and his friends leave the Oriental luxury (which, incidentally, is a literal account of his apartment) for the streets of Milan, an ancient, crumbling city that within the previous few years had become modernized. Marinetti contrasts the moribund palaces and stagnant canals with 'the formidable sound of the enormous double-decked trams that jolted past, magnificent in multicoloured lights like villages at holiday time that the flooded Po has suddenly rocked and wrenched from their foundations'. There, they find 'three snorting beasts' – their new automobiles. 'Let's go!' Marinetti cries. 'Let's go, friends! Let us go out. Mythology and the Mystic Ideal are finally overcome. We are about to witness the birth of the centaur and soon we shall see the first angels fly! – The doors of life must be shaken to test the hinges and bolts! – Let's take off! Behold the very first dawn on earth!'

This furious drive becomes, in Marinetti's account, an epitome of existence. He flourishes all the metaphors and images of Romanticism to dismiss them as valueless – but also to destroy the notion of value itself. Sitting behind the steering wheel that is like a guillotine blade, himself like a corpse in a coffin, he scorches along, squashing dogs under his tyres, until he at last skids into a ditch. But the car is resurrected, and it is as it speeds away again that the driver declaims the eleven principles of Futurism.

The only value is action. Man may become whatever he wills. He does not need to imagine angels and centaurs, because he is a centaur (in his automobile), an angel (in his aeroplane). But Marinetti not only dismisses traditional ideals – the very notion of the Ideal – but despises rationality: 'Let's break away from rationality as out of a horrible husk. . . . Let's give ourselves up to the unknown, not out of desperation but to plumb the depths of the absurd!'

Marinetti's 'Founding and First Manifesto of Futurism' is a call to a
new form of life. The artist must be the Hero. Art is a form – the only
true form – of action. Although Marinetti had brought together strands of
thought from many nineteenth-century sources, his true mentor was
Nietzsche: his 'dithyrambic' style is that of *Thus Spake Zarathustra*; his
Hero is Nietzsche's Superman. He concludes with a startling image.

'The oldest among us are thirty. . . . When we are forty, let others –
younger and more daring men – throw us into the wastepaper baskets like
useless manuscripts! They . . . will rush to kill us, their hatred so much the
stronger as their hearts will be overwhelmed with love and admiration for
us! And powerful and healthy Injustice will then burst radiantly in their
eyes. For art can only be violence, cruelty, and injustice.'

There are two kinds of problem set by this First Manifesto. First, and
most profoundly, it is against most known, accepted, civilized values. It
agrees implicitly with Nietzsche, when he wrote: 'The *meaning of all culture*
is the reduction of the beast of prey "man" to a tame and civilized
animal, a *domestic animal* . . . but who would not a hundred times sooner
fear where one can also admire than *not* fear but be permanently
condemned to the repellent sight of the ill-constituted, dwarfed, atrophied
and poisoned?' (*Genealogy of Morals*, I, 11.) This is a *moral* problem. The
second problem is more technical; a problem for the artist. Its ideal of art
is clearly similar to the state that in his *Birth of Tragedy* Nietzsche had
called Dionysiac: 'no longer the *artist*, he has himself become a *work of art*:
the productive power of the whole universe is now manifest in his
transport.' If Futurism was a state of being, an ethical condition, what
were the consequences for the traditional forms of art?

It is clear from a reading of the First Manifesto that it offers a credo
embracing all the arts and giving guidance to none. Marinetti himself saw
Futurism as embracing all aspects of human activity. Drawn by his
vigorous activity, a number of writers, painters, sculptors and other artists
became Futurists. The First Manifesto was followed by manifestos on
Futurist painting, sculpture, music, photography, architecture, noises and
clothes. Marinetti himself signed manifestos, written either individually or
in concert with friends, on literature, cinema, theatre and politics. On 11
March 1915, Giacomo Balla and Fortunato Depero issued a manifesto on
the 'Futurist Reconstruction of the Universe'.

Given the Futurist ethos as defined by Marinetti, what *form* was
Futurist painting, sculpture, literature, music or theatre to take?
Marinetti faced this problem as a poet in his 'Technical Manifesto of
Futurist Literature' of 11 May 1912, which began: 'Sitting on the gas
tank of an aeroplane, my stomach warmed by the pilot's head, I sensed
the ridiculous inanity of the old syntax inherited from Homer.' Most
important, though, was the principle 'Destroy the *I* in literature: that is,
all psychology' and instead substitute an *intuitive psychology of matter*, the
principle revealed to Marinetti in the aeroplane. In this way the writer
could invent 'wireless imagination', *words-in-freedom*. 'Futurist poets! I
have taught you to hate libraries and museums, to prepare you *to hate
intelligence*, reawakening in you divine intuition, characteristic gift of the
Latin races. Through intuition we will conquer the seemingly uncon-
querable hostility that separates human flesh from the metal of motors.'

The problem of how to *be* Futurist was felt acutely by the painters; and the painters were the first to become Futurist. Soon after the publication of Marinetti's First Manifesto, a number of Italian painters, who included Umberto Boccioni, Carlo Carrà and Luigi Russolo, introduced themselves to him and, according to Carrà's recollection, drew up their own 'Manifesto of the Futurist Painters'. This was eventually published by proclamation to an audience from the stage of the Politeama Chiarella, Turin, on 8 March 1910. (The date attributed to the manifesto is 11 February 1910, as Marinetti favoured the number eleven.) It was addressed to the young artists of Italy, and was a hollow sequel to Marinetti's First Manifesto. It deplored the decadence of contemporary Italian art, still exploiting 'the glories of the ancient Romans', and demanded a new art that would reflect 'the frenetic life of our great cities and the exciting new psychology of night-life; the feverish figures of the bon viveur, the cocotte, the apache and the absinthe drinker.' It was tame stuff. Principle 8, in particular, was a very prosaic sequel to Marinetti's explosive poetry. 'Support and glory in our day-to-day world, a world which is going to be continually and splendidly transformed by victorious Science.' Two other painters, Giacomo Balla and Gino Severini, joined Boccioni, Carrà and Russolo in signing this manifesto, but none of them, at that point, had painted anything that deserved the name Futurist. It is not certain that they had any idea of how this could be done.

However, the same five quickly followed this with the 'Futurist Painting: Technical Manifesto' published on 11 April 1910. 'The gesture which we would reproduce on canvas shall no longer be a fixed *moment* in universal dynamism. It shall simply be the *dynamic sensation* itself. . . . On account of the persistency of an image upon the retina, moving objects constantly multiply themselves; their form changes like rapid vibrations, in their mad career. Thus a running horse has not four legs, but twenty, and their movements are triangular.'

In other words, the Futurists first conceived their new art as an attempt to show the world, not as it really was, but as it was *really experienced*. But though their theory called for a 'sharpened and multiplied sensitiveness', in practice they replaced the conventions of the museums with those of photography and a current theory of colour. In their representation of movement they were influenced by the multiple exposures of moving figures made and published in the last years of the nineteenth century by E. J. Marey. Their colour was based on Pointillism or Neo-Impressionism – patterning with touches of pure colour – first developed in the 1880s by the French painter Georges Seurat.

Nevertheless, despite the manifesto's ingenuous concentration on dynamic sensation, only one of the Futurists was consistently concerned with the representation of movement. This was Giacomo Balla, the oldest of the group and the teacher of Boccioni and Severini. Although it was he who first introduced the group to the practice of Neo-Impressionism, and although he had agreed to sign the first 'Manifesto of Futurist Painting', he did himself not paint a certainly Futurist work until 1912. Then, abruptly, after a visit to Düsseldorf, he painted, in a little over a year, a brilliant series of paintings of movement. The earliest and best known, *Dynamism of a Dog on a Leash*, is also the least impressive. It is so clearly

E. J. Marey
Chronophotograph 1887 (?)

based on the study of multiple-exposure photographs. *Rhythm of a Violinist* is similar, but the use of prismatic strokes of colour to represent the disintegration of the hand into a vibrating pattern of lines is ingenious. *Girl Running on a Balcony* is more than ingenious. It too is unmistakably derived from Marey's photographs, but Balla dissolved the entire surface into a mosaic of coloured dabs in the Neo-Impressionist manner. In this way the spectator has simultaneously to form the dabs into a single figure (the girl) and see the girl as moving (in several blurred stages) across the balcony. Finally, there is a neat contrast between the repeated representations of the parts of the girl, each of which is the same individual at different points of time, and the repeated verticals which are different railings stationary at different points in space. Even his later paintings of swifts in flight (taken again from Marey), and of an automobile in movement, are simply heightened sequels to this image. Quite different, and altogether strange, are the series of totally abstract paintings of 1912, the *Iridescent Interpenetrations*, which he developed out of his study of light and colour.

Despite his seniority, or perhaps because of it, Balla was not representative of Futurist painting at any time. Perhaps the first impressively Futurist paintings were by Carlo Carrà. *The Swimmers* of 1910 and *Leaving the Theatre* of 1910–11 are his first inventions, but his most complete painting came with the *Funeral of the Anarchist Galli* of 1910–11. Angelo Galli had been killed during the general strike in Milan in 1904. Carrà had seen the riot that had developed at his funeral, when clashes between police and workers had almost knocked the red-draped coffin to the ground. In his painting he represents the fight not as a moment between individuals but as a clash of lines and colours. The figures are anonymous and their limbs blur into sheaves of lines

Giacomo Balla
Dynamism of a Dog on a Leash 1912

Giacomo Balla
Rhythm of a Violinist 1912

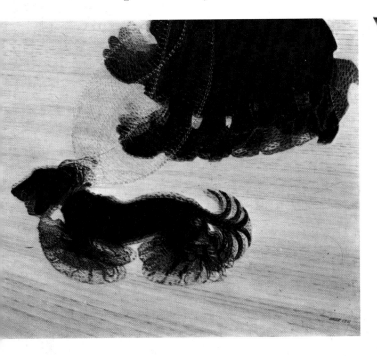

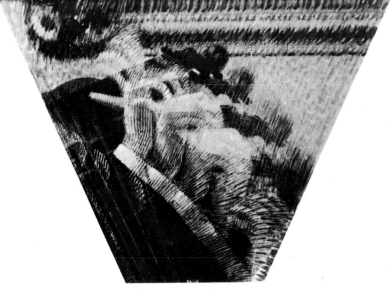

Carlo Carrà
The Swimmers 1910

Carlo Carrà
Leaving the Theatre 1910–11

Carlo Carrà
Funeral of the Anarchist Galli 1911 (detail)

Giacomo Balla
Girl Running on a Balcony 1912

representing their movement. Carrà was certainly influenced by Marey's photographs, but his theme is unmistakably more complex than the mere representation of physical movement.

Luigi Russolo, who was the youngest of the five painters, was also the most extreme. He was a trained musician and spent a great deal of time developing a Futurist art of noises. He issued a manifesto on the 'Art of Noises' on 11 March 1913, in which he declared: 'For many years Beethoven and Wagner shook our nerves and hearts. Now we are satiated and WE FIND FAR MORE ENJOYMENT IN THE COMBINATION OF THE NOISES OF TRAMS, BACKFIRING MOTORS, CARRIAGES AND BAWLING CROWDS THAN IN REHEARSING, for example, THE "EROICA" OR THE "PASTORAL".' On 21 May 1914, he gave a concert of noises – many produced by devices of his own invention – at the Teatro Dal Verme, Milan. As a painter, Russolo was self-taught and less impressive, but here too he was ambitious and ingenious. He was the first of the Futurists to explore the possibilities of synaesthesia. This is the association of the experiences of one sense with those of another, as when a colour feels hot or cold, or a musical composition is colourful, and especially when any set of shapes, colours, sounds or tastes seem to evoke a mood or state of mind. Kandinsky, in Munich, expounded a theory of synaesthesia in his *Concerning the Spiritual in Art*, and after its publication in 1912 several Futurists issued manifestos on it as a Futurist phenomenon.

Russolo first painted a picture in which the impressions of one sense were represented in terms of another when, in 1909, he painted *Perfume*. It is a weak, sentimental picture, badly drawn, but attempts to represent the erotic quality of the woman's odour by enveloping wavy lines of brilliant colour. *Music* of 1911 became a set-piece of Futurism. The pianist crouches satanically over the keyboard, several hands feverishly pounding out the music that swirls in a visible polychrome wave above his head. Around him the spirits of the composition are represented by

Luigi Russolo
Memories of a Night 1911

Luigi Russolo
Perfume 1909–10

Luigi Russolo
Music 1911

garish sightless masks. It is, however, his *Memories of a Night* of 1911 that
is truly representative of Futurist ambitions. It is a disjointed composition,
with slouching figures, street-lights, houses, horses, women's heads and
other details placed in uncertain juxtaposition. But, as its title reveals, it is
not concerned with a specific incident, a certain place, or even a certain
precise time, but with the nature of experience. Here, the Futurists were
influenced by the popular French philosopher Henri Bergson, who

pointed out that perception and experience were not instantaneous. Memory played a fundamental role in our experience, which was inevitably extended over time. *Memories of a Night* and *Solidity of Fog* blend such effects of the persistence of vision as are instanced in the 'Manifesto of the Futurist Painters' within a larger panorama.

It was during 1911 that several of the Futurist painters visited Paris. The reason seems to have been that Gino Severini, a signatory of the manifestos, who lived in Paris, persuaded the others that their work would improve if they could visit the studios of the Cubists. Whatever the reason, late in the year, Boccioni and Carrà went to Paris, and Severini introduced them to his friends and acquaintances as well as taking them to the Salon d'Automne where there were works by Metzinger, Gleizes, Léger, Le Fauconnier, La Fresnaye and others. They also visited Picasso's studio, where they met Apollinaire, who recorded the visit in his gossip column in the *Mercure de France*.

'I have met two Futurist painters, M. Boccioni and M. Severini. . . . These gentlemen wear clothes of English cut, very comfortable. M. Severini, a native of Tuscany, favours low shoes and socks of different colours. . . . This Florentine coquetry exposes him to the risk of being thought absent-minded, and he told me that café waiters often feel obliged to call his attention to what they suppose is an oversight, but which is actually an affectation. I have not yet seen any Futurist paintings, but, if I have correctly understood what the new Italian painters are aiming at in their experiments, they are concerned above all with expressing feelings, almost states of mind (the term was employed by M. Boccioni himself). . . . Furthermore, these young men want to move away from natural forms and to be the inventors of their art.

'"So," M. Boccioni told me, "I have painted two pictures, one expressing departure and the other arrival. The scene is a railway station. In order to emphasize the difference of moods I have not repeated in the arrival picture a single line in the other."'

Apollinaire thought that this kind of painting 'would seem to be above all sentimental and rather puerile'.

Boccioni was, as Apollinaire discovered, the theoretician of the group. He was also the most talented. Nevertheless, he was (with the exception of his teacher Balla) the last of the painters to develop a distinctive Futurist form. He was a year younger than Picasso. For a short time, in 1901, he studied with Severini in Balla's studio in Rome, and his early work shows Balla's influence, particularly in his use of a Neo-Impressionist palette. Many of the drawings he made when he was in his middle twenties have something of the harsh solidity of early drawings by Van Gogh. He was, until 1908, an able but unoriginal member of the Italian Neo-Impressionist school that included Balla, Segantini and Previati.

It was then that he apparently became dissatisfied with this tradition of Impressionist realism. He began to explore the varieties of modernism which, as they were available to him, were forms of Art Nouveau and Symbolism. It was then that he discovered Marinetti and Futurism. Boccioni's first Futurist works illustrate that the movement was essentially an attitude to life. Using a variety of techniques – drawn from Neo-

Umberto Boccioni
The City Rises 1910

Umberto Boccioni
States of Mind I: The Farewells 1911

Umberto Boccioni
The Noises of the Street Invade the House 1911

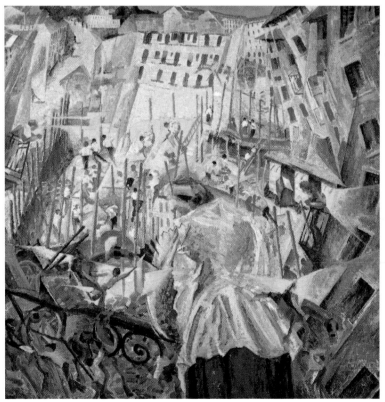

Impressionism, and from Edvard Munch – he painted scenes of riot, of mourning, of a modern *femme fatale*. These show little originality. His major work of 1910 began as a triptych that, in the manner of certain works by Balla, showed Work at three times, Dawn, Day and Night. This developed into his great canvas *The City Rises*, which epitomizes the generation of the modern world of the city in the contrast between pygmy men and their mighty engines harnessed for construction (which, in 1910, still included horses).

There is little about *The City Rises*, apart from its vitality and its subject, that would have seemed original to contemporaries. But, soon after that, Boccioni embarked on a series of canvases which he must have left half-finished in his studio when he visited Paris late in 1911. These are works representing 'states of mind', as Apollinaire recorded. In addition to a triptych which showed *The Farewells* of couples at a railway station, and *Those who Go* on the journey and *Those who Stay*, he was painting a café scene that was called *The Laugh*. His preliminary studies show he developed a swirling, abstract rhythm, derived from Munch and Art Nouveau. The final canvases, after the visit to Paris, show the strong influence of Cubism. This is least successful in *The Laugh*, in which the easily recognizable head of the plump woman who is laughing is in jarring contrast with the Cubist angularities into which the rest of the café and her admirers are shattered by her laughter. Of the three *States of Mind*, *The Farewells* is the best known and the most integrated invention; what might be a still-life after Braque unfolds under observation to reveal the embracing couples, like Dante's whirlwind of lovers, among the indifferent machines of the railway station. It is arguably the one great Futurist painting.

The complexity and ambiguity of the problems the Futurist painters set themselves are illustrated by two of Boccioni's other works of 1911. *Simultaneous Visions* and *The Noises of the Street Enter the House* at first look very similar – so similar that they have been persistently confused. Reproductions published in the London *Sketch* for 6 March 1912, at the time of the Futurists' exhibition, leave no doubt about the pictures' identities, yet a more profound ambiguity remains. *The Noises of the Street Enter the House* appears the more straightforward representation of things seen. It is a view from a balcony, and, although influenced by Cubism, contains nothing the woman shown on the balcony might not have seen, not necessarily simultaneously. The lost *Simultaneous Visions*, on the other hand, mixed details from a street scene with a still-life of a bedroom washstand; it seems to have been 'the synthesis of what one remembers and what one sees', as Boccioni wrote. The two titles could indeed be changed over.

The Futurists' visit to Paris was a preparation for the exhibition of their works at the Galerie Bernheim-Jeune in February 1912. Their catalogue preface – 'The Exhibitors to the Public' – has become known as the definitive statement of Futurist painting. The Futurists took care to deny that they were followers or plagiarists of Cubism. The Cubists still 'worship the traditionalism of Poussin, of Ingres, of Corot, aging and petrifying their art with an obstinate attachment to the past. . . . Our object is to determine completely new laws which may deliver painting

from the wavering uncertainty in which it lingers. . . . We have proclaimed ourselves to be *the primitives of a completely renovated sensibility.*'

At first, Apollinaire was hostile; later he came round. He admired Marinetti and Boccioni, and was soon writing in their defence. On 29 June 1913 he even published his own Futurist manifesto: 'L'Anti-tradition futuriste'.

Mutual suspicion and hostility between Cubists and Futurists remained. The Futurists did owe a bigger debt than they cared to admit. Ironically, it was a Frenchman and a Cubist who painted two of the best and most notorious Futurist paintings. Marcel Duchamp, brother of Jacques Villon and Raymond Duchamp-Villon, painted at the time of the Futurists' visit to Paris *Sad Young Man in a Train*, a work that might be a direct illustration of one of the examples given in 'Futurist Painting: Technical Manifesto'. He then painted a study of the body in motion, *Nude Descending a Staircase*, which is in every way closer to Futurism than it is to Cubism, and which, when it was shown in New York in 1913, became the most notorious specimen of 'Modern Art' in the world.

Marcel Duchamp
Sad Young Man in a Train 1911

Marcel Duchamp
Nude Descending a Staircase, no. 2 1912

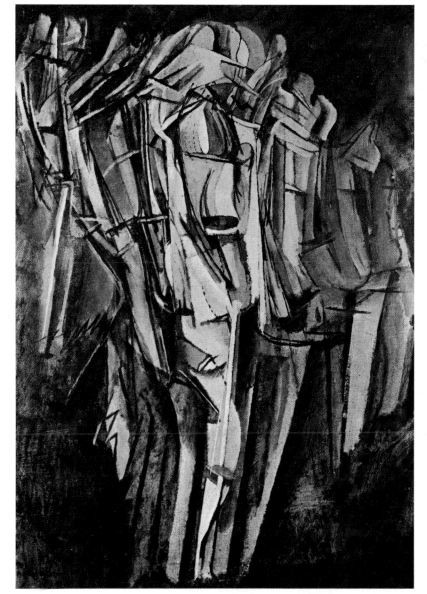

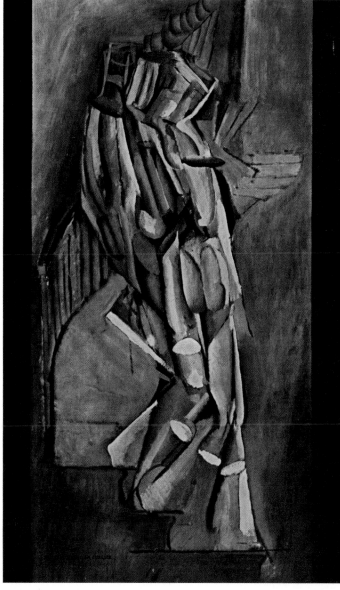

The Paris exhibition was the first major showing of Futurist work
outside Italy. It was a success and quickly moved first to London, in
March 1912, and on to Berlin, Brussels, the Hague, Amsterdam and
Munich. One of the most interesting of the Futurists was Gino Severini,
whose huge *Pan Pan at the Monico* was a Toulouse-Lautrec subject of
dancers at a cabaret translated into gaudy splinters of colour. He was
given a one-man exhibition the following year at the new Marlborough
Gallery in Duke Street, London. Futurist – the word, at least – had
become both notorious and fashionable.

Until then, Marinetti had favoured Futurist evenings held at theatres
to promote the movement. In 1910 and 1911 he had held events at
Trieste, Milan, Turin, Naples, Venice, Padua, Ferrara, Mantua, Como
and Treviso. But these evenings of outrageous readings from Futurist
writings, and even more outrageous results – even blows – exchanged
between Futurists and audience, were most suitable in Italy, where actors
and audience shared a language. Internationally the picture exhibition

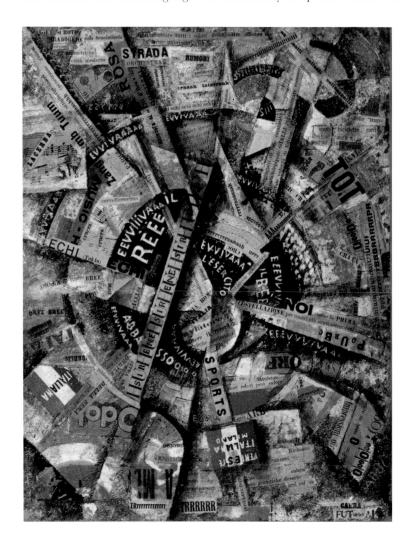

Carlo Carrà
Interventionist Demonstration 1914

was a more powerful weapon, and the Futurists exploited it. By the outbreak of the war, Futurism had established, in the eyes of the world, that Modernism, in Art, was Extremism. Russolo's art of noises, Marinetti's typographical poems, his 'words-in-freedom', freely scattered across the page, Carrà's collages of newspaper cuttings that were at once incomprehensible abstract pictures and outrageous 'free-word' poems, Boccioni's sculpture built of scraps of junk – these set a precedent. Dada, the movement established in Zurich during the First World War, learned directly from the Futurists. One of the Dadaists later admitted: 'We had swallowed Futurism, bones, feathers and all.'

The war ended Futurism. As believers in war as the world's hygiene, Marinetti, Boccioni and Russolo joined up almost immediately. Of the principal Futurists, only Sant' Elia (a promising architect) and Boccioni were killed (he, ironically, by a fall while exercising a horse); but when Marinetti set out to reform the movement after the war, it had been overtaken by such later forms as Dada and the various movements to total abstraction of which the Constructivists movement was the most important.

Constructivism

In their essay 'On Cubism' of 1912, Gleizes and Metzinger wrote one sentence that was much repeated: 'Let the picture imitate nothing and let it present nakedly its *raison d'être*.' This has been understood as a demand for an abstract art, but it is not certain that it is. There had been, for many years, a wish to remove from art the taint of imitativeness – unoriginality. Even the writer Gustave Flaubert had written in a letter of 1852–53, 'what I should like to write is a book about nothing, a book dependent on nothing external, which would be held together by the strength of its style'.

Much later, in 1935, Picasso explained the relation of his own work to reality when he said: 'I want nothing but emotion to be given off' by the painting. However, he also said: 'There is no abstract art. You must always start with something. Afterwards you can remove all traces of reality.'

The idea of an art that imitated nothing was not easy to crystallize. In the second decade of the twentieth century several versions and systems were developed, and, for all except the abstractions of Wassily Kandinsky, Cubism was a formative influence.

The oldest of the artists to be influenced by Cubism was a Dutchman, Piet Mondrian. He was already thirty-nine when he arrived in Paris in 1911, but although he had been painting for a number of years he was still searching for a new form of art. Soon after his arrival in Paris, he was strongly influenced by Cubism. His canvases of trees and of still-life were representations reduced to bold, simple outlines. But he was already a convert to Theosophy, and because of this he looked for an art that would be transcendental rather than representational. Even before he left Paris he painted works in which the motif was reduced to such simple forms – staccato plus and minus signs spread across the canvas – as to be almost totally unidentifiable.

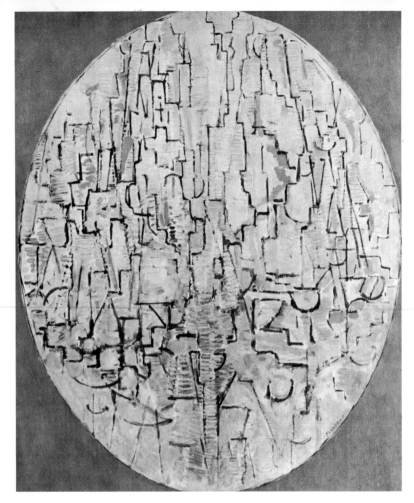

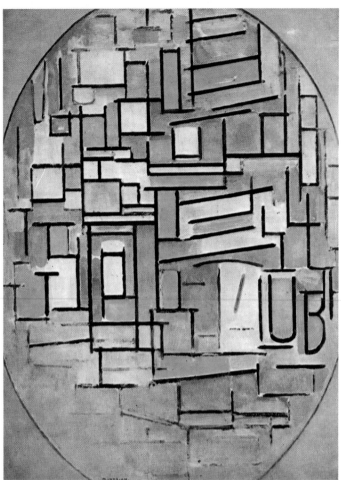

Back in Holland during the war, Mondrian became one of a group called De Stijl. The group published a periodical called *De Stijl* which was edited by the propagandist of the movement, Theo van Doesburg. From the writings of Mondrian and Van Doesburg, De Stijl emerges as standing for a unification of the visual arts, and as utopian in its ambition.

Mondrian said in 1919: 'The truly modern artist is aware of abstraction in an emotion of beauty; he is conscious of the fact that the emotion of beauty is cosmic, universal. . . . The new plastic idea cannot, therefore, take the form of a natural or concrete representation, although the latter does always indicate the universal to a degree, or at least conceals it within. This new plastic idea will ignore the particulars of appearance, that is to say, natural form and colour. On the contrary, it should find its expression in the abstraction of form and colour, that is to say, in the straight line and the clearly defined primary colour. . . .

'We find that in nature all relations are dominated by a single primordial relation, which is defined by the opposition of two extremes. Abstract plasticism represents this primordial relation in a precise manner by means of the two positions which form the right angle. This positional relation is the most balanced of all, since it expresses in a perfect harmony the relation between two extremes, and contains all other relations.'

Piet Mondrian
Oval Composition (Trees) 1913

Piet Mondrian
Oval Composition 1913–14

Mondrian saw painting as a model or exemplar of universal harmony or true beauty, and believed that as man developed so he would replace painting by a total environment in which he could live in harmony. De Stijl concerned itself as much with architecture and design as it did with painting and sculpture. And because he believed that his verticals and horizontals did in fact express a perfect harmony and contain all other relations, when, in 1925, he saw Van Doesburg's compositions including diagonals, he denounced them as personal and subjective, and left the movement.

De Stijl was one of the most influential movements of modern art; so too was the art that accompanied the Russian Revolution of 1917.

The Modern Movement in Russian art was a function of Russia's own historic development from medieval feudalism to nineteenth-century capitalism to revolution within a single lifetime. Russian painting of the eighteenth and early nineteenth centuries had been dependent on the values and achievement of Western European painting. But in the later nineteenth century, Russian society and Russian artists began to rediscover a native strength. It can be no coincidence that one of the first great patrons of the second half of the century, Savva Mamontov, was a railway tycoon, or that the artists he patronized rediscovered the values and achievements of medieval native Russian art. Other merchants travelled west and continued to patronize Western painters; but the works they brought back to Moscow were of the most modern. Ivan Morozov bought the paintings of Monet, Cézanne and Gauguin. Sergei Shchukin, another Moscow merchant, was among the boldest collectors of his day. From 1906 to 1914, he visited Paris constantly and bought, from their studios, many works by Matisse and Picasso.

Piet Mondrian
Composition in Colour A 1917

Piet Mondrian
Composition with Red, Yellow and Blue 1921

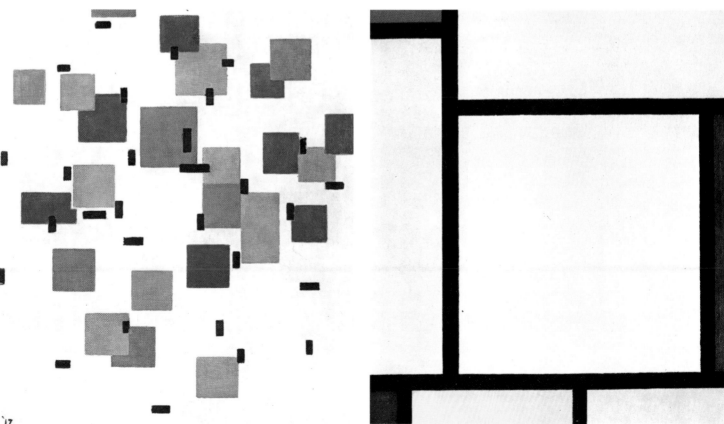

The railroad took the Russians to the West not only to see but to be seen. In 1906, Serge Diaghilev was the organizer of a Russian section at the Salon d'Automne. It was an exhibition that began with medieval icons and ended with the work of the Moscow avant-garde.

The most talented of the young Russian painters represented at the Salon d'Automne of 1906 were Mikhail Larionov and Natalia Goncharova. Both were born in 1881, the same year as Picasso. They met as students in Moscow and soon became leaders of the avant-garde there. They were equally influenced by the advanced art of the West and the primitivism of Russian icons and folk art. They were inspired by Cubism and the Futurist manifestos; and when, in 1913, Larionov issued a manifesto for a new style he called Rayonnism, it had a distinctly Futurist ring: 'We declare the genius of our days to be: trousers, jackets, shoes, tramways, buses, aeroplanes, railways, magnificent ships. . . . We deny that individuality has any value in a work of art. . . . Hail nationalism! – we go hand in hand with house-painters. . . . Here begins the true freeing of art: a life which proceeds only according to the laws of painting as an independent entity.'

But in 1914 Larionov and Goncharova left Russia to join Diaghilev as designers for his ballet. They never lived again in Russia or contributed to the vital years that followed.

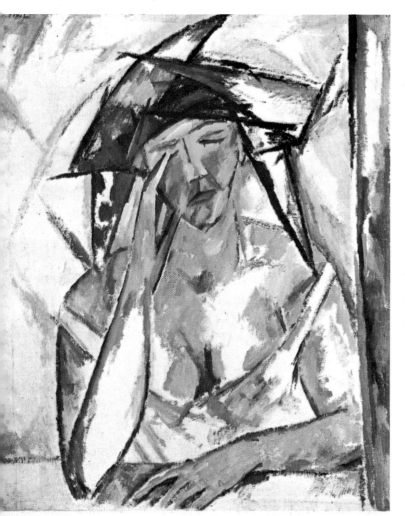

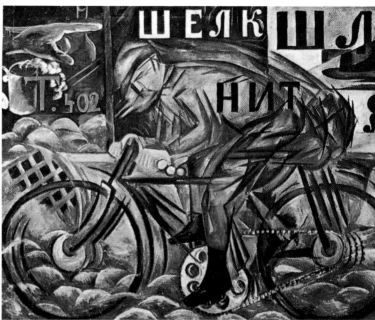

Natalia Goncharova
The Cyclist 1912–13

Mikhail Larionov
Portrait of a Woman 1911

The achievements of the next years were largely those of two rivals, Kasimir Malevich and Vladimir Tatlin. Malevich, the son of a foreman in a sugar factory in Kiev, was largely self-educated. He studied art at the Kiev School of Art, but was twenty-seven before he came to Moscow in 1905, soon to be discovered by Larionov's circle. Between 1909 and 1914, Malevich developed rapidly. From a kind of proto-Cubism, recalling the work of Léger as much as that of Picasso, he passed through a sequence of phases that led him, in 1913, to a type of fragmented collage (anticipating the Dada images of Kurt Schwitters as much as those of Picasso) that he called 'nonsense realism'. These were brilliantly witty, even surreal images, but he quickly moved beyond them – almost inadvertently, it might seem – when he was the designer for Kruchenikh's Futurist opera *Victory over the Sun* (*Pobeda nad Solntsem*) of 1913. The costumes were witty Cubist-Futurist concepts, not quite as outrageous as those Picasso created a few years later for the ballet *Parade*; but it was one of the backcloths that was significant for Malevich. This was simply a square divided into black and white triangles. From this image, Malevich claimed, he moved

Kasimir Malevich
The Knife-Grinder 1912

Kasimir Malevich
An Englishman in Moscow 1914

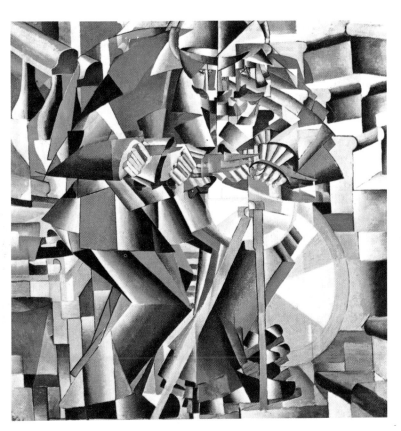

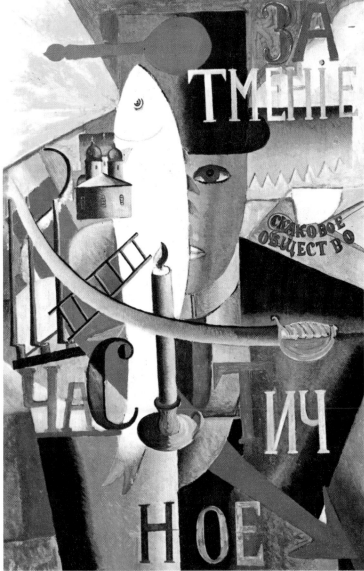

on immediately to purely abstract paintings of which the first was a black square on a white canvas. He had begun the art he called 'Suprematism'.

It was soon after this that Vladimir Tatlin began his own equally original road. Tatlin was seven years younger than Malevich, having been born in 1885. He ran away to sea when he was eighteen and began to study art only after his first voyage. He moved to Moscow in 1910, and, after only a year as a student, began to exhibit with the circle round Larionov. Influenced at first by Larionov and Goncharova, in 1913 he quarrelled with them and travelled west, first to Berlin and then to Paris.

He visited Picasso and asked to become a kind of apprentice. Picasso did not agree, and so Tatlin returned to Moscow. But in Picasso's studio he had seen the unconventional collages and reliefs that Picasso had made from scraps of cardboard, string and other junk; inspired by these, Tatlin made some of the most revolutionary works of modern art. They were totally non-representational constructions from junk, the most ingenious

Kasimir Malevich
Suprematist Composition: Red Square and Black Square 1915 (?)

Kasimir Malevich
Yellow, Orange and Green c. 1914

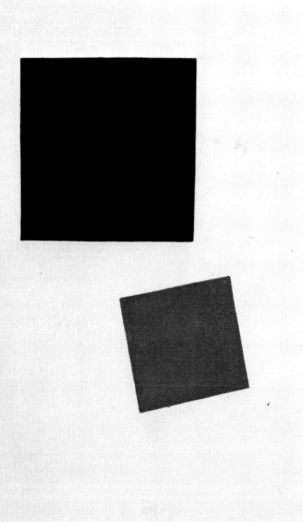

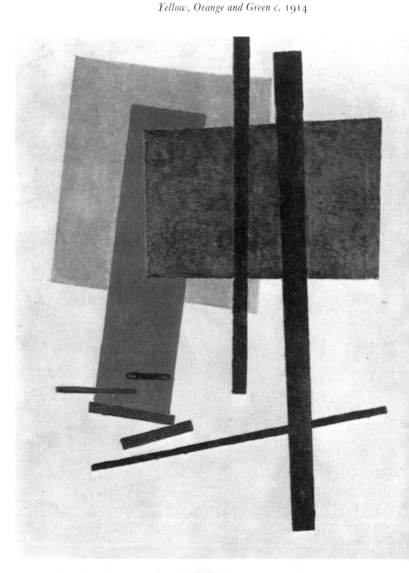

being designed to span the corner of a room. These were the first works to be called 'constructions'.

Malevich and Tatlin were brought together in two avant-garde exhibitions in 1915. At the first, called 'The Futurist Exhibition: Tramway V', held in Petrograd in February, Tatlin showed reliefs, Malevich his Cubo-Futurist collages of two years earlier. Many works by other artists followed comparable styles, and the entire exhibition could indeed be seen as the first Futurist exhibition in Russia. But it was in the following December, at '0.10. The Last Futurist Painting Exhibition', that a crisis arose. Malevich wanted to exhibit his completely abstract Suprematist compositions. Tatlin was furious and called them amateur. Eventually their works were hung in separate rooms. With this exhibition, the avant-garde was established in Russia.

The October Revolution of 1917 created the moment for which the avant-garde was ready. The artists accepted that revolutionary art was a necessary complement to the political and social revolutions, and threw themselves into the struggle. They organized demonstrations and decorations. In the words of the poet Mayakovsky, they set out to make the streets their brushes and the square their palette. An enthusiasm for revolution, for a reconstruction that would be Futurist as much as Bolshevik, gripped the artists.

But as the chaos that immediately followed the Revolution gave way to the beginnings of a new order and a new bureaucracy, the enthusiastic co-operation of those early days dissolved as the different artists looked for positions of power in the new structures. In 1918 a Department of Fine Arts (IZO) was established by the first Commissar of Education, Anatoly Lunacharsky, and he made a number of appointments from the artists of the avant-garde.

Among the many innovations made by IZO, the most significant was the amalgamation, in 1918, of the Moscow College of Painting, Sculpture and Architecture with the Stroganov School of Applied Art into the Higher Technical-Artistic Studios, known as Vkhutemas. Among those who had studios there were Malevich, Tatlin, Kandinsky and Antoine Pevsner. The Institute of Artistic Culture (Inkhuk) delegated the creation of a teaching programme to Kandinsky, previously a member of the *Blaue Reiter* group in Munich, the creator of the only form of abstract art not directly influenced by Cubism, and, at fifty-two, Inkhuk's senior member.

Kandinsky's programme (published in 1920) was in effect his theory of art. He proposed that studies should be in two parts, of the 'Theory of separate branches of art' and of the 'Combination of the separate arts to create a monumental art'. Kandinsky's vision was of a new and profound relation between art and society, but the relation was essentially a religious one (like Mondrian, he was a Theosophist). He believed the artist was the man with a loftier spiritual vision than his fellow men; and abstract art was the purer means of communicating this vision. The purpose of artistic training was to provide an Art Dictionary of conscious line and form for each medium. For example, colours were to be studied both individually and in combinations, and 'these studies are to be co-ordinated with medical, physiological and occult knowledge'. With this knowledge, the artist would be able to attack the second part of the

programme, the work of monumental art that could produce quite specific and controlled responses ('ecstasy') in its audience.

Kandinsky's programme was voted down by Inkhuk. It was put into practice only after he left Russia in 1922 for Walter Gropius' Bauhaus in Weimar.

Of the younger artists, Malevich was perhaps the most in sympathy with Kandinsky's theories, but he was too independent to work under Kandinsky or indeed anyone else. Invited by the director of the Vitebsk School of Art, Marc Chagall, to teach there, Malevich took advantage of Chagall's temporary absence in Moscow to declare himself Director and rename the school Unovis, the College of the New Art.

As early as 1916, when he announced his art of Suprematism (which led him from a black square on a white canvas in 1913 to a white square on a white canvas in 1918), Malevich had claimed: 'I have destroyed the ring of the horizon and escaped from the circle of things . . . To reproduce beloved objects and little corners of nature is just like a thief being enraptured by his legs in irons.' The Futurists 'took an enormous step forward: they gave up meat [i.e. the nude] and glorified the machine'; but unfortuntely this only substituted one kind of copying for another. 'The forms of Suprematism, the new realism in painting, are already proof of the construction of forms from nothing, discovered by Intuitive Reason.' Unlike Futurism, unlike Cubism, said Malevich, 'our world of art has become new, non-objective, pure'.

Like Mondrian, like Kandinsky, Malevich distrusted representational art because he distrusted the world it represented, the world of the senses. However, in the brief time he was director of Unovis at Vitebsk he gallantly insisted that Suprematism was utilitarian.

He wrote in a manifesto of 1920, on 'The Question of Imitative Art': 'Every form is the result of energy moving along the path of an economic principle. Hence stem man's rights and politics. . . . Freedom of action is not action independent, separate and outside the community, for it is an economic, i.e. completely prosaic principle. . . . The general philosophical path of these trends leads to the disintegration of things, to the non-objective and to Suprematism, as a new real utilitarian body and to the spiritual world of phenomena. . . . We are going to work on new creative constructions in life. . . .

'Three cheers for the overthrow of the old world of art.

'Three cheers for the new world of things.

'Three cheers for the common all-Russian auditorium for construction.

'Three cheers for the Red leaders of contemporary life and the Red creative work of new art.'

But two years later, on 12 February 1922, he was writing to a group of Dutch artists to complain that his compatriots had 'failed to comprehend the importance of the painter or of any art worker for human culture'. This was true even of those who called themselves Constructivists.

Malevich's faith was in a spiritual art. The battle was won, temporarily, by the Constructivist, objectivist factions. These were working in Moscow, at Vkhutemas, and were themselves divided. The faction closest to Malevich centred round two sculptors, Antoine Pevsner and his brother Naum Gabo, who issued a 'Realistic Manifesto' in

Moscow on 5 August 1920. In it they condemned Cubism and Futurism and called for an Art 'erected on the real laws of Life'. They continued: 'The plumb-line in our hand, eyes as precise as a ruler, in a spirit as taut as a compass . . . we construct our work as the universe constructs its own, as an engineer constructs his bridges, as a mathematician his formula of the orbits.'

How different this ideal was from that of Malevich can be seen more clearly in Gabo's later explanation (1937). 'I do not hesitate to affirm that the perception of space is a primary natural sense. . . . Our task is to bring it closer to our consciousness; so that the sensation of space will become for us a more elementary and everyday emotion, the same as the sensation of light or the sensation of sound.' He continued: 'The shapes we are creating are not abstract, they are absolute. . . . The emotional force of an absolute shape is unique and not replaceable by any other means. . . . Shapes exult and shapes depress, they elate and make desperate. . . . The constructive mind which enables us to draw on this inexhaustible source of expression and to dedicate it to the service of sculpture.'

This is an art of real materials in real space, such as Tatlin had called for; but it still is an art for the mental faculties, an art concerned with expression and emotion. Tatlin himself saw art as the product of a decadent society, and took as his slogan 'Art into Life'. He remained, as he had been for half-a-dozen years, the opponent of Malevich. He became more and more a designer of things. He designed, in the hard days of 1918–19, a stove to consume the minimum of fuel and give the maximum heat. He designed a worker's outfit of clothes. He spent years attempting to perfect a flying machine, *Letatlin*, with wings like a falcon's. His greatest conception was his design for a *Monument to the Third International*, commissioned in 1919 to be erected in the centre of Moscow. A model exhibited at the Eighth Congress of Soviets in December 1920 showed a strange skeletal structure, intended to be twice the height of the Empire State Building in New York and tilted on a diagonal axis, as if the Eiffel Tower had been reconstructed as a rocket-launching pad. It contained within its spiral framework three geometrical solids, halls for meetings, which were to revolve once a year, once a month and once a day respectively. On cloudy nights it would project slogans on to the sky above Moscow.

The clash of ideologies that divided the Constructivists and other artists of the Revolution was never settled within Russia. As the central government became established, the initiative of these revolutionaries was put down. Instead an art that the people could understand became more favoured, until, at last, the *Small Soviet Encyclopedia* (3rd edn, 1960) described Constructivism as 'a formalistic tendency in bourgeois art, which developed after the First World War 1914–18. Anti-humanistic by nature, hostile to realism, Constructivism appeared as the expression of the deepest decline of bourgeois culture in the period of the general crisis of capitalism.'

Kandinsky, Pevsner and Gabo left Russian in 1922 and 1923 and never returned. Kandinsky accepted a post at the Bauhaus, a school which in some ways resembled the Moscow Vkhutemas, and in which the

Vladimir Tatlin
Monument to the Third International 1919–20

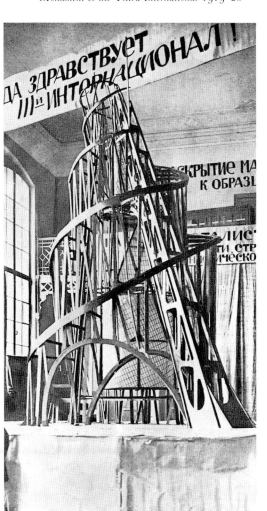

uselessness of traditional Fine Art and the mere utilitarianism of machine-produced objects were to be transcended by good functional design.

Of the Russians bringing Constructivism to the West, the most important was one of the youngest, El Lissitzky, born in 1890. He was both architect and graphic designer. His paintings called *Prouns* owed a good deal to Malevich, and might be seen either as abstracts or as designs for a new architecture. They were also ingenious and witty. This is the secret of his brilliant graphic designs, which combine geometrical shape, photographic images and typography in a revolutionary way. His street poster of 1919–20 called on the People to *Beat the Whites with the Red Wedge*, and the design showed a red triangle penetrating a white circle.

Lissitzky too left Russia in 1922, and went first to Berlin where he organized an exhibition of 'Modern Russian Abstraction' at the Van Diemen gallery. His influence on De Stijl, on the teaching of the Bauhaus,

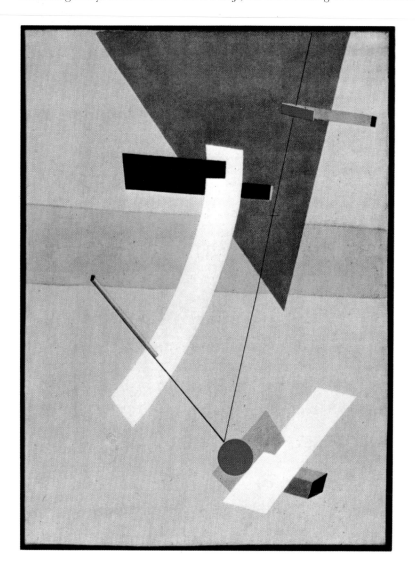

El Lissitzky
Proun 12 E c. 1920

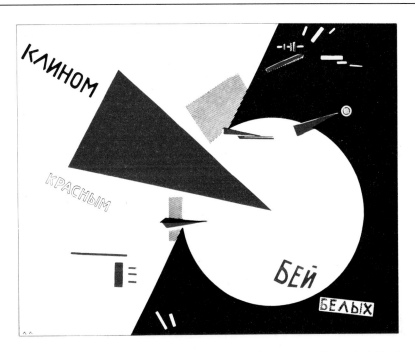

El Lissitzky
Beat the Whites with the Red Wedge 1919

and on Western abstract art in general, was important. He ended his days in Russia as a designer of exhibitions and posters.

The principles of Constructivism were codified in Western Europe by the pedagogic programme taught at the Bauhaus between 1923 and 1928 by the Hungarian László Moholy-Nagy. In an eclectic programme that owed much to Kandinsky but more to Lissitzky, Moholy-Nagy eschewed the mysticism of Mondrian, Kandinsky and Malevich. Abstract art, he said 'projects a desirable future order'. Art, he said, 'is the senses' grindstone, sharpening the eyes, the mind and the feelings'. It 'creates new types of spatial relationships, new inventions of forms, new visual laws – basic and simple – as the visual counterpart to a more purposeful, cooperative human society'.

5 *Dada and Surrealism*

DAWN ADES

Dada

The bourgeois regarded the Dadaist as a dissolute monster, a revolutionary villain, a barbarous Asiatic, plotting against his bells, his safe-deposits, his honours list. The Dadaist thought up tricks to rob the bourgeois of his sleep. . . . The Dadaist gave the bourgeois a sense of confusion and distant, yet mighty rumbling, so that his bells began to buzz, his safes frowned, and his honours list broke out in spots.

(The Navel Bottle by Hans Arp)

TO THE PUBLIC
Before going down among you to pull out your decaying teeth, your running ears, your tongues full of sores,

Before breaking your putrid bones,

Before opening your cholera-infested belly and taking out for use as fertilizer your too fatted liver, your ignoble spleen and your diabetic kidneys,

Before tearing out your ugly sexual organ, incontinent and slimy,

Before extinguishing your appetite for beauty, ecstasy, sugar, philosophy, mathematical and poetic metaphysical pepper and cucumbers,

Before disinfecting you with vitriol, cleansing you and shellacking you with passion,

Before all that,

We shall take a big antiseptic bath,

And we warn you

We are murderers.
(Manifesto signed by Ribemont-Dessaignes and read by seven people at the demonstration at the Grand Palais des Champs Elysées, Paris, 5 February 1920).

You are all indicted; stand up! Stand up as you would for the *Marseillaise* or *God Save the King*. . . .

Dada alone does not smell: it is nothing, nothing, nothing.

It is like your hopes: nothing.

like your paradise: nothing.

like your idols: nothing.

like your politicians: nothing.

like your heroes: nothing.

René Magritte
Natural Graces 1963

like your artists: nothing.

like your religions: nothing.

Hiss, shout, kick my teeth in, so what? I shall still tell you that you are half-wits. In three months my friends and I will be selling you our pictures for a few francs.

(*Manifeste cannibale dada* by Francis Picabia, read at the Dada soirée at the Théâtre de la Maison de l'Œuvre, Paris, 27 March 1920.)

The Dadaists believed that the artist was the product, and, traditionally, the prop, of bourgeois society, itself anachronistic and doomed. The war finally demonstrated its rottenness, but instead of being able to join in the construction of something new, the artist was still trapped in that society's death throes. He was thus an anachronism whose work was totally irrelevant, and the Dadaists wanted to prove its irrelevance in public. Dada was an expression of frustration and anger. But the Dadaists were after all painters and poets, and they subsisted in a state of complex irony, calling for the collapse of a society and its art on which they themselves were still in many ways dependent, and which, to compound the irony, had shown itself masochistically eager to embrace Dada and pay a few sous for its work in order to turn them into Art too.

The Dadaists wrote innumerable manifestos, each one colouring the concept of Dada according to his temperament. But how else can you express frustration and anger? Dada turned in two directions, on the one hand to a nihilistic and violent attack on art, and on the other to games, masks, buffoonery. 'What we call Dada is a harlequinade made of nothingness in which all higher questions are involved, a gladiator's gesture, a play with shabby debris, an execution of postured morality and plenitude', Hugo Ball wrote in his diary, *Die Flucht aus der Zeit*. Picabia and Man Ray produced perfect Dada works of aggression in objects like Picabia's *Portrait of Cézanne*, a stuffed monkey, or Man Ray's *Gift*, an ordinary flat iron with sharp tacks stuck on the bottom, which, combined with Duchamp's suggestion for a Reciprocal Readymade: 'Use a Rembrandt as an ironing board', functions as a metaphor for Dada.

Art had become a debased currency, just a matter for the connoisseur, whose taste was merely dependent on habit. Jacques Vaché, who died of an overdose of opium in 1918 before he had even heard of Dada, but whose flamboyant character and letters full of ironic despair, and humour, were powerful influences on the future Paris Dadaists, wrote to his friend André Breton in 1917: 'ART does not exist, of course – so it is useless to sing – however! we make art because it is thus and not otherwise – . . . So we like neither ART, nor artists (down with Apollinaire) AND HOW RIGHT TOGRATH WAS TO ASSASSINATE THE POET!' Picabia wrote disrespectfully in *Jésus-Christ Rastaquouère*: 'You are always looking for already-felt emotions, just as you like to get an old pair of trousers back from the cleaners, which seem new when you don't look too closely. Artists are cleaners, don't let yourself be taken in by them. True modern works of art are made not by artists but quite simply by men.' Or even, he might have said, by machines.

When Marcel Duchamp in 1913 mounted a bicycle wheel upside down on a stool, and in 1914 chose the first readymade, a bottle-rack, from the

Bazaar de l'Hôtel de Ville, it was the first step in a debate that Dada was to do much to foster – did this gesture of the artist elevate the ordinary mass-produced object into a work of art, or was it like a Trojan Horse, penetrating the ranks of art in order to reduce all objects and works of art to the same level? Of course these are really two sides of the same coin. Anyway, at first the readymades just lay around in his studio, and when he moved to New York in 1915 his sister threw away the *Bottlerack* with the rest of his accumulated rubbish. (He chose another one later.) He only gave them the name Readymade in America, where he began to 'designate' more manufactured objects. Duchamp himself was quite clear that the point was not to turn them into works of art. He explained that the choice of readymade 'depended on the object in general. It was necessary to resist the "look". It is very difficult to choose an object because after a couple of weeks you begin to like it or hate it. You must

Marcel Duchamp
Bicycle Wheel 1913

reach something like such indifference that you have no aesthetic
emotion. The choice of readymades is always based on visual indifference
at the same time as a total absence of good or bad taste. . . . [Taste is]
habit: the repetition of something already accepted.' So they were
exercises in the avoidance of art (habit). Duchamp once exhibited a
readymade, the *Hat-rack*, and the public unconsciously collaborated in the
game by not recognizing it as an exhibit and hanging their hats and coats
on it. At an exhibition in London, 'Pioneers of Modern Sculpture', the
Bicycle Wheel and *Bottlerack* appeared enigmatic and intact after fifty years
within the anti-art tradition.

 Duchamp also interprets his mechanical drawings and paintings (at
first paintings depicting machine-like organs, such as *The Passage from the
Virgin to the Bride*, and then increasingly mechanical in execution,
eliminating any interest in sensuous paint surface, texture, etc., like
Chocolate Grinder No. 2, 1914) as ways of escaping the tyranny of taste.
These culminate in one of the most deliberately obscure, esoteric
paintings of the century, *The Bride Stripped Bare by her Bachelors, Even*,
executed on glass between 1915 and 1923 when he abandoned it
'definitively unfinished'. It is accompanied by a number of notes by
Duchamp, which reveal that it is a 'love machine', consisting of two parts,
the upper one, the domain of the Bride, the lower one, the Bachelors.

Marcel Duchamp
Chocolate Grinder no. 2 1914

Each part was scrupulously planned beforehand (many studies for the individual elements exist), and then placed within a very rigid if idiosyncratic perspective, which has the disturbing effect, in the lower half of the work, of making parts of the machine look literally three-dimensional while at the same time enforcing the flatness and transparency of the glass surface. Duchamp then incorporated several experiments with chance. For example, he left the glass by the open window of his New York studio for several months to gather dust, then wiped away the dust (after it had been photographed by Man Ray), leaving it only on the 'Sieves', the conical shapes arranged in a half circle, where he fixed the dust with glue.

After 1913, except for the single 'record of the readymades', *Tu m'* of 1918, Duchamp abandoned conventional oil painting on canvas for good. In 1923 he apparently abandoned all artistic activity (apart from isolated objects such as *Female Fig Leaf*, and Surrealist exhibitions), preferring to

Marcel Duchamp
The Bride Stripped Bare by Her Bachelors, Even (The Large Glass) 1915–23

play chess. His silence was perhaps the most forceful and disquieting of all Dada myths. However, after his death in 1968, it was revealed that he had spent over twenty years, 1944–66, secretly working on an assemblage, a room called *Etant donnés: 1 La chute d'eau, 2 Le gaz d'éclairage*, also traceable back to the *Large Glass* notes.

Duchamp and Francis Picabia had met and immediately became close friends at the end of 1910. Picabia was ebullient, rich and totally nihilistic, and liked the grotesque humour of Alfred Jarry. Duchamp was withdrawn, ironical and esoteric in his tastes. Both were looking for a way out of being trapped and type-cast among the Paris avant-garde, which was predominantly Cubist, and both had an extreme distaste for reverential attitudes towards the 'special nature' of the artist. In 1911, shortly after making contact with the avant-garde's chief spokesman, the poet Guillaume Apollinaire, they attended a performance of Raymond Roussel's *Impressions d'Afrique* which seemed to them a monument of absurd humour. Among the incredible collection of objects and machines (which foreshadow the best Surrealist objects) is a painting machine, activated by rays of sunlight, which of its own accord paints a masterpiece. Roussel's demystification of the work of art, and his systematic destruction of order by pursuit of the absurd, strengthened

Francis Picabia
Parade amoureuse 1917

Francis Picabia
Title-page for *Dada 4/5* 1919

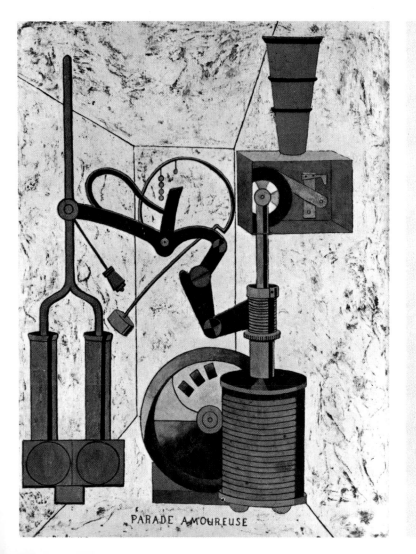

PARADE AMOUREUSE

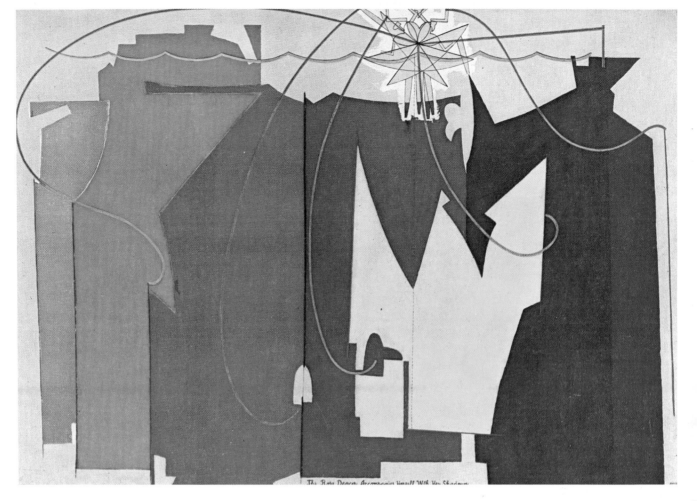

Man Ray
The Rope Dancer Accompanies Herself with Her Shadows 1916

their own similar aims, while the bizarre linguistic games which Roussel describes as the genesis of many of his ideas and objects in *Comment j'ai écrit certains de mes livres* are not unlike the esoteric way in which Duchamp set about constructing his works.

Francis Picabia began making machine drawings under the influence of Duchamp, developing the blasphemous potential of the sex/machine metaphor. He carried the machine drawing to its logical conclusion in 1919 in Zurich when, fittingly, he dismembered a watch, dipped the parts in ink and printed them (title page of *Dada* 4–5). He had published his first machine drawing in Alfred Stieglitz's magazine *Camera Work* at the time of the Armory Show in New York in 1913. The Armory Show had been the first real taste of advanced European art for the American public, and the uproar had centred on a painting by Duchamp, *Nude Descending a Staircase*, so Duchamp was already notorious in New York when, in 1915, both he and Picabia arrived there from Europe. Picabia was furnished with a military commission and money to buy molasses from Cuba, which he immediately put out of his mind. They joined a group of equally insurrectionary poets and painters including John Covert and Man Ray. Arthur Cravan was there intermittently. He had been, in Paris, author of some vitriolic pamphlets, *Maintenant*, and once challenged the ex-heavyweight champion of the world, Jack Johnson, to a disastrous fight in Barcelona, and escaped with his fee. Duchamp and his

friends arranged for Cravan to lecture to a glossy New York audience on modern art, but he arrived drunk, and, unsure what he was there for, began undressing on the platform. He finally disappeared while trying to row across the shark-infested Gulf of Mexico.

This group remained ignorant of the European 'movement' Dada, which had been given a name in Zurich in 1916. Picabia went to Barcelona for a few months, to recover from excesses of alcohol and opium, and there in 1917 produced the first numbers of his itinerant review *391*, best and longest lived of the many periodicals informed with a Dada spirit. The activities of the New York group culminated in the publication of the New York issues of *391* in 1917, which coincided with a spectacular gesture of Duchamp's. Invited to serve on the jury of an exhibition at the Grand Central Gallery, which, modelled on the lines of the Indépendants in Paris, gave anyone the right to exhibit, Duchamp sent in a white porcelain urinal with the pseudonym R. Mutt roughly painted on the side (*see* p. 306). When it was rejected, he resigned from the jury, and the incident was publicized in the broadsheets *The Blind Man* and *Rongwrong*.

Dada in Zurich

Many people were momentarily Dada, and Dada itself varied widely according to place, time and the people involved. It was essentially a state of mind, focused by the war from discontent into disgust. This disgust was directed at the society responsible for the terrifying waste of that war, and at the art and philosophy which appeared so enmeshed with bourgeois rationalism that they were incapable of giving birth to new forms through which any kind of protest could be made. In place of the paralysis to which this situation seemed to lead, Dada turned to the absurd, to the primitive, or the elemental.

Dada was christened in Zurich in 1916, although the circumstances – and the intended meaning of the name – are still disputed. Richard Huelsenbeck, then a young refugee poet, says that he and Ball discovered the word by accident in a German–French dictionary, and that the child's word (meaning hobby-horse), 'expresses the primitiveness, the beginning at zero, the new in our art'. It was adopted by the group of young exiles, mostly painters and poets, who had come to Switzerland to take refuge from the war on neutral ground, and gathered at the Cabaret Voltaire, a 'literary nightclub' organized by Hugo Ball at the beginning of 1916. There was for a while much discussion of a new art, and new poetry, which would revitalize a worn-out and debased language. A member of the group who was both painter and poet, Hans Arp, described the situation: 'In Zurich in 1915, losing interest in the slaughterhouses of the world war, we turned to the Fine Arts. While the thunder of the batteries rumbled in the distance, we pasted, we recited, we versified, we sang with all our soul. We searched for an elementary art that would, we thought, save mankind from the furious folly of these times. We aspired to a new order that might restore the balance between heaven and hell. This art gradually became an object of general reprobation. Is it surprising that the "bandits" could not understand us?

Marcel Janco
Cabaret Voltaire 1916

Their puerile mania for authoritarianism expects art itself to serve the
stultification of mankind.'
 The Zurich Dadaists included Hugo Ball, Emmy Hennings, Hans
Richter and Richard Huelsenbeck, from Germany, Hans Arp from
Alsace, Marcel Janco and Tristan Tzara from Romania, and occasionally
the enigmatic Dr Walter Serner. Dada's public manifestations took place
in riotous evenings at the Cabaret Voltaire. Tzara describes one in his
Dada diary:
'1916 July 14 – For the first time anywhere. Waag Hall.
'1st Dada night
(Music, dances, theories, manifestos, poems, paintings, costumes, masks)
'In the presence of a compact crowd Tzara demonstrates, we demand we
demand the right to piss in different colours, Huelsenbeck demonstrates,
Ball demonstrates, Arp *Erklärung* [Statement], Janco *meine Bilder* [my
pictures], Heusser *eigene Kompositionen* [original compositions], the dogs
bay and the dissection of Panama on the piano and dock – shouted poem
– shouting and fighting in the hall, first row approves second row declares
itself incompetent to judge the rest shout who is the strongest. . . . Boxing
resumed: Cubist dance, costumes by Janco, each man his own big drum
on his head, noise, Negro music/trabatgea bonooooo oo ooooo/ 5 literary
experiments: Tzara in tails stands before the curtain . . . and explains the

new aesthetic: gymnastic poem, concert of vowels, bruitist poem, static poem chemical arrangement of ideas, Biriboom, biriboom . . . vowel poem a a ò , i e o , a i i'

A similar evening culminated in Ball's reading of his new abstract phonetic poem, *O Gadji Beri Bimba*. Encased in a tight-fitting cylinder of shiny blue cardboard, with a high blue and white striped 'witch-doctor's hat', he had to be carried up to the platform. As he began to declaim the sonorous sounds, the audience exploded in laughing, clapping, cat-calls. Ball stood his ground, and, raising his voice above the uproar, began to intone, 'taking on the age-old cadence of priestly lamentation: *zimzim uralalla zimzim urallala zimzim zanzibar zimzalla zam.*'

It was as if he were illustrating his description of Dada in his diary *Die Flucht aus der Zeit*: 'What we are celebrating is at once a buffoonery and a requiem mass. . . . The bankruptcy of ideas having destroyed the concept of humanity to its very innermost strata, the instincts and hereditary backgrounds are now emerging pathologically. Since no art, politics or religious faith seems adequate to dam this torrent, there remain only the *blague* and the bleeding pose.'

Dada works have their only real existence as gestures, public statements of provocation. Whether at exhibitions or demonstrations (and the distinction between them as far as Dada was concerned was deliberately blurred), the Dada object, painting or construction was an act which expected a definite reaction.

Inevitably, some of the experiments of the Dadaists in poetry and the plastic arts seem to some extent to be borrowing the voices of other movements. Hans Richter's *Visionary Self-portrait* is an Expressionist work. Above all, Dada is full of echoes of Italian Futurism, in the violent language of its manifestos, and in its experiments with noise (bruitism) and with simultaneity. George Grosz's Dadaist *Funeral Procession, Dedicated to Oscar Panizza* of 1917, like the Futurist Carlo Carrà's painting *Funeral of the Anarchist Galli* (1911), suggests a funeral that has become a riot. Its dynamic criss-crossing lines and the interpenetrating houses, lights and people also owe a great deal to Umberto Boccioni's more sophisticated concept of simultaneity. Arp referred, in Futurist terms, to the 'dynamic boomboom' of the strong diagonals in his early abstract collages. Arthur Segal's hectic *Harbour*, with its parodied Cubist facets, owes a great deal to Futurism. Very often a style, a device is borrowed in order to satirize itself, to be turned into a grotesque parody. Tzara's 'Simultaneist Poem' is an example – a poem composed of banal verses in three languages, read simultaneously to the accompaniment of noises offstage, mimicking the idea of expressing simultaneous impressions. The Futurists' serious and optimistic attempts at portraying the dynamism, or heroism, of modern life were easy prey for the Dadaists, who regarded this particular branch of artistic activity as the most futile of all.

There was, however, a gulf between the artist in the privacy of his own studio and the same person joining in Dada's public activities. Marcel Janco, for instance, was experimenting with purely abstract plaster reliefs and at the same time making masks for the Dada demonstrations, which Arp remembers happily in 'Dadaland': 'They were terrifying, most of them daubed with bloody red. Out of cardboard paper, horsehair, wire

George Grosz
Funeral Procession, Dedicated to Oskar Panizza
1917

Marcel Janco
Dada, Military Armour 1918–20

and cloth, you made your languorous foetuses, your lesbian sardines, your ecstatic mice.'

Arp was one of the group's most loyal members; although he had little taste for the violence and noise of the Cabaret, he had a very definite idea of the value and meaning of Dada. In this respect he was very close to Hugo Ball. In an essay called 'I become more and more removed from aesthetics' he wrote, 'Dada aimed to destroy the reasonable deceptions of man and recover the natural and unreasonable order. Dada wanted to replace the logical nonsense of the men of today by the illogically senseless. That is why we pounded with all our might on the big drum of Dada and trumpeted the praises of unreason. Dada gave the Venus de Milo an enema and permitted Laocoon and his sons to relieve themselves after thousands of years of struggle with the good sausage Python. Philosophies have less value for Dada than an old abandoned toothbrush . . . Dada denounced the infernal ruses of the official vocabulary of wisdom. Dada is for the senseless, which does not mean nonsense. Dada is senseless like nature. Dada is for nature and against art. Dada is direct like nature. Dada is for infinite sense and definite means.'

Dissatisfied with the 'fat texture of expressionist paintings', Arp began constructing works with simple lines and structures. He made severely geometric collages, and also abstract designs which Sophie Taeuber (later his wife) executed in tapestry or embroidery. He and Sophie were working in ignorance of Mondrian's similar experiments with straight lines and coloured squares and rectangles, and it was only in 1919 that they saw reproductions of them in the Dutch magazine *De Stijl*.

Perhaps one of the reasons why Dada in Zurich came close to being a modern art movement was that Zurich, unlike Paris, was shocked and horrified by all new art. Richter remembers the occasion when Arp and Otto van Rees were asked to paint the entrance to a girls' school: 'On either side of the school entrance appeared two large abstract frescoes (the first to be seen so near the Alps) intended to be a feast for the eyes of the little girls and a glorious sign to the citizens of Zurich of the progressiveness of their city. Unfortunately all this was fearfully misunderstood. The parents of the little girls were incensed, the city fathers enraged, by the blobs of colour, representing nothing, with which the walls, and possibly the little girls' minds, were sullied. They ordered that the frescoes should at once be painted over with 'proper' pictures. This was done, and *Mothers, Leading Children by the Hand* lived on the walls where the work of Arp and Van Rees died.'

Arp soon abandoned oil painting on canvas in favour of using other materials like wood, embroidery, cut-out paper, newspaper, often collaborating with Sophie in his desire to get away from the 'monstrous egoism' of the artist to an ideal of communal work. He described some of these works as 'arranged according to the laws of chance' (although compared with torn papers of the 1930s they look carefully planned). 'We rejected everything that was copy or description, and allowed the

Sophie Taeuber-Arp
Composition with Triangles, Rectangles and Circles 1916

Jean (Hans) Arp
Illustration from *Onze peintres vus par Arp*
1949

Elementary and Spontaneous to react in full freedom. Since the disposition of planes, and the proportions and colours of these planes, seemed to depend purely on chance, I declared that these works, like nature, were ordered "according to the law of chance", chance being for me merely a limited part of an unfathomable *raison d'être*, of an order inaccessible in its totality.'

In his poetry at this time Arp used chance in a more radical, Dada-like, manner, taking words and phrases at random from newspapers and building them into a poem. Some of his wood reliefs were made from bits of rotten wood that look like flotsam and jetsam. Many of the reliefs of 1916–17 are deliberately left with the wood rough and unpainted, and nail heads protruding. Other wood reliefs, like the *Forest* or *Egg Board*, are brightly painted and made up of highly concentrated forms which later open out into the biomorphic abstraction of his sculptures. It was a flexible morphology. Richter remembers painting an enormous backcloth with Arp for a Dada demonstration. Starting at opposite ends, he says, they covered the roll of paper with yards of 'giant cucumber plantations'. Arp's development towards organic abstraction was helped by the automatic drawings he was experimenting with at this time, a technique

Jean (Hans) Arp
Head 1926

later to be taken up and systematized, for rather different reasons, by the Surrealists.

For the first couple of years in Zurich Dada was thus still seen, particularly by Ball and Arp, as offering possibilities of a new artistic direction. Ball's desire to restore magic to language, Arp's search for directness in art, can be seen in this way. Ball said: 'The direct and the primitive appear to [the Dadaist] in the midst of this huge anti-nature as being the supernatural itself'. It was even presented publicly in this light; Tzara was to describe the Zurich review *Dada*, when he introduced it to Picabia, as a 'modern art publication'. But with Picabia's arrival in Zurich in August 1918, there was a radical change. The Dadaists had never experienced anyone with such a total disbelief in art, and such an acute sense of the meaninglessness of life. Richter says that meeting him

Jean (Hans) Arp
Forest 1916

Jean (Hans) Arp
Trousse d'un Da 1920

was like an experience of death, and that after such meetings his feelings of despair were so intense that he went round his studio kicking holes in his paintings.

Tzara, the chief impresario and publicist of Zurich Dada, immediately fell under the spell of Picabia's overpowering and magnetic personality; and in his famous *Dada Manifesto 1918* he harnesses his extreme verbal agility to the service of nihilism.

'Philosophy is this question: from which side shall we look at life, God, the idea or other phenomena? Everything one looks at is false. I do not consider the relative result more important than the choice between cake and cherries after dinner. The system of quickly looking at the other side of a thing in order to impose your opinion indirectly is called dialectics, in other words, haggling over the spirit of fried potatoes while dancing method around it.

'If I cry out:

> *Ideal, ideal, ideal,*
> *Knowledge, knowledge, knowledge,*
> *Boomboom, boomboom, boomboom,*

'I have given a pretty faithful version of progress, law, morality and all the other fine qualities that various highly intelligent men have discussed in so many books.'

Dada in Paris

It was Tzara's 1918 Manifesto ('I write a manifesto and I want nothing, yet I say certain things, and in principle I am against manifestos as I am also against principles' that seduced André Breton and other members of the Parisian *Littérature* group. Tzara reached Paris at the very beginning of 1920, and immediately, with the help of Picabia, Breton, the poets Louis Aragon, Philippe Soupault and Georges Ribemont-Dessaignes, and others, set about making the Dada revolt public through outrageous works such as Picabia's *Feathers*. On 23 January the first Dada demonstration took place at the Palais des Fêtes, and as it set the tone for subsequent manifestations it is worth describing in some detail. A talk billed as 'La crise du change' ('The Exchange Crisis') by André Salmon, which had attracted the small shopkeepers of the *quartier* in expectation of financial enlightenment, turned out to be about the overturning of literary values since Symbolism. The audience began to melt away. But Breton's presentation of some Picabia paintings (Picabia never liked to present himself on the stage) began the real event. A large canvas was wheeled on, covered with inscriptions: 'top' at the bottom, 'bottom' at the top, and underneath in large red letters the obscene pun *L.H.O.O.Q. (Elle a chaud au cul)*. As the insult began to sink in, the audience started to shout back at the stage, and with a second 'work' there was uproar. A blackboard appeared, covered with more inscriptions, under the title *Riz au nez*, which Breton immediately rubbed out with a duster. Not only was this not a work of art; it was destroyed before the audience's very eyes. The culmination of the evening was the arrival on stage of Monsieur Dada from Zurich, Tristan Tzara, to present one of his works. He

Francis Picabia
Feathers 1921

immediately began to read Léon Daudet's latest speech from the
Chamber of Deputies, accompanied in the wings by Breton and Aragon
energetically ringing bells. The audience, which included figures like Juan
Gris who had come to encourage the younger generation, reacted
violently. One avant-garde editor began to shout 'Back to Zurich! To the
stake!' Dada had set a fine trap, and after this its audience came ready.

Dada in Germany

After the war Dada spread with the dispersal of the Zurich Dadaists to other places in Europe, where often only the name was needed to consecrate already protoDada activities. In Cologne, in 1919, Johannes Baargeld and Max Ernst were joined by Arp, whereupon, as Arp put it, they produced 'the finest fruits on the Dada tree', fruits which included the *Fatagagas*, collages made by Arp and Ernst in collaboration. Baargeld distributed his anti-patriotic radical periodical *Der Ventilator* at factory gates: and in the atmosphere of post-war Germany, already showing signs of a new, militaristic nationalism, Dada took on a more obviously political role. One of the most successful Dada events in Cologne was an exhibition at a beer-hall, the Bräuhaus Winter, held in a small courtyard reached through the lavatory, where on the opening day a young girl dressed in a white first-communion dress recited obscene poems. At the entrance stood a wooden 'sculpture' by Max Ernst, with an axe attached and the invitation to destroy it. Some of the objects in the exhibition had the enigmatic quality of later Surrealist objects – for instance Baargeld's *Fluidoskeptrick der Rotzwitha van Gandersheim*, a fish tank filled with red-stained water, with an alarm clock at the bottom, a fine head of hair floating on the top, and a wooden dummy's hand sticking out. In the course of the exhibition this was destroyed.

Ernst and Baargeld were summoned to police headquarters and charged with fraud, on the grounds that they had demanded an entrance fee for an art exhibition that manifestly had nothing to do with art. Ernst replied, 'We said quite plainly that it is a Dada exhibition. Dada never claimed to have anything to do with art. If the public confuses the two that is no fault of ours.'

It was in Berlin that Dada's potential for political action came nearest to being fulfilled. Huelsenbeck arrived, in pursuance of his medical

Max Ernst
Here Everything is still Floating. Fatagaga: The Third Gazometric Picture 1920

studies, in 1917. Berlin at that time, its people half-starved and desperate, near to defeat, where 'men's minds were concentrating more and more on questions of naked existence', was very different from the 'smug, fat idyll' of Zurich that he had left behind.

He immediately wrote a strident manifesto to redirect Dada: 'The highest art will be that which in its conscious content presents the thousandfold problems of the day, the art which has been visibly shattered by the explosions of last week, which is forever trying to collect its limbs after yesterday's crash. The best and most extraordinary artists will be those who every hour snatch the tatters of their bodies out of the frenzied cataract of life, who with bleeding hands and hearts hold fast to the intelligence of their time. Has Expressionism fulfilled our expectations of such an art, which should be an expression of our most vital concerns? No! No! No!'

A Club Dada was formed, its members including Hannah Höch, Johannes Baader, George Grosz, Wieland Herzfelde and his brother John Heartfield (who had Anglicized his named during the war), Raoul Hausmann, and Huelsenbeck. Numerous periodicals appeared under the Dada flag, were banned and reappeared under a new name. The 'First

Raoul Hausmann
Mechanical Head 1919–20

Hannah Höch
Collage 1920

Opening of the 'First International Dada Fair' at Dr Otto Burchard's gallery, Berlin, June 1920. Left to right: Raoul Hausmann, Hannah Höch, Dr Burchard, Johannes Baader, Wieland Herzfelde, Mrs Herzfelde, Otto Schmalhausen, George Grosz and John Heartfield

International Dada Fair' was held in 1920, and homage was paid to the new revolutionary art in Russia: 'Art is dead. Long live the new machine art of Tatlin.' From the ceiling hung a dummy dressed in a German officer's uniform, with the head of a pig and a placard, 'Hanged by the Revolution'.

Dada was presented in Berlin with a real problem of identity. It had in a sense to compete directly with the serious revolutionary fervour of the activist wing of the literary Expressionists. The Dadaists immediately singled them out as their enemy, hating their lofty and pompous rhetoric about the Value of Art, which they treated as a kind of social therapy. On the other hand, although actively involved in the post-war social upheavals, in the brief occupation of Berlin by the Communists in November 1918 (during which Huelsenbeck even held an official post), and after that in unceasing propaganda against the Weimar Republic, the Dadaists kept their Dada autonomy. The Communists mistrusted them as dilettante anti-artists, and the bourgeoisie inevitably saw them as Bolshevik monsters.

Partly as a reaction to this position, they wrenched their work forcibly back into contact with real life in the transformation of collage into photomontage, creating a unique weapon for visual polemics. The Berlin Dadaists called themselves *Monteure* – fitters or assemblers, as opposed to artists. After Dada had ceased to exist in Germany, Heartfield went on using pure photographic montage to attack the growing power of Nazism (*Das ist das Heil, das sie bringen*).

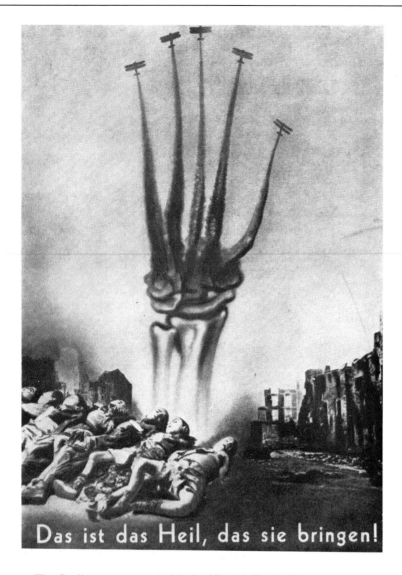

Das ist das Heil, das sie bringen!

John Heartfield
This is the Salvation They Bring 1938

The Berlin group were critical of Zurich Dada. Huelsenbeck wrote, 'I find in the Dadaism of Tzara and his friends, who made abstract art the cornerstone of their new wisdom, no new idea deserving of very strenuous propaganda. They failed to advance along the abstract road, which ultimately leads from the painted surface to the reality of the post office form.' But the manifesto he and Hausmann drew up, 'What is Dadaism and what it wants in Germany', in its violent swings from rational to extravagant demands, mirrors Dada's uneasy position. '*Dadaism demands*: the international revolutionary union of all creative and intellectual men and women on the basis of radical Communism. . . . The Central Council demands the introduction of the simultaneist poem as a communist state prayer.'

Kurt Schwitters, who operated 'merz', a one-man movement with Dada leanings, in Hanover, tried to join the Berlin group but was

rejected. He had, in fact, more in common with those Zurich Dadaists like Arp whom he called 'kernel' Dadaists as opposed to 'husk' Dadaists. The 'kernel' Dadaists include Arp, Picabia, and rather surprisingly, the sculptor Alexandre Archipenko, an indication that the range of Dada sympathizers and friends was much wider than the handful of names usually associated with the movement would lead one to expect. Unembarrassed at calling himself an artist, Schwitters was looking for a renewal of the springs of artistic creation, outside conventional means. He nailed or glued his pictures together from scraps of material, string, wood, bus tickets, chicken-wire and odds and ends he picked up in the street, and then painted them. The result, as in his apparently irrational poems like *Anna Blume*, was an almost lyrical beauty. 'Every artist must be allowed to mould a picture out of nothing but blotting paper, for example, provided he is capable of moulding a picture.'

Dada was a genuinely international event, not just because it operated across political frontiers, but because it consciously attacked patriotic nationalism. Its total effect was far in excess of the energy any individual Dadaist put into it. Each Dadaist brought something different to it and came out with a different idea of what Dada was. The splinters from the bombshell altered the face of art for good.

Kurt Schwitters
Merzpicture 25A. The Star Picture 1920

Kurt Schwitters
Mz 26, 41. okola 1926

The 'Sleep Period'

Dada in Paris lasted two years. In 1922 it collapsed in a series of internal quarrels which laid bare the differences between the old Dadaists, Tzara and Picabia, and the younger French group, including Breton. Perhaps the latter were never really Dadaists at all: Breton had certainly attempted to organize several grand projects which had little or nothing to do with Dada. The 'Trial of Maurice Barrès', patriot and man of letters, whom Breton could not forgive for the early fascination he had exercised over him, took place in 1921; it disgusted Ribemont-Dessaignes, who said, 'Dada could be criminal, coward, plunderer, or thief, but not judge.' Breton, acting as a judge, sternly brought back 'witnesses' when they strayed into irrelevancies or Dada irrationalities, and the interrogations produced a mingled philosophical quest and painful truth game, of a kind which was to be characteristic of Surrealism. With Jacques Rigaut, who was to kill himself in 1929, Breton had the following conversation:

BRETON: 'According to you, nothing is possible. How do you manage to live, why haven't you committed suicide?'

RIGAUT: 'Nothing is possible, not even suicide. . . . Suicide is, whether you like it or not, a despair-act or a dignity-act. To kill yourself is to admit that there are terrifying obstacles, things to fear, or just to take into consideration.'

There was a gap of two years between the dissolution of Dada in Paris in 1922 and the publication of the first *Surrealist Manifesto* by André Breton in the autumn of 1924. The interlude, 1922 to 1924, was spent in a series of experiments, a tentative search for something positive that could lead out of the Dada *impasse*. Breton wrote:

> Leave everything.
> Leave Dada.
> Leave your wife leave your mistress.
> Leave your hopes and your fears.
> Sow your children in the corner of a wood.
> Leave the substance for the shadow. . . .
> Set out on the road.

One even that falls historically within Dada in Paris was of great importance for the future development of Surrealism. This was an exhibition of collages by Max Ernst, which was planned for the summer of 1920 but did not in fact take place until 1921. As they unpacked the collages, Breton, Aragon and the other Dadaists felt an overpowering excitement, seeing a new kind of poetic image in key with their own ideas. Also, probably, they saw in Ernst an artist capable of challenging Picabia, who as far as the Paris public was concerned was the incarnation of Dada, but whose mixture of nihilism and cynical worldliness disturbed Breton, who was already searching for a positive formula to escape from Dada's death grip.

Breton wrote a preface to the exhibition in which he defines the collages in terms that are almost identical to his later definition of the Surrealist poetic image: 'It is the marvellous faculty of attaining two

widely separate realities without departing from the realm of our experience, of bringing them together and drawing a spark from their contact; of gathering within reach of our senses abstract figures endowed with the same intensity, the same relief as other figures; and of disorienting us in our own memory by depriving us of a frame of reference – it is this faculty which for the present sustains Dada. Can such a gift not make the man whom it fills something better than a poet?' In the Surrealist manifesto of 1924 he uses the same electrical metaphor of the spark to describe the bringing together of 'two distant realities', although this time he lays emphasis on the necessarily unpremeditated nature of the image. What he saw in Ernst's collages was the visual equivalent of Lautréamont's famous phrase, 'as beautiful as the chance encounter on a dissecting-table of a sewing-machine and an umbrella'. The collages, small in format, use old engravings, pieces cut out of old magazines (often geological ones showing sections of rock formations which exercised a special fascination for Ernst), and photographs, to create a scene in which the spectator, deprived of a frame of reference, is disoriented.

The disorientation of the spectator is a step towards the destruction of his conventional ways of apprehending the world and dealing with his own experiences according to preconceived patterns. The Surrealists believed man had shut himself into a straitjacket of logic and rationalism which crippled his liberty and stultified his imagination. Inheriting this attitude from Dada, Breton found in the revelations of Sigmund Freud about the unconscious a possible guideline for the liberation of the imagination. Without too much respect for the detail of Freud's model of the mental processes, he seized on the idea that there is a vast untapped reservoir of experience, thought and desire, hidden away from conscious, everyday living. Through dreams (whose direct connection with the unconscious Freud had proved in *The Interpretation of Dreams*, published in 1900), and through automatic writing (the equivalent of the free-associative monologue of psychoanalysis), Breton believed that access could be gained to the unconscious, and the barrier between the conscious and the unconscious, maintained in the interests of order and reason, could eventually, in a sense, be broken down. 'Man proposes and disposes. It is up to him to belong to himself altogether, that is to say to maintain in an anarchic state the band, every day more powerful, of his desires.' This was, of course, to ignore the whole point of Freud's psychoanalytic theory, which was to *cure* disturbances in the psyche and enable the patient to lead an ordinary, orderly life. Many of the Surrealists, including Aragon, thought Freud was a bourgeois reactionary; and Freud for his part had little sympathy or understanding for the young Surrealists and the curious use to which they were putting his discoveries. 'I believe,' Breton said, 'in the future resolution of the two states, apparently so contradictory, of dream and reality, in a sort of absolute reality, of *surreality*.'

By 1922 Breton was already using the term 'Surrealist' – originally coined by Apollinaire, probably by analogy with Nietzsche's superman (*Surhomme*) and Jarry's *Surmâle*, and used to describe his play *Les Mamelles de Tirésias* – to mean 'a certain psychic automatism which corresponds quite well to the state of dream'. But he believed at this time that 'psychic

automatism' could be produced through hypnotic sleep, and this is the source of the term *période des sommeils*. The future Surrealists, including Breton, Aragon, Soupault, René Crevel, Robert Desnos and Max Ernst, experimented with group and individual hypnosis. Breton himself never succeeded in becoming hypnotized. Desnos was the most adept at falling into a self-induced sleep, and in this state produced monologues and drawings that he felt he would not have been capable of in ordinary waking life. Hypnotic sleep seemed to offer a direct source of poetic imagery from the unconscious. But after a series of disturbing incidents it became clear that these experiments were dangerous and could become uncontrollable; also, perhaps, the results, after the initial excitement at the mysterious phenomenon, were not as spectacular or as sustained as originally expected. The 'Sleep Period' brought out too clearly a tension always inherent in Surrealism, between the idea of artists or poets as unconscious transmitters, 'modest recording devices', of images, and that of their status as conscious creators with a predetermined sense of what is beautiful. The balance between the two shifted, with Breton periodically reaffirming the necessity for the springs of Surrealist activity to remain unconscious, to flow underground. The problem was greatest for the painters, many of whom refused to submerge their creative, active personality by using exclusively those automatic techniques proposed by Breton. It was not a question of the self-important, egoistic artist intervening. Arp, for instance, always longed for an anonymous collective art, and yet, the most naturally 'unconscious' artist, he did not really like Surrealist theories of automatism: 'I am no longer doing the forming' (*'Ce n'est plus moi qui forme'*).

Surrealism and Painting

The definition of Surrealism given in the First Manifesto of 1924 was intended to be conclusive.

'SURREALISM, noun. Pure psychic automatism by which it is intended to express, either verbally or in writing, the true function of thought. Thought dictated in the absence of all control exerted by reason, and outside all aesthetic or moral preoccupations.

'*Encycl. Philos.* Surrealism is based on the belief in the superior reality of certain forms of association heretofore neglected, in the omnipotence of the dream, and in the disinterested play of thought. It leads to the permanent destruction of all other psychic mechanisms and to its substitution for them in the solution of the principal problems of life.'

This certainly makes the scope of Surrealism clear. Although Breton was later to describe it as fundamentally an attack on language in the interests of poetry, this was on the natural understanding that language is fundamental to our knowledge of the world, and that poetry is not just the printed word on the page but keeping oneself permanently open, available to all new experience. Jacques Baron, a schoolboy at the time, remembered the overwhelming experience of walking the Paris streets with Aragon or Breton, and the intense relationships between the Surrealists which he called *poésie-amitié*.

Painting was mentioned in the Manifesto only in a footnote, and in spite of one or two close friendships between poets and painters, notably between Breton and Masson, and Eluard and Ernst, the painters kept themselves a little apart from the group. This was to maintain their independence, for Breton had an intense desire to control everything that went on around him, and although he wrote many articles which try to define the Surrealist nature of the paintings, they seldom fit neatly into his rather rigid definition, and to describe them in terms of Surrealism is often inadequate. Significantly, the title of the most important series of articles was 'Surrealism and Painting' (1927), not 'Surrealist Painting'. Painting had a tangential relationship with the core of Surrealist activity. However, in *Artistic Genesis and Perspective of Surrealism*, Breton does define two major routes open to the Surrealist artist: firstly automatism, and secondly 'the *trompe-l'œil* fixation of dream images'. This serves to establish broad categories for the paintings, although individual painters, and even individual paintings, by no means stick rigidly to one or the other.

In the winter of 1922–23 Joan Miró and André Masson met at a party and discovered that they had adjoining studios in an old building on the rue Blomet (where Arp later came to join them). They immediately became close friends, and a little later Miró asked Masson whether he should go to see Picabia or Breton. 'Picabia is already the past,' Masson replied; 'Breton is the future.' The atmosphere of excitement and constant ferment of new ideas generated by the Surrealists were much more stimulating to them than the various groups of painters in Paris who still seemed to be locked in an increasingly unprofitable relationship with Cubism. 'I'll smash their guitar,' Miró once said. By 1924 Miró, Masson and the young writers who had gathered round Masson including Michel Leiris, Antonin Artaud and Georges Limbour, had become part of the Surrealist movement, part of a 'moral community', as Leiris describes it.

At first, although in different ways, it was the ideas behind the principle of automatism that attracted Miró and Masson. In the First Manifesto Breton describes his first attempts, as early as 1919 and influenced by Freud, to write down 'a monologue delivered as rapidly as possible, on which the critical mind of the subject should make no judgment, which should not, consequently, be hampered by any reticence, and which should be as nearly as possible *spoken thought*'. He and Philippe Soupault, who joined in the experiment, were astonished at the result, 'a considerable choice of images of a quality such that we would have been incapable of producing a single one in the normal way of writing'. These pages were published in 1919 under the titles *Les Champs magnétiques*, Magnetic Fields.

In 1924 Masson began to make automatic drawings. Using a pen and Indian ink he let his hand travel rapidly over the paper, forming a web of lines from which images began to emerge, which Masson then either develops or leaves in a suggestive stage. In the best of these drawings there is an extraordinary coherence, a textural unity, which in for instance the horse's head suggests water, pebbles, seaweed, fishes, behind the dominant image of the horse. Others have suggestions of obsessive sexual imagery, twined bodies and clasped hands. Masson was interested in the moment of metamorphosis, when a line was in the process of

becoming something else. The effect of these drawings on his paintings, hitherto sombre, rather inflexible and heavily influenced by Cubism, was an immediate loosening-up; but working in oil paint he could never achieve the same fluidity. Connected with the automatic drawings were a series of sand paintings he began in 1927. Roughly spreading a canvas with glue, he then sprinkled or threw handfuls of sand on it, tipping the canvas to retain sand only on the glued bits. He then added a few lines or patches of colour, which, as in the drawings, would evoke the image he found there. One of his most radical acts was in the ironically named *Painting*, 1927, where the thick coloured lines have been applied direct from the tube of paint. An exchange between Masson and Matisse in 1932 exemplifies the fundamental difference between Surrealism and other modernist traditions.

André Masson
Painting (Figure) 1927

André Masson
Dreamed Embraces 1927

Masson explained: 'I begin without an image or plan in mind, but just draw or paint rapidly according to my impulses. Gradually, in the marks I make, I see suggestions of figures or objects. I encourage these to emerge, trying to bring out their implications even as I now consciously try to give order to the composition.'

'That's curious,' Matisse replied. 'With me it's just the reverse. I always start with something – a chair, a table – but as the work progresses I become less conscious of it. By the end, I am hardly aware of the subject with which I started.'

Whatever the influence certain Surrealist techniques (such as Masson's use of paint direct from the tube) may have had on subsequent abstract artists, such as the Action Painters, the end result for Masson, as for Ernst in his frottages, was fundamentally different, the move being, in Breton's phrase, 'towards the object'.

Max Ernst made his first frottage in 1921, but did not develop the idea any further until 1925, when he took it up as a direct answer to the poets' automatic writing. 'The procedure of frottage, resting thus upon nothing more than the intensification of the irritability of the mind's faculties by appropriate technical means, excluding all conscious mental guidance (of reason, taste, morals), reducing to the extreme the active part of that one

Max Ernst
Head 1925

Max Ernst
Forest and Dove 1927

whom we have called up to now the "author" of the work, this procedure is revealed to be the exact equivalent of that which is already known by the term *automatic writing*.' Becoming obsessed by the cracks in some floorboards, he decided 'to examine the symbolism of this obsession and, to assist my meditative and hallucinatory powers, I obtained from the floor-boards a series of drawings by dropping on them at random pieces of paper I then rubbed with black lead.' So far the technique is not new, but in Ernst's hands the 'drawings steadily lose, thanks to a series of suggestions and transmutations occurring to one spontaneously . . . the character of the material being studied – wood – and assume the aspect of unbelievably clear images of a nature probably able to reveal the first cause of the obsession'. Ernst began to include other materials, sacking, leaves, thread, and other things, and their transformation in the final frottage, worked now into a harmonious and balanced picture, sometimes makes the original material unrecognizable.

Ernst adapted this technique to oil painting, by scraping a canvas, previously spread with pigments, when it was placed on an uneven surface, enabling, in his words, 'painting to travel with seven-league boots a long way from Renoir's three apples, Manet's four sticks of asparagus, Derain's little chocolate women, and the Cubist's tobacco packet, and to open up for it a field of *vision* limited only by the "irritability" capacity of the mind's powers. Needless to say this has been a great blow to art critics who are terrified to see the importance of the "author" being reduced to a minimum and the conception of "talent" abolished.' Ernst's *Forest and Dove* of 1927 uses this *grattage* technique to build up an evocative image of the forests that had haunted him since his childhood at Brühl, near Cologne, when he used to accompany his father into the forest to paint.

Miró, although he too used automatic procedures to a certain extent, treated them more cavalierly than Ernst or Masson, focusing far more intently on the work itself and less on any theoretical overtones such procedures might have. But there is no doubt that the Surrealists were responsible for the flowering of a fantastic imagination in the *Tilled Field* (1923–24). Basically the same subject as *The Farm*, painted a year earlier, his family's farm in Catalonia, in place of the delicate and precise illusionism, with every detail of the tufts of grass on the farm wall painted

Joan Miró
The Farm 1921–22

Joan Miró
The Tilled Field 1923–24

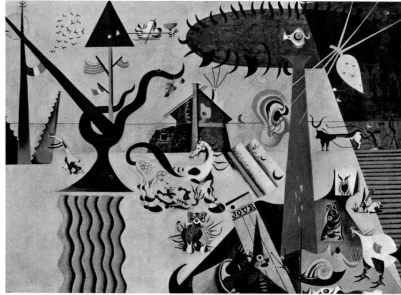

in almost like a Douanier Rousseau, the landscape is suddenly filled with extraordinary creatures (some with an ancestry going back to Bosch), and the man-and-plough on the right reappears grotesquely as a bull-man with all its sexual connotations (Minotaur?) on the left. The technique, although flatter, is still fairly illusionistic, but in 1925 he began to cover his canvases freely with great waves of colour, sometimes with a brush, sometimes rubbing with a rag. On this background, now floating in a space which has nothing to do with perspectival space and the horizon line, he places forms and lines from his developing language of signs (*The Birth of the World*). It was of paintings like these that Miró wrote: 'I begin painting, and as I paint the picture begins to assert itself, or suggest itself, under my brush. The form becomes a sign for a woman or a bird as I work. The first stage is free, unconscious.' But, he added, 'the second stage is carefully calculated.'

Breton expressed reservations about these paintings in *Le Surréalisme et la peinture*: 'Of the thousands of problems which preoccupy him to no degree at all, even though they are the ones which trouble the human spirit, there is only one perhaps towards which Miró has any inclination: to abandon himself to painting, and only to painting (which is to restrict himself to the one domain in which we may be sure he has the means), to give himself over to pure automatism to which, for my part, I have never

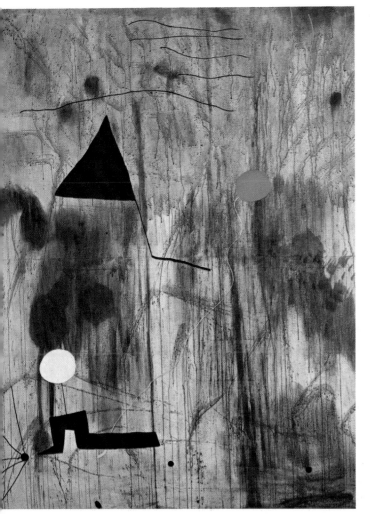

Joan Miró
The Birth of the World 1925

Joan Miró
Smile of My Blonde 1925

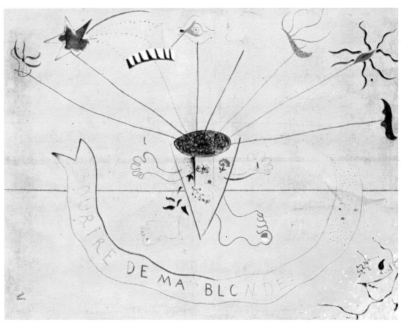

ceased to appeal, but of which I fear that Miró has come too summarily
to the proof of its worth and its deep rationale. Perhaps, it is true, for that
reason, that he will pass for the most "Surrealist" of us all. But how far
we are in his work from that "chemistry of the intellect" of which we had
been speaking!'

This 'chemistry of the intellect' which Breton praised was Masson's
work. Aragon was to criticize Miró in the same spirit when he talked of
his 'imbecile harmonies'. Criticism like this does little but rebound upon
the critic; however it does demonstrate the kind of demand Surrealism
made of painting: that its interest should not lie in the sensuous pleasure
of the paint surface, but in the enigmatic, hallucinatory or revelatory
power of the image. 'Only the marvellous is beautiful,' wrote Breton in
the First Manifesto, and in *Le Surréalisme et la peinture* he says: 'It is
impossible for me to consider a painting in any other way than as a
window, and my first concern is to know what it looks out on to.'

After 1924 Miró's painting became intricately linked in various ways
with the poetry of the Surrealists and of those poets they admired, like
Rimbaud and Saint-Pol-Roux. *Portrait of a Dancer* is a monosyllabic
evocation; *Smile of my Blonde* is an emblem of Miró's beloved, her hair
bearing symbols, sexual attributes, in a way similar to Rimbaud's poem
'Voyelles', where each vowel is associated with a colour and a series of
esoteric metaphors for parts of the female body:

> A, black corset hairy with glittering flies
> that buzz around cruel smells
> Gulfs of darkness . . .

The '*trompe-l'œil* fixation of dream images' which Breton defines as the
other route open to Surrealist painters, is perhaps a misleading term. The
illusionistic 'hand-painted dream picture' is not necessarily dealing
specifically with symbolic dream images, and one should be careful of
treating it as an entity open, as dreams may be, for analysis. It *may* be
using dream images; it may use images culled from different dreams; it
may merely remind us of certain general characteristics of dreams. It is
illusionistic painting, but not of the external world – the model is an
interior world.

Tanguy's visionary paintings are based on a deep space in which
strange objects float or stand, casting black shadows. In a general way
they are like dreams, or the state of mind immediately before sleep which
gives an internal sensation of endless space. Tanguy was one of the few
self-taught Surrealist painters. He was fascinated by Giorgio de Chirico,
and in *Mama, Papa is Wounded* (a title apparently taken from a psychiatric
case history) the diagrammatic lines leading back to the enigmatic
structure in the background perhaps refer to de Chirico's metaphysical
paintings which contain blackboards covered with diagrams and
equations, or to Ernst's *Of This Men Shall Know Nothing*. *A Large Painting
which is a Landscape* of 1927 also has echoes of de Chirico, but the
disorientation of the spectator is peculiar to Tanguy. An endless desert
stretches out to the horizon, but is covered with wisps that suggest
seaweed and the bottom of the sea. The spiky sculpture in *Infinite
Divisibility* casts a deep shadow back into pure space, into what appears

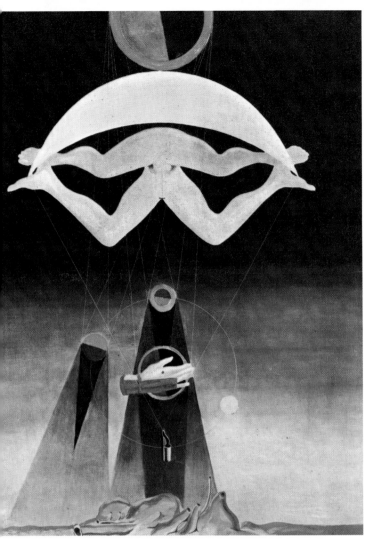

Max Ernst
Of This Men Shall Know Nothing 1923

Yves Tanguy
Infinite Divisibility 1942

to be sky, and little shells, or bowls of water reflect the sky but are placed where the sky itself should be. Tanguy's later paintings become increasingly crowded with rock-like shapes that bear an affinity to the rocky beaches of his native Brittany.

Ernst, Tanguy and Magritte were all deeply influenced by de Chirico. It was the sight of one of his paintings in a gallery window that persuaded Tanguy to become a painter. But de Chirico himself was never a Surrealist. After 1917 his paintings reverted to academicism and held no more interest for the Surrealists – they felt he had betrayed himself. But from about 1910 to 1917 his enigmatic paintings of arcaded Italian squares, statues, railway stations, towers have a hallucinatory and dream-like intensity, filled with a potent and unconscious sexual imagery. Unseen objects cast menacing shadows, and the clock in the *Conquest of the Philosopher* suggests the anguish of departure – the train is perhaps a memory of his engineer father, building railways in Greece where de Chirico spent his childhood. De Chirico might be celebrating the end of the domination of the ideal of classical beauty – an ideal being violently

challenged in 1910 in Italy, where de Chirico was living, by the
Futurists. But while they sought to substitute the beauty of the modern
mechanical world of speed and power, de Chirico painted forgotton
Greek statues, empty, bleached towns. He remembers sitting in a square
in an Italian town staring at a statue, very weak after a long illness, and
suddenly seeing the whole scene in an extraordinarily clear, hallucinatory
light, with an enigmatic intensity which he wanted to reproduce in his
paintings. Sometimes objects appear, disconnected, as though surfacing
from a dream. In *The Song of Love* the green ball, red glove and classical
mask are coupled, like an Ernst collage. The paintings are almost always
empty of human beings, but after a while manikins enter to inhabit the
increasingly stage-like settings.

In 1921–24 Max Ernst did a series of paintings, including *Elephant
Celebes*, *Oedipus Rex* and *Pietà or Revolution by Night*, which are strongly
influenced by de Chirico in their structure and cool intense light as well
as in their actual imagery. They remain very obscure in meaning; if they
are dream images, it is necessary to remember Freud's warning, when he
was asked to contribute to a Surrealist anthology of dreams: 'a mere
collection of dreams, without the dreamer's associations, without

Giorgio de Chirico
Conquest of the Philosopher 1912

Giorgio de Chirico
The Song of Love 1914

Giorgio de Chirico
Disquieting Muses 1917

knowledge of the circumstances in which they occurred, tells me nothing, and I can hardly imagine what it would tell anyone.'

Wary of psychoanalysis in the absence of the conditions required by Freud, we may still suggest, in *Oedipus Rex*, bearing in mind Ernst's frequent and ambiguous references to his father, that the Oedipus legend as interpreted by Freud, whom Ernst had read, bore a personal significance for him. Oedipus blinded himself, and the references to eyes in the painting are disturbingly underlined by the balloon behind, a quotation from Odilon Redon's *The Eye like a Strange Balloon*.

Ernst shared the Surrealists' taste for exotic and primitive art. In *Elephant Celebes* the elephant itself is based on a photograph of an African

Max Ernst
Collage from *Une Semaine de bonté* 1934

corn bin transformed in Ernst's imagination into this grotesque animal,
and a bull's head, reminiscent of an African mask, is suspended on the
end of its pipe-trunk. One of his most striking paintings is *The Robing of the
Bride*, where the figure of the bride is clothed only in a magnificent cloak
inspired by Breton's description of a 'splendid and convulsive mantle
made of the infinite repetition of the unique little red feathers of a rare
bird, which is worn by Hawaiian chieftains'. Driven out by this
overpowering and youthful primitive figure is a little cowering creature, a
grotesque parody of the old hermaphrodite Tiresias of Greek legend.
Ernst also made a number of sculptures, above all while he lived in
Arizona after the Second World War, often directly inspired by African
and Oceanic art. Breton himself owned a superb collection of primitive
sculpture, objects and masks. Wifredo Lam, the Cuban painter who
joined the Surrealists in 1938, painted a number of pictures which are

poetic evocations of the voodoo masks and totemic objects with which he was familiar. It was in objects such as these that the Surrealists found directness of vision, an escape from the rational and the stereotyped hierarchies of Western thought, and above all that element of the marvellous that alone for them constituted beauty.

Among the most disturbing of all Surrealist works are the series of collage novels Ernst made, *La Femme 100 têtes* (1929) and *Une Semaine de bonté* (1934). Constructed almost entirely of old engravings, they consist of disorienting scenes in which often the scale is completely disrupted. In one scene from *Une Semaine de bonté* a man with a bird's head is seated in a railway carriage, and looking through the window is what at first appears to be the gigantic head of the Sphinx of Gizeh. There is a kind of delayed action in the effect of these collages; often after the immediate shock one becomes aware of more disturbing details, ambiguous textures, double images. Paul Eluard wrote about Ernst in *Beyond Painting*: 'It is not far – through the bird – from the cloud to the man; it is not far – through the images – from man to his visions, from the nature of real things to the nature of imagined things. Their value is equal. Matter, movement, need, desire, are inseparable. Think yourself a flower, a fruit or the heart of a tree, since they wear your colours, since they are necessary signs of your presence, since your privilege is in believing that everything is transmutable into something else.'

Max Ernst
The Robing of the Bride 1939–40

Man Ray
Observatory Time – The Lovers 1932–34

Of the other makers of the 'hand-painted dream picture', the former Dadaist Man Ray produced perhaps the most spectacular images, such as *Observatory Time – The Lovers*. Victor Brauner's paintings, such as *The Philosopher's Stone*, are metamorphoses, evoking magical icons. In the work of Pierre Roy, and above all in that of René Magritte, the image is fixed in a flat, dead paint surface.

Some Magritte paintings may really be memories of dreams. *The Lovers*, with their heads swathed in cloth, could be a dream transformation of his terrible memories of his mother's death, when he was a child; she was found drowned with her white gown wrapped round her head. It is impossible to know. But most of his paintings take the form of a dialogue with the world, a questioning of the reality of real phenomena, and their relation with their painted image (*The Human Condition*). Sometimes by disruption of the scale of objects he can turn something harmless into something menacing (like the monstrous Alice-through-the-looking-glass apple in *The Listening Room*) or puzzling (*Personal Values*). Often, although the image exists – there it is in the painting – it is impossible to grasp it because it is beyond our logical understanding: in *The Field-Glass* an open window reveals blackness beyond. Clouds are reflected in the shut casement, but the other casement is open, revealing an empty frame. *On the Threshold of Liberty* is a room panelled with motifs from Magritte's own paintings, with a cannon threatening violence or rape. His cover for a Surrealist magazine is perhaps his frankest expression of the violence underlying Surrealist imagery.

In 1949 Magritte wrote a manifesto, *Le Vrai Art de la peinture* (which incidentally contains an attack on the 'magnetic fields of chance', an allusion to Breton and Soupault's early work), to explain his idea of the true function of painting, as opposed to its real rival, the cinema. 'The art

Right, above:

René Magritte
On the Threshold of Liberty 1929

René Magritte
Personal Values 1952

Right, below:

René Magritte
Cover of *Minotaure*, no. 10, 1937

René Magritte
The Human Condition I 1933

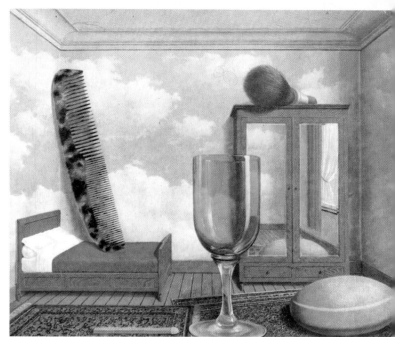

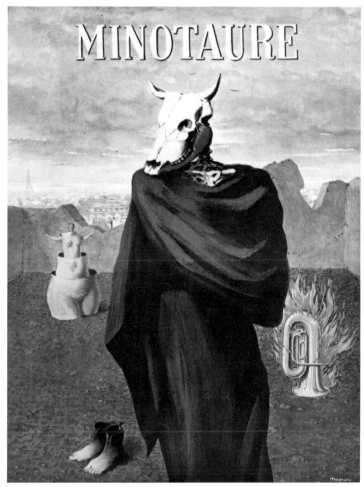

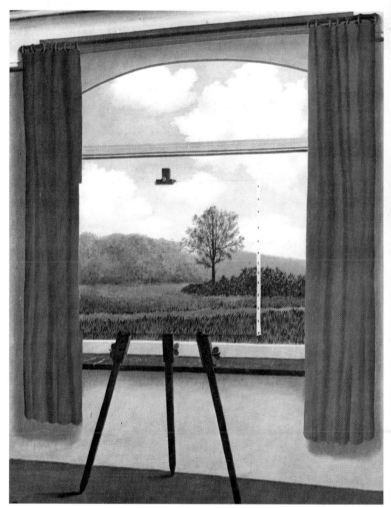

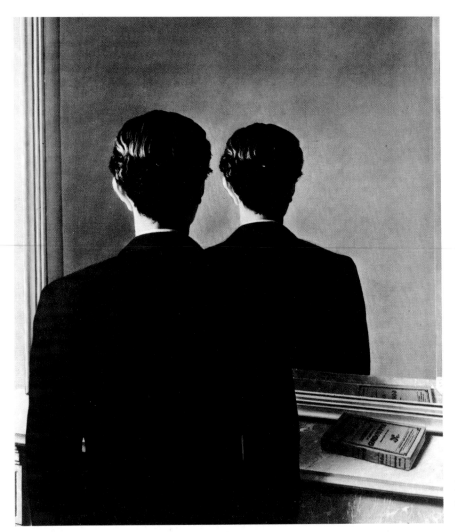

René Magritte
Reproduction Prohibited (Portrait of Mr James)
1937 (detail)

of painting is an art of thinking, whose existence underlines the
importance of the role held in life by the eyes of the human body.' He
goes on to state something that is in fundamental opposition to our
conception of a kind of immortality granted to art: 'The perfect painting
produces an intense effect only for a very short time, and emotions
resembling the first emotion felt are to a greater or lesser extent soiled by
habit. . . . The true art of painting is to conceive and realize paintings
capable of giving the spectator a pure visual perception of the external
world.' It is not beyond the technical powers of a moderately skilful artist
to evoke on canvas a blue sky – 'but this poses a psychological problem
. . . what do you do with the sky?' Magritte's process is to make us aware,
by contradiction ('in full obscurity', he says), of the appearance of a sky,
a pipe, a woman, a tree. 'This is not a pipe', he writes underneath a
perfectly banal painting of a pipe.

Magritte belonged to the Belgian Surrealist group, together with Paul
Nougé and E. L. T. Mesens. They kept their distance from the Paris

Surrealists. Paul Delvaux, also a Belgian, participated in Surrealist exhibitions while, like Magritte, keeping a certain distance between himself and the 'arbiter' of Surrealism, André Breton. Delvaux's often large canvases are of silent cities, sometimes entered by a train from a De Chirico painting, and peopled with sleep-walking nudes. Dream-like (it is usually night), they seem really to be the dreams of the figures themselves (*Sleeping Venus*), therefore curiously self-contained.

Salvador Dali, who met and immediately joined the Surrealist movement in 1928, provokes the most difficult questions about the possible realization of dreams on canvas, and hence about the symbolic function of the imagery.

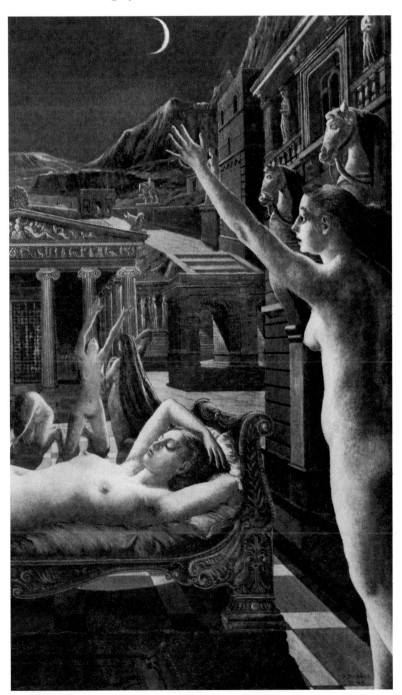

Paul Delvaux
Sleeping Venus 1944 (detail)

First, one must remember that the dream for Freud, and also for Breton, was a direct path to the unconscious; the way in which a dream deals with its subject, condensing, distorting, allowing contradictory facts or impressions to exist side by side without any conflict – what Freud calls dream-work – is characteristic of the processes of the unconscious. The manifest content of the dream, what we remember when we wake up, probably masks latent, hidden meanings, which may be revealed by the dreamer's associations, achieved through analysis. For most of the Surrealists dreams were valuable simply for their poetic content, as documents from a marvellous world, whose hidden sexual symbolism none the less filled them with delight. The first number of the Surrealist periodical *La Révolution surréaliste* contained simple accounts of dreams by Breton, De Chirico, Renée Gauthier; 'Only the dream leaves man with all his rights to liberty.' Dali, on the other hand, especially in the late 1920s and early 1930s, presents dream images whose content is made

Salvador Dali
The Dismal Sport 1929

Salvador Dali
Giraffe in Flames 1935

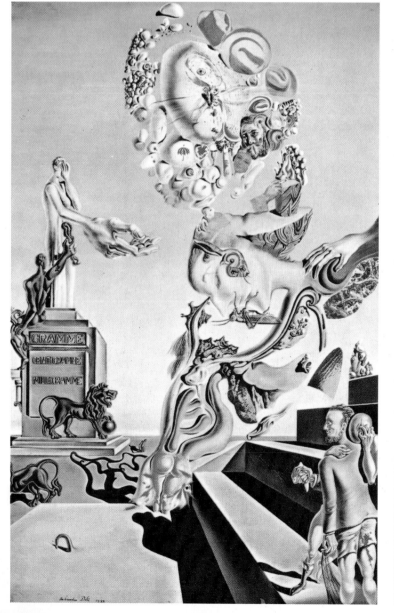

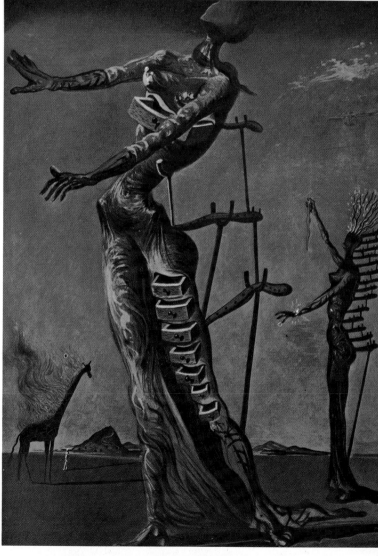

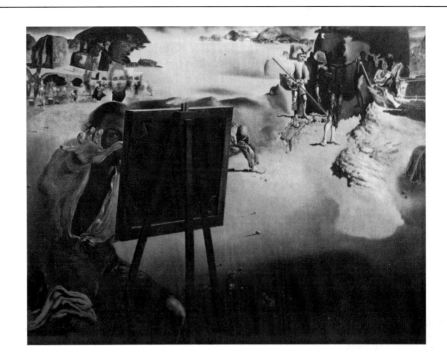

Salvador Dali
Impressions of Africa 1938

manifest. Freud, who met Dali, and found him infinitely more interesting than the other Surrealists, immediately understood what Dali was doing. 'It is not the unconscious I seek in your pictures, but the conscious. While in the pictures of the masters – Leonardo or Ingres – that which interests me, that which seems mysterious and troubling to me, is precisely the search for unconscious ideas, of an enigmatic order, hidden in the picture. Your mystery is manifested outright. The picture is but a mechanism to reveal itself.' Dali had read Freud, as well as Krafft-Ebing on the psychopathology of sex, and his 'vice of self-interpretation, not only of my dreams but of everything that happened to me, however accidental it might seem at first glance', is clear not only in his paintings but in books like *Le Mythe tragique de l'Angélus de Millet*, in which the hidden content of Millet's painting, and hence the cause of Dali's obsession with it, reveals itself to him through a series of associations, coincidences and dreams.

The Dismal Sport (*Le Jeu lugubre*), a painting which made the Surrealists hesitate before admitting Dali to their group, fearing it revealed coprophiliac tendencies in Dali, swarms (as does *Illumined Pleasures*) with examples of symbols straight from the pages of text-books of psycho-analysis. It is impossible to tell what may be a dream image, and what Dali's analysis of it. Certainly the images make perfectly clear Dali's fear of sex, guilt about masturbatory fantasies, and consequent castration fears. In another series of paintings Dali interprets the legend of William Tell as a kind of reversed Oedipal myth about castration. Like *The Dismal Sport*, the *Giraffe in Flames* bunches its matter into concentrated areas of canvas, a deliberate analogy with Freud's description of dream-work.

'The only difference between myself and a madman is that I am not mad,' Dali once said. He turned his willed paranoia into a system that he

called 'paranoiac critical activity', defined as 'a spontaneous method of irrational knowledge based upon the interpretive-critical association of delirious phenomena'. 'Paranoiac-critical activity discovers new and objective significances in the irrational; it makes the world of delirium pass tangibly on to the plane of reality.' Paranoiac phenomena are 'common images having a double figuration'. In other words one object can be read as itself and as another quite different object, and so on; in theory the ability to continue to see double or treble figuration depended, like Ernst's frottage technique, on the spectator's powers of voluntary hallucination. *Impressions of Africa* (1938) has a whole train of double images, becoming increasingly minute, in the top left-hand corner, starting from Gala's eyes, which are also the arcades in the building behind. On the right, curious rock formations, inspired by the volcanic rocks near his home at Port Lligat, in Catalonia, turn into human figures. In fact Dali is fixing and making visible for us his own double images, rather than inviting us to read into it what we will.

Dali deliberately used an ultra-illusionistic technique, a 'return to Meissonier' (a much-abused nineteenth-century academic painter), as a kind of anti-art. 'The illusionism of the most abjectly *arriviste* and irresistible imitative art, the usual paralysing tricks of *trompe-l'œil*, the most analytically narrative and discredited academicism, can all become sublime hierarchies of thought and the means of approach to new exactitudes of concrete irrationality.' He describes works like *Six Apparitions of Lenin* . . . as 'instantaneous and hand-done colour photography'.

In 1928 Dali collaborated with Luis Buñuel on the film *Un Chien andalou*, and in 1930 they made *L'Age d'or*, whose more openly sacrilegious and political themes in fact are predominantly the work of Buñuel. A manifesto written by the Surrealists was included in the programme of *L'Age d'or*, together with drawings by Dali, Miró, Ernst, Man Ray and Tanguy. It included the following passage:

'All those who are not yet alarmed by what the censorship allows them to read in the newspapers must go and see *L'Age d'or*. It complements the present stock exchange crisis perfectly, and its impact is all the more direct just because it is Surrealistic . . . just as in everyday life, accidents occur in bourgeois society while that society pays no attention

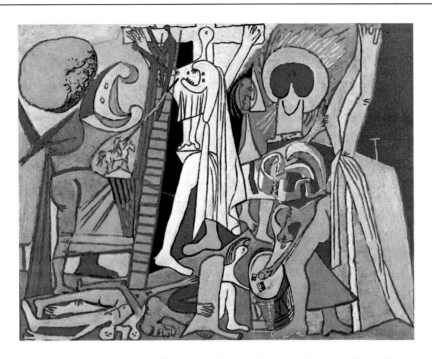

Pablo Picasso
Crucifixion 1930

whatsoever. But such accidents (and it must be noted that in Buñuel's film they remain uncorrupted by plausibility) further debilitate an already rotting society that tries to prolong its existence artificially by the use of priests and policemen. The final pessimism born within that society as its optimism begins to wane, becomes a powerful virus that hastens the process of disintegration. That pessimism takes on the value of negation and is immediately translated into anti-clericalism; it thus becomes revolutionary, since the fight against religion is also the fight against the world as it is.'

But is is *love* [*l'amour*, or desire] which brings about the transition from pessimism to action; Love, denounced in the bourgeois demonology as the root of all evil. For love demands the sacrifice of every other value: status, family and honour. And the failure of love within the social framework leads to Revolt.'

In the work of some artists Surrealism avowed a perverse kinship (as in Ernst and Lam) to religion. Picasso's most Surrealist work is a violent *Crucifixion*.

The Surrealist Object

At the International Exhibition of Surrealism in Paris in 1938, the emphasis was not so much on paintings as on objects and the creation of a whole environment. Duchamp conjured up the installation of the exhibition. The main hall had a thousand sacks of coal hanging from the ceiling, with leaves and twigs littering the ground, a grass-bordered pool, and a large double bed in one corner. The corridor leading to the hall was bordered with manikins or dummies, embellished in various ways – Masson's wore a G-string covered with glass eyes, had its head in a cage

and was gagged with a black band, with a pansy where the mouth should have been. In the courtyard at the entrance stood Dali's *Rainy Taxi*, dripping with water, with live snails crawling all over it and a hysterical blonde passenger.

Surrealist objects are essentially found objects transformed, or mechanical objects 'functioning symbolically'. Dali's *Aphrodisiac Jacket* is a dinner jacket hung all over with glasses; Oscar Dominguez metamorphosed an Art Nouveau statuette into the indescribable *Arrival of the Belle Epoque*.

Alberto Giacometti's sculptures in the early 1930s, when he was very close to the Surrealists, sometimes take on a symbolic function – in *Suspended Ball* for instance. He explained the genesis of the fragile *Palace at 4 a.m.* in the palaces built of matches that he used to construct at night

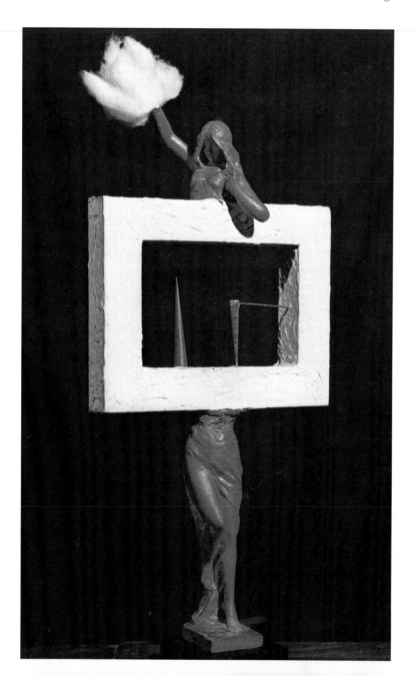

Oscar Dominguez
Arrival of the Belle Epoque 1936

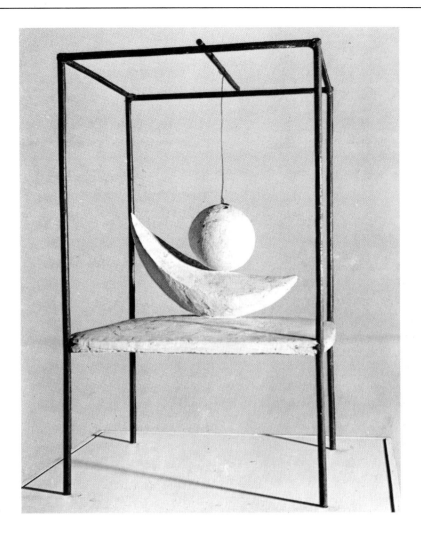

Alberto Giacometti
Suspended Ball (The Hour of the Traces) 1930

with the woman he once lived with. The skeletal bird and the spinal
column refer to incidents connected with her. The woman in *The Invisible
Object* of 1934, with her hands slightly apart as if holding something,
remained incomplete until one day walking with Breton in the Paris Flea-
market he saw an old-fashioned gas-mask which he then incorporated as
the head.

In an essay published in *What is Surrealism?* under the title of 'The
Communicating Vessels', Breton discusses Dali's proposition to make
movable and erotic objects which would procure a particular sexual
emotion by indirect means. These would, he thinks, be much less effective
than objects 'less systematically determined'. When the latent content is
deliberately contrived, as it is in Dali's account of his method, the shock
effect is destroyed for the spectator. Such objects would lack 'the
astonishing power of suggestion of the gold leaf electroscope' (two sheets
of gold foil which spring apart when a metal rod approaches them). In
another essay, 'Beauty will be convulsive', its title taken from the last

Hans Bellmer
Ball Joint 1936

words of his extraordinary novel *Nadja*, 'La beauté sera CONVULSIVE ou ne
sera pas', he discusses more precisely the nature of that which he finds
beautiful. He remains, he says, profoundly insensible to natural spectacles
and works of art that do not '*immediately produce in me a state of physical
disturbance* characterized by the sensation of a wind brushing across my
forehead and capable of causing me really to shiver. . . . *I have never been
able to help relating this sensation to erotic pleasure and can discover between them
only differences of degree.*' By 'convulsive', Breton understands not movement
but 'expiration of movement' (a locomotive abandoned to virgin forest,
the red feathers of the Hawaiian chieftain's cloak). He compares the work
of art to a crystal, both as regards appearance, 'same hardness, rigidity,
regularity and lustre on all its surfaces, both inside and out, as the
crystal', and the *spontaneous* method of its creation. It is impossible to
create this beauty by logical means. Clearly it is a matter of indifference
whether the object that produces this sensation is made or found. Hans
Bellmer's explicitly erotic objects, such as *Ball Joint*, of 1936, aim to
disturb in the way Breton urged. What matters is the spectator's power to
'recognize the marvellous precipitate of desire'.

Postscript

I have severely limited this essay in several directions. Firstly, rather than directly discuss the relationship between Dada and Surrealism, I have by implication stressed the differences rather than the similarities. They were of course sufficiently alike for many former Dadaists like Ernst, Man Ray, Arp, to join the Surrealists without making any radical changes in their work. As Arp said, 'I exhibited with the Surrealists because their rebellious attitude towards "art" and their direct attitude to life were wise, like Dada.' Surrealism inherited the same political enemies. But, clearly, it was a less anarchic, generous movement than Dada, erecting rigid rules and principles based on carefully formulated theories.

Secondly, painting is only one, and even a rather ancillary Surrealist activity. Much more of its energy was spent in the fields of poetry, philosophy, and politics. But for rather crucial reasons Surrealism became best known through its plastic works, because they proved to be the most direct way of *imposing* Surrealist vision.

Because the discussion has been confined more or less to the 1920s and 1930s it has been necessary to omit painters like Matta, who, joining the movement in 1937, was the last new recruit to have a powerful effect on the visual expression of Surrealism.

Roberto Matta Echaurren, a Chilean who began his career studying architecture in Le Corbusier's office, joined the Surrealists in 1937 and began painting in 1938. He and Arshile Gorky, an Armenian-American, were really the last painters to offer new paths towards the visual expression of Surrealist thought. Paintings by Matta like *Inscape* (*Psychological Morphology No. 104*), 1939, and *The Earth is a Man*, 1942, are like metaphors for an inner landscape, with small, brightly lit cells appearing in places, giving a sensation of superimposed layers of matter which can peel away to reveal other worlds inside; these works were a strong influence on Gorky.

The presence of many of the Surrealists in America during the War, including Breton, Ernst, Matta, and Dali, confirmed several young painters in one of the directions indicated by Surrealism – that of spontaneous automatic execution. As Jackson Pollock said in 1944: 'I am

Matta
The Earth is a Man 1942

Matta
Inscape (Psychological Morphology no. 104)
1939

Arshile Gorky
The Leaf of the Artichoke is an Owl 1944

particularly impressed with their concept of the source of art being the unconscious. The idea interests me more than the specific painters do, for the two artists I admire most, Picasso and Miró, are still abroad.

Gorky, a painter whom Breton admired, had also served an apprenticeship to Picasso, Miró and Kandinsky. In paintings like *How my Mother's Embroidered Apron Unfolds in my Life* (1944) and *The Leaf of the Artichoke is an Owl* (1944), paint is allowed to drip and run freely on the canvas. Gorky opened up new possibilities for expressing spontaneous and simultaneous impressions and perceptions. Breton wrote of him in *Le Surréalisme et la peinture*: 'By hybrid I mean the results produced by the contemplation of a natural spectacle in compounding itself with the flux of childhood memories that the extreme concentration before this spectacle provokes in an observer who possesses in the highest degree the gift of emotion. It is important to underline that Gorky is, of all Surrealist artists, the only one who keeps in direct contact with nature, in placing himself to paint *in front of it*. It is no longer a question, however, with him, of taking the expression of that nature for an *end*, but rather of summoning up from it feelings that can act as a springboard towards the deepening, in knowledge as much as in pleasure, of certain states of mind.'

Finally, I have not discussed in any detail the various techniques invented by the Surrealists to explore automatism further, like decalcomania, which involved spreading a sheet of paper with gouache or oil, laying another sheet of paper, on top, and peeling this off when the paint was nearly dry to reveal strange cavernous landscapes in the resulting configurations; or to invoke chance, like *Cadavre Exquis*, the child's game of head, body and legs. They were, as Breton said, only

techniques, 'lamentable expedients', in the Surrealists' fight to conquer the imagination.

Surrealism was not a style of painting. As Breton said of poetry in 1923, 'It is not where you think it is. It exists outside words, style etc. . . . I cannot acknowledge any value in any means of expression.' The Surrealist painters illustrated here are those who, by their relationship with the core of Surrealist thought, demonstrate most clearly the vision the Surrealists wanted to impose on the world.

'Surrealism has suppressed the word "like". . . .

'He who fails to see a horse galloping on a tomato is a fool. A tomato is also a child's balloon.'

André Breton, Paul Eluard and Valentine Hugo
Cadavre Exquis c. 1930

6 Abstract Expressionism

ANTHONY EVERITT

The social and political upheavals of the Depression and the disruption caused by the war against Hitler had a profound effect on young artists in Europe and America. Technological advances no longer seemed a guarantee of social or political progress. The hopeful rationalism of modern society was discredited. As far as art was concerned, the logical, idealistic premises of Cubism and the movements which flowed from it in the years between the two wars had lost their appeal.

The generation which began to paint in the 1930s and early 1940s was in a desperate frame of mind. A new approach was urgently needed to resolve what was seen as a crisis of subject matter. 'The situation was so bad that I know I felt free to try anything, no matter how absurd it seemed,' the American painter Adolph Gottlieb observed. He and many of his contemporaries were tentatively moving towards an aesthetic which repudiated the hegemony of intellect and allowed the artist to express himself freely and subjectively. As another American, Robert Motherwell, put it: 'The need is for felt experience – intense, immediate, direct, subtle, unified, warm, vivid, rhythmic.'

Many painters began to concentrate on the act of painting itself, unimpeded by anything save the decision to paint. Their thinking rested on an already well-established principle. If they emptied their minds of preconceptions, and applied pigment with a maximum of spontaneity, the images they made would be an expression of the deepest levels of their being. Everybody was agreed that this was a worthy objective: modern depth psychology appeared to show that the conscious mind could exert a repressive authority on the unconscious, and that, if it released its hold, the springs of feelings would flow clear again. Art, then, became a method of self-realization.

The Surrealists had shown the way. Taking their cue from the procedures of psychoanalysis – especially free association – they formulated the technique of automatism, according to which the painter or writer operated, metaphorically speaking, blindfold. He welcomed accident and exploited the random, doing anything in fact that would send the ego to sleep. André Breton's original definition of Surrealism, given in the First Manifesto of 1924, still held good: 'SURREALISM, noun. Pure psychic automatism by which it is intended to express, either verbally or in writing [he soon enlarged this definition to include visual art], the true function of thought. Thought dictated in the absence of all control exerted by reason, and outside all aesthetic or moral preoccupations.'

Mark Rothko
No. 61 1953

Other influences were at work as well. Many artists were indebted to Paul Klee, who took a post-Freudian interest in dreams and combined a sophisticated wit with child-like candour. In fact, the simplicities of the art of children and psychotics were felt by many to be as instructive as the work of their own professional antecedents. A group of Northern European artists drew German Expressionism into a vigorous, painterly style. The so-called matter painters devised a novel variant of collage: by mixing sand, plaster and other materials with pigment they gave the flat canvas something of the three-dimensional solidity of sculpture.

It was not only a re-evaluation of the contemporary Western tradition that contributed to the new emphasis on gesture or 'the act of painting'. Artists found much in Oriental art, and more particularly calligraphy, which threw light on their crisis of subject matter. In Chinese calligraphy, the brush-stroke is of prime importance. The painter-scribe abolishes the contradiction between subject and object, and, by concentrating on the process of sign-making, feels that he is actively participating in a continuous and potentially endless series of events (paralleling the cosmic process of generation and regeneration). In a telling phrase, a Chinese commentator, Père Tchang-Ming, remarked that ideograms are 'congealed gestures'.

Perhaps it is worth drawing a connection between graffiti in public places and calligraphy: graffiti too are congealed gestures, and the fact that these gestures represent, not a sense of unity with all things as in Oriental art, but a social estrangement, appealed to disillusioned men for whom painting was a heroic assertion of their identity. Far from escaping from self in the Eastern manner, they wished to proclaim it. Creativity was a sequence of free, unconditioned choices, through which they could redeem their alienation from society and from the given aesthetic tradition. It was a form of self-defence.

Existentialism offered a theoretical basis for this attitude, perhaps more as a climate of opinion than as a coherent philosophy. The writings of Jean-Paul Sartre provide the classic texts; and abstract artists, both in America and Europe, sympathized with his argument that man alone is responsible for his fate, which he has to make and re-make for himself. Man's consciousness is subjective and can never become aware of itself objectively and surely except through the 'gaze of the Other'. If other people function as mirrors in which to see oneself, so too can the work of art. Sartre did not hold a 'salvation through art' position for long, but it is a concept which had an interesting resonance for the many artists who found themselves in an isolated situation. It enabled them to acquire self-assurance by means of their work; and the Existentialist thesis that 'being is doing' gave intellectual justification to an approach which emphasized *process* at the expense of *product*.

Within this whole tradition of 'the act of painting', there is a radical distinction to be drawn between the School of Paris and the New York School. Painters in France never really abandoned content as ordinarily defined – a message or a sign – and even the traditional principles of composition can be detected in their work. New York painters tried hard to go beyond both. They explored the full implications of the discovery that 'what was to go on the canvas was not a picture but an event'.

New York Background

The American artist has always been a loner, and he was one of the first to suffer from the economic débâcle of the 1920s and 1930s. Patrons were few and far between, and, when they did buy his work, treated him as a courtier paid to cater to their tastes. The general public had little time for him, and his status was to be neatly illustrated during the Second World War by the lists of those without a right to deferment of military service: 'clerks, messengers, office-boys, shipping clerks, watchmen, footmen, bellboys, pages, sales clerks, filing clerks, hair dressers, dress and millinery makers, designers, interior decorators and artists'.

Nevertheless, something had to be done to support professional painters and sculptors during the Depression if they were not to be forced on to the streets. A few experimented, more or less unsuccessfully, with self-help schemes; and a group of New Yorkers picked up an idea from France for avoiding dealers and bartering direct with the public: work would be exchanged for 'anything reasonable'.

Rescue came from the unlikely direction of the Federal Government. In December 1933, as Roosevelt's New Deal got under way, the Public Works of Art Project was set up. In the half-year of its existence it hired 3,749 artists who turned out 15,633 works of art for public institutions. This was doing pretty well, but not well enough. The more ambitious Federal Art Project, which came to be known as the 'Project', took the principles of the PWAP a stage further. Within twelve months over 5,500 artists, teachers, craftsmen, photographers, designers and researchers were in the Project's employ. The salary was $95 a month for 96 hours' work. Easel painters were expected to submit periodic evidence of studio activity.

The politicians were probably hoping that culture would in this way be harnessed to the country's new-found social idealism. 'Could we, through actors and artists who had themselves known privation, carry music and plays to children in city parks, and art galleries to little towns?' asked Harry Hopkins, to whom Roosevelt had entrusted responsibility for the various art relief programmes. 'Were not happy people at work the greatest bulwark of democracy?'

This optimism did not in the event do much to alter the ingrained American suspicion of the arts. Free concerts in hospitals or schools, and murals in post offices, were of greater aid to the producer than to the consumer. For the Project's historic achievement was to bring artists together and give them a chance to pursue their interests freely and with a minimum of economic distraction. Thus, Willem De Kooning was able to take up painting full time only when he landed a contract with the Project.

The American art scene at the time was fragmented. Representational painters rallied to the flag, and under the general heading of Regionalism offered a folksy celebration of the American agrarian past – perhaps in compensation for the collapse of industry. With the rise of Fascism many younger talents became pre-occupied with international socialism. In New York the Communist Party attracted artists of many aesthetic persuasions, including a devoted band of Social Realists. Their canvases

are radical and polemical, and deal with issues such as the gaoling of a leading trade unionist and the Sacco and Vanzetti affair. A dynamic realism indebted to the Mexican revolutionary painters José Clemente Orozco, David Alfaro Siqueiros and Diego Rivera, was the order of the day.

Both the Regionalists and the Social Realists turned their back on abstraction and the inventions of the European avant-garde. However, since the epoch-making Armory Show of 1913, a faltering abstract tradition had come into being. Josef Albers founded an association of painters in 1937 called American Abstract Artists. It staged exhibitions, published books and organized lectures. Its members decisively rejected Impressionism, Expressionism, and above all Surrealism, for a structural, geometric, post-Cubist manner. But young painters soon tired of AAA's derivative formulas. The innovators of Abstract Expressionism stayed away, preferring to meet in loose groupings of their own.

Regionalism and Social Realism ran out of steam too; both styles were too restricted to allow for much experiment or change. Artists discovered that left-wing politics were time-consuming, and that they had their knuckles rapped if they stepped out of line. The painter Stuart Davis, an ardent activist, broke his friendship with Arshile Gorky for this reason: 'I took the business as seriously as the serious situation demanded and devoted much time to the organizational work. Gorky was less intense about it and still wanted to play.'

Naturally, those for whom the business of painting was more than 'play' fell away. Others were shaken by the Nazi–Soviet non-aggression pact of 1939, and support for the Communists declined.

The Second World War led to the arrival in the United States of many key figures of twentieth-century art, in exile from their home countries – Breton, Chagall, Ernst, Léger, Lipchitz, Masson, Matta and Mondrian among them. Surrealists such as Masson and Matta, who offered spontaneous, semi-abstract canvases filled with forms drawn from the depths of the unconscious, were now a direct presence, not a remote example. By chance of war New York assumed the mantle of Paris; Americans felt at the centre of affairs for the first time and no longer in a cultural outback. The effect of this can hardly be exaggerated.

In 1943 the Federation of Modern Painters and Sculptors pointed to the parallel between America's new international political role and her increasing strength in the arts: 'As a nation we are now being forced to outgrow our narrow political isolationism. Now that America is recognized as the centre where art and artists of the world meet, it is time for us to accept cultural values on a truly global plane.'

If there is a single quality which distinguishes the American Abstract Expressionists from their contemporaries elsewhere, it is an intensity of purpose which allowed them to ride roughshod over both stylistic convention and what Clement Greenberg called 'paint quality'. Greenberg argued that the American vision was characterized by a 'fresher, opener, more immediate surface', offensive to standard taste. He related this quality to a 'more intimate and habitual acquaintance with isolation', which was, in his view, 'the condition under which the true quality of the age is experienced'.

Myths and Symbols

André Breton, the chief ideologue of Surrealism, wrote in 1927: 'Freud has shown that there prevails in the "unfathomable" depths a total absence of contradiction, a new mobility of the emotional blocks caused by repression, a timelessness and a substitution of psychic reality for external reality, all subject to the principle of pleasure alone. Automatism leads straight to this region.'

However, neither psychic reality nor pleasure principle were enough in themselves; and instead of Sigmund Freud the New York painters looked to C. G. Jung, for whom the unconscious opened doors not merely to individual neuroses but to the universal archetypes of human experience. His view was that the unconscious is 'mythopoetic' – that it naturally creates myths – and that the arts are an important means by which myths and symbols are kept alive in an otherwise one-sidedly 'conscious' world.

Jung showed that primitive art was a virgin quarry of symbols that were as relevant to the contemporary world as they had been in the prehistoric past. Mark Rothko observed in 1943: 'Those who think that the world is more gentle and graceful than the primeval and predatory passions from which these myths sprang are either not aware of reality or do not wish to see it in art. The myth . . . expresses to us something real and existing in ourselves, as it was to those who first stumbled upon the symbols to give them life.'

The young Jackson Pollock was interested in Jung as early as the mid-1930s, and went to a Jungian analyst when he began psychiatric treatment for alcoholism in 1937. He equated what he saw as the best contemporary Western art with American Indian painting, praising the Indians for their 'capacity to get hold of appropriate images and their understanding of what constitutes painterly subject matter'.

The imagery that Pollock and his fellows employed was based on 'biomorphic' forms related to animal and plant structures, to primitive symbols, to the shapes that flow from a free handling of paint, and to the semi-conscious patterns of automatism.

Arshile Gorky stands rather to one side of the new mythic manner; his 'hybrids' (to use Breton's expression) are related to it in character, but

Arshile Gorky
Composition 1932–33

they also have the obsessive sexuality of a Freud-based Surrealism. He did not cut his bridges to Europe, and should perhaps be regarded as a precursor of the New York School who happened to overlap its first decade, rather than a founder member. Born Vosdanig Manoog Adoian in Turkish Armenia in 1904, he arrived in the United States from Eastern Europe in 1920. He studied at the Rhode Island School of Design and later the Grand Central School of Art, where he was both pupil and teacher. He acquired a reputation as a brilliant *pasticheur*, and his early work bears witness to an almost programmatic intention to live through most of the major styles of modern art.

His starting point was Impressionism, but he soon graduated to Cézanne and to Synthetic Cubism. Between 1929 and 1934 Picasso, Braque and Gris were major influences (as in the *Composition* of 1932–33), and he was nicknamed 'the Picasso of Washington Square'. 'I was *with* Cézanne for a long time,' he remarked, 'and now naturally I am with Picasso.' Gorky then moved on to Tanguy, Masson and Matta (for their unstable shifting spaces) and Miró (for his curlicued figures). Around 1936 he adopted a biomorphic abstract style. In the early 1940s he became interested in Kandinsky.

Gorky was not unaware of the dangers of his situation. According to a possibly apocryphal anecdote, he called some fellow-artists to his studio in the mid-1930s and told them sadly: 'Let's face it, we're bankrupt.' Whatever the truth of the matter, a proud tactfulness or a dilettante sensibility delayed Gorky's artistic maturity until the final years of his short life; he killed himself following a cancer operation in 1946 and a car crash in which he broke his neck.

Around 1943, in his *Garden in Sochi* series, he made his breakthrough. In *Water of the Flowery Mill* the paint lies in thin, brilliant washes of colour which are allowed to overflow and overlap. Soft, feminine forms mingle with spiky masculine ones, and although they refer to Gorky's aesthetic forebears (the Synthetic Cubists in this instance) they are distinguished by a dreamy, meandering feeling for line. His encounter with the Surrealists in New York had given him the confidence to experiment with spontaneous draughtsmanship which submerged, if it did not eliminate, his Cubist inheritance.

Gorky's hybrids, curious vegetable and animal composites, suggest a mental doodling in front of nature. In his eyes landscape had a symbolic and sexual content, which stems from memories of his childhood in rural Armenia. Had he lived, it is hard to resist the impression that his playful epicureanism would have set him apart from the other Abstract Expressionists; his work lacks the urgency of Pollock or Newman.

Thus, in *The Betrothal II*, painted in 1947, pale greenish-yellow figures outlined in black stand against warm ochre; bristly verticals mingle with visceral fruit-like forms. The canvas retains the freshness of a sketch while also attaining a kind of academic classicism: not for nothing was Gorky called 'the Ingres of the unconscious', and behind some of his rounded shapes lies the example of Ingres' *Odalisques*.

William Baziotes' work came into sharp focus during this 'mythic' phase of Abstract Expressionism, and did not change radically thereafter. He agreed with Jung's emphasis on 'a primordial art', which allows 'a

Arshile Gorky
Water of the Flowery Mill 1944

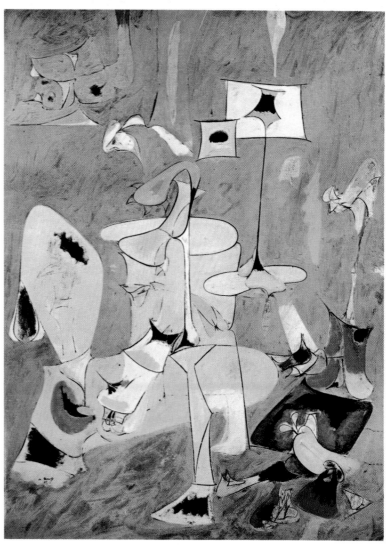

Arshile Gorky
The Betrothal II 1947

glimpse into the unfathomed abyss of what has not yet become'. This 'abyss' often resembles an undersea world where protozoic marine forms float in a filtered light. Amoebic dwarfs, spiders and birds are also included in Baziotes' scheme of things. 'Every one of us finds water either a symbol of peace or fear,' he wrote in 1948. 'I know I never feel better than when I gaze for a long time at the bottom of a still pond.' But the silence and order of his pictures is not usually placid, and the symbols which people them are discrete, sinister and obsessive.

Born in 1912, Baziotes came to New York from Pittsburgh in 1933, studied at the National Academy of Design, and joined the Federal Art Project. He worked in comparative obscurity before showing at Peggy Guggenheim's Art of This Century Gallery in 1944. He was influenced by the precise, exotic colours of Persian miniatures and also by Klee, Miró and, especially, Picasso. In 1940 he met the Surrealist Matta and was excited by the idea that abstraction could be a vehicle for psychic meanings. In 1942 he was represented in the New York 'International Surrealist Exhibition'.

Baziotes learned to equalize the surface tension of his designs by eliminating sculptural or three-dimensional depth and replacing it with

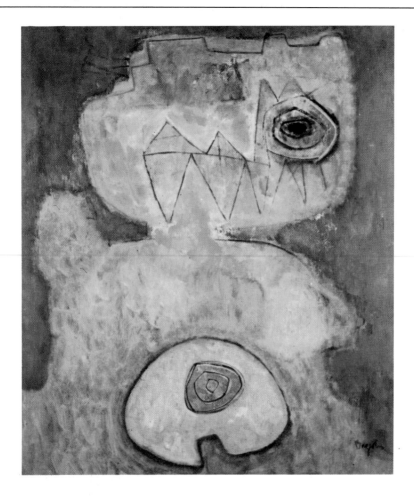

William Baziotes
The Dwarf 1947

an integrated paint surface and an all-over tonal harmony. Also, with time, he reduced the number and increased the size of his figures. *Dwarf*, painted in 1947, shows Baziotes at the height of his powers. The fuzzy green figure and the mauve ground are tonally similar, and the all-over effect is reinforced by his method of painting – a soft brushing which gives the picture surface a mistily liquid quality. From 1950 until his death in 1963 Baziotes moved in the direction of greater sophistication and control. His later works have a tasteful decorativeness which is matched by a certain caution and avoidance of risk.

The All-over Field

It is not surprising that the American artists, interested as they were in the processes of painting and drawing, should have responded with enthusiasm to some aspects of Oriental art, in particular Chinese calligraphy. Mark Tobey was one of the first to pay serious attention to East Asian painting, although he was not personally associated with the New York School. Like his Oriental masters, he pursued a calmly meditative goal. Born in Wisconsin in 1890, he taught in Seattle on the

West Coast between 1922 and 1925. During this period he became interested in American Indian art and Japanese woodcuts. A convert to the Baha'i World Faith, a universalistic and optimistic religious sect, he devoted himself to the reconciliation and union of Eastern and Western cultures. He studied Eastern painting at the University of Washington, taught at Dartington Hall in England, and in 1934 travelled to China and Japan where he spent a month in a Zen monastery.

This journey liberated his aesthetic development, and on his return he started the series of paintings called 'white writings' which continued through the 1940s and 1950s. In *Edge of August*, painted in 1953, we see the culmination of Tobey's adaptation of calligraphy to painting. A labyrinth of white thread-like script lies on a reddish ground: perspective is destroyed, and form, to use his own words, 'smashed'. The communicative function of the sign gives way to a rhythmic working

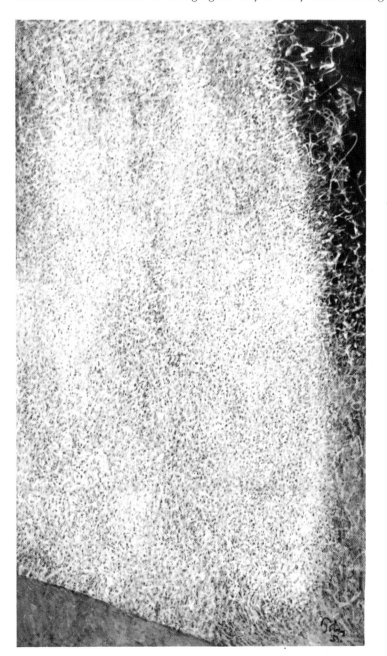

Mark Tobey
Edge of August 1953

which creates an all-over texture and effectively dematerializes the brush-stroke. The best of Tobey has a slight fussy tranquillity; because his central area of concern is religious, he never identified himself with the Abstract Expressionists' drastic re-evaluation of the bases of contemporary art.

Tobey's 'white writings' resemble Jackson Pollock's 'drip paintings'. The comparison comes out to Pollock's credit, and once again the issue resolves itself into one of intensity. Pollock was prepared to 'go the full length'. As in the case of Rimbaud, this entailed a profligacy of effort, a capacity to push his luck to the point of incoherence in his work, and perhaps of self-destruction in his life. More than any of his contemporaries he dared to test his ideas till the cracks showed and they began to give way. This authenticity, or, in Sartre's phrase, 'good faith', has been as influential as his pictures.

To trace his career is to analyse the key elements in the gestural phase of the New York School; and, although he did not make all the technical discoveries (Hans Hofmann, for instance, was the first to use a drip technique), he can lay claim to their most energetic exploitation. Born in 1912 on a sheep ranch in Wyoming, Pollock was the son of relatively poor parents ('excellent craftsmen', according to his brother Charles, 'they knew how to grow things, they knew how to make things. But neither of them had a sense for business or commercial profit'). The family moved house many times during his childhood. There was little in his background to suggest he would become an artist.

His rise to fame is in the classic mould of the American success story: from the Wild West he travelled to the big city, took the world by storm, but found his triumph hard to manage. The prototype for this kind of folk hero is the early twentieth-century author Jack London; and the lives of the two men have a number of curious analogies. Like London, Pollock had a severe drink problem and died at the height of his celebrity, exhausted and apparently in despair. Some critics have suggest that the geography of the West and the ceaseless travels of his early years left their mark on Pollock's painting. He certainly enjoyed the immensity of the American landscape and the temptations of the open road; it may be no accident that it was on the open road he died, in 1956, violently driving his car too fast round a bend and crashing into a tree.

D. H. Lawrence, in an essay on Walt Whitman, offers some insights into American culture which are remarkably apposite to Pollock and to his fellow-frontiersmen of the New York School: 'It is the American heroic message. The soul is not to pile up defences round herself. She is not to withdraw and seek her heavens inwardly, in mystical ecstasies. She is not to cry to some God beyond, for salvation. She is to go down the open road, as the road opens, into the unknown, keeping company with those whose soul draws them near to her, accomplishing nothing save the journey, and the works incidental to the journey.'

It took some time before the young Pollock came into direct contact with the international avant-garde. By 1930 he and his brother were studying painting under Thomas Benton at the Art Students' League. Benton was a Romantic Regionalist of a reactionary turn of mind: 'I wallowed in every cockeyed ism that came along and it took me ten years

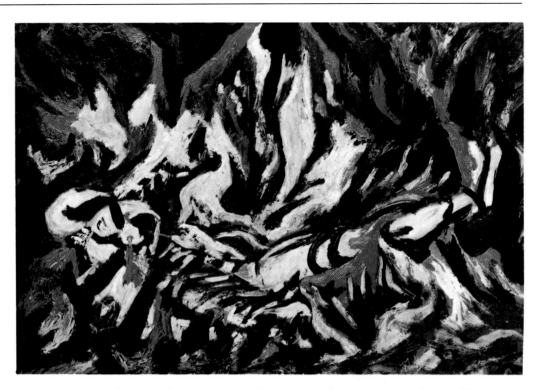

Jackson Pollock
The Flame 1937

to get all the modernist dirt out of my system,' he is reported to have said. He had made his name with vigorously distorted and sometimes satirical accounts of the American scene.

Pollock reacted *through* Benton rather than against him, abandoning his realistic subject matter but picking on and developing the older man's feeling for painterly rhythms which he in turn had drawn from Rubens, Michelangelo and El Greco. In *The Flame*, painted in 1937, there is a recognizable content, but it is subordinated to Pollock's fascination with pigment, tonal contrasts and a heightened tempestuousness of treatment.

In 1935 Pollock worked for the Federal Art Project; he admired the Mexican revolutionary artists and took note of Kandinsky, Miró, Klee, and the Surrealists, including Masson. But the strongest influence of all was Picasso. Pollock spent nearly ten years developing a semi-figurative symbolic vocabulary. His interest in Jung has already been remarked on, and he paid cautious tribute to the Surrealists. His pictures illustrate, in a partly automatist style, primitive myths, especially those which dealt with passionate sexuality. Three characteristic titles from 1943 were *Pasiphaë* (which was to have been called *Moby Dick*), *The She-Wolf* and *The Moon Woman Cuts the Circle*.

The She-Wolf illustrates Pollock's preoccupation with totem motifs. However, the violent composition and crudely vigorous brushwork also embody private anxieties. The wolf's red, unwinking eye falls in line with the disembodied eyes which recur cryptically throughout Pollock's career.

In 1947 recognizable imagery disappeared, and his canvases became surfaces which simply recorded his passage. The conventional techniques and materials of painting were not flexible or sensitive enough for this

purpose; so Pollock devised his famous 'drip' method of applying paint. This is how he described it:

'My painting does not come from the easel. I hardly ever stretch my canvas before painting. I prefer to take the unstretched canvas to the hard wall or the floor. I need the resistance of a hard surface. On the floor I am more at ease. I feel nearer, more a part of the painting, since this way I can walk around it, work from the four sides and literally be *in* the painting. This is akin to the method of the Indian sand painters of the West.

'I continue to get further away from the usual painter's tools such as easel, palette, brushes, etc. I prefer sticks, trowels, knives, and dripping fluid paint or a heavy impasto with sand, broken glass and other foreign matter added.'

Two masterpieces, *Cathedral* painted in 1947, and *Blue Poles*, painted in 1953, reveal the extent of Pollock's originality. His previously glutinous pigmentation yields to an airy grace. A shallow space is created, but does not subvert the substantiality of the materials used nor the integrity of the picture plane. The composition is an all-over field; despite the fact that the network of threads and cords of paint is usually contained within the edges of the canvas, it could, the spectator senses, be indefinitely extended. This is reinforced by the size of Pollock's paintings: they resemble portable murals and establish the New York School's

Jackson Pollock
Drawing c. 1948

Jackson Pollock
The She-Wolf 1943

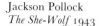

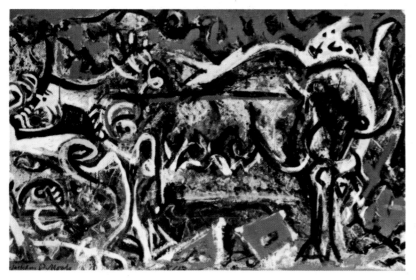

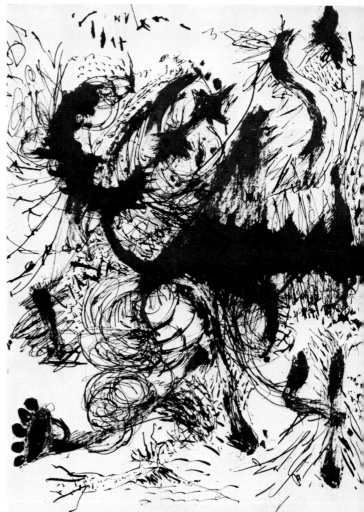

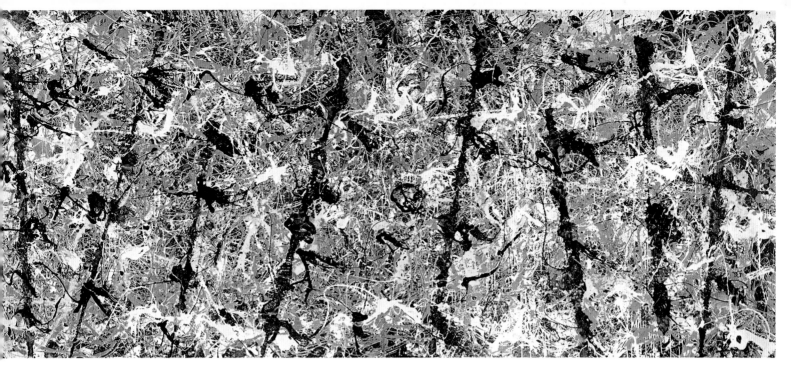

Jackson Pollock
Blue Poles 1953

preoccupation with scale: 'There was a reviewer a while back who wrote that my pictures didn't have any beginning or end. He didn't mean it as a compliment, but it was. It was a fine compliment.'

The predominance of black and white in *Cathedral* is a reminder that Pollock is essentially a draughtsman. The critic Frank O'Hara noted his 'amazing ability to quicken a line by thinning it, to slow it by flooding, to elaborate that simplest of elements, the line – to change, to re-invigorate, to extend, to build up an embarrassment of riches in the mass of drawing alone'.

Above all, in these pictures, there is an overpowering release of energy, a euphoric dynamism. Pollock used to work very rapidly, after slow periods of walking around the canvas and brooding. What looks like chance is at most the exploitation of chance: 'When I am painting, I have a general notion as to what I am about. I *can* control the flow of paint: there is no accident.' At the same time, decisions were passive rather than active (as one would expect of an inheritor of Surrealist automatism): 'I have no fears about making changes, destroying the image, etc., because the painting has a life of its own. I try to let it come through.'

By 1953 Pollock found that he had exhausted the potential of 'drip' painting. His personal life was also in confusion, and, after two teetotal years, he withdrew again into alcoholism. He abandoned colour and returned to figuration. One consequence was the loss of the field effect, and his designs break down into broad puddled areas of pigment. He produced many fine things, many of which – *Easter and the Totem*, painted in 1953, is a case in point – denote a return to his old subject matter with more sophisticated means.

Pollock's contemporaries in New York watched his career with mounting excitement, for it raised in an undiluted form many of the aesthetic preoccupations of the day. More than anything else, it

represented a commitment to emotional honesty. Robert Motherwell wrote in 1950: 'The process of painting then is conceived of as an adventure, without preconceived ideas, on the part of persons of intelligence, sensibility and passion. Fidelity to what occurs between oneself and the canvas, no matter how unexpected, becomes central. . . . The major decisions in the process of painting are on the grounds of truth, not taste. . . . No artist ends up with the style he expected to have when he began.'

Willem De Kooning shared the leadership of the New York gestural avant-garde with Pollock. However, he remained on far closer terms with his aesthetic antecedents than did many of his peers. The movement which specially attracted him was Cubism; but his general attachment to tradition can also be seen in his acceptance of the human figure as a suitable subject for painting.

Jackson Pollock
Cathedral 1947

Jackson Pollock
Easter and the Totem 1953

Born in Rotterdam in 1904, he spent his first twenty-one years in Europe and studied in Antwerp, Brussels and Rotterdam. He moved to the United States in 1926, but only started to paint full-time when he found employment with the Federal Art Project. In his early work he painfully came to grips with the problem of treating three-dimensional figures without upsetting the integrity of the picture surface. In works of the early to middle 1940s, from the *Seated Woman* of 1940 to the *Pink Angel* of 1947, his solution was to play down modelling and, gradually, to isolate individual parts of the human body and treat them as planes. Painterly silhouettes, suggesting household objects and also biomorphic forms (he was a close friend of Arshile Gorky), are crowded together on a plain ground; there is little sense of space, of *in front* or *behind*, and the images and the gaps between them become to some extent interchangeable.

After 1942, De Kooning experimented with automatism, which loosened his handling of paint and encouraged him to exploit the ambiguity of semi-abstract signs. It also introduced a new vehemence in his brushwork. All this laid the ground for his sudden adoption in 1947 of a new style in a series of black and white pictures in household enamel

Willem De Kooning
Seated Woman c. 1940

Willem De Kooning
Pink Angel c. 1947

paint (he was too poor at the time to afford oils). Individual anatomical segments are now released from their representational context and are assembled, in (say) *Dark Pond*, painted in 1948, as a fleshy jigsaw – what one critic called a 'wall of living musculature'. There is now no distinction at all between figure and field. De Kooning painted a succession of remarkable pictures in a similar vein, at the same time returning to colour: an example is the *Excavation* of 1950.

De Kooning was not a gesture-for-gesture's-sake artist who happened to retain an element of figuration; the significance of his subject matter was seldom far from his mind. 'Art never seems to make me peaceful or pure,' he said in 1951. 'I always seem to be wrapped in the melodrama of vulgarity.' Seldom making concessions to economic necessity, and living the Bohemian life of a 'loft rat', he expressed his own restless response to the modern city.

Around 1951, he resumed his *Women*, monstrously ugly but seductive females – part fertility goddesses, part graffiti. It was an obsessive image: 'It did one thing for me: it eliminated composition, arrangement, relationships, light – all this silly talk about line, colour and form – because that [i.e. the *Women*] was the thing I wanted to get hold of.'

In 1955 De Kooning returned to semi-abstraction, this time recalling 'landscapes and highways and sensations of that, outside the city – the feeling of going to the city or coming from it'. He simplified his draughtsmanship and enlivened his palette. In *Door to the River*, painted in 1960, there is a broad, expansive painterliness – almost as if the artist had

Willem De Kooning
Door to the River 1960

Willem De Kooning
Excavation 1950

reworked a blown-up detail of an earlier composition. In the 1960s he resumed the *Women* theme – but now his figures are softer, more fluid and palpable.

Because De Kooning had little to offer the colour field artists of the 1960s he has been neglected to the advantage of Pollock. His great achievements lie in combining a personal content with a repudiation of style (in a sense of stylishness), and in marrying figuration to an extreme gestural manner.

Pollock and, to a lesser extent, De Kooning turned their canvases into all-over fields by means of a lattice of brushmarks or drips; but other artists, among them Mark Rothko, Clyfford Still and Barnett Newman, were more interested in colour than gesture. Flat areas of paint replaced impasto and line. 'Instead of using outlines, instead of making shapes or setting off spaces, my drawings declare the space,' Newman wrote; 'instead of working with the remnants of space, I work with the whole space.'

Scale was the major ingredient. As Clement Greenberg put it in 1948, 'There is a persistent urge, as persistent as it is largely unconscious, to go beyond the cabinet picture, which is designed to occupy only a spot on the wall, to a kind of picture that, without actually becoming identified with the wall, like a mural, would spread over it and acknowledge its physical reality.'

Very large canvases altered the relation of the spectator to the work: he was no longer able to 'take it in' or frame it with a single glance. In fact, he was often overtaken by an expanse of colour which stretched beyond his range of vision. Rothko argued in 1951 that 'To paint a small picture is to place yourself outside your experience, to look upon an experience as a stereopticon view or with a reducing glass. However you paint the larger picture, you are in it. It isn't something you command.' It was now no longer an object in an environment but an environment in itself.

Objects of great size are awe-inspiring, and the fact that colour field pictures were not only very large in themselves but, like some of Pollock's work, contained implications of boundlessness, suited the transcendental aspirations of Newman and Rothko. They used the all-over colour field as an assertion of the mystery of being. Newman is fond of the term 'sublime', and refers to Edmund Burke's *Philosophical Enquiry into the Origin of Our Ideas of the Sublime and the Beautiful* for a definition. According to Burke's elaboration of the classical author Longinus, the basis of beauty is pleasure, and that of sublimity is pain or fear. Space, solitude, vastness and infinity (among other things) lead to the sublime. Newman's 'non-relational' canvases, empty of everything but colour and (as he says) drained of 'the impediments of memory, association, nostalgia, legend, myth or what have you', fitted the bill. The New York painters were not scholars; they picked on Burke because his ideas lent the authority of tradition to their style of painting, a style which, in Motherwell's words: 'becomes sublime when the artist transcends his personal anguish, when he projects in the midst of a shrieking world an expression of living and its end that is silent and ordered'.

Barnett Newman was born in New York in 1905 and died there in 1970; he studied at the Art Students' League, City College of New York

and Cornell University. He taught during the 1930s, and did not participate in the Federal Art Project: 'I paid a severe price for not being on the project with the other guys; in their eyes I wasn't a painter; I didn't have a label.' During the 1930s he was attracted by left-wing thinking, and he has been quoted as saying: 'My politics went towards open forms and free situations; I was a very vocal anarchist.'

Newman was an important polemicist, and passed through all the phases of Abstract Expressionism. In 1947, with Rothko, Motherwell and Baziotes, he helped to found a school called 'Subjects of the Artist' and to edit *Tiger's Eye*, a magazine which argued the case for an aesthetic based on myth. Although he rebelled against academic Surrealism, Newman explored automatist procedures. The archetypal forms and plastic energy of the North-West Coast Indians impressed him, as did pre-Columbian art; 'My idea was that, with an automatic move, you could create a world.'

Barnett Newman
Untitled 1945

Barnett Newman
Onement I 1948

Barnett Newman
Achilles 1952

Something of what he meant appears in *Untitled* (1945); the gesture creates a world in which biomorphs and a prophetic road-like band cross a remote, creamy cosmic space. By 1948 Newman was ready to abandon subject matter, whether abstract or figurative. *Onement I*, painted in that year, marks the turning point in his style. A thickly painted vertical strip lies just off-centre over masking tape. No doubt Newman had intended quite another picture; and, as Charles Harrison points out, the refusal to lift the tape or to 'paint up' the ground were long-meditated decisions.

The picture prefigures the basic features of his later work. A repudiation of sensuously handled paint goes hand in hand with the disappearance of 'form' – that is, of pictorial elements and of design. The canvas becomes an undifferentiated field which is defined rather than divided by the stripe (or, as in *Vir Heroicus Sublimis*, painted in 1950–51, stripes). These thin bands neutrally echo the boundaries of the picture plane, and read like a serial sequence which could be repeated indefinitely beyond them.

But for all its importance, drawing is subordinate to colour. In *Vir Heroicus Sublimis* and in *Achilles* of 1952, the great expanse of red subdues the ego and inspires a kind of tranquil awe. The non-painterliness of Newman's technique, however, prevents the spectator from indulging himself in sensation. By its dryness and banality, it draws attention away from the experience towards the idea.

Mark Rothko's soft, luminous palette is more sensuous than Newman's. Veils of thin pigment wash over the canvas and soak into it; warm colour lies over cool, cool over warm, dark over light, and light over dark. But sensuousness is not the same as hedonism. Rothko's colour fields have a contemplative intensity and invite a surrender of self. Among the ingredients of his art he listed: 'A clear preoccupation with death. All art deals with intimations or mortality.'

Born in Russia in 1903, Rothko emigrated with his family to the United States at the age of ten, in 1913. Between 1921 and 1923 he studied at Yale University and attended Max Weber's drawing classes at the Art Students' League. In 1953 he was co-founder of the Ten, a group of Expressionistic artists who opposed the post-Cubist abstraction represented by American Abstract Artists. Before the war he painted human figures in deserted cityscapes.

In the early 1940s, like many of his contemporaries, he experimented with automatism and Jungian biomorphism. He painted amalgams of human, plant, animal and fish forms. His figures are arranged schematically against soft light-filled grounds (*Entombment I*, 1946). They express, as Rothko said of an early painting in this manner, 'a pantheism in which man, bird, beast and tree – the known as well as the unknowable – merge into a single tragic idea.'

Around 1947, that *annus mirabilis* of the New York School, Rothko exchanged his linear emblems for soft-focus blurs of colour, eventually reducing them to two or three roughly rectangular shapes stacked one on top of the other. At the same time he increased the size of his canvases and started to work on a monumental scale.

Although Rothko's compositions can be broken down into separate components, he found ways of preserving the integrity of the 'field'. There

Mark Rothko
Black on Grey 1970

Mark Rothko
Red, White and Brown 1957

is no central point of attention. His rectangles fill the picture, the shape of which they repeat and confirm. Because of his use of wash the unifying texture of the canvas shows through. With a touch of irony, he encourages a contradiction between the illusion of a cloudy depth and the hard, visible fact of a surface.

The atmosphere of mature works such as *Red, White and Brown* of 1957 is passive and meditative. Opaque mists of disembodied colour invite the spectator into a quiet space, metaphorically equivalent to reverie. They express a not displeasing melancholy, close in feeling to Vergil's *sunt lacrimae rerum et mentem mortalia tangunt*: 'There are tears in the nature of things, and hearts are touched by transience.'

Rothko did not change this stylistic formula, but his colours gradually darkened. Late canvases such as *Black on Grey* are bleakly pessimistic. His life ended in suicide in 1970.

Adolph Gottlieb's development followed the same pattern as Rothko's: mythic figuration yielded to abstract emblems on a blank ground. However, he did not go so fast or so far. Born in 1903 in New York, he trained at the Art Students' League, travelled through Europe and spent some time in Paris. During the 1930s he painted realistic views of the American scene. Under the impact of Surrealism and Freudian psychology, as well as Klee and Mondrian, Gottlieb devised a personal

manner based on an irregular grid, containing images drawn from primitive art and parts of the human anatomy, for paintings which he called *Pictographs*. He adopted this name because 'it was necessary for me to utterly repudiate so-called "good painting" in order to express what was visually true for me'. Curiously, as his career progressed, he appears to have become increasingly concerned with technique. His pictures are tidy and personable and present themselves to their best advantage.

In the early 1950s, after a decade of *Pictographs*, Gottlieb rationalized his principles of composition: as in *Frozen Sounds No. 1*, an earth-like band stretches across the lower part of the canvas, and in a pale 'sky' above hangs a row of ovoid or rectangular discs. Further reduction followed in 1957 with his *Burst* series. A single 'sun' now dominates the top half of the picture: it has a passivity which is in sharp contrast to the active linearity of the interlaced bundle of brush-strokes below. Gottlieb's observations on Gorky some years previously are a good description of his own *Bursts*: 'What he felt, I suppose, was a sense of polarity, not of dichotomy: that opposites could exist simultaneously within a body, within a painting or within an entire art.'

In a picture like *Brink*, painted in 1959, Gottlieb has nearly arrived at a colour field position. But his discs and exploding patches remain anecdotal incidents; he was willing to generalize and abstract the 'pictograph' or sign, but he refused to banish it altogether, whether by elimination (Newman) or magnification (Rothko). Cautious and consistent, Gottlieb stayed within what he knew until his death in 1974.

Adolph Gottlieb
Brink 1959

Adolph Gottlieb
The Frozen Sounds Number 1 1951

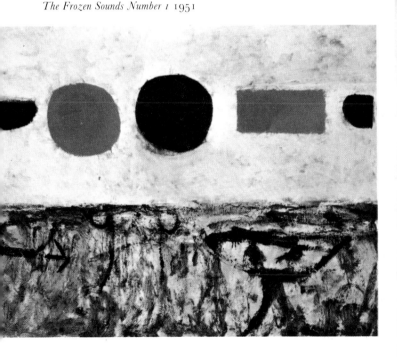

Clyfford Still is an artist of a more uncompromising frame of mind. His attitude to the avant-garde was as dismissive as that of Pollock's teacher, Benton; and, having passed through Bauhaus, Dada, Surrealist and Cubist phases, Still then obdurately turned his back on contemporary art movements. 'That ultimate in irony – the Armory Show of 1913 – had dumped on us the combined and sterile conclusions of European decadence,' was his final conclusion. In its place he cultivated a pioneering individualism – an attitude which, in its way, is as American as apple-pie. Art was a way of life, a matter of conscience: 'Hell, it's not just about painting – any fool can put colour on canvas.'

Still, born in North Dakota in 1904, studied at Spokane and Washington State universities, obtaining a master's degree in 1935, and spent six years as a teacher. The representational work he did during these years anticipates his later abstractions: a vertical figure stands in an open landscape, and there is a moral duality symbolized in sun and earth, light and dark.

Still moved to an early 'myth-making' manner which resembled that of Rothko and Gottlieb, although arrived at independently. In 1941 his artistic production was curtailed by war work; after a one-man show in San Francisco in 1943 he resumed full-time painting, and during the next few years he abandoned figuration for good. He did so with a characteristic decisiveness, saying later: 'I have no brief for signs or symbols or literary allusions in painting. They are crutches for illustrators and politicians desperate for an audience.'

Clyfford Still
Painting 1948–D 1948

Clyfford Still
1951 Yellow 1951

Clyfford Still
Painting 1958

Clyfford Still
Painting 1951

Still devised a distinctive format to which he has since kept. *Painting 1948-D*, *1951 Yellow*, and *Painting 1951* show a colour field corroded by torn flame-like verticals. Still's designs are rationally organized and are, as Lawrence Alloway has observed, 'like the colour code of a map . . . that is turning back into a substantial reality; not a key to somewhere else, but itself a land'.

Although this is a useful metaphor, the reference to landscape should not be taken too literally. 'The fact that I grew up on the prairies has nothing to do with my paintings, with what people think they find in them,' Still said in an interview. 'I paint only myself, not nature.'

During the 1940s he reduced his originally brilliant chromaticism: his fields became black or opaque purple. Forms or pictorial disturbances which had occurred in the centre of the picture are pushed to the sides. Then, in the 1950s, an unexpected lyricism makes an appearance, and in works like *Painting 1958* colours seem more content to please than previously.

Still, like Newman, has an exalted notion of art. His aim is to purify the act of painting so that it can transcend itself and become a self-sufficient assertion of the sublime. He once compared the artist to a man who journeys through a wasted terrain and reaches a high plateau: 'Imagination, no longer fettered by the laws of fear, became as one with Vision. And the Act, intrinsic and absolute, was its meaning, and the bearer of its passion.'

Allies and Successors

Ad Reinhardt qualifies for no more than temporary membership of the New York School. He was at heart opposed to Abstract Expressionism; immediacy and indeterminacy were equally alien to him. The hieratic clarity of Eastern forms of expression was more to his way of thinking, and he sought the 'ultimate' painting that would be, like the Buddha image, 'breathless, timeless, styleless, lifeless, deathless, endless'. He admired Mondrian, rejected Surrealism, and ignored calligraphy: 'Nowhere in the world has it been clearer than in Asia that anything irrational, momentary, spontaneous, unconscious, primitive, expressionistic, accidental or informal cannot be called serious art.'

For most of his life Reinhardt adhered to a geometric form of abstraction, but in the 1940s he struck up friendships with Newman, Rothko and Still, and started to paint all-over canvases. These were

Ad Reinhardt
Red Painting 1952

Ad Reinhardt
Painting 1950

composed at first of blurs and lines, then of small brushed rectangles (*Painting*, 1950), and then of overlapping horizontal rectangles with hard edges (*Red Painting*, 1952). By 1951 he was well on his way to the all-black *Ultimate Paintings* of his final minimal style, which, with their close values and barely discernible rectilinear divisions, are deliberately made almost impossible to reproduce.

Despite, or perhaps because of, their ambition to extend the frontiers of art and to carve a territory that would be all their own, the Abstract Expressionists wanted to know what it was that they were leaving. They listened eagerly to teachers and critics who could tell them of developments in Europe and provide them with working formulas they could apply to their own activities. Hans Hofmann took a lifelong interest in art education, and was also a distinguished painter, who ranks high in the second rank of the New York School. Born in Germany in 1880, he started out as a scientist (inventing a magnetic comptometer), also studied art, and settled in Paris between 1904 and 1914, meeting Matisse, Picasso and Braque, together with Delaunay, who taught him his colour theory. Hofmann founded his own art school in Munich in 1915. He emigrated to the United States in 1932, and soon opened another school in New York.

Hofmann's finest paintings summarize the conflicting achievements of early twentieth-century art within the context of an individual manner. He taught that 'creative expression is . . . the spiritual translation of inner concepts into form, resulting from the fusion of these intuitions with artistic means of expression in a unity of spirit and form'. Painting was

Hans Hofmann
Transfiguration 1947

'forming with colour', and his interest, both pedagogic and creative, lay in finding a synthesis of Cubist structure and a Fauvist palette. (Clement Greenberg claimed that 'you could learn more about Matisse's colour [from Hofmann] than from Matisse himself'.)

Hofmann painted in a semi-abstract manner between 1936 and 1941; his subjects were always identifiable and were organized in brightly coloured, structured areas. From 1942 he swam with the tide, practising automatism and devising a biomorphic vocabulary of forms. He also invented an original drip and splash technique (anticipating Pollock).

In 1946 Hofmann began the series of abstractions for which he is best remembered. *Transfiguration*, of 1947, for instance, consists of energetically painted areas with some linear elements. Traces of Cubist organization remain, but the design is held in balance by the 'push and pull' interaction between three-dimensional depth and two-dimensional surface. 'Every movement releases a counter-movement,' he wrote. 'A represented form that does not owe its existence to a perception of movement is not a form.' In the 1950s Hofmann experimented with many different modes of expression. In some canvases, such as *Fantasia in Blue*, rectangles overloaded with richly coloured pigment are placed among free gestural areas, and in others, towards 1960 and after, such as *Rising Moon*, broad semi-transparent washes glow from a white ground.

Robert Motherwell is another New York artist with a distinctively European bent. Born in 1915, he entered Stanford University and later

Hans Hofmann
Fantasia in Blue 1954

Hans Hofmann
Rising Moon 1964

Harvard, where he studied art history. He took a somewhat dilettante
view of culture and the good life, and lamented the disappearance of 'the
wonderful things of the past – the late afternoon encounters, the leisurely
repasts, the discriminations of taste, the graces of manners, and the
gratuitous cultivation of minds'.

In 1940 he met the Surrealists-in-exile, and, as well as introducing him
to automatism and Freudian psychology, they confirmed his instinct for
nineteenth-century French aesthetics. Leaning on Baudelaire's theory of
correspondences, according to which 'scents, colours and sounds respond
to one another', Motherwell held that complete abstraction was
impossible: 'The "pure" red of which certain abstractionists speak does
not exist. Any red is rooted in blood, glass, wine, hunter's caps and a
thousand other concrete phenomena.'

Motherwell experimented with collage, and his early works are
influenced by Picasso, Matisse and Schwitters; but his first major
paintings, the series entitled *Elegies to the Spanish Republic*, were begun in
1949 (by 1965, he had finished more than a hundred). Vertical rectangles
and ovals spread across these long frieze-like canvases. The colouring is
usually black on white. According to Motherwell, 'the pictures are . . .
general metaphors for life and death, and their interrelation'. This

Robert Motherwell
Je t'aime, II A 1955

Freudian conjunction of Eros and Thanatos is one of his characteristic
themes, and is here indicated by the phallic configuration of his forms.

There are other oppositions in Motherwell's work: figure and ground
edges overlap so that both are grafted into a unified surface, and gesture
and field (flat planes and a simple monumentality, recalling colour field
abstraction), are handled in painterly fashion with random drips and
splashes.

Motherwell often paints on an intimate scale, as in his *Je t'aime* series
during the mid-1950s; but his unique contribution lies in the intimacy
and personal feeling with which he can fill a monumental canvas.

Around 1950, emboldened by the success of Pollock and his fellow-
pioneers, four painters abandoned figuration for Abstract Expressionism.
They were none of them young men, and they had spent their careers
working in traditional styles.

Franz Kline, born in 1910, trained in painting at Boston University
and spent a few years in England. Until the late 1940s he produced
studies of city scenes. Then, quite suddenly, he switched to gestural black-
and-white canvases, which look as if they are gigantic enlargements of
ideograms. In fact, the resemblance to Oriental calligraphy is misleading:
'people sometimes think I take a white canvas and paint a black sign on

Franz Kline
King Oliver 1958

Franz Kline
Chief 1950

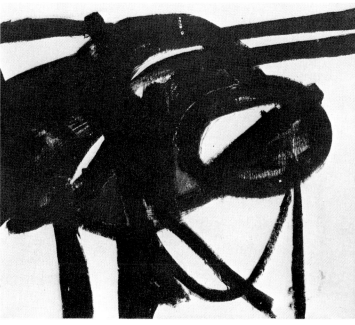

it, but this is not true. I paint the white as well as the black, and the white is just as important.'

Kline's compositions are abstract, but they reflect the patterns of urban lanscape: 'If someone says, "That looks like a bridge," it doesn't bother me really. A lot of them do. . . . I think that if you use long lines, they become – what could they be? The only thing they could be is either highways or bridges.'

Kline's work at its best conveys a sense of barely controlled excitement with the act of painting. As he puts it, 'Paint never seems to behave the same. Even the same paint doesn't, you know. It doesn't dry the same. It doesn't stay and look at you the same way.' Corrections, erasures and overpainting give the spectator the impression that he is himself taking part in the creative process: Kline seems to be, as he said of Bonnard, 'organizing in front of you'.

In the last years of his life, his pictures became blacker and more atmospheric. Kline also began to experiment with colour: but *King Oliver*, for instance, fine as it is, is only the old monochrome Kline translated, and he did not find his way to an authentic chromaticism before his comparatively early death in 1962.

Philip Guston was born in Canada in 1913 and studied at the Otis Art Institute in Los Angeles. He visited Mexico to see the murals of Rivera and his colleagues, and evolved a figurative style in which memory played an essential part: painting was 'a tug-of-war between what you know and what you don't know.'

In 1951 he embraced abstraction, but never supposed that this meant

Philip Guston
Passage 1957–58

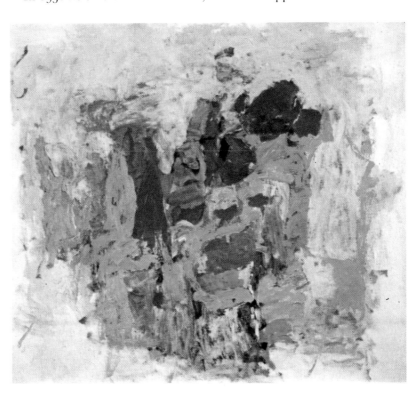

the complete abolition of subject matter: 'There is something ridiculous and miserly in the myth we inherit from abstract art: that painting is autonomous, pure and for itself, and therefore we habitually analyze its ingredients and define its limits. But painting is "impure". We are image-makers and image-ridden.'

For a while Guston deployed hatched brush-strokes vertically and horizontally on the canvas (a recollection of Mondrian); his colours were hesitant, pastel and luminous, and he was nicknamed an Abstract Impressionist on account of their atmospheric lyricism. From 1954, however, he painted in larger but less geometric areas, using a sombre palette and bolder brushwork. Later still, there is a partial return to representation: half-identifiable objects emerge from the paint surface – traces of old forgotten things which the mind cannot quite recall.

For James Brooks, Pollock was as gigantic a figure as Picasso or Matisse. The great drip paintings had the same liberating effect on Brooks in his middle age that Cubism had had on him as a young man. Born in St Louis, Mo., in 1906, he studied at the Southern Methodist University and the Dallas Art Institute. In the 1930s he was associated with the Regionalist movement (although he did not repudiate European modernism), and the area where he grew up provided him with his main source of inspiration. From Picasso he learnt how to abstract from nature while preserving a recognizable image. He became well known as a muralist.

After discharge from military service in 1945, Brooks explored Cubism and then started looking for ways to loosen the closed structure of his compositions; Pollock's automatism gave him the cue he needed. He painted the backs of his canvases, and cautiously worked and re-worked the chance patterns that had soaked through into subtle, integrated rhythms. The end-product, as in the *No. 36* of 1950, is a shifting flux of transparent zones threaded with thin lines. In 1953 his pigmentation increased in density, and large gestural forms jostled for attention, gently pulling and pushing against one another.

Bradley Walker Tomlin was born in 1899, brought up in New York, and educated at the College of Fine Arts of Syracuse University. He earned a living as an illustrator and also painted murals. Little of his early work survives. From about 1939 he adopted a decorative Cubism into which straightforwardly representational elements are incorporated. A dreamy symbolism takes first place over design. After 1945 he became friendly with Gottlieb, whose example persuaded him to introduce more spontaneity into his pictures. He painted white calligraphic signs on a black ground, but feeling uncomfortable without a linear structure went on to transform them into curved bands fitted together on a loose grid. In *No. 20* (1949), during his final period, these bands were reduced to small rectangular dabs. Tomlin's gentle, melancholy canvases are evidence that gesture painting was able to accommodate passivity and elegance.

During the 1950s critics, collectors, museums, and the public at large realized that they now had to reckon with an American art of world stature. Artists became rich and famous, and painting was no longer a career for congenital 'loft rats'. In a sense this made life difficult for new arrivals on the scene. The major discoveries had all been made, and the

desperate pressures against which the Abstract Expressionists had so heroically and successfully reacted no longer existed. Reforming zeal was, therefore, out of place, and young artists adopted a cool, uncommitted stance. Rather than Pollock or De Kooning, they took the colour field painters, Newman and Still, as their point of departure. However, they were more interested in the minimality of colour field art than in its pursuits of the sublime; and they agreed with Reinhardt's insistence on anonymity and the absence of emotion.

Nevertheless, a few continued to offer gestural abstraction, usually in terms of colour. Helen Frankenthaler (born 1928), who married Robert Motherwell, developed a staining technique that derived from Pollock's drip paintings and from Rothko's dyed washes. The autographic brush-stroke disappears, and pictures such as *Blue Territory* express an impersonal delight in pure colour, light-filled and arranged in free,

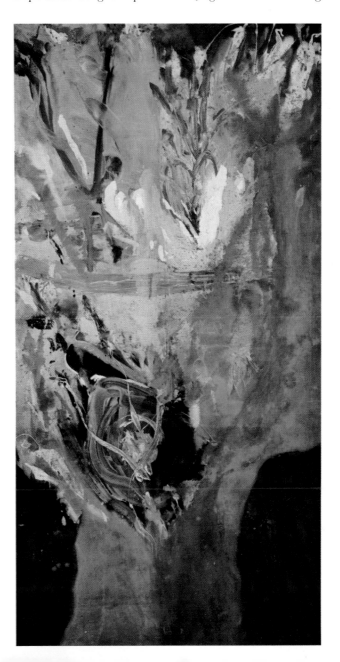

Helen Frankenthaler
Blue Territory 1955

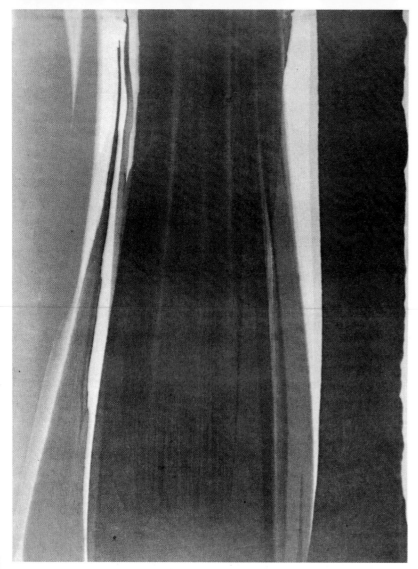

Morris Louis
Untitled 1959

Morris Louis
Sky Gamut 1961

accidental patterns. In 1952 Morris Louis (1912–62) came across Pollock's work and met Helen Frankenthaler, who introduced him to staining. In his series known as *Veils*, diaphanous colour curtains flow over one another: later, in the *Unfurled* series, diagonal rivulets of brilliant colour pour down the lower corners of otherwise untouched canvases. This was followed by the *Stripe* or *Pillar* paintings which codify colour into striped fasces or bundles. Louis metamorphosed his Abstract Expressionist inheritance: pigment has become optical and insubstantial, and the wandering edges of his forms are determined only by the drying process. Colour speaks for itself released from the artist's intentions.

The painting of Louis and Frankenthaler is a far cry from the frontiersman hacking his way into new territories and surveying the canvas as if it were an empty land on which to impose his will. Only a few years after their triumphs, the Abstract Expressionists appeared as remote as the Founding Fathers of the Republic. Their successors paid them due respect and admiration, but the adventure was over. Consolidation does not require the same skills as conquest.

Europe

The independent growth of gestural abstraction on both sides of the Atlantic is not as remarkable a phenomenon as it seems at first sight. Simultaneity of invention is common in the sciences; when conditions are broadly the same in different parts of the wood, there is nothing surprising in a coincidence of brush fires.

Immediately after the Second World War, Europe and America shared the inheritance of Cubism and Surrealism, the post-war malaise, and the crisis of subject matter. Accordingly, the princples of the new European Abstract art, variously known as Informal art (or *art informel*), Lyrical Abstraction and Tachism, had a good deal in common with those of the New York School: there was plenty of talk about spontaneity of technique, liberation from the old formal conventions, cultivation of the unconscious, and the rejection of illusionistic space.

Nevertheless, the resemblances conceal varying objectives. Europe – its artistic life still centred on Paris – was less radical than America. Thus, Pollock and his European contempoary Jean Dubuffet were both excited by the potential of unfamiliar materials and techniques. Just as the one poured fluid paint on the canvas, mixing it with 'sand, broken glass and other foreign matter', the other built up his impasto with plaster, glue, putty and asphalt. However, Dubuffet's attention was fixed on the materials themselves ('I do my best to rehabilitate objects regarded as unpleasing'); Pollock, on the other hand, was only concerned with facilitating the creative act. Again, we do not find in Europe the repudiation of easel painting by enlargement of scale: there is no all-over colour field.

This said, the triumph of the United States has led to an under-valuation of the post-war School of Paris, or at least of its leading figures. Clement Greenberg summed up the New York orthodoxy in 1953: 'For all the adventurousness of their "images", the latest generation in Paris still go in for "paint quality" in the accepted sense. They "enrich" the surface with films of oil or varnish, or with buttery paint. Also, they tend to tailor the design so that it hits the eye with a certain patness: or else the unity of the picture is made to depend on a semblance of the old kind of illusion of depth obtained through glazing or tempered colour.'

This critique, acute is it is, does not do justice to the major talents. Georges Mathieu, painter and leading publicist of Lyrical Abstraction, protested at the animosity of the Abstract Expressionists in America: 'I have been surprised that in New York you had not immediately recognized Wols as the Rimbaud of painting. I do not want to believe that a narrow-minded nationalism has had anything to do with the reserves you showed at the time of his exhibit.'

Wols was the *nom de guerre* of Wolfgang Schulze. Born in Berlin in 1913, he was a skilled violinist and photographer as well as a student of zoology, geology, botany and ethnology. He never saw painting as a profession, and as far as possible avoided the world of dealers and exhibitions. In his youth he came into contact with Paul Klee, Otto Dix and George Grosz, all of whom, especially Klee, influenced his work. Disgusted by the Nazis, he left Germany in 1932 and settled in Spain until he was deported to

France in 1936. His early watercolours and drawings are elaborate automatist doodles. However, Wol's playfully horrific grotesques are marked by an Expressionistic and German anguish as well as a Surrealistic spontaneity and wit.

The Second World War and the German occupation confirmed him in his pessimistic view of life. He drew some comfort from observing the forms of nature ('the stones, the fish/The rocks seen through a glass/The sea-salt and the sky/Have made me forget the importance of man'). In his drawings organic shapes merge with imaginary biomorphs suggested by the half-awake mind (he used to close his eyes and let involuntary hypnogogic images form). They convey a perturbing eroticism.

Wols worked on a small scale: 'the movements of the hand and fingers suffice to express everything. The arm movements necessary in painting a canvas involve too much ambitious purpose and gymnastics.' Nevertheless, by the mid-1940s he was ready for a change. At the suggestion of a gallery owner he launched, almost against his will, on a sequence of paintings, executed rapidly and in something approaching a hypnotic state over a period of a few months. In *Composition V*, painted in 1946, Wols has achieved his mature style. His brushwork is free, gestural and unplanned, and his use of colour creates a vague, uncertain space, an arena in which he can trace his familiar threaded squiggles. Although the imagery is abstract and intuitive, there are intimations of a microscopic molecular universe.

Wols
Composition V 1946

Like Pollock, Wols was an adventurer who used his art as a vehicle for self-revelation. His eccentric, Bohemian life-style was itself a creative achievement, in (as Mathieu suggests) the Rimbaudian vein. Alcoholism led to an early death in 1951; but his bleak career was felt to be a success in the Existentialist sense of the assertion of existence through action, and was extremely influential during the 1950s.

Jean Dubuffet was the second major figure to emerge in post-war France. Fascinated by the painting of children, psychotics and amateurs, he coined the term *art brut* (i.e. raw, untreated or crude art) to define its rough-and-ready anti-art quality: 'I hold to be useless those types of acquired skill and those gifts (such as we are used to finding in the works of professional painters) whose sole effect seems to me to be that of extinguishing all spontaneity, switching off and condemning the work to inefficacy.'

Born in 1901 in Le Havre Dubuffet moved in his teens to Paris where he studied art for a time and also occupied himself with literature, music, philosophy and languages. In 1924 he gave up painting, and apart from a brief interlude in Buenos Aires as an industrial designer spent most of the next two decades in the wine business. He did not paint full-time again until 1942. Two years later he held an exhibition in Paris in which he showed Klee-like images of houses, still-lifes and other representational scenes, all as if drawn by a child. They embody a certain messiness, a *maladresse anti-plastique*; the term implies a *rejection* of the concern with 'paint quality' of which Greenberg accuses the School of Paris.

Dubuffet held another exhibition in 1946, 'Mirobolus, Macadam & Cie., Hautes Pâtes', a title intended to evoke the magical 'naïveté of the street conjuror'. It was now that he began experimenting with new materials, making a paste he could play with like a child with plasticine. He was moved by the unnoticed poetry of everyday objects, especially those without formal properties, such as dust or walls. In the early 1950s Dubuffet launched three new series, the *Ladies' Bodies*, large female figures

Jean Dubuffet
Table, Constant Companion 1953

with primitive fertility associations, and *Soil and Ground* and *Radiant Land* in which 'friendly animals and nice little men' are set against backgrounds suggesting geological structures and fossils.

In *Table, Constant Companion*, painted in 1953, a flat frontal image is richly textured. If the figure is a table, it also has animal associations, looking rather like a headless and tailless elephant. However, Dubuffet's delight in materials and his whimsical simplicity of form indicate that he is not primarily concerned with representation. He occupies a position somewhere between figuration and abstraction, where the 'thisness' or physical presence of his canvases is as significant as the child-like bestiary with which he peoples them. In 1956, Dubuffet evolved a new technique based on collage: he cut small pieces from painted fabric – stars, discs and lozenges – and stuck them on to the canvas in a mosaic, sometimes adding bits of tinfoil, dried flowers or leaves.

New approaches to the physical 'matter' (or *matière*) of painting are found in the work of many Europeans who wished, like Dubuffet, not only to widen their expressive scope but also to attack the conventions of 'fine art'. Antoni Tàpies, born in Barcelona in 1923, adopted a matter-based style in 1953, using a mixture of glue, plaster of Paris and sand. His motives included a despair with the industrial present and a yearning for the 'natural'. Tàpies, who insists that art must have a 'moral substratum', aims to remind man of his real nature not by large statements but gentle specific reminders. His admiring comment on Anton Chekhov sums up

Antonio Tàpies
White and Orange 1967

his own intentions: 'It's extraordinary, he tells you almost nothing. He is almost absent. He gives you bits of reality in its raw state, which cross his mind.'

In *White and Orange*, painted in 1967, Tàpies, like Dubuffet, gives the painting the substantiality of a wall (his name, by a coincidence which pleases him, means 'walls' in Catalan), and a symmetrical design has been scored and gouged into the thick plastered surface. In other works, by dialectical contrast, formal balance is either eliminated or submerged in spontaneous gestural techniques, including a manner of painting – and overpainting – that shows an awareness of the New York School. Tàpies' attempts to make the canvas a concrete object is weakened by an underlying illusionism (*White and Orange* sets out to look like a wall, but isn't), and he went some way to solve this problem in later years by incorporating real objects in his work, such as baskets, furniture and pieces of wood, and transforming them into whimsical, quietly Surrealistic assemblages.

The Italian artist Alberto Burri, born in 1915, handled – or, to be precise, damages – ready-made materials. He is best known for his *Sacks*, in which he creates a design from pieces of sacking and cloth; he has also produced collages from metal, wood and packaging. In *Sack No. 5*, painted in 1953, the holes in the sacking and the dark ground recall bandaged wounds and derive from what he saw as a medical officer during the Second World War. Burri's pictures are a melancholy, partly

Alberto Burri
Sack no. 5 1953

autobiographical critique of the age; unfortunately, they manage to be neat and pretty - too much so to convey a powerful emotional charge.

Another Italian, Lucio Fontana (born in Argentina in 1899; he died in Italy in 1968), has been grouped with the matter painters. His matter was the canvas itself, often monochrome, which he slashed or gouged. In these literal ways he opened up the picture plane: the spectator can see through it to three-dimensional space beyond, which itself becomes an element of the composition. Fontana's destructive methods may also be taken as an ironic dismissal of easel painting; and they record with some precision a gesture – namely, cutting with a knife. However, in 1946 he issued his *White Manifesto*, in which he makes it clear that perception and the sensation of perception are his primary concerns: 'We need an art which draws its value from itself, and not from any ideas we might have about it. Colour and sound are found in nature, and linked with matter. Matter, colour and sound – these are the phenomena whose simultaneous evolution forms an integral part of the new art.'

Lucio Fontana
Spatial Concept 1960

Elsewhere in the document Fontana observes that 'sensation' was everything in primitive art: 'it is our intention to develop this original condition of man'. From the mid-1940s Fontana's work became increasingly sculptural, and he experimented with relatively unorthodox media – such as electric light – in his pursuit of a total 'synthesis' of colour, sound, movement, time and space.

In France, a number of artists confirmed the matter painting of Dubuffet and the Informalism of Wols more directly. Jean Fautrier, born in 1897, attracted attention with his series of *Hostages*. He used a gluey paste made from cement, plaster and paint which he applied with a palette knife. Vague human forms or faces, which are built up from layer after layer of whitish-coloured pigment, float against a blurred opalescent ground. These images refer to some executions Fautrier witnessed during the war. In his later work, though, the significance of his subject matter became more cryptic, and he widened it to include objects, nudes and

Jean Fautrier
Hostage 1945

Jean-Paul Riopelle
Painting 1951–52

landscapes – semi-abstract and only just identifiable. He also produced
completely abstract pictures. As a rule, his compositions are dominated
by a flat central image.

Jean-Paul Riopelle is a Canadian painter and sculptor, born in Quebec
in 1923. He was influenced by the Surrealists and met Wols and several
like-minded French Informalists in 1945. His work has its roots in an
affection for landscape; and by the end of the 1940s he had developed a
'non-figurative pantheism'. Technically, he became interested in texture
and broke down his designs into small brightly coloured patches
irradiated by thin lines of force. This gives such works as *Painting* (1951–
52) an all-over quality, although modified by atmospheric spatial effects
and a palette that evokes the colours of nature. A growing preoccupation
with mass in space has led Riopelle in recent years to a series of sculptural
experiments.

If matter is one dimension of the post-war School of Paris, gesture is
another. The brushmark or the calligraphic sign – seen as a record of
psychic activity – was a sufficient content. This entailed an emphasis on
'the act of painting'; but, in contrast with the United States, it was
seldom whole-hearted. For Ecole de Paris painters it was a means of
making new kinds of design which they could isolate and lovingly
preserve, or exploit for decorative effect.

Hans Hartung was born in Leipzig in 1904, and it was not until 1935,
after numerous vicissitudes, that he settled in Paris. During his formative
years, he had been influenced by Kandinsky and Klee. Following active
service in the war (he was wounded and lost a leg), he became a French
citizen. His work is consistently marked by what Klee called 'psychic
improvisation'. His mature style, from 1934 on, depends on a nervous,
automatist manner and owes a good deal to Oriental art. Painting for
him is a kind of abstract sign language in which human psycho-motor
energies are translated into concrete form. In 1947 he observed, using an
interesting analogy (compare Tobey, p. 261), that 'Our contemporaries,

or the generations to come, will learn to read, and one day this direct writing will be found more normal than figurative painting, just as we find our alphabet – abstract and unlimited in its possibilities – more rational than the figurative writing of the Chinese.'

After 1954 his paintings became increasingly Informal: they record without embarrassment the artist's second thoughts. Hartung treats a smooth blank ground as a field for the expression of energy. Spiralling networks and meshes of coloured line create a variable rhythmic depth. In time Hartung's self-confidence grew, and his later canvases are distinguished by a controlled technical virtuosity. His designs look more and more like practised ideograms. There is little indecision in *T 1958–4*: instead, routine vitality framed within a tidy, contained image. For all their energy, Hartung's brushmarks seem neutralized, like flies in amber.

Hartung has frequently been compared with Pierre Soulages, whose

Hans Hartung
T 1958–4 1958

compositions are made up from a lattice of broad black bands, like the enlarged strokes of a housepainter's brush. Born in 1919 in France, his early interests were in prehistoric and Romanesque art. He was impressed by exhibitions of Cézanne and Picasso which he saw in 1938–39. After 1946 he began to exhibit in Paris. Although, like many of his contemporaries, Soulages was attracted to gesture, to the wide sweep of the arm across the canvas, this was more for the architectonic possibilities which it offered than for the excitement of movement. His pictures, of which *Painting* (1959) is a characteristic example, follow a rational programme: a framework of black bands is painted on a more or less plain, brightly coloured ground, and this, in turn, is overlaid with folding vertical or diagonal bands. The result is a gravely monumental structure: the upper levels set up dynamic formal and spatial rhythms, but these are firmly contained within the lower ones. Such formality contrasts with the more spontaneous gestures of, say, Kline's *King Oliver* (1958). Soulages was firm in his commitment to abstraction itself: 'I do not start from an

Pierre Soulages
Painting 1959

Georges Mathieu
Mathieu from Alsace goes to Ramsey Abbey

object or from a landscape with a view to distorting them, nor, conversely, do I seek, as I paint, to provoke their appearance.' (Compare, again, Kline's easy-going attitude, p. 281).

Georges Mathieu, born in 1921, was one of the earliest Frenchmen to appreciate the significance of the New York School, and has been a tireless propagandist for what he refers to as Lyrical Abstraction. He admires the art of the age of Louis XIV, and seems to have seen his role as that of an arbiter of taste, a contemporary Le Brun. A great organizer of exhibitions and publisher of manifestos, usually formulated in high rhetorical terms, he began to paint in 1942, under the Surrealist influence of Matta and Masson. Deeply moved by paintings of Wols which he saw in 1947, he soon developed his own personal style. Both in principle and in practice he was close to the Abstract Expressionists. He talked of 'the intrinsic autonomy of the work of art', and of the 'phenomenology of the "very act of painting"'.

Mathieu believes that conscious intention is best expelled from painting by an extreme rapidity of execution. He has painted in public on a number of occasions, and in Tokyo he once completed a canvas over twelve metres long in less than twenty minutes. However, except for some early works, his pictures are more decorative than aggressive: as in *Mathieu from Alsace . . .*, laceries of bright pigment (red, white, black and blue are his favourite colours) stretch horizontally across the middle of the pictures or spread out from a central coagulation of pigment like overpainted Chinese characters. Because they keep a good distance from the edges of the canvas, they do not function as an all-over field. Mathieu's work has an appealing *joie de vivre*, although his real achievement lies in the field of publicity.

Henry Michaux, born in Belgium in 1899, moved freely throughout his life between literature and visual art. His preferred medium was ink on

Henri Michaux
Painting in India Ink 1966

paper, and painting was for him a non-verbal extension of writing – a carrying on of poetry by other means. Like Hartung and Mathieu, he was influenced by Oriental calligraphy; and he spoke of being 'possessed by movements, completely tensed by these forms which came at me full speed, in rhythmic succession'. This is a good summary of his drawing technique; blots (*taches*) pour on to the paper in quick succession, under the pressure of emotion and, on occasion, mescalin. As in *Painting in India Ink*, of 1966, these blots come together into a so-called field of energy, which the eye can read, passing from one small expressive sign to another.

A host of subsidiary figures complicate the post-war Parisian art scene. Many had been working in figurative styles in the 1930s, and their early concerns informed their later manners. Jean Bazaine, born in 1904, moved in his forties from a representational post-Cubist position towards a free abstraction inspired by nature, as in *Child and the Night* (1949). An original feature of his work is that his compositions seem to pour over the edge of the canvas and so subvert its arbitrary rectangularity. Alfred Manessier, born in 1911, has followed much the same course as Bazaine, ending up with a symbolic, landscaped-based abstraction which expresses a mystical Christian viewpoint; a typical title is *Night in Gethsemane*. His

Jean Bazaine
Child and the Night 1949

Alfred Manessier
Night in Gethsemane 1952

Maurice Estève
Friselune 1958

finest work is in stained glass. Maurice Estève, born in 1904, passed through most phases of modern art before devising his own variant of free abstraction, in which painterly but static compositions are assembled and unified by a rich palette. Although he has been defined as a colourist, a work like *Friselune* (1958) also has a constructed planar quality deriving from Cézanne.

Nicolas de Staël was born in St Petersburg in 1914 and lived mostly in Belgium and France until his suicide in 1950. By his economical illusionism and his decorative palette, De Staël achieved considerable popularity. But he was never a painter's painter, and made comparatively little impression on his contemporaries or successors. His career is of interest because it reflects an unwillingness to make a complete commitment either to abstraction or to figuration. Not unlike the *Nocturnes* of Whistler, his vividly coloured designs read equally well as harmonious arrangements of pure form or as stylized but atmospheric evocations of landscape. In one respect the tables are turned: his titles, unlike Whistler's, suggest representation (*Figure by the Sea*, 1952). Ambivalence permeated De Staël's whole aesthetic approach: 'For myself, in order to develop, I need always to function differently, from one thing to another, without an *a priori* aesthetic. I lose contact with the canvas every moment and find it again and lose it. This is absolutely necessary, because I believe in accident – as soon as I feel too logical, this upsets me and I turn naturally to illogicality.'

The Surrealists and German Expressionists attracted a following in the smaller countries of Northern Europe. In the late 1930s some Danes harnessed automatism and a painterly manner to their national folklore,

Nicolas de Staël
Figure by the Sea 1952

filling their canvases with the trolls, gods and dragons of Nordic mythology. This runic Expressionism was offered as a corrective to 'sterile abstraction'. It drew some support from painters in Belgium and Holland. The movement was institutionalized when in 1948 a group of Danish, Belgian and Dutch artists in Paris formed 'Cobra' (named from the first letters of Copenhagen, Brussels and Amsterdam). They included Karel Appel, Constant, Corneille, Christian Dotremont, Asger Jorn and Philippe Noiret; they were joined later by Atlan, Pierre Alechinsky and the Germans Karl Otto Götz and Otto Piene.

A keynote of Cobra was a high-spirited violence both in terms of style and content. In the aftermath of war, its members saw themselves as resistance fighters for art. They delighted in expressive exaggeration: 'It is snowing colours,' said Dotremont. 'The colours are like a scream.'

The dominant figure was Asger Jorn, born in Jutland in 1911. With a background of automatist Surrealism, he saw the artist, in familiar terms, as a heroic individualist, and painting as an existential gesture: 'Art is the unique act of man or the unique in human actions.' Kandinsky, Miró

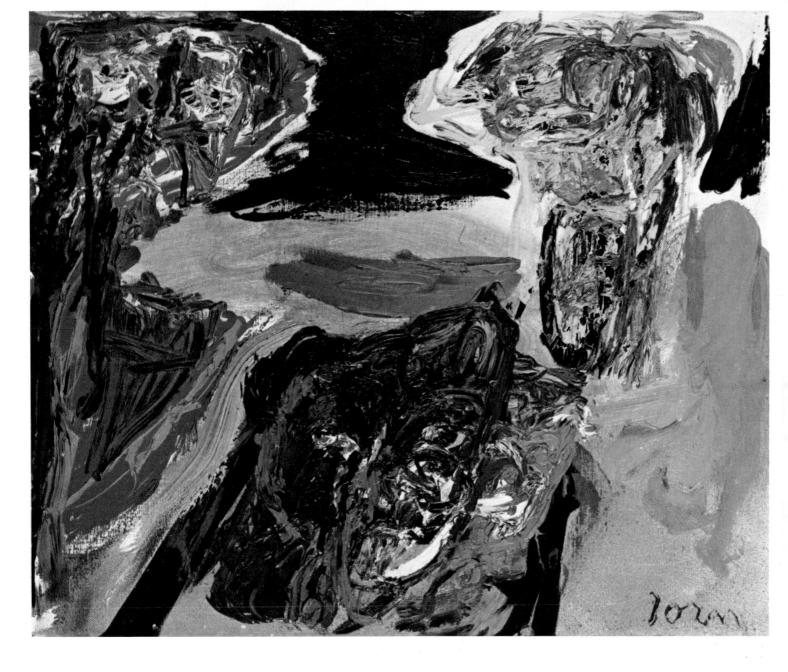

Asger Jorn
Unlimited 1959–60

and Klee influenced his work; but Le Corbusier and Léger also impressed him by their rigorous simplifications. A linear technique slowly gave way to a savage painterliness, and at the height of his powers in the second half of the 1950s, Jorn applied pigment in broad bands and blotches of luminous colour (*Unlimited*, 1959–60). He never altogether abandoned his obsession with myth, and the hallucinatory images of legend lurk within his disturbed, swirling compositions.

Corneille, born Cornelis van Beverloo in Belgium in 1922, studied drawing in Amsterdam. His inspiration is drawn from landscape, and his Informal Abstractionist paintings are tranquil and cheerful, especially in comparison with his excitable colleagues. His early work is indebted to

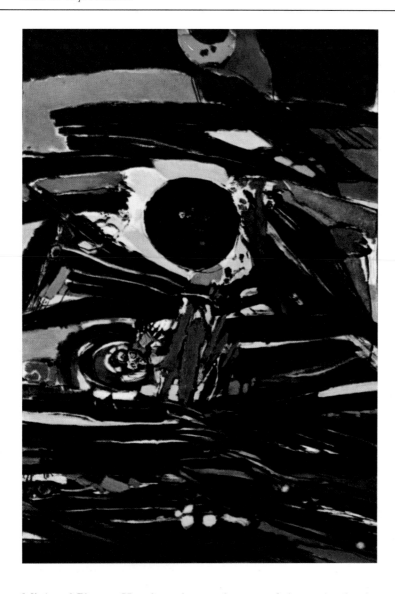

Corneille
Play of Sun on Waves 1958

Miró and Picasso. He adopted a novel means of abstracting landscape, taking a bird's eye view and presenting a flat patchwork of warm colours rather like an aerial photograph of fields. The *Play of Sun on Waves* of 1958 can be recognized as a gestural seascape. More recently he has lightened his palette and produces more fluid designs.

Karel Appel, born in Amsterdam in 1921, is intoxicated by the process of painting, which he regards as a 'tangible sensuous experience'. He has been nicknamed the 'wild beast of colour': not altogether an accidental echo of 'Fauve', for he takes a Matisse-like joy in brilliant primary colour. However, his immediate antecedents were Jorn and his own compatriot De Kooning. His technique, as in the fiery *Two Heads in a Landscape* of 1958, is extremely vigorous: 'My paint tube is like a rocket which describes its own space.' His figures, especially his nudes, have a fetishistic

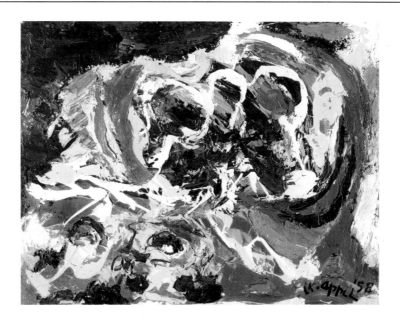

Karel Appel
Two Heads in a Landscape 1958

quality which owes something to primitive art and recalls the spontaneity of children's painting.

British painters, having cultural associations both with the mainland of Europe and the United States, were in a particularly strong position during the transitional post-war period when the leadership of contemporary art was passing from Paris to New York. The St Ives Group came together in the early 1940s round two senior figures, the sculptress Barbara Hepworth and the painter Ben Nicholson, and included Terry Frost, Patrick Heron, Roger Hilton and Peter Lanyon. Although they worked in very different styles, they had in common an interest in abstracting landscape and visual impressions. They exchanged their French heritage for a tactful Abstract Expressionism. It is interesting to observe how William Scott, born in 1913 in Scotland, shifted his allegiance from Gauguin and Cézanne to Rothko and other members of the New York School, and after a visit to New York in 1953 began to open up his canvases into broad 'fields' occupied by flat, symbolic forms.

Patrick Heron, born in Leeds in 1920, was another who was

Patrick Heron
Manganese in Deep Violet: January 1967 1967

Alan Davie
Heavenly Bridge no. 3 1960

encouraged by the reductive example of the American painting. In his paintings, flat, undifferentiated shapes hover against plain grounds (*Manganese in Deep Violet*, January 1967); sharp contrasts of brilliant colour, equalized in intensity, stimulate optical figure/field reversals, and create a visually ambiguous depth.

Alan Davie, another Scot, born in 1920, has always stood apart from the mainstream of British art. For one thing, he identifies himself more firmly than most with the elevated European concept of the role of the artist. His comment that 'the artist was the first magician and the first spiritual leader, and indeed today must take the role of arch-priest of the new spiritualism', has a Rimbaudian ring. Davie's gestural *élan* and his liberating sense of colour set him beside the Cobra group as well as reflecting his discovery of Pollock. However, his main interest is in colour-space relationships which are articulated in structural terms, in a highly individual manner (*Heavenly Bridge No. 3*, 1960). His solid international reputation bears witness to the precision with which he exemplifies the preoccupations of his age.

In a statement of his artistic aims in 1960, Davie identified the general direction in which he and his contemporaries on both sides of the Atlantic were, in their various ways, moving: 'I paint because I have nothing, or I paint because I am full of paint ideas, or I paint because I want a purple picture on my wall, or I paint because after I last painted, something appeared miraculously out of it . . . something strange, and maybe something strange may happen again.'

Glossary

Abstract Expressionism is the term applied specifically to those American painters, discussed on pp. 256–75 of this chapter, who developed a style of painting based on the free, expressive use of colour and on an attempt at spontaneous depiction of the imagery of the unconscious; their later work combines this expressionism with abstraction (the absence of imagery) in works which present all-over configuration (or fields) on a scale which dwarfs the spectator. The marks on the canvas serve as records of the gesture, the 'act of painting'. The all-over field later took the form, in the work of such artists as Newman, of a colour field (see below). The relationship between European and American painting in this vein is discussed here on pp. 254, 285. See the definitions below. The varied terminology reflects differences of usage rather than distinctions of meaning.

Action Painting is an alternative term to describe abstract or semi-abstract paintings dominated by the traces of bold arm gestures; known in Europe as Gestural Abstraction.

Art Brut (raw or crude art) is Jean Dubuffet's expression for the spontaneous art of psychotics, children and those who scrawl on walls.

Art Informel (Informal art) is a term used on the continent of Europe to denote an art based on 'psychic improvisation'; the implication is that what is produced is the trace of a gesture rather than a material shape.

Colour field: the large-scale all-over field of Abstract Expressionism when it appears, as it does in the work of Newman and Still, without gestural marks or all-over configuration.

Gestural abstraction is any abstract art based on the record of a 'gesture' made by the artist as he paints.

Lyrical Abstraction is the term most commonly used to denote the post-war painting in Europe which corresponds to Action Painting in the USA. It combines free handling of paint, the rejection of geometrical abstraction and an interest in simple images derived from the unconscious. Dubuffet, Fautrier, Mathieu and Wols were held to be its leading exponents.

Matière (Matter) painting is any form of gestural abstraction which appears to do violence in some way to the materials used by the artist (Fontana, Tàpies, Burri).

Tachism (from *tache*, 'blot' or 'stain') is a term which has been used, pejoratively, to describe the Fauves and the Impressionists. In the 1940s it came to be synonymous with Action Painting. It equates the painter's mark with the ritual act of painting, and has been applied both to Frenchmen such as Michaux and to Americans such as Pollock.

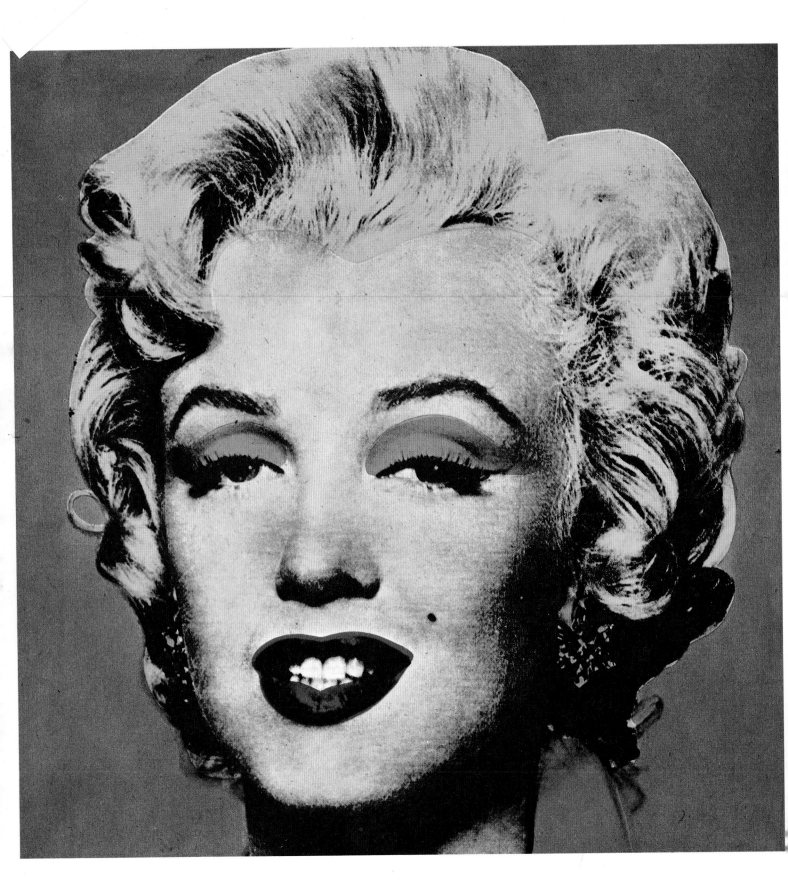

7 *Pop*

SIMON WILSON

The term 'Pop art' refers to a stylistic development in Western art which occurred roughly between 1956 and 1966 in Great Britain and the United States. There were related developments in Europe during the same period.

Pop art has three major distinguishing characteristics. Firstly, it is both figurative and realist, something that avant-garde art had not been since its very beginnings with Courbet's Realism. In 1861 Courbet published a manifesto of Realism in the Paris *Courrier du dimanche* in which he stated that for an artist the practice of art should involve 'bringing to bear his faculties on the ideas and objects of the period in which he lives'. Six years earlier he had stated the same thing in more personal terms in the short manifesto attached to the catalogue of his 1855 exhibition: 'To know in order to be able to do, that was my thought. To be in a position to translate the habits, the ideas, the appearance of my time . . . in a word, to make a living art, that is my aim.' This vitally important idea that artists must deal with the contemporary world and with life as well as with art is also the basis of Pop art. Just over a century after Courbet's manifesto, Roy Lichtenstein, one of the creators of Pop art in America, told an interviewer: 'Outside is the world; it's there. Pop art looks out into the world.'

Secondly, Pop was created in New York and London, and the world it looks out on is therefore the very special world of the great mid-twentieth-century metropolis. Pop is rooted in the urban environment. Not only that, but Pop looks at special aspects of that environment, aspects which because of their associations and cultural level seemed at first impossible as subjects of art. These were: comics and picture magazines; advertisements and packaging of all kinds; the world of popular entertainment, including Hollywood movies, pop music and fairgrounds, amusement arcades, radio, television and tabloid newspapers; consumer durables, especially perhaps refrigerators and automobiles; highways and gas stations; foodstuffs, especially hot dogs, ice cream and pie; and, last but not least, money.

Thirdly, Pop artists deal with this subject matter in a very special way. On one hand they insist that the comic strip or soup can or whatever is simply a 'motif', an excuse for a painting, like an apple in a still-life by Cézanne. Roy Lichtenstein, for example has stated: 'Once I am involved with the painting I think of it as an abstraction. Half the time they are upside down anyway when I work.' On the other hand, whereas in a Cézanne the motif is a traditional and familiar one, and it is easy for the

Andy Warhol
Shot Light Blue Marilyn 1964

spectator to ignore it and concentrate on the formal qualities of the
painting, in Pop art the motif is in no way traditional, is of a kind which
had never before been used as a basis for art, and therefore strongly
engages the spectator's attention.

Not only was the motif of a new kind; its presentation was often
(especially in the work of Roy Lichtenstein and Andy Warhol) startlingly
literal – it looked more like the real thing than ever before in the history
of art. The result was a kind of art which combined the abstract and the
figurative in a quite new way: it was realism, but done in the light and
full knowledge of all that had happened in modern art since the time of
Courbet.

New York

Marcel Duchamp arrived in New York from Paris in 1915. With him he
brought, as a present for his friend, the collector Walter Arensberg, one of
his own works, a part of Paris (some of its air, in fact) simply enclosed in
a glass globe. Duchamp had begun to produce works of this type, called
'readymades', two years before in 1913. They were bits of reality –
usually man-made objects, but sometimes, as with *Paris Air*, taken from
nature – presented as art, either modified ('assisted') or with no more
intervention by the artist than an inscription or just a signature. The first
'assisted readymade' was the 1913 *Bicycle Wheel* (*see* pp. 204–06), and it
was in New York in 1917 that he produced his most notorious
readymade, the *Fountain*, a men's urinal of the wall-mounted type which
Duchamp simply signed R. Mutt (apparently the name of a sanitary
engineer). These works were not intended as sensuous objects but as
demonstrations of an idea. The assisted readymades illustrate the
proposition that the work of an artist – any artist – consists essentially in
the assembling of pre-existent materials, which may perfectly well be

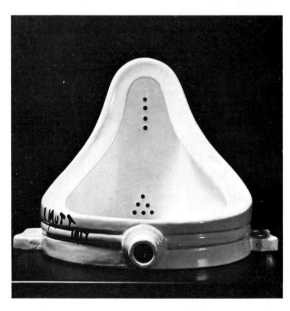

Marcel Duchamp
Fountain 1917

readymade ones. The readymades proper go even further in showing that the creating of art need not necessarily be a manual activity but can be purely a matter of making choices. They also showed that no aspect of the world could be considered to lie outside the artist's scope. These were the ideas that were taken up again in New York (where Duchamp was still living and working) by Robert Rauschenberg and Jasper Johns, and passed on by them to the Pop artists.

In 1955 Rauschenberg made his painting *Bed*, consisting of real bedclothes with paint slurped and dripped over them, the whole then mounted and hung on the wall. This was one of the first of his so-called combine paintings, in which the paint is used to integrate real objects into the work. These paintings, often intruded parts of themselves into the

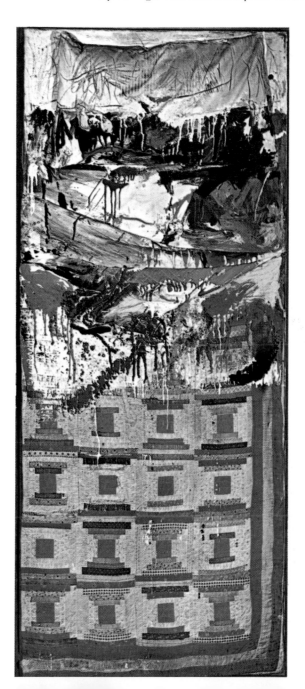

Robert Rauschenberg
Bed 1955

Robert Rauschenberg
Coca-Cola Plan 1958

spectator's space – i.e. they became part of the real world – and it was at the time he was making them that Rauschenberg also made his significant and much-quoted remark that he was operating 'in the gap between art and life'. As well as the combine paintings Rauschenberg made fully three-dimensional works, one of which, *Coca-Cola Plan* of 1958, prominently incorporated three Coca-Cola bottles, objects which were later to become one of the major motifs of Pop art.

Like Rauschenberg, Jasper Johns is both a painter and a constructor of objects, and his contribution to the development of Pop art was, if anything, more significant than that of his fellow artist. Also from about 1955, Johns began to produce extraordinary paintings of familiar, even banal, objects and images, initially targets and the American flag, although later he used maps of the USA and numbers. These motifs possessed three vital qualities for Johns: they were very familiar; they were two-dimensional; and they were simple and visually striking. Depicting a two-dimensional object like the American flag in the two-dimensional medium of painting resulted in works which were at a casual

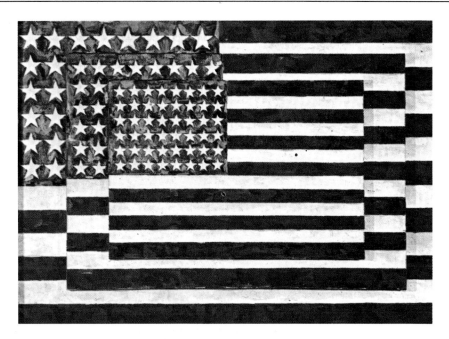

Jasper Johns
US Flag 1958

glance indistinguishable from the real thing, an effect Johns strongly reinforced in some of his flag paintings by taking the flag right to the edge of the canvas and eliminating any illusion of it being an image on a ground. At the same time the flag is a bold abstract design, and Johns's paintings of it are executed in a range of ravishing colours (sometimes close to the original, sometimes not), in a technique of extreme painterly refinement and sensuousness, so that they mark the first appearance in American painting of that combination of strong formal and abstract qualities with familiar, immediately recognizable imagery which is a characteristic of Pop art.

Johns applied the same system in three-dimensional art when he made his famous sculpture of two Ballantyne Ale cans in 1960. More perhaps than the flag paintings, these beer cans looks so close to their source as

Jasper Johns
Ale Cans 1964

almost to preclude the possibility of their being art. But in fact they are beautifully cast in patinated bronze; the labels are meticulously hand-painted; and, thus translated, the twin cylinders assert a strongly sculptural quality.

The new possibilities offered by the art of Johns and Rauschenberg were taken up by the Pop artists in New York partly in reaction against the dominance of Abstract Expressionism. This kind of painting was based on the idea that art should be a direct record of the artist's inner impulses and states of mind, and it was therefore intensely personal and unworldly – precisely the opposite of Pop art, in fact. It manifested itself in a variety of forms, between the two extremes of Jackson Pollock's dynamic, gestural action painting and Mark Rothko's static, softly brushed fields of colour. It was Roy Lichtenstein who best articulated the Pop artists' attitude to Abstract Expressionism when he said: 'art has become extremely romantic and unrealistic, feeding on art, it is utopian, it has less and less to do with the world, it looks inward'. And again, commenting on the situation in the late 1950s when Abstract Expressionism had become hugely successful and was being rapidly debased as a style by second-rate artists: 'It was hard to get a painting that was despicable enough so that no one would hang it – everybody was hanging everything. It was almost acceptable to hang a dripping paint rag, everybody was accustomed to this. The one thing everybody hated was commercial art; apparently they didn't hate that enough either.'

The problem was twofold: art had become inward-looking and unrealistic, and it had become debased through commercial exploitation. The Pop artists' solution was to bring art firmly back into contact with the world and with life, and to look for subject matter that would ensure a degree of unacceptability. It is one of the ironies of art history that, as Lichtenstein wryly points out in his final remark quoted above, Pop art in New York became at least as commercial as Abstract Expressionism, if not more so, and in less than half the time.

Roy Lichtenstein began his career as a painter about 1951 with pictures which were, in his own words, 'mostly reinterpretations of those artists concerned with the opening of the West, such as Remington, with a subject matter of cowboys, Indians, treaty signings'. From 1957 his work became Abstract Expressionist in the prevailing mode, but about 1960, he says, 'I began putting hidden comic images into those paintings, such as Mickey Mouse, Donald Duck and Bugs Bunny. At the same time I was drawing little Mickey Mouses and things for my children and working from bubble gum wrappers. I remember specifically. Then it occurred to me to do one of these bubble gum wrappers, as is, large just to see what it would look like.' The result, he found, was extremely interesting, and thus began his use of advertising and comic strip imagery which in the next few years was to make him one of the most prominent New York Pop artists. Asked why he chose to use such apparently degraded, unaesthetic source material, Lichtenstein spoke perhaps for all the Pop artists when he replied: 'I accept it as being there, in the world. . . . Signs and comic strips are interesting as subject matter. There are certain things that are useable, forceful and vital about commercial art.'

Roy Lichtenstein
Roto Broil 1961

Roy Lichtenstein
Chop 1962

Lichtenstein's early works drawn from advertising, *Roto Broil* (1961), *Chop* (1962), *Woman in Bath* (1963), reveal his striking ability to organize the crude but vital designs of his original sources into unified, powerful and coherent formal structures, while still retaining references to the original so strong that the spectator is constantly kept aware both of the figurative image, with its source (advertisements or comics), and of the traditional physical facts of painting – colour, line, form, composition and so on.

However, the formal, abstract message of Lichtenstein's painting was far from clear to everyone in the early days; many critics complained that he was simply blowing up comic strips and advertisements, that he did not 'transform' his sources. It is important to realize that Lichtenstein does alter his sources, although he still insists that he does not transform them. In 1963, replying to his critics, he said: 'Transformation is a strange word to use. It implies that art transforms. It doesn't, it just plain forms. Artists have never worked with the model – just with the painting. . . . My work is actually different from comic strips in that every mark is really in a different place, however slight the difference seems to some.'

Lichtenstein's working procedure is in fact, as follows: having located a source image he then makes a drawing or sketch of it (just as, for

Roy Lichtenstein
Woman in Bath 1963

example, John Constable would make a sketch of a particular piece of
Suffolk landscape for later elaboration into a full-size painting). The
purpose of the sketch is to recompose rather than reproduce the original,
and although Lichtenstein says he tries to make as little change as
possible he sometimes combines two or three sources into one image or
even makes it up altogether. He then projects the drawing on to the
canvas using an epidiascope and traces it in pencil. Further compositional
adjustments may be made at this stage, before the dots are stencilled on,
the colours applied and the characteristic thick black or blue lines put in.
The dots in particular help to reproduce the feel of the printing process
used for comic strips and advertisements, but Lichtenstein retains too the
bright primaries and impersonal surfaces of his sources, and he once said
that he wanted to hide the record of his hand.

The results of this procedure can be seen in *Roto Broil*, where the
appliance itself, placed symmetrically against a uniform field of red, is
treated in terms of bold simplified masses of black and white. Particularly
striking is the rendering of the drainage holes in the frying-pan as black
discs which take on a life of their own in the same way as they would in a
completely abstract painting such as, for example, Vasarely's *Supernovae*.
The symmetry of the composition is calculatedly broken by the black lines
(paradoxically indicating highlights) on the right side of the appliance
and by the protruding handle of the pan on the same side. And in *Woman
in Bath* the prominent square grid contrasts strongly with the amazing
system of flowing, swelling, organic linear forms which represents the

girl's hair. This ability to create forms and compositions which are powerfully expressive in themselves yet remain readable as vivid representational images lies at the very core of Lichtenstein's genius and is the source of the extraordinary richness and complexity of his paintings.

Between 1963 and 1965 Lichtenstein produced two large groups of paintings which stand out from the rest of his work. In them forms, lines, colours, are increasingly abstract and expressive in themselves, and at the same time subject matter comes into greater prominence: based on romance and war comics respectively, these two groups of works deal with some of the fundamental dramas of human life. *M – Maybe* of 1965 depicts a girl (very attractive as in all Lichtenstein's love-comic paintings) waiting for a man (a theme taken up in a number of these works) in an imprecise but emphatically urban setting. Both her expression and the caption, 'M – Maybe he became ill and couldn't leave the studio', make it clear that she has been waiting a long time and is worried. Beyond that, like a Victorian narrative painter, Lichtenstein invites the spectator to speculate: who is the girl? who is the man with the studio? film star,

Roy Lichtenstein
Sweet Dreams, Baby

Roy Lichtenstein
As I Opened Fire . . . 1964

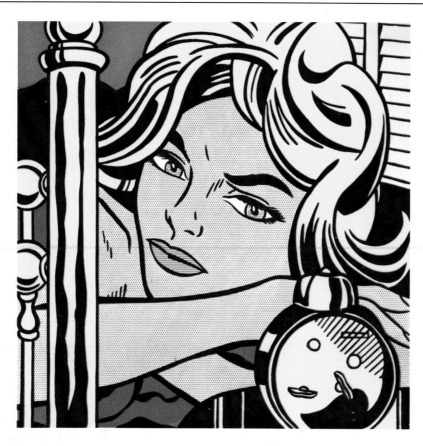

Roy Lichtenstein
Blonde Waiting 1964

photographer, broadcaster, artist even? and what is the nature of the
situation? has he stood her up for another woman? is he really ill? fatally
injured perhaps?

Sweet Dreams, Baby, like the war images, is an icon of aggression,
depicting as it does the single knockout blow that every man secretly
wishes he could deliver in answer to an insult, to settle an argument, to
win or protect a girl, and it refers to the American ideal of masculinity in
more ways than one: the fist is a very clear phallic symbol, and although
the recipient of the blow is a man the words of the caption, 'Sweet
dreams, baby!' could equally well be addressed to a girl and take on an
erotic implication. There is an interesting subgroup of the romance-comic
paintings which consists of paintings exclusively of girls' heads. One of
these is the *Blonde Waiting* of 1964, one of the most beautifully and most
strangely composed of all Lichtenstein's paintings, one of the masterpieces
of Pop.

Andy Warhol was born in Pittsburgh, USA, probably in 1928. He
went to Carnegie Institute of Technology in Pittsburgh from 1945 to
1949, then moved to New York where he remained. During the 1950s he
worked as a commercial artist and was highly successful, winning the Art
Directors' Club Medal for Shoe Advertisements in 1957. He had several
one-man exhibitions of drawings and published a number of books of
drawings on a variety of themes (cats and boys were two of them). His life

style at this time was affluent and elegant, and he collected art, having, it appears, a particular taste for Surrealist paintings (he owned works by Magritte among others).

In 1960, at the same time as, but quite independently of, Roy Lichtenstein, he began to make paintings based on comic strips and advertisements. One of the earliest of these is *Dick Tracy* of 1960, which still shows strong Abstract Expressionist influence: the caption is partially obscured by loosely brushed paint, drips of paint run down over Tracy's face, and that of his companion is treated partly as hard, comic-strip outline and partly again as loosely brushed paint. Thus, as in a work of Rauschenberg of the mid 1950s, popular imagery is still being integrated into a painterly structure, although Warhol is already presenting that imagery in a much more dispassionate manner than ever Rauschenberg

Andy Warhol
Dick Tracy 1960

Andy Warhol
Green Coca-Cola Bottles 1962

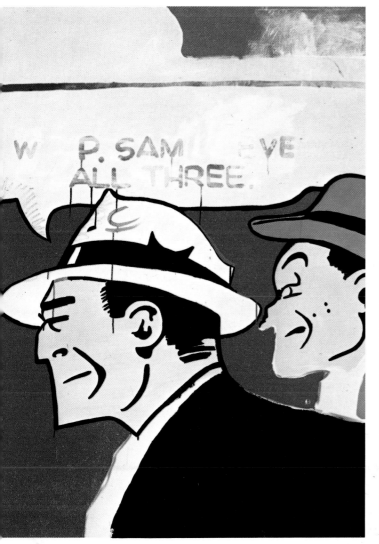

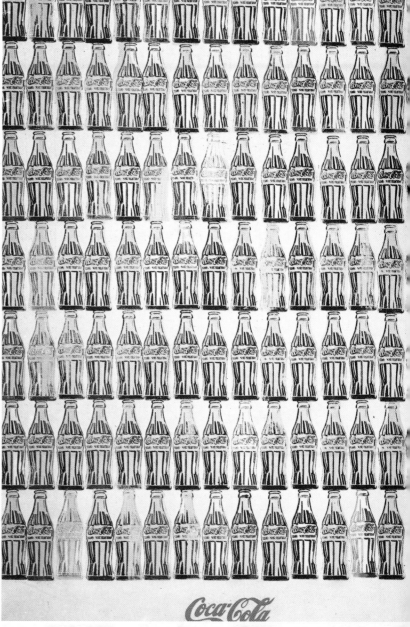

did. Unlike Lichtenstein, Warhol almost immediately abandoned comic-strip imagery, probably as being too anecdotal, and began to base his work on commercial and popular images that were much less obviously chosen by the artist with an eye to their content or visual quality. Indeed one of the crucial qualities of Warhol's images is their extreme obviousness: the most famous brands, Campbell's Soup, Coco-Cola; the most famous people, Elvis, Marilyn Monroe, Elizabeth Taylor; the most famous painting of the past, the Mona Lisa; the most familiar objects, dollar bills, newspapers. And when the individual image is chosen in itself an unfamiliar one, as with the car crashes, electric chairs, race riots, H-bomb explosions and so on, it always belongs to a category of images very familiar through the mass media. The effect of this choice of imagery is to give the baffling impression, even more strongly than in the case of Lichtenstein, that the artist has no interest in his images, that he is making no comment, that the images have no particular significance. Further, Warhol presented them in such a way that they appeared to have undergone little or no processing by the artist – they had not been 'transformed' into art, although his early paintings were in fact meticulously hand-done.

In 1962 he began to make his paintings by the silk-screen printing process, a sophisticated form of stencil usually used by artists for the multiple production of graphic work. Not only did he take the unprecedented step of using a printing process for the production of paintings but he adopted a recent commercial development of silk-screen printing whereby the image, instead of being laboriously cut by hand, is applied to the screen by photo-mechanical means. The actual printing Warhol did continue to do by hand, although it would often be carried out by an assistant under his supervision. In adopting this mechanical method Warhol seems to have simply been pursuing the logic of an art based on mass-produced imagery. But its effect, combined with the banality of his images, was to make his paintings appear completely meaningless, and this was reinforced by his frequent practice of repeating his images, often a large number of times, either on the same canvas or on separate canvases in series.

Of course, the paintings are not really meaningless. Warhol's images, in spite of their familiarity, in spite of their ready availability elsewhere than in his paintings, in spite, or even because, of their dispassionate presentation, remain extremely potent. His work, looked at overall, reveals certain constant and significant preoccupations with fame, with glamour, with death, with violence and disaster and with money. Nor do the images lack formal or aesthetic significance. Repetition is the means that Warhol used to reduce them to the status of elements in the composition – Cézanne's apples again. The spectator's attention is directed away from the image as such and towards a consideration of what the artist has done to it. A close scrutiny of say *200 Campbell's Soup* or *Marilyn Diptych*, both early silk-screen paintings, reveals that no single image is quite the same as any other. There are for example variations in paint texture and density which affect the detail, and the colours are sometimes out of register, producing distortions of form. Even *Cow Wallpaper* is more comic statement than mechanical repetition.

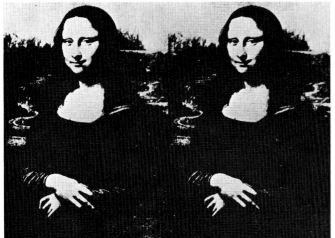

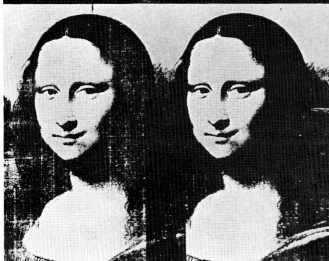

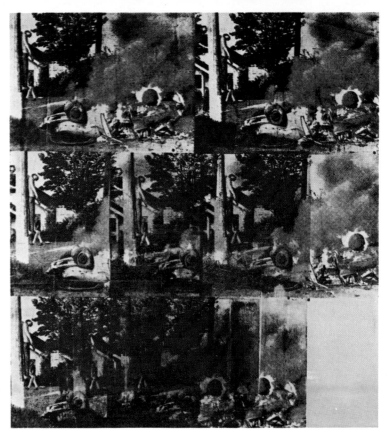

Andy Warhol
Green Disaster 1963

Andy Warhol
Four Mona Lisas 1963

As John Copland has pointed out, 'Though the silk-screen process is simple many things can go wrong. For instance, if the medium is stroked across the image unevenly, if the density of the medium varies, if the squeegee is worn or dirty, or if there is insufficient medium to complete a stroke, the image will not print evenly. Parts of the image will become occluded or the dirt will print tracks, etc. The sharpness of the image will also vary according to the pressure exerted on the squeegee, or the angle it is held at. Many of these defficiencies will often work their way into the mesh and, unless the screen is cleaned, will show up in subsequent images. These normally accidental effects are often deliberately sought by Warhol.' So in Warhol's hands the silk-screen becomes a highly flexible means of creating expressive paint surfaces and forms. He exercised far more control over the production of his work than is generally supposed. As Richard Morphet tells us, 'Those who physically helped to make paintings in The Factory [Warhold's name for his studio] have explained how in even the most casual-seeming serial paintings Warhol was minutely concerned about the degree of painterly texture in background colours, and the exact choice of colour itself, not always taking it straight from the can but often mixing it into new hues and testing on strips of canvas until the desired shade was obtained'. Furthermore, Warhol

frequently heightened his screened images with touches of colour applied with a brush (he did this in some of the *Marilyn* paintings for example); and of course both the arrangement of the images (in regular rows, or occasionally in slightly more complex configurations, as in *Mona Lisa 1963*, where some of the images are on their side) and the determining of the relationship of the image or block of images to the ground are conscious compositional procedures.

There is no doubt that the most striking formal aspect of Warhol's painting is his vivid, varied and highly expressive use of colour, ranging from the close correspondence to the original in *200 Campbell's Soup* through the sinister monochrome washes of *Orange Disaster* and *Green Disaster*, and the sumptuous and subtle harmony of orange, blue and yellow of *Marilyn Diptych*, to the stunning variations (to which no

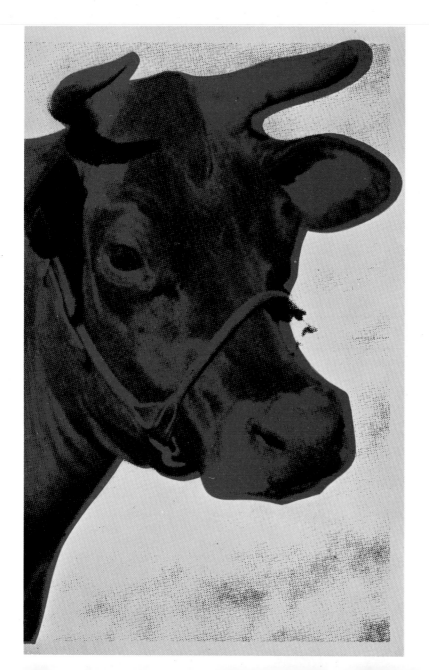

Andy Warhol
Pink Cow (Cow Wallpaper) 1966

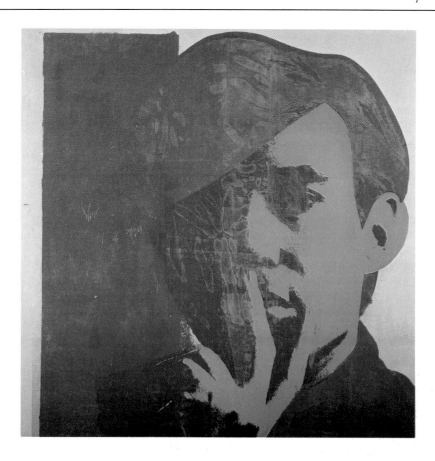

Andy Warhol
Self-portrait 1967

reproduction can remotely do justice) of the *Marilyn* prints of 1967.
Finally, the almost complete dissolution of the image by intense and
vibrant colour takes place in the great *Self-Portraits* of 1967.

In these, among his last works before he abandoned painting for film
making and other activities, the wheel has turned full circle: after his first
portraits of Marilyn in 1962 Warhol himself became a star, a celebrity,
became in fact a subject for his own art. But these self-portraits must be
among the most self-effacing in the history of art: the image is difficult to
read, and deciphering it brings the realization that Warhol has based the
painting on a photograph taken with his hand in front of his face half
hiding it. Once again, and more forcibly than in any of his previous work,
he is directing our attention away from the image, to the painting as
something to look at in terms of coloured surfaces as you would look at a
Monet or a Matisse. As he himself said, 'I think painting is the same as it
has always been. It confuses me that people expect Pop art to make a
comment or say that its adherents merely accept their environment. I've
viewed most of the paintings I've ever loved – Mondrian's, Matisse's,
Pollock's – as being rather deadpan in that sense. All painting is fact and
that is enough; the paintings are charged with their very presence. The
situation, physical ideas, physical presence – I feel this is the comment';
and: 'If you want to know about Andy Warhol just look at the surface of

my paintings and films and me and there I am. There's nothing behind it.'

Claes Oldenburg was born in Sweden in 1929 and brought to the United States, where his father was on diplomatic service in New York, as a small child. In 1936 the family moved to Chicago, where Claes grew up and after taking a degree in Art and Literature at Yale University became an apprentice newspaper reporter. In 1952 he decided to become an artist and for two years attended the Art Institute of Chicago. In 1956 he moved to New York and settled on the Lower East Side, an area he has continued to live in, and which has exerted an important influence on him. From the beginning he had an exceptionally strong sense of engagement with the urban environment, 'the experience of the city', but in a significantly different aspect of it from those which had drawn the attention of Lichtenstein and Warhol: 'The streets, in particular, fascinated me. They seemed to have an existence of their own where I discovered a whole world of objects that I had never known before. Ordinary packages became sculptures in my eye, and I saw street refuse as elaborate accidental compositions.'

The results of this activity, his first mature works, were shown in two exhibitions at the Judson Gallery in 1959 and 1960. The second of these exhibitions was actually called 'The Street', and consisted of figures, signs and objects constructed from discarded or fragile materials: cardboard, paper, sacking, string. Many of the works were *Ray Guns* – strange objects made in a variety of materials but based on the ray gun of space comics, a kind of mascot and basic form for Oldenburg that engenders endless variations. It is a symbol of the city itself – Ray Gun spelt backwards is Nug Yar, which Oldenburg says sounds to him like New York – and as a phallic symbol also it relates to another of Oldenburg's fundamental preoccupations: the erotic. Taken as a whole, the exhibition was an extraordinary poetic evocation of the city through the medium of some of its humblest and least valued materials.

In the autumn of 1960, recalls Oldenburg, 'I drove around the city one day with Jimmy Dine. By chance we drove through Orchard Street, both sides of which are packed with small stores. As we drove I remember having a vision of 'The Store'. I saw, in my mind's eye a complete environment based on this theme. Again it seemed to me that I had discovered a new world, I began wandering through stores – all kinds and all over – as though they were museums. I saw the objects displayed in windows and on counters as precious works of art.'

In late summer 1961, Oldenburg moved to a studio in East Second Street which became 'The Store', filled with sculptures of food, clothing and other objects, made mainly of chicken-wire and plaster-soaked muslin or sacking, cheap and commonplace materials as before. In September 1962 he extended the idea of 'The Store' in a second version shown at the Green Gallery.

'The Store' sculptures were brightly, even vividly painted. Their colour is a very significant aspect of them; they are paintings as well as sculptures – and, as Oldenburg has stated, the paints themselves carry a direct reference to their source in the urban store: 'The Street was a metaphor for line. The Store became a metaphor for colour. In an East

Side paint store, I found a line of paints, Frisco Enamel, which came in seven particularly bright colours that seemed to symbolize the store to me. These colours became my palette. The paint would be used straight from the can without any mixing or blending of colour to paint reliefs of store objects.'

These works – *Giant Blue Pants, Breakfast Table, Kitchen Stove, White Shirt and Blue Tie* are a few of them – do not, as a work by Warhol or Lichtenstein does, refer you immediately to their source in the outside world. Some of them, it is true, incorporate real objects – the stove and the table for example – but these are primarily a means of display, like a sculpture pedestal in a museum. The effect of the reliefs of the store objects themselves is to stimulate the imagination. They are pants, shirt, food; but they could also be almost anything else, or simply abstract shapes, accumulations of plaster and paint. This effect has been well

Claes Oldenburg
Kitchen Stove 1962

described (as reported by the critic Rublowsky) by a visitor to Oldenburg's studio who noticed an object he had made. 'It was a vaguely wedge-shaped piece of plaster crudely spattered with aluminium paint. He picked it up and tried to identify it. "It's a lady's handbag," he said, as he turned the object about his hand. "No, it's an iron. No, it's a typewriter. No, it's a toaster. No, a piece of pie." Oldenburg was delighted: the object, which was nothing more than a shape the artist had been toying with, was exactly what the visitor had described. All the objects he named were embodied in that small wedge-shaped bit of plaster.'

This equivalence of form, the way in which one form can simultaneously relate to many other forms, fascinates Oldenburg and is the basis of his art.

In the second 'Store' exhibition Oldenburg showed a number of sculptures which differed from those in the rest of the show, and from his earlier works, in two important ways. Some of them had been enormously scaled up, like the *Hamburger, Popsicle, Price*, which is three feet (0.9m)

Claes Oldenburg
Hamburger, Popsicle, Price 1962

Claes Oldenburg
Giant Soft Swedish Light Switch 1966

Claes Oldenburg
Giant Fireplug 1969

Claes Oldenburg
Trowel Scale B 1971

high; and some of these were, a thing unprecedented in the history of sculpture, soft and yielding rather than hard and unchanging. One of the earliest of these soft sculptures was the *Floorburger (Giant Hamburger)* of 1962, which is seven feet (2.13m) across and a little over four feet (1.21m) thick. It is made of canvas filled with foam and cardboard and painted.

Both these changes related to Oldenburg's interest in the equivalence of forms. The change in scale of the hamburger opens up a whole new range of references, and, by removing the art object even further from its original source, draws the spectator's attention even more strongly than before to the purely sculptural qualities of the work: its shape, colour, texture and so on. This concern for scale culminated in the plans for giant monuments which Oldenburg drew up from 1965 onwards. These monuments are colossal versions either of street furniture, like the *Giant Fireplug* which Oldenburg has imagined placed in the Civic Centre in

Chicago, or of everyday objects, like the *Trowel Scale B*, one of the
regrettably few Oldenburg monuments to have been built and installed.

The change from hard to soft was even more far-reaching; for a soft
sculpture does not just passively refer to other forms but can actually
metamorphose, change its shape. A soft sculpture by Oldenburg never
looks the same in successive installations; and while it remains installed
the action of gravity produces gradual changes: Oldenburg actually
harnesses a fundamental natural force as part of the sculptural process.
The *Giant Soft Swedish Light Switch* of 1966, with its mysterious sagging
forms, is a marvellous example of this.

Claes Oldenburg has tried to create an art which is universal in its
significance. Taking his point of departure from the specific and familiar
in everyday life, he has attempted to make sculptures which stand for
everything: sculptures that are embodiments of and metaphors for the
whole of life. That this is his aim is made quite clear in his statement, one
of the most moving manifestos in the history of modern art, first published
in 1961:

'I am for an art that is political–erotical–mystical, that does something
other than sit on its ass in a museum.

'I am for an art that grows up not knowing it is art at all, an art given
the chance of having a starting point of zero.

'I am for an art that embroils itself with the everyday crap & still
comes out on top.

'I am for an art that imitates the human, that is comic, if necessary, or
violent or whatever is necessary.

'I am for an art that takes its forms from the lines of life itself, that
twists and extends and accumulates and spits and drips and is heavy and
coarse and blunt and sweet and stupid as life itself.'

James Rosenquist studied art at the University of Minnesota from 1952
to 1955. During one of his summer vacations he took a job with an
industrial decorating company, travelling through the Midwest painting
the outsides of warehouses and enormous grain storage bins. In 1955 he
won a scholarship to the Art Students' League in New York where he
completed his studies. In the following years he supported himself in a
number of different jobs, but in particular he worked for some time
painting billboards for an advertising company. Both the industrial
decorating and the billboard painting clearly had a considerable effect on
his development as an artist, affecting his subject matter, the overall scale
of his work, and particularly his sense of scale *within* the painting, as well
as his highly individual way of composing.

Recalling the first of his jobs, Rosenquist said: 'Now picture this scene:
there's this stretch of wall at least as big as a football field and way down
in one corner is this man with a bucket of paint.' Speaking of the time he
worked on the thirty- by one-hundred-foot billboard of the Astor-Victoria
cinema in Times Square, he said that he had the opportunity 'to see
things in a new relationship'. Working on a particular bit of figure or
letter of the alphabet, 'you couldn't see the whole thing at once, it was
like infinity . . . everything looked different'. These statements have a
direct reference to the pictorial devices used in Rosenquist's paintings like
I Love You with my Ford (1961), one of his earlier masterpieces, in which

James Rosenquist
I Love You with my Ford 1961

enormous out-of-focus fragments of Ford motor car, girl's face, spaghetti in tomato, are brought together to express the erotic theme implied in the title: the Ford phallic symbol looms over the face of the girl, her eyes closed and lips parted in ecstasy, while below the consummation is somehow symbolized by the writhing, glutinous masses of spaghetti. Rosenquist's pictures reflect his own experience of billboard painting, but they also reflect the similarly fragmented kaleidoscopic visual experience of the city dweller as he walks through busy streets with buildings and hoardings towering over him or catches a brief glimpse of them from the windows of a car or bus.

Tom Wesselmann's university career was sporting rather than scholarly or artistic, and it was only when he was drafted into the army that he began to learn to draw, with the ambition of becoming a cartoonist. With this in mind, after leaving the army he enrolled at the Cincinnati Art Academy and then spent from 1957 to 1960 at the Cooper Union art school in New York. It was there that he discovered painting and the world of art, and towards the end of his final year he abandoned cartooning altogether and turned his whole attention to painting and collage. His early collages involved old newspapers, rags, leaves and old package labels used for the sake of their colour and texture, but a crucial

Tom Wesselmann
Great American Nude no. 99 1968

development in his art took place in 1960 when he began to use collage
elements to represent themselves, and combined them with paint in works
dealing in a new way with two traditional themes – the nude and the
still-life. The subjects of his still-lifes are taken from billboard
advertisements for food, drink, cigarettes and consumer durables (these
last often represented by the real thing, so well integrated into the
composition that it is difficult to tell whether it is painted or not).

Wesselmann's nudes, most of which belong to the series of *Great
American Nudes* which he started in 1962 and is still continuing, derive
their formal strength and qualities from Matisse, an important influence
on Wesselmann; but they refer also to the soft-core porn glamour nude of
the *Playboy* type of magazine. However, they are often both more frankly
and more effectively erotic than any *Playboy* nude; and perhaps
Wesselmann's greatest achievement has been to fill a long-standing gap in
the history of art by fully eroticizing the nude in 'high-art' painting.

Robert Indiana uses words as images, and presents them in his
paintings, not only as forceful visual experiences but also as injunctions,
slogans or messages to the spectator. These words relate to the American
Dream and other aspects of American life which, however, Indiana does
not accept without comment. It is pretty hard to swallow the whole thing
about the American Dream. It started the day the Pilgrims landed, the
dream, the idea that Americans have more to eat than anyone else. But I
remember going to bed without enough to eat.' In his 1961 painting
titled *The American Dream*, and in the later *Demuth Five*, the dream is seen
in terms of a pinball game where winner takes all and a false move brings
up the tilt sign. Using hard-edged imagery taken from the pinball
machine, and flat areas of very bright colour, Indiana incorporates his
message in a particularly abstract, impersonal and deadpan form, and he
once said: 'I still use a brush because I have not found a machine

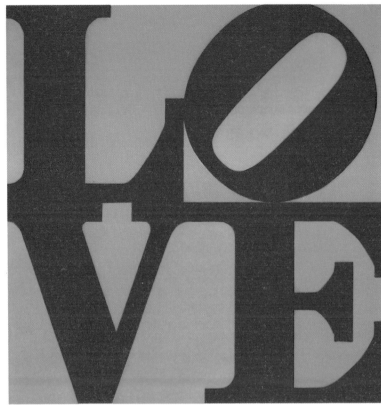

Robert Indiana
The Demuth Five 1963

Robert Indiana
Love 1967

inexpensive enough to take its place.' Other paintings simply proclaim
EAT, DIE, HUG, ERR, or, most famous of all, with its flat interlocking areas
of shimmering complementary colours, LOVE.

 Allan D'Arcangelo had his first exhibition in New York in 1963, by
which time Pop art was thoroughly established. However, he at once
made his own a particular area of imagery – the American highway –

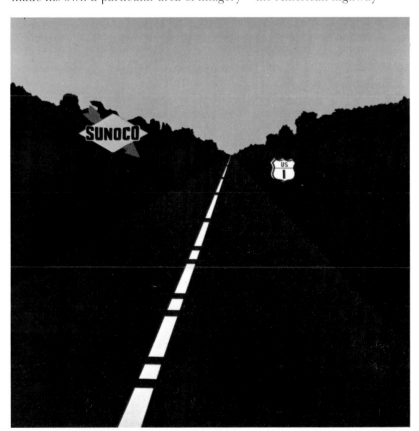

Allan D'Arcangelo
Highway no. 2 1963

and has produced a whole series of paintings like *Highway No. 2* (1963), in which the immense distances of the United States are romantically evoked through the use of zooming perspective and the imagery of road signs. Like Robert Indiana, D'Arcangelo paints in an extremely tight, flat manner, his imagery always subsumed in a precise geometric composition.

The West Coast

American Pop art was created and developed in New York, but found rapid and early acceptance and a particular individual character on the West Coast, where activity was focused on the two centres of Los Angeles in the south and San Francisco in the north. Los Angeles emerged as the more important centre, and was the first to recognize the genius of Andy Warhol, giving him his first one-man show as a fully fledged Pop artist in 1962. The city of Los Angeles itself, perhaps the most extraordinary urban environment in the world, was an important influence on West Coast Pop, and it is also, of course, the home of Hollywood, itself an important influence on Pop art everywhere. Equally significant were the various exotic subcultures that flourish in the area: those of the surfer, the hot-rodders, the drag-racers, the car customizers and the outlaw motor cycle clubs like Satan's Slaves and, most famous of all, Hell's Angels.

Commemorated in the title of Tom Wolfe's essay *The Kandy Kolored Tangerine Flake Streamline Baby*, the amazing paint jobs and baroque bodywork created by the car customizers and the elaborate decorations of the California surfboards are examples of an industrial folk art of great impact and brilliance which set the tone for much West Coast Pop art. So too were the bizarre drag-racing cars and hot rods, and so was the Hell's Angels' 'chopped hog', a Harley-Davidson 74 which in the hands of the Angels was stripped down and rebuilt to become virtually a mobile piece of sculpture. The Angels' uniform was also a rich item of folk art, particularly the sleeveless denim jacket bearing the 'colours': a winged skull wearing a motor cycle helmet with the name Hell's Angels above with, below, the letters MC and the local chapter name, e.g. San Bernardino. These jackets were further decorated with chains, swastikas and other signs, slogans and emblems: such as the number 13 (indicating use of marijuana), and the notorious red wings.

The world of customizing and of the big bikes is strongly reflected in the work of one of the two major Los Angeles Pop artists. Billy Al Bengston has worked since 1960 on a series of paintings of chevrons and motor-bike badges and parts treated as heraldic devices, the images placed centrally on the canvas and painted in glowing colours with immaculate precision and a high degree of finish. About 1962 his painting took on an even greater richness and gloss, when he began to use sprayed cellulose paint on hardboard and later actually on sheets of metal, thus getting even closer to the technique and medium of his sources. Some of these metal sheet works are artfully crumpled, thus adding a suggestion of accident and death to the glamorous perfection of the painted emblem.

The other major Los Angeles Pop artist is Ed Ruscha (pronounced, the artist insists, as Ruschay). He began using Pop imagery (packaging) in

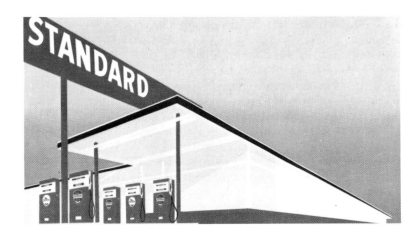

Edward Ruscha
Standard Station, Amarillo, Texas 1963

1960 in paintings like *Box Smashed Flat*, where presentation of commercial imagery and what looks like Edwardian commercial lettering is still combined with a painterly style. But his painting quickly took on an almost inhuman exquisiteness, precision and perfection of finish, as in *Noise . . .* of 1963.

Like Indiana, Ruscha is fascinated by words, and these have always formed the principal subject matter of his paintings and graphics. In some works the words appear in isolation floating against backgrounds of beautifully graded colour that give a feeling of infinite coloured space. Sometimes associated images are introduced, such as the cocktail olive in *Sin*, and somtimes the word is given a specific context, as with the company names (e.g. 'Standard') for which the architecture becomes a

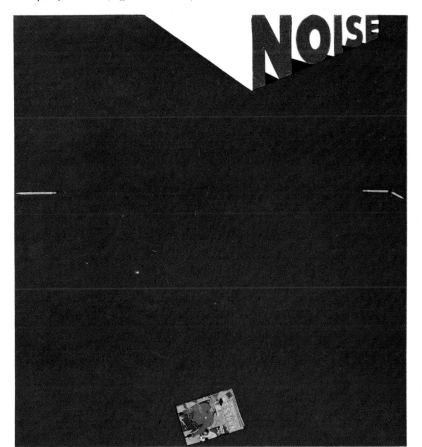

Edward Ruscha
Noise, Pencil, Broken Pencil, Cheap Western
1963

setting in Ruscha's garage paintings (*Standard Station, Amarillo, Texas*). One lithograph, where the word Hollywood streams unforgettably out of the sunset in the steep zooming perspective and giant lettering of wide-screen title sequences, exemplifies the manner in which Ruscha depicts his words in such a way that their meaning is conveyed pictorially as well as verbally.

Garages in themselves are one of Ruscha's most important motifs after words. They first appear in his work in 1962, not in painting or graphic work, but in a book: *Twenty-six Gasoline Stations*, consisting of 26 absolutely deadpan, factual, non-arty photographs of Western garages. The attitude behind these photographs comes very close to that of the New York Pop artists, and especially Warhol: the acceptance of aspects of the world which no one had considered in an art context before. *Twenty-six Gasoline Stations* was followed by *Various Small Fires* (1964), *Some Los Angeles Apartments* (1965), *On the Sunset Strip* (1966, a twenty-seven foot fold-out continuous photograph of every building on the Strip), *Thirty-four Parking Lots* (1967) and others. As with Warhol's work, the nature of the motif eventually directs the spectator's attention to the manner of its presentation. Ruscha's books are beautiful visual objects, models of cool elegance and immaculate typography, finely printed in limited editions at the artist's expense, although there is little of the connoisseur in his attitude towards them; asked once about the expense of production he replied: 'It's almost worth the money to have the thrill of seeing 400 exactly identical books stocked in front of you.' In the end it seems certain that these will be his most significant contribution to Pop art.

In North California, Pop art was similarly dominated by two major artists, who, like Bengston and Ruscha, have a certain amount in common both in their technique and in the way they handle their imagery.

Wayne Thiebaud employs thick, luscious and brilliantly hued paint to depict, as he says, 'Things which I feel have been overlooked. Maybe a lollypop tree has not seemed like a thing worth painting because of its banal references.' Thiebaud's subject matter consists mainly but not exclusively of cakes, sweets, pies, ice-creams and similar goodies which he presents in the usual deadpan, frontal or repetitive way of Pop art. But the way he actually paints these items is unique to Thiebaud: he uses the paint not to depict them illusionistically but to recreate their textures and colours. Thiebaud has explained that his interest is in 'what happens when the relationship between paint and subject matter comes as close as I can get it – white, gooey, shiny, sticky oil paint spread out on top of a painted cake to 'become' frosting [icing]. It is playing with reality – making an illusion which grows out of an exploration of the propensities of materials.' *Refrigerator Pies* (1962) is typical of Thiebaud's work; and if in the end his paintings, like this one, have a highly synthetic as well as edible look about them it is because his source material itself is largely synthetic.

Mel Ramos uses similarly luscious paint but to rather different ends: he does not imitate textures like Thiebaud, nor does he interest himself in the same type of subject matter. After an early phase about 1962–63 of painting comic-book heroes and heroines, Ramos quickly found his own

Wayne Thiebaud
Refrigerator Pies 1962

specific and personal iconography of nude pin-up girls. These young
ladies are depicted by Ramos in often quite explicit sexual situations with
either appropriately phallic forms of packaging, consumer goods or food
like Coca-Cola bottles, cigarettes (in *Philip Morris*), a corn cob (in *Miss
Corn Flakes*) or, particularly in later works, with various animals, either
symbolically phallic such as weasels and pelicans, traditionally highly-
sexed like monkeys, or simply representative of brute maleness – gorillas
for example. *Ode to Ang* plays a favourite Pop game with high art (the
source is Ingres); and in depictions of girls with pumas and other big cats
he has extended his range of erotic feeling by introducing an element of
refined, almost decadent perversion. Ramos's art is probably intended as

Mel Ramos
Philip Morris 1965

Mel Ramos
Ode to Ang 1972

mild parody of the obvious Freudianism of Madison Avenue, but there is
no doubt that it is also extremely enjoyable for what it is: light hearted,
witty, glamorous, very high-quality pornography.

Great Britain

By the time artists in the USA began to take up modern urban culture
and its imagery as a source for their art, Pop art had already established
itself in Great Britain and embarked on an entirely distinct and separate
development which was influenced by American life, as seen through the
mass media, but not by American art. In the late 1940s two artists
emerged who were to have an important influence on the development of
British Pop art. These two precursors were Francis Bacon and Eduardo
Paolozzi.

From 1949 onwards Bacon began to use photographs, from mass-media sources among others, as a basis for his paintings. They were always considerably transformed, it is true, but Lawrence Alloway, a critic who was around when these paintings first appeared, has written of the earliest of them, the series of screaming heads of 1949, that 'the photographic reference was conspicuous and much discussed at the time'. The source image for these (and many later works) was a still from Eisenstein's film *Battleship Potemkin* (1925), a close up of the face of the wounded nurse in the Odessa steps massacre sequence. He later moved on to using photographs by Eadweard Muybridge, made in the 1880s, of animals and humans in motion, and another major source has been *Positioning in Radiography*, a medical textbook on the making of X-ray photographs.

At the same time as he began to use photographs, Bacon also established the practice of basing paintings on works of art from the past. Here, one of his most important sources has been a reproduction of the famous portrait of Pope Innocent X by Velázquez in the Palazzo Doria in Rome, although significantly enough Bacon has never seen the original, and once, when he was in Rome, did not take the opportunity to do so.

Above all, Bacon combines in his paintings powerfully evocative images with equally forceful formal statements. Painting, he wrote in 1953, should be concerned 'with attempting to make idea and technique inseparable. Painting in this sense tends towards a complete interlocking of image and paint, so that the image is the paint and vice versa. Here the brush stroke creates the form and does not merely fill it in. Consequently every movement of the brush on the canvas alters the shape and implication of the image.' In spite of the clarity of his published views, many of his early critics discussed Bacon's work exclusively in terms of its imagery, ignoring its formal statement, just as they later did with the work of the Pop artists.

Finally, as Alloway has pointed out, 'Bacon was the only painter of an earlier generation who was regarded with respect by the younger artists in London. Moore, Nicholson, Pasmore, Sutherland . . . were considered to be irrelevant to any new art in the 1950s'. An important reason for this respect was the tough, uncompromising quality of his art and indeed its positive offensiveness to the then current standards of taste. Even as late as 1962 it was possible for one of London's leading critics to write of Bacon: 'Cruelty, ambiguous sex, a penchant for the perverse, all these occur in his art . . . he both gloats over the unusual and derives stimulus from the decadence he paints.' Any older artist capable of evoking this kind of response must have appealed greatly to the rebellious young.

While Francis Bacon stands as a father figure to British Pop art, Eduardo Paolozzi, born in Edinburgh of Italian immigrant parents in 1924, played a direct and crucial part in its development. From the earliest steps of his art education at Edinburgh College of Art, where he went in 1941, Paolozzi displayed a strong interest in popular culture and drew disapproval from his teachers for copying pictures of aeroplanes, footballers and film stars. At this time he also began making collages of material taken from magazines and other sources, including images from science fiction, aviation technology, advertisements for food, domestic

appliances and cars, comics, films, pin-ups, newspapers and medical diagrams. Some of these collages are direct and amazingly early harbingers of Pop art: *I Was a Rich Man's Plaything* of 1947, for example, not only has the word Pop in it but also contains a pin-up, a part of a food advertisement, and, most remarkable of all, a Coca-Cola bottle and the Coca-Cola sign simply presented, in an emblematic way, as they so often were to be in Pop art more than a decade later.

The fact that Paolozzi's teachers disapproved of his interest in popular culture is highly significant. As John Russell says, 'Pop was a resistance movement: a classless commando which was directed against the Establishment in general and the art-Establishment in particular. It was against the old-style museum man, the old-style critic, the old-style dealer and the old-style collector' and Richard Morphet has written that 'important roots of British Pop art lie in the anti-elitist attitudes of a generation whose daily life in their formative years steeped them exceptionally thoroughly in their eventual source material, the admass culture of modern life.'

British Pop art grew out of a whole generation's rejection of upper-class culture and out of a revolt within the art education system itself, against the provincialism and parochialism of English art colleges, where at that time Sickert and John were names to conjure with while Picasso and Matisse were considered dangerous foreigners.

Paolozzi was one of the first young artists to implement this revolt, and, as soon as he had finished at the Slade School in 1947 (he did not bother to sit the diploma examination), he removed himself to Paris where, at least, modern art was taken seriously.

In the early 1950s the Institute of Contemporary Arts in London was an informal meeting-place for artists, architects and writers, where they could drink and talk and the artists could show their work in the tiny gallery. In 1952 the management apparently began to feel that it had lost touch with the younger generation, and the result was the creation of what was in effect a sub-committee of the Institute which became known as the Independents' Group or IG. This group, first convened in the winter of 1952–53, then re-convened in winter 1954–55 after missing a year, was responsible for the formulation, discussion and dissemination of most of the basic ideas not only of Pop art but of much other new British art in the late 1950s and early 1960s.

The first season's programme concentrated largely on technology, a novel concern for artists in Britain at that period and one that was to play an important role in British Pop art; but the very first meeting was dominated by a lecture entitled *Bunk*, given by Paolozzi, during which he projected a large number of his collages, as well as many pulp images presented directly, untampered with except for the act of isolation. These included covers from *Amazing Science Fiction*, advertisements for Cadillac and Chevrolet cars, a page of drawings from the Disney film *Mother Goose Goes to Hollywood*, and sheets of US Army aircraft insignia. This was the first time that pulp imagery had been talked about in public in a serious way, although even within the IG, it seemed, the idea that such imagery not only could be the source of art, but (as Paolozzi had implied) could be art itself, took some time to gain acceptance.

Eduardo Paolozzi
I Was a Rich Man's Plaything 1947

In 1953, however, the IG staged an exhibition with the significant title 'Parallel of Art and Life', which consisted of blown-up photographs, not only hung all over the walls of the ICA Gallery but suspended from the ceiling and even propped against the walls. The exhibition was arranged by Paolozzi and four others (Nigel Henderson, Peter and Alison Smithson and Ronald Jenkins), and, like Paolozzi's lecture (which he gave at a number of other places after the ICA, including the School of Architecture at Cambridge and the Arts Club, Oxford), it presented the organizers' world, a world in which life and art have equal importance through the association, without comment, of a large number of images. These included photographs of paintings by Picasso, Kandinsky, Klee and Dubuffet, microscope and aerial photographs, photographs of Pompeii victims, primitive settlements and technological processes.

When the IG was re-convened in 1954 by Lawrence Alloway and John McHale, the theme this time was, quite explicitly, popular culture. Alloway later wrote: 'This topic was arrived at as the result of a snowballing conversation in London which involved Paolozzi, the Smithsons, Henderson, Reyner Banham, Richard Hamilton, John McHale and myself. We discovered that we had in common a vernacular culture that persisted beyond any special interest or skills in art, architecture, design or art criticism that any of us might possess. The area of contact was mass-produced urban culture: movies, science fiction, advertising, Pop music. We felt none of the dislike of commercial culture standard among most intellectuals, but accepted it as fact, discussed it in detail, and consumed it enthusiastically.'

Richard Hamilton was a member of the Independents' Group from the beginning, and in 1954–55 he began to play an increasingly important part in the development of Pop art both inside and outside the Group. In 1955 he had an exhibition of his work of the last four years at the Hanover Gallery. These paintings were much discussed by the IG, particularly the four *Trainsition* (sic) ones and *Carapace*, which, as Alloway pointed out, were concerned with a classic situation of the Hollywood movie of the time – the speeding car seen from a moving train, and (in *Carapace*) the view through the windscreen of a moving car. Also in 1955, Hamilton designed and organized an exhibition, 'Man, Machine and Motion', which was shown in Newcastle upon Tyne as well as at the ICA in London, and which pursued, mainly through photographs, the ideas of the aesthetic possibilities of the machine which had been discussed in the first sessions of the IG in 1952. Then, in 1956, the IG organized an exhibition called 'This is Tomorrow' at the Whitechapel Gallery in London. The exhibition was intended as an exploration of the possibilities of integrating the various visual arts; in it, twelve teams, each supposedly consisting of a painter, a sculptor and an architect, worked to produce as many environments.

Hamilton, with John McHale and the architect John Voelcker, produced a section which included a profusion of images from popular magazines, comics and film publicity, including the sixteen-foot robot which had been used to advertise a science fiction film at the London Pavilion and a life-size still of Marilyn Monroe in *The Seven Year Itch*. A juke box played continuously.

For the exhibition poster, and for reproduction in the catalogue, Hamilton made a special collage. *Just What Is It That Makes Today's Homes So Different, So Appealing?*, a comprehensive anthology of Pop imagery and sources, with its comic hung on the wall as a painting, its can of ham displayed as sculpture, its pin-up imagery and emphasis on glamorous consumer goods, is uncannily prophetic of later developments in Pop art. Also it prominently features the word Pop as an abbreviation for 'popular culture' or 'popular art'. Artists at that time still did not use the word to refer to what they themselves did; when the Independent Group talked about Pop art they were still referring to mass commercial culture itself, and in January 1957 Hamilton produced a now famous list of its qualities:

> Popular (designed for mass audience)
> Transient (short term solution)
> Expendable (easily forgotten)
> Low Cost
> Mass Produced
> Young (aimed at Youth)
> Witty
> Sexy
> Gimmicky
> Glamorous
> Big Business

This formulation Hamilton included in a letter to Alison and Peter Smithson, who had also been involved in 'This is Tomorrow', and in the same letter he proposed, as a follow-up to 'This is Tomorrow', another exhibition similarly created by teams, *in which the work exhibited would conform to his definition of Pop* – it would in other words be Pop art in the sense that the term later generally came to be understood: 'fine' or 'high' art based on commercial art sources.

From then on Hamilton attempted to fulfil the definition in his work both by actually giving it the qualities he had listed (although he would not make it expendable) and by treating those qualities as part of his subject matter. Since 1956 one of Hamilton's principal preoccupations has been with consumer goods and their role in society, particularly as revealed through the ways in which they are advertised. The motor car, of course, is *the* consumer good, and the first two paintings he made after 'This is Tomorrow', *Hommage à Chrysler Corp* (1957) and *Hers is a Lush Situation* (1958), both take their point of departure from advertisements for American cars, of the type that use glamorous women to sell the car. Both already reveal the elaborate and witty transformations Hamilton imposes on his source imagery, and his deep interest in the process of painting itself.

Later in 1958 Hamilton produced another consumer goods painting, *\$he*, which perhaps more than any other of his early works encapsulates his formal, iconographic and sociological preoccupations. It is one of the first masterpieces of British Pop art. The theme of this painting, put at its simplest, is the use of sex by advertisers to sell consumer appliances, a theme wittily suggested by Hamilton in the title, where the first letter is

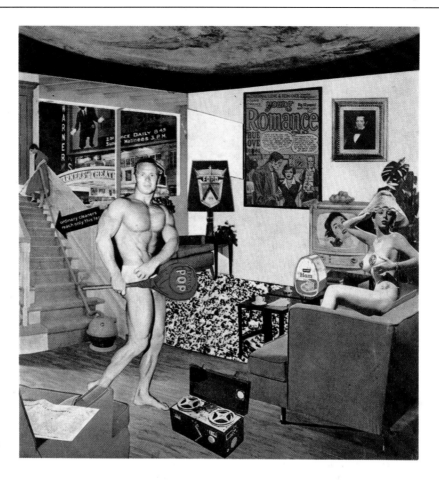

Richard Hamilton
*Just What Is It That Makes Today's Homes So
Different, So Appealing?* 1956

written as a dollar sign. Or, as Hamilton himself put it, '*$he* is a sieved
reflection of the ad man's paraphrase of the consumers' dream.' He also
said that 'Woman in the Home' was a possible alternative title for the
picture. These two statements occur in a lengthy account, 'An Exposition
of *$he*', by Hamilton, published in the magazine *Architectural Design* in
October 1962. He begins by comparing the artist's image of woman in
the 1950s with the ad man's image of her at the same period: 'Art's
Woman in the fifties was anachronistic, as close to us as a smell in the
drain; bloated, pink-crutched, pin-headed and lecherous; remote from the
cool woman image outside fine art.' In the advertisement, 'she is truly
sensual but she acts her sensuality and the performance is full of wit.
Although the most precious of adornments, she is often treated as just a
styling accessory. The worst thing that can happen to a girl, according to
the ads, is that she should fail to be exquisitely at ease in her appliance
setting – the setting that now does much to establish our attitude to a
woman in the way that her clothes used to. Sex is everywhere, symbolized
in the glamor of mass-produced luxury – the interplay of fleshy plastic
and smooth, fleshier metal.' Hamilton rejected the fine-art image of
woman in favour of the commercial-art one with its much greater
relevance to the realities of contemporary life; and in *$he* he brilliantly

Richard Hamilton
$he 1958–61

introduced it into fine art, creating a new vision of art's most ancient
motif.

The immediate visual sources for the paintings were as follows. For the
woman a photograph from *Esquire* magazine of a model known as Vikky
(The Back) Dougan, who specialized in modelling backless dresses and
swimsuits. In the *Esquire* photo she is seen from behind wearing a dress
plunging so low as to reveal the beginning of the cleavage of her buttocks.
Hamilton notes: 'The only pin-up I can remember having a greater
impact in art circles was Brigitte Bardot spread piecemeal through *Reveille*
in October 1957.' Then, for the appliances, firstly what Hamilton
described as 'a brilliant high shot of the cornucopic refrigerator' – an
advertisement for an RCA Whirlpool fridge/freezer which gave him the

overall layout for the painting – and secondly, for the object in the foreground, two advertisements, one for a Westinghouse vacuum cleaner and one for GEC small appliances.

The source images are elaborately processed by Hamilton, and these processes are perhaps the key to an understanding of his art, for their effect is to produce a highly abstract painting in which the artist's most obvious concern is with the extension of the language of painting, in other words the exploration of the medium itself. This is dazzlingly illustrated in *She* by the virtuoso range of treatment of the individual elements of the composition: the fridge door is a smooth fleshy pink (the colour of the original in the ad, which Hamilton called Cadillac pink and which he said 'was adopted with enthusiasm for the painting'), while within it is a Coco-Cola bottle treated in the traditional manner of European still-life painting, although perhaps its most recent ancestors are the bottles in Manet's *Bar at the Folies-Bergère*. The combined toaster and vacuum cleaner in the foreground (named the 'Toastuum' by Hamilton) is immaculately air-brushed (i.e. sprayed) in aluminium paint, while the linking passage from Toastuum to fridge door is entirely painterly, even to the extent of paint being allowed to run down the picture surface, no doubt a conscious reference to Abstract Expressionism. The woman's shoulder and breasts are, in Hamilton's phrase, 'lovingly air-brushed', this time to the exact tone and texture the flesh of women takes on in glossy magazines; but her single eye is a piece of collage, a joke winking plastic eye, given to Hamilton by a friend from Germany after he had already been working on *She* for two and a half years, and instantly incorporated by him into the painting. (The element of chance often plays a vital role in Hamilton's otherwise highly controlled art.) This eye is a characteristic piece of wit, as is the row of dots springing from the Toastuum, which indicate the flight path of the toast when it is automatically popped up. The woman's skirt is collage, and in relief as well, made of $\frac{1}{8}$-inch plywood and given an extra sculptural quality by delicate modelling of the surface, which Hamilton says can best be explored by sensitive fingers rather than the eye. Also collage is the freeze part of the fridge, a photograph of a detail from an advertisement for an automatic defrosting system, blown up and stuck into the painting.

Finally, the mechanisms of Hamilton's apparently arbitrary selection of particular fragments from his sources, and his also apparently arbitrary manipulation of them once selected, can be best understood by reference to the figure of the woman in *She*: for example, the shape of the area of her breasts and shoulders is partly the result of Hamilton's desire to combine Vikky Dougan's back ('too good to miss', he said) with breasts – essential to the ad man's image of woman (the breasts are in fact from another pin-up) and partly from his desire also to perpetrate a mild erotic joke by giving the breasts two alternative readings, one of which introduces a large, pointed, dark-aureoled nipple into the immaculate kitchen. Similarly, the scooped-out part of the relief represents the area of flesh revealed by the deep plunge line of Vikky Dougan's dress, but, says Hamilton, 'it also suggested an apron effect in negative: this was nice – an apron, however minute, is fundamental to the woman-in-the-house image'.

Hamilton has always been one of the least productive, in quantitative terms, of all major contemporary artists, but everything he does produce is elaborately considered, deeply pondered and densely packed with ideas. Every work is a major statement, the result of a complex conceptual process, and it is not surprising therefore that they have the look more of the products of the engineer's drawing-board than of those of the artist's easel. He was the direct inheritor of Duchamp's attitude towards the making of art.

At the time when Richard Hamilton was creating his technologically and ad-mass orientated art, Peter Blake, an artist ten years younger, was developing a rather different kind of Pop art, remote from the cool intellectualism of Hamilton. Blake is interested neither in technology nor in consumer goods, as he explained in an interview in 1963: 'For me Pop art is often rooted in nostalgia: the nostalgia of old popular things. And though I'm also continually trying to establish a new Pop art, one which stems directly from our own time, I'm always looking back at the sources of the idiom and trying to find the technical forms that will best recapture the authentic feel of folk pop.' Blake's ultimate sources thus lie in Victoriana and Edwardiana, and his art is directly rooted in the world of his own childhood and youth (toy shops, comics, badges), in the world of pop music (Elvis Presley, Cliff Richard) and popular entertainers and film stars (Sammy Davis Jr), and in the world of fairgrounds where he has drawn on the traditional heraldic carnival style of lettering and decoration as well as on fairground personalities (tattoed ladies, etc.) and the bric-à-brac of fairground prizes. He also has a great affection for two popular entertainments particularly dear to the British, all-in wrestling and strip-tease. Like other major Pop artists, he also uses other art, both contemporary and of the past, as part of the subject matter of his own.

On The Balcony, which Blake painted between 1955 and 1957, is, like Hamilton's *$he*, one of the first substantial masterpieces of British Pop art. In it Blake has painted no less than twenty-seven variations on the theme *On The Balcony*, the most important of which is the row of four young people in the centre of the picture. Three of them are displaying an array of badges including 'I Love Elvis', 'I Like the Hi-Los', and badges of children's clubs like ABC Minors and I-Spy. Two of them are wearing Union Jacks, indicating their allegiance to Queen and Country, and this kind of pop patriotism, very much in the air in the 1950s in the aftermath of the Festival of Britain and the Coronation (people talked about a New Elizabethan Age), is a major theme of the painting, taken up again in no less than three representations of the Royal Family (the whole family on the balcony at Buckingham Palace, the *Life* magazine cover of Princess Margaret, and the Queen Mother with Winston Churchill). This emphatic Britishness remains an important part of Blake's art.

The fourth figure looks very like a self-portrait, and this reading seems to be confirmed by the fact that the figure displays no badges, only a portrait of John Minton, an artist who had considerable influence in British art schools in the 1950s, who taught Blake at the Royal College, of whom Blake once said: 'if he looked at your picture you felt it was worth while going on', and who committed suicide in 1957. The portrait of him in Blake's picture is inscribed 'In sincere memory', and was clearly added

as a personal tribute. The fourth figure is also holding a painting, which would seem to identify him as an artist. These are the first of the many references to art in *On The Balcony*. The most obvious is the reproduction of Manet's famous painting *The Balcony* of 1869, but Blake has also included, very interestingly, his idea of what three contemporaries, two of whom have since become well-known abstract artists, might have done with the same subject. In the middle behind the royal family is a Robyn Denny, immediately below it is a Richard Smith, and lower down is a thickly impastoed Leon Kossoff.

Commercial art sources are introduced in the various renderings of packaging, especially the still-life group on the table (the table acting as a 'balcony'), which prominently features a Kellogg's corn flake packet.

One of the most significant aspects of this painting is the way in which Blake plays on the difference between illusion and reality. The corn flake packet is a three-dimensional object rendered on the flat canvas in a traditional illusionistic way, but the magazine covers for example, being flat themselves, look as if they might be collage (a method Blake has made extensive use of), while the Leon Kossoff is a real miniature abstract painting – you could almost cut it out and frame it.

Peter Blake
On the Balcony 1955–57

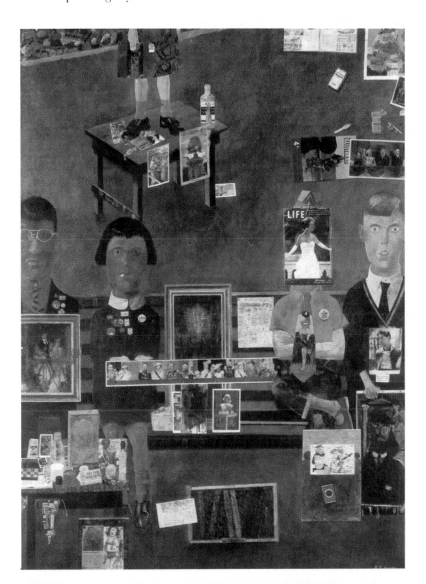

In 1960 Blake had an important one-man exhibition at the ICA, where he showed a large group of recent works combining painting and collage. These works were done, not on canvas, but on solid pieces of board sometimes treated as a plain surface but frequently divided into compartments by beading or strips of wood and sometimes resembling doors or walls. In the compartments were images of pop stars, pin-ups or entertainers. In contrast to these collage elements and forming a setting for them, the boards were emblazoned with abstract designs, emblems and lettering painted in enamels in a manner strongly reminiscent of the traditional decoration of fairground booths. The exhibition included *Elvis and Cliff*, *Girlie Door*, *Kim Novak Wall*, *Sinatra Door* and *Everly Wall*.

In 1961 Blake made *Love Wall*, his largest work until then, a remarkable compilation of images of love ranging from contemporary pin-ups, romance comics, film stills and seaside postcards to Edwardian wedding photographs, valentines and birthday cards. The word LOVE

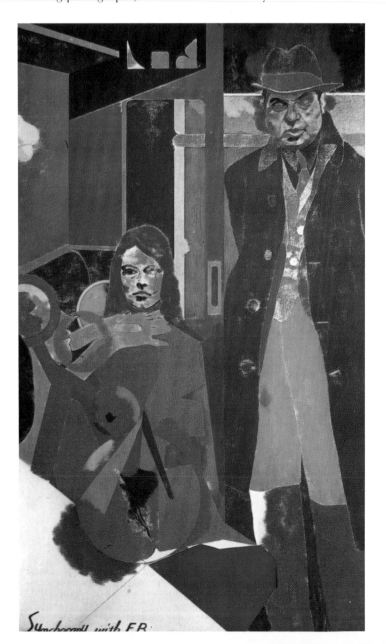

R. B. Kitaj
Synchromy with F. B. 1968–69

(above an emblematic heart) is painted into one of the panels, forming a small individual painting which is remarkable for its strong, hard-edge forms and abstract use of colour.

Peter Blake's contribution to the first phase of British Pop art has often been underestimated; by 1961 he had produced a whole group of works, including those shown in his 1960 ICA show, which are the purest Pop art in that they combine vivid Pop imagery and direct collage elements with equally vivid abstract forms derived from the same Pop sources.

The second phase of British Pop art began in 1961, when David Hockney, Allen Jones, Derek Boshier, Peter Phillips, Patrick Caulfield and others, all students at the Royal College of Art, made a great impact with the work they showed at the 'Young Contemporaries' exhibition. Besides inheriting the situation created by Bacon, Paolozzi, Hamilton and Blake, this young group were also influenced by two other artists of the same age as Blake, Richard Smith and the American R. B. Kitaj, although neither was strictly speaking a Pop artist.

Kitaj was a fellow-student of Hockney and the rest at the Royal College from 1957 to 1961. He was older, more experienced and more seriously involved in art than any of them, and his paintings were concerned with exploring problems of representation. Allen Jones spoke perhaps for all the Royal College group when in 1965 he recalled: 'I learned more, I think, about an attitude to painting merely from watching him. I didn't speak to him very much, but suddenly I thought this was something vital in comparison to everything else at the College, in other words the influence wasn't one of imagery but of a dedicated professionalism and real toughness about painting.' There is no doubt that Kitaj's actual way of painting, in which significant figurative images are integrated by strongly painterly means (loose brushwork, etc.) into an often complex compositional structure, had a strong impact particularly on Hockney, Jones and Boshier.

Richard Smith was one of a small group of British painters (Robyn Denny and Bernard Cohen were others) who, in the later 1950s and early

Richard Smith
Quartet 1964

1960s, were looking at Pop sources but using them as the basis for a completely abstract art. Smith left the Royal College in 1957, went to America, where he stayed until 1961, and there developed a painterly, large-scale art rooted in the mass-media but in which the source material was not presented (as it always is in true Pop art) as a strongly figurative image. Rather, certain of its qualities, of colour or of shape, were isolated as the basis for the painting. In his series of cigarette-packet paintings of the early 1960s, for example, form and colour are derived from the packet itself, and the large scale and soft-focus treatment come from wide-screen cinema cigarette advertisements where a packet may appear six feet high and, when viewed from close to, dissolves into blurred and shifting washes of colour.

Smith has explained that he wanted to extend the expressive range of painting, to create a new kind of fine art experience through the use of commercial art: 'This would be possible, I thought, through paintings that shared scale, colour, texture, almost a shared *matière* with an aspect of the mass-media.' This attitude in itself must have been influential, but Smith's paintings also demonstrated to the younger Pop artists not only a new sense of scale, quite different from that of Hamilton and Blake, but also the possibility of a broad painterly treatment of Pop source material.

David Hockney, like Allen Jones, has recorded his appreciation of R. B. Kitaj, who, he says, has affected him more than anyone else 'not only as an artist but as a person'. Other influences on Hockney were Francis Bacon and the French artist Jean Dubuffet, who may well have drawn his attention to the aesthetic possibilities of the most important of his early stylistic sources, graffiti, an aspect of the urban scene not really looked at by any other Pop artist. Indeed, although the debt to Bacon, especially, is apparent in Hockney's work in the early 1960s, its primary visual quality comes from the extraordinary graffiti-like drawing of the figures and from the scrawled messages and individual words, parts of words and numbers which in some cases come to dominate the painting. (Hockney has explained that he wrote on many of his paintings at this time in order to make his meaning as clear as possible.) His paintings also have the usual Pop characteristic of combining strongly abstract elements with vivid figurative imagery. In, for example, *The Cha Cha Cha that was Danced in the Early Hours of the 24th March* (1961), one of his best early paintings, the dancing figure and the words and messages are set against flat rectangles of emblematic red and blue at the top of the picture, a large expanse of raw untouched canvas in the middle and a flat strip of mauve at the lower edge.

The subject matter of Hockney's art is broadly autobiographical, and in the early 1960s, while still at the Royal College, his principal preoccupations, not surprisingly perhaps, were with art, and the making of art, and sex. These themes come strongly through in his painting, even when, as in another major early work, his shaped canvas painting of a Ty-Phoo tea packet, he is ostensibly concerned with that other major Pop subject, packaging and advertising imagery. In particular, the title of this work, *Tea Painting in an Illusionistic Style*, draws attention to the formal statement, while the artist's erotic interests are expressed in the life-size figure of a naked boy who appears (part of the whole illusionistic joke of

David Hockney
Tea Painting in an Illusionistic Style 1962

David Hockney
California Seascape 1968

the painting) to be actually sitting inside the packet. Further evidence of the way in which Hockney at this time was taking the language of painting as part of his subject matter is provided by the fact that he exhibited the Ty-Phoo picture in 1962 under the title *Demonstration of Versatility – Tea Painting in an Illusionistic Style*. It is one of four *Demonstrations*, another of which, *A Grand Procession of Dignitaries in the Semi-Egyptian Style*, also marks his first (but by no means his last) use of earlier art as a source.

There is no doubt that David Hockney was the dominant personality in the Royal College group, and he has had a greater success than any of them. In fact his brilliant success and his personal style have made him,

like Andy Warhol in America, a Pop star himself; and many of his later paintings depict the surroundings of successful Pop personalities – *California Seascape*, and the series of California swimming pools, for example – as well as the personalities themselves.

Allen Jones, like David Hockney, gained a rapid success after the 1961 'Young Contemporaries' exhibition. His earliest themes were, in rather odd contrast, sex on the one hand and buses, aeroplanes and parachutists on the other. His style was both painterly and abstract, closer to Richard Smith in its approach than any of the other artists of the Royal College group (although, as we have seen, Kitaj was also important to him). As well as adopting a painterly approach, Jones also used the important formal device of the shaped canvas. In his famous series of bus paintings of 1962–63, many of the canvases are staggered rectangles that seem to lean forward along the wall, physically implying movement; and in a number of them, too, the wheels were painted on a separate piece of canvas and literally attached to the bottom of the canvas. The effect of this is to give the image a greater reality and impact than it could have if simply depicted as a figure on a ground.

Erotic imagery first appeared in two *Bikini* paintings in 1962, although these were still, like the bus paintings, very abstract. The eroticism became explicit in paintings of couples and hermaphrodites like *Man–Woman* (1963), and in the single figure pin-up girls like *Curious Woman* (1964), which has the breasts actually modelled in three dimensions. Later Jones's obsession became more intense, and he expressed it in a much tighter, glossier style than before. His sources lie particularly in those sex magazines catering for underwear, rubber and leather fetishists, and in 1969 he produced a number of pieces of erotic furniture consisting of very realistically modelled and glamorous girls wearing leather boots

Derek Boshier
Identi-Kit Man 1962

Allen Jones
Girl Table 1969

Antony Donaldson
Girl Sculpture (Gold and Orange) 1970

and harness, offering themselves as seats, hatstands and *Girl Tables*.

Derek Boshier was the third member of the Royal College group to adopt a painterly semi-abstract approach to painting Pop imagery, but right from the beginning he tended to blend passages of extreme painterliness with bold, clear cut figurative images. In *Identi-Kit Man* (1962), one of his very best early works, the raw canvas is beautifully brushed with long feathery strokes of white, blue and mauve to create an effect of pale atmospheric colour which contrasts strongly with the flat, sharply outlined giant green toothbrushes and the vivid red and white stripes of the toothpaste. It is clear that the heraldic quality of the striped toothpaste made a strong appeal to Boshier, and in the next few years he evolved a kind of bright jazzy painting based on such sources but from which all figurative references were eliminated. Since 1964 he has been a completely abstract artist.

Anthony Donaldson was at the Slade School, and did not develop a fully-fledged pop iconography and treatment until about a year later than the Royal College group. But from 1962 he produced brightly coloured paintings, based mostly on repeated images of strippers, in which the tones are manipulated in such a way as to produce a constant strong image-ground reversal which makes the painting extremely abstract in its effect. By 1963 he was producing jazzy, optically active works in which the imagery was no longer readable, although there were still strong references to the source. Later his work became more figurative and more specifically erotic, and *Girl Sculpture* (1970) effectively combines the sensuality of the nude girl with the extreme sensuousness of a beautiful gold flake acrylic paint job.

Superficially Patrick Caulfield is the British artist who appears to be the closest to Roy Lichtenstein: he presents, like Lichtenstein, boldly outlined figurative images which in fact are part of a rigorously abstract formal structure. However, his imagery has none of the assertiveness usual in Pop art, and he does not draw on advertising or indeed any of the

Patrick Caulfield
Pottery 1969

Right:

Eduardo Paolozzi
The Last Idols 1963

Far right:

Joe Tilson
Transparency Clip-O-Matic Lips 1968

usual Pop sources. Instead he uses images which, while being instantly familiar and recognizable, as in *Pottery*, for example, are so extremely unassertive as to emphasize to a degree greater than in any Pop artist the purely formal message of the work.

Having played a major part in laying the foundation of Pop art in Britain in the 1950s, Paolozzi insists that he is not a Pop artist and that, if anything, he is a Surrealist. However, it is almost impossible to look at Pop art in Britain in the 1950s and not to take his work into account,

particularly his striking sculptures based on machinery and the heavy industrial aspects of the city landscape like electricity sub-stations. *The Last of the Idols* (1963) combines solid architectural forms with a wheel, is topped off with what looks like a heavy electrical insulator and has a hard paint finish like that of heavy machinery.

Significantly these works (from 1962 onwards) were made for Paolozzi at an engineering works near Ipswich, and they are assembled (welded) either from stock machine parts available from manufacturer's catalogues or from machine parts made to Paolozzi's own specifications. More than any Pop artist, Paolozzi has pursued the logic of using industrial processes to make an art whose source itself lies in the industrial world.

Like Paolozzi, Joe Tilson is an artist whose sources lay in the urban, industrial and commercial scene, but whose aesthetic aims in almost all his work of the 1960s were very different from those of the Pop artists. However, Tilson made a number of purely Pop works, in particular the series of *Transparencies* started in 1967 and including images of Yuri Gagarin, Che Guevara and the Five Senses, one of which, *Transparency Clip-O-Matic Lips*, with its huge glistening mouth and gleaming teeth, is a stunning presentation (relating more to the erotic than to the sense of taste which it is supposed to represent) of an image presumably culled from a toothpaste ad.

Continental Europe

It has frequently been pointed out that true Pop art, both for sociological and intellectual reasons, is an Anglo-Saxon phenomenon. But the revolt against Abstract Expressionism which gave rise to Pop art in America found its counterpart in Continental Europe at the same time, and produced a kind of art clearly related to Pop. This art is best understood in the context of *Nouveau Réalisme* or New Realism, a movement founded originally in 1960 by the French critic Pierre Restany and a small group of artists (among them, Yves Klein and Arman); the term quickly came to be applied to any artist following this tendency, whether he was a member of Restany's original group or not.

Restany published the first manifesto of New Realism in April 1960 in Milan (New Realism was to operate mainly on a French–Italian axis, with the Germans keeping somewhat to themselves). In it he stated in florid rhetoric his rejection of the existing situation in art: 'We are witnessing today the exhaustion and sclerosis of every existing vocabulary, of all the languages, of all the styles', and then went on to propose a remedy. 'What are we going to put in their place? The fascinating adventure of the real seen as itself and not through the prism of an imaginative and intellectual transcription.' In spite of the firmness with which Restany asserts that there will be no imaginative or intellectual transformation of the source material, there is no doubt that the basic attitude of the New Realists towards urban reality was both intellectual and romantic, whereas that of the Anglo-Saxon Pop artists was intellectual and *cool*, i.e. classic. This is made clear by Restany himself in the second manifesto, published in Paris in 1961: 'The New Realists consider the world as a picture, the great fundamental masterpiece from which they take fragments endowed with universal significance.' This significance, for Restany, was a sociological one: 'And through these specific images the whole social reality, the common wealth of human activity, the great republic of our social intercourse, of our social activity, is brought before us.'

This second manifesto of New Realism bore the title 'Forty Degrees above Dada', a clear acknowledgment of Restany's debt to that movement, and especially to Duchamp. Like the American and British Pop artists, he took his point of departure from the readymade. 'In the present context,' he wrote, 'Duchamp's readymades take on a new significance. They translate the right to direct expression of a whole organic sector of modern life, that of the city, the street, the factory, of mass production. . . . The anti-art gesture of Duchamp will henceforth be *affirmative*. . . . The readymade is no longer the height of negativity but the basis of a new expressive vocabulary.'

There is no doubt that the most original and the most influential of the New Realists was Yves Klein, who died prematurely in 1962. His aims were, ultimately, quite different from those of the rest of the group. Klein's works which have most relevance to New Realism are his *Anthropometries*, paintings of the female nude made by applying the paint direct to the girl's body and imprinting her on the canvas. Klein's real concern was not with the external world but with the reality of art, and

Yves Klein
Suaire ANT-SU 2 (Anthropometry) 1962

Yves Klein
Relief (Arman) 1962

particularly with the reality of colour, which he felt embodied the essence of art. From 1949 onwards he produced a large number of monochrome paintings in pink, blue and gold, and finally, in 1957, settled on blue as representing the essence of colour. In the last few years of his life he produced a series of 194 paintings in an unearthly, pure ultramarine blue which became known to the art world simply as IKB – International Klein Blue. Being the essence of art, this blue could be applied to any support, and *Lecturer IKB Elegant* is one of the many works Klein made basically from sponges soaked in his blue. His portrait of Arman, a cast of

the artist's torso coated with IKB and mounted on a gold-leaf ground, is considered by many to be his masterpiece.

Apart from Klein the New Realists tend to fall into a number of groups using different approaches and techniques. First, the painters: Alain Jacquet, Martial Raysse, Valerio Adami, Gerhard Richter, Konrad Lueg and Winfred Gaul. Second, those who use the techniques of assemblage but in a basically two-dimensional form related to painting: Arman and Daniel Spoerri. Third, those who use techniques of assemblage in a fully three-dimensional sculptural form: César and Christo. Fourth, those who use collage: Michelangelo Pistoletto and Oyvind Fahlström. Fifth, those who use décollage, that is, the torn poster technique: Raymond Hains, Mimmo Rotella and Wolf Vostell.

Alain Jacquet uses the silkscreen process to put his images through a succession of transformations which makes them more and more abstract. *Déjeuner sur l'herbe* is one of his best-known works, one of the series he calls *camouflages*, which are all based on very well known works of art. In this case Jacquet has reconstructed, using live models beside a swimming-pool, and photographed, Manet's famous *Déjeuner*. (The Manet itself, of course, was based on a famous engraving after Raphael by Marcantonio Raimondi.) His photograph of this group has then been blown up to such enormous size that, when silk-screened onto the canvas, it functions as strongly as an abstract pattern of colour as it does as a figurative image with complex references both to art and to life.

Valerio Adami depicts the urban and suburban landscape, as in his *Showcase*, in a style in which objects are simplified, abstracted and distorted to the point where they are often difficult to read, and are painted in flat, brilliant Pop colours surrounded by strong black outlines.

Valerio Adami
Showcase

Martial Raysse is one of the best-known New Realists, largely because his work is probably closer to Pop art than that of any of the other Europeans. Raysse has made extensive use of assemblage and mixed media, creating complete tableaux like his *Raysse Beach*, which uses an inflatable children's paddling-pool, garish plastic beach equipment and photographs of girls in bathing suits, but his most interesting works in the context of Pop art are his more or less straight paintings (some have neon attachments) in which images of girls have garish, extremely synthetic colour superimposed on them. He has also made a series of *tableaux affreux* (awful pictures), generically titled *Made in Japan* (still in the early 1960s a phrase implying cheapness, imitation, etc.), in which revered old master paintings like Ingres' *Odalisque* were, like the girls, rendered in lurid colour.

The German artists Gerhard Richter and Conrad Lueg organized the 1963 'Demonstration of Capitalist Realism' in Düsseldorf, and both of them use photographic sources for their paintings, although in very different ways. Richter most characteristically uses landscapes, or people in movement, but blurs them to convey a cinematic sense of instability

Martial Raysse
Made in Japan en Martialcolor 1964

and scale. Lueg's paintings on the other hand present strong, sharply outlined images in which internal details are run together to create large abstract areas of colour somewhat like Lichtenstein.

Winfred Gaul began his career as a painter of imaginary landscapes but in 1961 a visit to Rome turned him onto the urban environment and in particular to traffic signs and signals. After that he painted virtually nothing else, and he said of his paintings that 'their aesthetics are grounded in the garish colours and gigantic forms which are the new dimensions of city life, they constitute an art-form which has its habitat amongst the skyscrapers and the new industrial buildings, amongst the lines of traffic at the intersections on the motorways'.

Arman (Armand Fernandez) is one of the best known and most typical exponents of New Realism. Already in 1959 before the group was formed he was making what he called *Allures*, which involved making impressions on the canvas using objects dipped in paint; and in the same year he began the use of assemblage which has remained his basic technique. *Anger – Broken Table* (1961) is one of his early series of assemblages of smashed everyday objects all titled *Anger*. Also at this time he began to explore the aesthetics of accumulation, piling up valueless objects like

Arman
Anger – Broken Table 1961

bottle caps and presenting them in glass fronted cases, or later, embedded in slabs of clear plastic to become precious art works. One of his most striking accumulations, however, is a fully three-dimensional work, the famous *Torso* of 1967 in which dozens of rubber gloves are embedded in a clear plastic female torso, creating the disturbing impression that the woman is being groped from within by disembodied male hands.

Daniel Spoerri's use of assemblage involves the element of chance to a very high degree. His *tableaux-pièges*, or 'snare paintings', are works in which accidental arrangements of everyday objects, e.g. a table top after a meal complete with dirty glass, crumbs, cigarette ash in the ashtray, would literally be trapped, fixed to a base, and then hung up on the wall.

César (César Baldaccini), the most eminent of the New Realist

César
Compression 1960

sculptors, has always been fascinated by machinery. From 1955 to 1960 he produced sculptures welded from scrap iron and machine parts, and in 1960 he began to make his *Compressions* – sculptures made from compressed car bodies or parts. The materials for these works are selected by César who also directs their arrangement in the car-crusher which plays the conclusive part in the creative process.

Christo (Christo Jaracheff) is a sculptor who works directly with existing objects, wrapping them up in many-layered parcels (the final layer sometimes being transparent polythene), so that the resulting sculptures, like his marvellous early work the *Wrapped Bottle* of 1958, take on a mysterious poetic quality and invite the spectator to speculate endlessly as to what they may contain while the original mundane object remains quite untampered-with inside. Afterwards Christo moved away

Christo
Wrapped Bottle 1958

from his involvement with objects and grappled directly with the city itself and with the natural world. He packaged his first building in 1968 (the Kunsthalle, Berne), and in 1969 he wrapped a one-mile section of the Australian coastline near Sydney.

Michelangelo Pistoletto and Oyvind Fahlström both use collage in a highly individual way. Pistoletto uses life-size photographs of people, usually in informal everyday poses, and – in his most effective works, like *Man Reading* – doing something that would not be out of place in an art gallery. These images are transferred on to a tissue paper and applied to large polished steel mirrors. The mirror reflects the environment in which the work is hung, so that Pistoletto's figures appear to be actually in the room or gallery together with the spectator, who, of course, in his turn becomes part of the work when reflected in it. Pistoletto has said that the first real figurative experience man has is when he recognizes his own image in a mirror.

Fahlström's use of collage is unique in that the collage elements of his paintings are movable, enabling the spectator to manipulate and rearrange their complex imagery relating, among other things, to politics, science, sport, day-to-day events, comic strips, and thus give the work a new appearance and a new meaning.

The décollage, or torn poster technique, of Hains, Rotella and Vostell has been a particularly fruitful development within New Realism. Their torn advertisements are a strong and direct way of presenting commercial art imagery while at the same time vividly evoking the sleazier aspects of the urban environment.

Wolf Vostell
Coca-Cola 1961

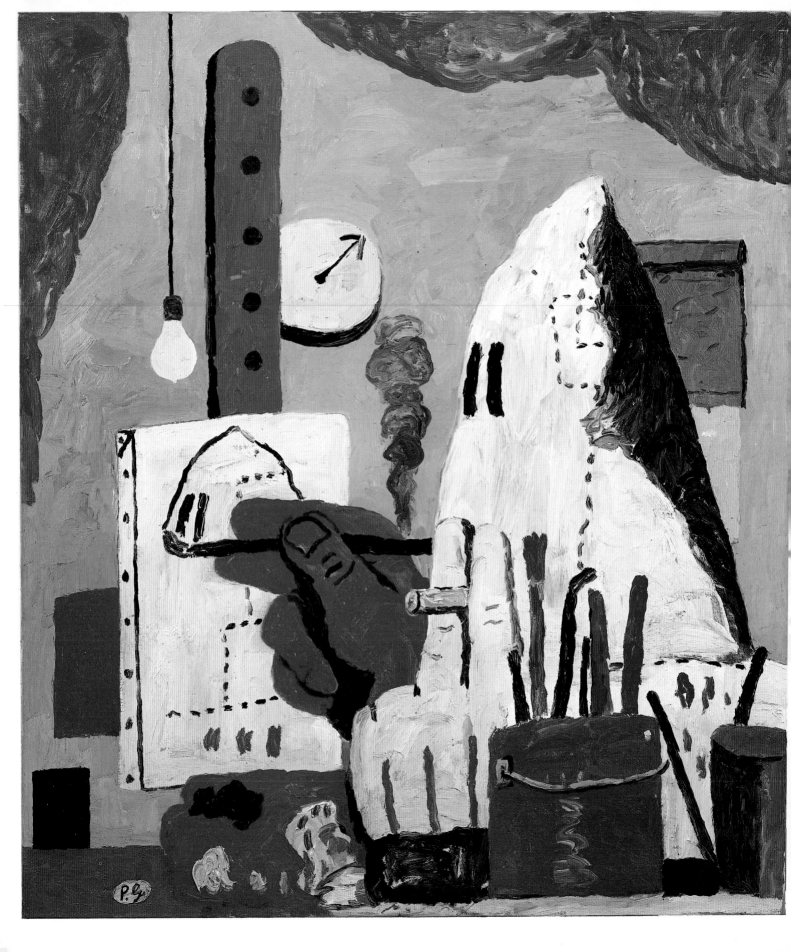

8 Pluralism since 1960

MARCO LIVINGSTONE

Increasingly through the twentieth century, and especially after the stranglehold exerted by Abstract Expressionism, powerful and idiosyncratic art has often been made against the prevailing ethos and in response not to theory but to a desire for directness and immediacy of experience. Nevertheless the proliferation of new movements at an ever accelerating pace has been one of the most marked characteristics of art since the early 1960s. The tendency for artists to react consciously against the tenets of their immediate predecessors, combined with their need to combat the isolation of the studio through friendship with other colleagues, has led repeatedly to the formation of new groupings often further encouraged by critics, dealers and museum administrators keen to be first at the scene of every new artistic development. There has been a widespread anxiety not to be left behind, like the conservatives who had resisted the rise of Modernism at the turn of the century. This has engendered an atmosphere conducive to experiments remote from the taste of the public at large. The pressures of a constantly growing and more powerful market for contemporary art during this period have likewise exercised a strong influence, especially in the United States, which has come to dominate a more genuinely international art world both in terms of its art criticism and the commercial gallery system centered in New York City. The effects of economic forces have been manifest not only in a sometimes grotesque parody of the built-in obsolescence of the consumer society, which requires new status-bearing products every season, but in the reaction of artists who have sought to subvert the system altogether by abandoning the manufacture of saleable commodities in favour of art forms which do not lend themselves so easily to such manipulation: for example Conceptual art, Video art, Performance art and Land art.

Given the existential emphasis within Abstract Expressionism, by which every brushmark was judged an authentic sign of the artist's personality and a gesture indicative of his or her free will, it was almost inevitable that subsequent generations would seek a demystification of both process and content as a release from this romantic inwardness. Such impulses were central to the origins of Pop art in the 1950s and to the evolution and influence of the movement in the following decade. Indications of this shift in the late 1950s occurred also in the work of American artists such as Helen Frankenthaler (born 1928) and Morris Louis (1912–62), whose variations on the procedures of Jackson Pollock's drip paintings largely stripped them of their implications as a form of

Philip Guston
The Studio 1969

handwriting conveying emotion; Louis in particular stressed simple actions, such as staining the canvas with rivulets or pools of thinned acrylic paint applied by pouring, to draw attention to the material properties of the painting as a flat surface suffused with colour.

One of Louis's close associates, Kenneth Noland (born 1924), while also favouring acrylic paint stained into rather than brushed on the canvas, introduced into his work a strong formal design as a structuring device for an art of colour and surface. In a number of paintings of the late 1950s and early 1960s he used a target-like motif of concentric rings of colour not as a way of expressing an ironic equivalence between the painting and a real object, as had been the case for Jasper Johns a few years earlier, but as a container for precisely judged relationships of hue; among the diverse precedents for this art of colour and geometry one could thus cite the Orphism of Robert Delaunay and the almost scientifically rigorous *Homage to the Square* paintings of Josef Albers (1888–1976).

Louis, Noland and Frankenthaler, along with other artists such as Frank Stella (born 1936), Ellsworth Kelly (born 1923), Al Held (born 1928) and Jules Olitski (born 1922), were grouped together by the critic Clement Greenberg under the banner of Post-Painterly Abstraction in an exhibition held in 1964. As the label suggests, Greenberg saw in these artists a shared reaction against the importance accorded to painterly gesture in certain types of Abstract Expressionism, arguing their case as a search for the essence of painting as a medium of flat coloured surfaces. Kelly, who was older than most of the artists in this group, had been working independently since the late 1940s on the creation of a concise language of geometric form, initially in painted wooden reliefs inspired by modern architecture; by the early 1960s his preference for clearly outlined brightly coloured shapes led him to being identified as one of the

originators of Hard-Edge Painting. Like many labels, this is misleading in its emphasis on a minor technical aspect of the work, as Kelly's concern was not simply with linear definition but with relationships of shape and colour and of self-sufficient form to nature. Another term which is sometimes applied to such work and to that of older American artists such as Barnett Newman and Mark Rothko is Colour Field Painting, which more helpfully emphasizes a shared concern with the effects of saturated hues over a large surface. The proliferation since the 1960s of terms, as of movements, needs to be treated with a certain amount of scepticism: what begins as a useful shorthand for identifying a common purpose may all too quickly degenerate into a restrictive label. Although Post-Painterly Abstraction was destined to remain more a convenient label than a coherent and lasting movement, it did help to define the parameters of much of the art produced during the 1960s: in its elimination of the personal touch as a sign of the artist's personality it heralded the anonymous surfaces of movements as diverse as Pop, Op and Minimal art; in its insistence on logic it set the tone for Conceptual art just as in its concentration on the most basic and essential attributes of painting it prefigured Minimal art; and in its concern with stripping bare the physical properties of each object as the result of a sequence of actions it provided a background for an emphasis on process in the work of other artists later in the decade.

Greenberg's immense influence and single-mindedness as a critic, while doing much to establish the reputations of the American artists he promoted, ultimately undermined the position of those who were judged to be too much under his control, especially when his exclusivity and formalist bias gradually lost favour. The artists whose work continued to develop and to affect the course of art, at least in America, were those who, like Stella and Kelly, had maintained a more independent stance from the beginning. In the late 1950s and early 1960s Stella produced

Frank Stella
Untitled 1962 (?)

some of the most austere and demanding paintings of the period, initially in single colours – black, aluminium and copper – and soon after in combinations of bold primaries. Provocatively rejecting the lofty philosophical intentions of the Abstract Expressionists, he insisted that 'What you see is what you see', by generating simple patterns of uniform stripes as a direct response to the structure of the painting as an object: each stripe, painted in a flat, unmodulated and unmixed colour, corresponded in width to the wooden stretcher bars supporting the canvas. Large in scale and subject to severe rules of logic, Stella's paintings appeared to be wiping the slate clean in preparation for a re-examination of the properties of the medium. Starting with the most extreme economy of means, during the 1960s he gradually added to his repertoire increasingly complex elements: he explored contrasts of colour, abandoned the conventional rectangle for a variety of shapes still self-evidently generated by the underlying structure and introduced interlaced semi-circles that replicated the standard shapes of draughtsman's tools. By the late 1970s he had abandoned all vestiges of restraint in large-scale metal reliefs in which vigorously thrusting shapes

David Smith
Cubi XXIV (Gate 1) 1964

Anthony Caro
Midday 1960

are luxuriantly covered in exuberant and seemingly arbitrary patterns and marks as if recklessly parodying the frenetic gestures of his Abstract Expressionist forebears; while in such works he may seem to have contradicted the logic and certainly the austerity of the art by which he made his name, through all these changes he has continued to insist on the appropriateness of one of the original definitions of Modernist painting as the decoration of a (flat) surface.

The matter-of-factness exemplified by Stella's paintings came to be a dominating feature of much of the art produced in the 1960s. In sculpture the American David Smith (1906–65) had begun as early as 1933 to ally his artistic process with steel welding techniques, culminating in the *Cubi* series (1961–65) whose burnished surfaces and metallic sheen have great painterly richness. Smith virtually redefined sculpture's premises about materials and methods, and its relationship to the base and the environment, while such formal concerns were matched by powerful emotive content. His influence on sculptural developments was as great as that of the Abstract Expressionists who were his contemporaries, and his ideas were taken further mainly by the Englishman Anthony Caro (born 1924), one of the most eloquent and influential younger sculptors. After meeting David Smith and Clement Greenberg on a visit to America in 1959 he began to produce brightly painted welded steel sculptures in which he left intact the industrially produced components as a means of stressing his concern with formal relationships; this was in stark contrast to the traditional emphasis on imagery and on the transformation of materials which continued to characterize the work of Henry Moore (1898–1986), for whom Caro had worked as an assistant in the early

Henry Moore
Reclining Figure 1959–64

1950s and who continued to be regarded as a major international figure in the grand tradition. Through his teaching at St Martin's School of Art in London Caro helped redirect the course of sculpture in Britain; among his former students who came to prominence at the Whitechapel Gallery's *New Generation* exhibition in 1965 were Philip King (born 1934), whose often fanciful variations of geometry were fabricated from industrial materials including plastic and fibreglass, Tim Scott (born 1937) and William Tucker (born 1935).

One of the most striking characteristics of Caro's work was his elimination of the conventional pedestal which had traditionally elevated sculptures from the environment in which they were sited. The supports for Caro's constructions were part and parcel of their construction, a straightforward device through which he was able not only to articulate the way in which form followed function, as had long been the case in Modernist architecture, but to seek a more democratic confrontation between his work and the spectator by acknowledging their interaction on the same literally down-to-earth level. A similar urge to involve the viewer directly motivated other tendencies during this period, in particular Op art and Kinetic art. For Op artists such as the English Bridget Riley (born 1931), the French Victor Vasarely (born 1908) and François Morellet (born 1926), the most pressing concern was with the act of perception itself, with the dazzling and often disorientating effect on the eyes of particular patterns of line, shape and colour. By definition such images require the active response of the spectator in order to take effect. While much Op art depended for its effect on phenomena that had been more ably investigated by scientists, in the hands of its most sophisticated practitioners it proved to be far more than a passing fashion or gimmick in spite of the speed with which it was consumed and imitated within popular culture in the wake of exhibitions such as *The Responsive Eye* (held at the Museum of Modern Art, New York) in 1965. Riley, for instance, followed her purely black and white paintings of 1963 with canvases of coloured stripes, deployed either as parallel lines or as wave patterns of alternating thickness, which functioned in many different ways. In some cases no more than three colours might be juxtaposed in a variety of configurations in order to create an illusion of an immense variety of colour by purely optical means involving after-images. Within the strict limits of her formal vocabulary she was able to continue such investigations throughout her later work in endless permutations.

Op art is sometimes treated as a branch of Kinetic art, given that both are concerned with movement: either actual motion, as in Kinetic art, or implied or imagined action, as in Op art. The dividing line between the two types can be ambiguous, as in the work of the Venezuelan artist Jesús-Rafael Soto (born 1923), who is best known for kinetic relief constructions in which constantly changing patterns are created by the optical interaction of forms suspended in front of a surface pattern of parallel lines. The quasi-scientific tone of much of this art can be gleaned from the very name of the Groupe de Recherche d'Art Visuel, the French group which during its existence from 1960 to 1968 numbered among its members Vasarely's son Yvaral (born 1934) and the Argentinian Julio Le Parc (born 1928). By contrast, however, other Kinetic artists introduced

Bridget Riley
Sea Cloud 1981

mystical and absurdist approaches to art in movement: the Greek artist
Takis (born 1925) created eerie musical environments of suspended
metallic objects activated by electromagnetism, while the Swiss Jean
Tinguely (born 1925), a latter-day Dadaist, delighted in creating
unwieldly clattering machines that endlessly repeated patently useless
actions.

A desire for directness of confrontation with the spectator was also one
of the motivating forces in the mid-1960s for the rise of Minimal art, a
movement which stressed simplicity of form and clarity of idea in the
creation of paintings and sculptures as objects that could be apprehended
in their totality virtually at a glance. Paradoxically the very sparseness of
their means, particularly when removed from the defining context of a
group of works conceived as a complete installation, guaranteed the
almost complete incomprehension of the public at large when faced with
works such as Carl Andre's *Equivalent VIII*, a rectangular solid formed by
120 standard bricks stacked in a simple formation in defiance of all

traditional notions of technical skill and composition. Minimal art was taken to its most extreme logical conclusion by certain American sculptors, notably Andre (born 1935), Donald Judd (born 1928) and Dan Flavin (born 1933), who made use of industrial materials, often in readily available prefabricated forms, for a sophisticated art of precise arrangement and interval. Flavin's structural elements, for instance, were fluorescent lights in standard lengths and colours, arranged in basic configurations or simply propped up as a single luminous line as a means of articulating or transforming the space of the room in which they were installed. A heightened awareness of place was essential, too, to the 'floor

Dan Flavin
Untitled 1976

Carl Andre
Aluminium-Copper Alloy Square 1969

pieces' made by Andre from metal plates laid edge-to-edge in a kind of chequerboard pattern, not only because the spectator was encouraged to stand on these works to experience their materiality and a sense of the space they occupied, but also because they were often conceived for particular gallery spaces or installed in such a way as to deflect attention onto the characteristics of the room itself.

Both Frank Stella and Ad Reinhardt, with his dictum that 'Less is more', prefigured and influenced the emphasis on literalness that characterized Minimal art; Reinhardt's 'black paintings' of 1960–66, each of which consisted of an almost invisible cruciform shape imposed on the dark background of a square canvas, were meant to look as much alike as possible so as to prepare the viewer to scrutinize the surface for almost imperceptible variations of hue and tone. With such works an initial impresson of immediacy, obviousness and emptiness, further encouraged by their display in series of nearly identical units, often gave way to an appreciation of the extremely subtle variations which occur both within a single painting or sculpture or from one work to the next. In the case of Robert Ryman (born 1930), for instance, every work he has created since the late 1950s could be described blandly as a white painting in a square format, but within these severe restrictions he has explored an immense variety of the properties of the medium: he has used different types of paint, ink and drawing materials (oil, acrylic, gouache, casein, enamel, gesso, emulsion, pastel) on supports ranging from stretched canvas, wood and paper to copper, steel and plexiglass; he has explored changes wrought by scale, different types of brushwork and variations in the relationship of the painted area to the edge; and he has drawn attention to the many ways by which the surface can be fixed to the wall. While

remarkable for the clarity and single-mindedness with which he has
systematically laid bare his medium, Ryman is not alone among Minimal
artists in achieving a state of heightened sensibility. During an equally
long development another American painter, Agnes Martin (born 1912),
has specialized in paintings covered with washes of colour or pencilled
grids of such delicacy as to be almost imperceptible in reproduction, each

Robert Ryman
Courier 1982

Agnes Martin
Untitled XXI 1980

Peter Joseph
Dark Ochre Colour with Red Border 1977

conveying highly specific experiences of light or landscape. Similarly the English painter Peter Joseph (born 1929) has focused his attention since the early 1970s on variations of a single format – a rectangle of a flatly painted colour surrounded by a border of a different hue – to convey introspective moods through the precise meeting of light and dark, that is to say, through the juncture of two colours in a particular proportional relationship.

While Minimal art proved flexible enough to accommodate such refinements of sensibility and emotion, it is for the often mathematical rigour of its logic that the movement remains best known. The sculptures of both Andre and Sol LeWitt (born 1929) have explored numerical permutations; Andre's much misunderstood brick piece, for instance, was one of four sculptures created for an exhibition entitled *Equivalents* in 1966 in which he stacked the same number of bricks in four configurations so as to stress the transformation of solid matter from a specific quantity of identical units. LeWitt, for his part, in the 1960s created room-size installations based on a grid formation in which he explored the changes that could be wrought to a form as basic as the cube; subsequently he made wall drawings generated by such strict principles that it could be left to others to execute them according to his instructions. Such reliance

Sol LeWitt
Wall Drawing no. 273 (7th wall) 1975

Donald Judd
Untitled 1981

on assistants and even on industrial manufacture, which also
characterized the work of Donald Judd, shifted attention from execution,
which was assumed to be as impersonally perfect as that of a mass-
produced industrial object, to the form as the material evidence of an
idea. Judd was consistently concerned with the properties of different
materials – among them plywood, galvanized iron, stainless steel,
anodized aluminium and plexiglass – and with questions of spacing and
proportion as structuring devices no less rigorous than those employed in
classical art and architecture.

Minimal art proved to be much longer-lived than might have been
expected of a movement predicated on such notions of simplicity, both in
the hands of its original practitioners and in the variations created in its
wake. As early as 1964, a year before the movement had even been
named, another American artist, Richard Artschwager (born 1924), was
creating sculptures made of formica on wood in which the standard
Minimalist cube was transformed into an image of an ordinary object
such as a piece of furniture; at once an illusion and a literal account of its
identity as an object manufactured from modern synthetic materials, it
proposed unsettling questions about such essential matters as
representation and the function of art. Among other artists who
maintained an idiosyncratic relationship with Minimal art was the
Austrian-born British painter Peter Kinley (1926–88), who from the mid-
1960s employed a representational language of emblematic simplicity to
convey highly personal responses to nature, animals and domestic life. In
a later work such as *Battleship* (1985), for instance, an image generally

Richard Artschwager
Table with Pink Tablecloth 1964

considered sinister materializes in brushwork of great tenderness; the artist acknowledged that far from being an image of militaristic aggression, he conceived it as a metaphor or vehicle for his own sense of resilience and fortitude at a time of his life when he felt isolated and under siege. While never considered to be Minimalists, Kinley and others who have similarly used a representational language of extreme economy, such as Susan Rothenberg (born 1945), have continued to demonstrate the possibilities of such forms for the expression not only of rigorous logic but also of intimate emotion.

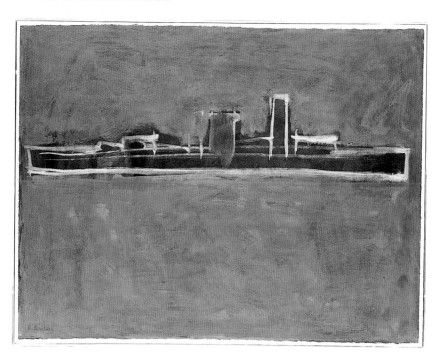

Peter Kinley
Battleship 1985

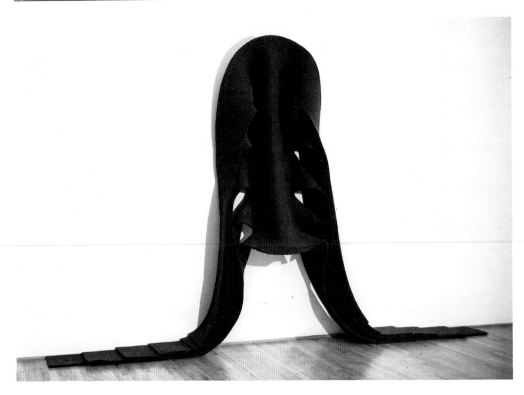

Robert Morris
Untitled 1970

One of the American artists associated with the origins of Minimal art, Robert Morris (born 1931), was also instrumental in the development from Minimalism of types of art which stressed the process by which they had come into being. In an influential article titled 'Antiform', published in *Artforum* in April 1968, Morris rejected form as an end in itself in favour of chance and indeterminate methods and materials which gave rise to objects of an ephemeral or changeable nature. Among the methods cited by him were 'random piling, loose stacking [and] hanging'. His materials could be as evanescent as steam and as malleable as felt, from which he made a number of large hanging works in the late 1960s and early 1970s; some of these bore more than a passing resemblance to paintings by Jackson Pollock and Morris Louis which had prefigured such an insistence on chance methods and shapes induced by process.

Process art, while never clearly identified or promoted as a coherent movement, was nevertheless an important force in American and European art by the end of the 1960s. Early in the decade the Pop artist Claes Oldenburg had begun to make sculptures representing ordinary objects on a heroic scale in both 'hard' and 'soft' versions, drawing attention to the characteristics of contrasting processes and materials in generating forms; from such experiments in malleable shapes a new type of sculpture emerged which became known as Soft art. In Europe much of this work, favouring materials previously deemed inartistic, was presented under the banner of Arte Povera; among the artists associated with these developments were the German Joseph Beuys (1921–86), along

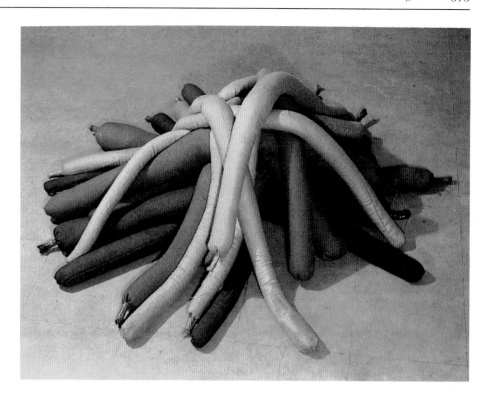

Barry Flanagan
Heap II 1968

with the Italians Mario Merz (born 1925), Giulio Paolini (born 1940) and the Greek-born Jannis Kounellis (born 1936). The diversity of methods and associations could encompass industrial procedures and techniques, especially in American art, as in the sculptures of crushed fragments of car bodies by John Chamberlain (born 1927) or in the lines formed from molten lead hurled against the junction of wall and floor by Richard Serra (born 1939). They could, however, also take a much more domestic or prosaic form, as in the *Heap* of coloured cloth presented as a

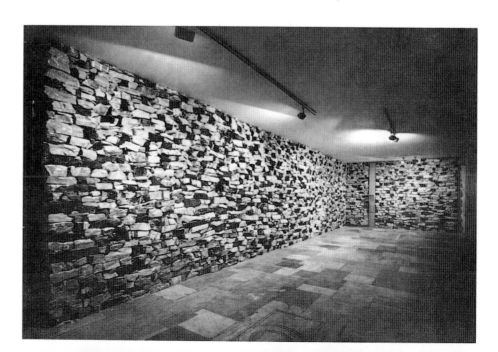

Jannis Kounellis
Untitled, Athens 1985

John Chamberlain
Captain O'Hay 1961

sculpture by the English artist Barry Flanagan in 1968, or in the emphasis
on ordinary methods of construction such as folding, tieing, stapling,
stitching and bolting together in paintings by the English artists Richard
Smith and Stephen Buckley (born 1944). For the German-born American
sculptor Eva Hesse (1936–70), the relationship established with the
spectator through this open avowal of the act of making could entail the

Stephen Buckley
Many Angles 1972

Joseph Beuys
Terremoto 1981

use of transparent materials such as fibreglass, which openly revealed
their structure, and a metaphorical equivalence between organic-looking
pendulous forms and the human body. For Joseph Beuys particular
materials such as felt and fat conveyed an essentially private mythology
rooted in his wartime experiences of protection and survival when near
death; his tendencies towards the esoteric were checked, however, by his

Eva Hesse
Sans II 1968

innate sense for the qualities of different materials and for the emotive effects and physical sensations stimulated by sculptures on an environmental scale. One of his last major works, an installation titled *Plight* (1985) at the Anthony d'Offay gallery in London, involved the virtual sealing off of the interior in bundles of felt to create a still, silent, warm and almost claustrophobically sealed shelter or womb-like space. Through such works and occasional performances and lectures Beuys made a strong case for the transcendence of the spirit and of elemental forces over matter, presenting himself as a shaman. Without perhaps ever being fully understood, he remained an immensely influential figure, especially in Germany, for his insistence on art as an instrument capable of healing the wounds of society.

For Beuys and other artists in the 1960s the gallery space was not merely a neutral or passive receptacle for art but an essential part of the art-work itself. The role accorded to presentation by the Minimal artists, for instance, was not simply one of professionalism or commercial astuteness but a means of articulating the meaning of individual works and of their inter-relationships in a specific context; as Barnett Newman had earlier avowed with his term 'hereness', Minimal artists and composers such as Steve Reich and Philip Glass alike sought a concentration of perception and physical being on the immediate moment and thus on the particularity of the place. In the wake of this stress on the exhibition itself as the work of art, artists of diverse stylistic allegiances have placed emphasis on the installation as a whole rather than on its individual components. Environmental art in this specific sense had historical precedents, particularly in pre-Pop works by Claes Oldenburg such as *The Street* (1960) and *The Store* (1961), but what had begun as temporary displays in an almost theatrical context has since become the standard form for artists who otherwise have little in common stylistically or in terms of subject matter. The often mysterious installations by Jannis Kounellis, for example, tend to include traces of the actions by which they came into being, such as the singeing of the gallery walls by smoke. There is little basis on which to relate such works to the highly specific theatrical tableaux created by the American Edward Kienholz (born 1927) or the manifestations of dream imagery produced by a younger

Ed Kienholz
Portable War Memorial 1968

Richard Long
England 1968

American, Jonathan Borofsky (born 1942). For each of them, however, the relationships established within the whole remain of greater importance than the constituent parts.

By the late 1960s such concern with the work of art as a total environment, combined with a desire to remove art from the commercial manipulation and rarefied context of galleries and museums, had helped create the basis of a new art form known as Land art or Earth art. Works by its most notable practitioners, especially in the United States, often occupied a vast space in remote locations and involved the direct interaction of man and nature with the earth itself as a raw sculptural material. Given the vastness of North America and the availability of large stretches of desert and other uninhabited areas of land, it was perhaps inevitable that many of the major artists associated with the movement were American and that their works were often characterized by a grandeur of scale; such was the case with Michael Heizer (born 1944), Dennis Oppenheim (born 1938) and Walter De Maria (born 1935). Other artists, such as the Englishmen Richard Long (born 1945), Hamish Fulton (born 1946) and David Tremlett (born 1945), travelled to places as distant and inhospitable as Greenland and Tibet in search of a suitable location for a communion with nature. The implicit actions performed on the land were often direct and immediate, involving the digging or removal of soil or rock or the restructuring of a site into an elemental and symbolic form such as a spiral, as in works by Robert Smithson (1938–73) such as *Spiral Jetty* (a 1500-foot [457.2-metre] long coil of mud, salt crystals, rock and water at Rozel Point, Great Salt Lake, Utah, 1970) and *Spiral Hill* (a hill at Emmen, Holland, made of earth,

Robert Smithson
Spiral Hill, Emmen 1971

black topsoil and white sand, measuring approximately 75 feet [22.8 metres] at its base, executed in 1971). The forms taken by Land art could involve nothing more than the subtle relocation of natural elements indicating the passage of a human being through a hitherto untouched environment, as in works by Richard Long such as *England* (1968), which consisted of a large X shape made on a grassy field by the removal of the heads of daisies; these works, documented in photographs, were temporary by definition, since the cycles of mortality at work in nature were built into their very structure. In this type of art it was often the case that the direct experience was afforded only to the artist himself, and it was left to the spectator's imagination to reconstruct its physical character by means of photographs, maps and written documentation of a sometimes overtly poetic nature, as in the work of Hamish Fulton. Long also produced works for installation in galleries, particularly floor pieces which bore some formal resemblance to the Minimal art of Andre but which made a specific connection through their materials – quantities of stone or driftwood – to specific natural locations as a way of connecting the two environments and the experiences which they represent. The preoccupations of other Land artists, particularly in the United States, were more overtly sculptural in a traditional sense, as in works by the Bulgarian-born artist Christo (born 1935) such as *Wrapped Coast* (Sydney, Australia, 1969) and *Valley Curtain* (Colorado, 1971), in which the shape and mass of large areas of land were articulated by massive quantities of cloth.

If much Land art indicated a nostalgic desire for an escape from civilization as well as from the corruption of art by its commercial exploitation, similar motivations encouraged the development of another art form during the 1960s: Performance art. Although its origins can be

Christo
Wrapped Coast – Little Bay, Australia 1969

traced to theatrical provocations early in the century by Futurists, Russian Constructivists, Dadaists, Surrealists and other Modernist artists, it was in the late 1950s that it began to take shape more explicitly as a means of making art in its own right, for example in the Happenings by New York artists associated with the origins of Pop art such as Allan Kaprow (born 1927), Claes Oldenburg, Jim Dine (born 1935), Red Grooms (born 1937), Robert Whitman (born 1935) and Robert Rauschenberg. Performances could be gruelling experiences for the artist and audience alike, both physically and intellectually, as in works by Joseph Beuys such as *How to Explain Pictures to a Dead Hare* and *Twenty-four Hours* (both 1965), which demanded high levels of concentration and physical stamina as part of their confrontational nature and examination of consciousness. Feats of endurance and physical pain, to which especially Europeans such as Hermann Nitsch (born 1938), Günter Brus (born 1938), Arnulf Rainer (born 1929), Gina Pane (born 1939) and Stuart Brisley (born 1933) subjected their bodies, often had ritualistic and

Stuart Brisley
And for Today – Nothing 1972

Robert Wilson
Still from *Einstein on the Beach* 1976

expressionist overtones as part of a purging of social or religious patterns
of behaviour. Artists associated with Body art, such as the Americans
Scott Burton and Lucinda Childs, used the human figure as a sculptural
element as part of a contemplation of time and space, while for others
such as the Canadian group General Idea (formed in 1968 by A. A.
Bronson, Felix Partz and Jorge Zontal), the British team of Gilbert and
George (born 1943 and 1942) and the Scottish artist Bruce McLean
(born 1944) doses of humour and vaudeville provided a means of
unmasking human behaviour and the pretensions of the art world.
Performances could be improvised and spontaneous or as intricately
scripted and visually exacting as the ambitious theatrical events staged by
the American Robert Wilson (born 1941), such as his collaboration with
the composer Philip Glass on the opera *Einstein on the Beach* (1976).
Performance art, in other words, while never achieving a very wide
public, proved to be as flexible and various as any art form in the styles,
moods and themes which it was able to convey. The ephemerality and
lack of marketability which had initially attracted many artists to such
work, however, in the end contributed to the marginalization of the form,
and many of those associated with it turned again to the production of
more conventional art objects as sculptors or painters.

Performance art, while particularly lucid in its emphasis on action in
time rather than on the creation of a finite object, was only one of several
media which challenged traditional artistic priorities during this period.
The Video art initiated early in the 1960s by the Korean Nam Jun Paik
(born 1932) and others, while dependent on the physical sensations
afforded by the latest technology, used television sets not as ends in
themselves but as a means of transmitting a specifically contemporary
experience of the modern world or of recording for posterity an otherwise
transient performance. For Paik in particular the medium offered a
suitable means of expressing and questioning the bombardment of the
senses effected by the mass media. All such moves away from standard

Nam Jun Paik
Beuys-Voice 1987

media, including Process art, Land art and Performance art, presaged a general emphasis in the later 1960s away from the object in favour of the generating idea. In its most extreme form, Conceptual art, the idea alone could be presented as the work of art. In an essay titled 'Art After Philosophy', published in *Studio International* in October 1969, the leading American exponent of Conceptual art, Joseph Kosuth (born 1945), cited Marcel Duchamp's invention of the 'unassisted Ready-made' as the single event which changed the focus of art from 'appearance' to 'conception', 'from the form of the language to what was being said'. Kosuth's own work often relied on photographic enlargements of dictionary definitions

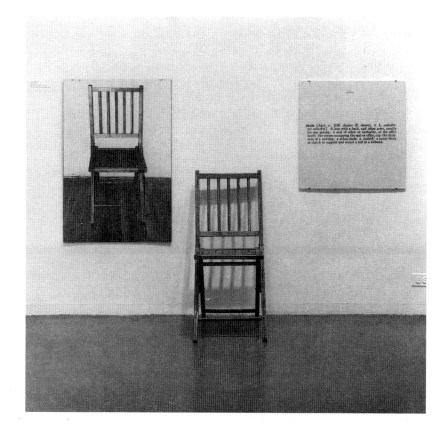

Joseph Kosuth
One and Three Chairs 1965

Marcel Broodthaers
La Salle Blanche 1975

presented as equivalents to real objects or to their representations in photographs. Much of Conceptual art was text-based, with the written word functioning as a replacement for visual signs, as in the handpainted phrases presented on gallery walls by the American Lawrence Weiner (born 1940); while much of this type of art was pedantically and ponderously intellectual, Weiner continued in his later works to use words for their visual suggestiveness, as in *BILLOWING CLOUDS OF FERROUS OXIDE SETTING APART A CORNER ON THE BOTTOM OF THE SEA* (1986), in the process making a strong case for the power of language and memory in conveying experience. Another artist who relished paradoxical interchanges between words, objects and images was the Belgian Marcel Broodthaers (1924–76), whose Conceptualism was at least partly rooted in the paradoxes of the Surrealist René Magritte; for example in an installation titled *La Salle Blanche* (1975) he reconstructed in wood the surfaces of two rooms in his house on which he had inscribed references both to standard images in painting (shadow, sunlight, clouds) and to things used in the making and promotion of art (canvas, easel, gallery, percentage, museum).

Conceptual art, in spite of its apparent affront to the marketing of art objects, was severely dependent on its context in order to express its meaning; outside a gallery or museum it ran the risk of failing to be recognized as art. The leading French Conceptual artist, Daniel Buren (born 1938), turned this situation into a virtue by basing his work on the changes wrought by different environments to a single visual sign – a simple pattern of alternating stripes – which through constant use was paradoxically transformed from an anonymous image into his personal trademark. It was through words, however, that most Conceptual artists conveyed their ideas; one of the most active groups, Art and Language,

A PROMISE OF TRADITION
You mustn't be too hard on them.
So many things to cope with. So much to do.
They keep rabbits. They keep house.
They keep up appearances.
If they fail to keep their word
you must excuse them. They're good people.
Almost all of them. They may not see you.
They may not hear you. They may not want to.
It's not their fault. They mean well.
They have promised to try again.

Victor Burgin
A Promise of Tradition 1976

Barbara Kruger
'Untitled' (I Shop Therefore I Am) 1987

Daniel Buren
Les Deux Plateaux 1986

even published its own magazine as a forum for its British and American members. In England a variant of Conceptual art dependent on the relationships established between written texts and photographic images provided the structure for philosophical, social and political enquiry; among the practitioners of this type of art were Victor Burgin (born 1941), John Stezaker (born 1949) and Stephen Willats (born 1943). In the 1980s two Americans, Barbara Kruger (born 1945) and Jenny Holzer (born 1950), were among those who even more explicitly sought to decode the methods of advertising and the mass media in order to reverse

the depersonalization and manipulation to which they generally subjected viewers assumed to be passive consumers.

Malcolm Morley
SS Amsterdam in Front of Rotterdam 1966

In its most extreme forms Conceptual art was perhaps ultimately too rarefied to be effective as an antidote to object-based art, but in retrospect virtually every ambitious form of art proposed since the 1960s has made its case on a central defining idea. On first sight nothing could seem further from the intellectual thrust of Conceptual art than the apparently unquestioning imitation of photographic forms of representation by the painters and sculptors associated with another movement of the same period, Photorealism. Painters such as the English-born Malcolm Morley (born 1931) and the Americans Richard Estes (born 1936), Robert Cottingham (born 1935) and Robert Bechtle (born 1932), however, were not concerned simply with replicating the appearance of a snapshot as a technical *tour-de-force*; their presentation of the canvas as a found object was a philosophical gesture that would have been unthinkable without the example of Duchamp, and their obsessive concern with equating the vision of eye and camera was a means of addressing issues of mimesis and perception which had challenged the thinking of artists for centuries. Photorealism was largely an American

Richard Estes
Paris Street-Scene 1973

movement, and like the Pop art which served as one of its sources it was often interpreted in terms of its subject matter either as a critique or a celebration of lowbrow suburban culture. In its very dependence on readymade imagery, however, it declared its detachment and non-judgmental scrutiny. Even in the life-size sculptural figures by John De Andrea (born 1941) and especially Duane Hanson (born 1925), the narrative social connotations which sometimes threaten to engulf the image in kitsch remain subservient to the physical presence and shock of recognition occasioned by the apparent fidelity to appearances.

Duane Hanson
Tourists 1970

While Photorealism was popular with collectors and with the general
public for its virtuosity and clarity of imagery, it proved short-lived as a
movement among both critics and other artists. Although initially
promoted as a return to figuration, by definition it held no real possibility
of development apart from that of technique for its own sake, since the
artist could aspire to nothing more than the duplication of evidence much
more easily amassed by the camera. By 1971 Morley had adopted
frenetically expressionist brushwork and violent gestures of fragmentation
in deliberate subversion of the cool neutrality of his earlier paintings.
Given the Photorealists' apparent lack of subjective involvement in the
act of picturing, any distinction drawn between abstraction and
representation was beginning to seem meaningless in any case. If it was
an immediate source of imagery that was required, why not simply use
photographs? Such seems to have been the conclusion reached by Gilbert
and George, the self-styled 'Living Sculptures' who had made their name
as performance artists, when they turned in the mid-1970s to the

Gilbert and George
Sleepy 1985

production of composite photographic images in which they presented themselves in the context of emblems of their emotions, perceptions and experiences. For the American Cindy Sherman (born 1954), too, photographs for which she always served as the model provided a direct measure of contrasting notions of identity, self-image and gender; the explicit appropriation of the presentation methods of film-stills in her first black-and-white and colour photographs of the late 1970s and early 1980s soon gave way to a greater reliance on her own ability to transform herself into different characters through gestures and changes in her appearance. It was, however, another American photographer, Duane Michals (born 1932), who from the late 1960s most eloquently used the medium to convey thoughts about mortality, desire, loneliness and vulnerability. Although he was widely influential for his formal innovations, such as the use of serial imagery for narrative purposes or the pairing of images with handwritten texts, it was in introducing an intimacy of tone that he made his most courageous and welcome inroads into the largely public sphere of contemporary art.

By the early 1970s a number of painters, too, were making a strong case not only for the continuing validity of their medium but for the subjectivity of a one-to-one relationship with subject and spectator alike. One of the most reticent of the Abstract Expressionists of the 1950s, Philip Guston (1913–80), shocked many of his former supporters when he turned in the late 1960s to an overtly representational style of almost cartoon-like vulgarity as a means of dealing unflinchingly with the circumstances of his studio existence and with passing thoughts, anxieties,

Cindy Sherman
Untitled no. 98 1982

Duane Michals
The Unfortunate Man 1976

THE UNFORTUNATE MAN

The unfortunate man could not touch the one he loved.
It had been declared illegal by the government.
Slowly his fingers became toes, and his hands became
feet. He began to wear shoes on his hands to hide his shame.
It never occurred to him to break the law.

memories and sensations. The generosity of spirit in his work, the
insistence on art as a reflection of the fullness of his attitudes about life,
presaged much of the painting that was to emerge towards the end of the
1970s from the studios of much younger artists. He was not alone,
however, in resisting the purely formal and materialist notions of painting
which had been so vigorously promoted in the 1960s by critics such as
Clement Greenberg. Since the late 1940s in England Francis Bacon had
steadfastly maintained his ambition to create figure inventions of such
physical immediacy and energy as to appear to emanate, as he explained,
from his nervous system. His work was a particular inspiration to other
painters working in Britain, including Leon Kossoff (born 1926) and two
German-born artists, Frank Auerbach (born 1931) and Lucian Freud
(born 1922), for each of whom the physical substance of the painting was
a direct materialization of the subject, often another human being
painted from life. For Auerbach each painting exemplified a constant
process of forming an image, scraping it down and then reconstituting it
until it corresponded in form, texture, weight, tone and colour to his sense
of the subject it represented; the accretion of paint, sometimes of such
density and thickness as to risk incoherence, itself became a sign for the
labour and time involved in the production of the image. In Freud's case

Frank Auerbach
Looking towards Mornington Crescent Station,
Night 1972–73

Lucian Freud
Esther 1980

the calculated application of each brush-stroke in conjuring a human presence functioned both as evidence of his obsessive scrutiny of the subject and as a material counterpart for the suppleness of human flesh. Such concern with what the art historian Irving Sandler has termed 'perceptual realism' also motivated painters of the human figure in other countries, notably the American Philip Pearlstein (born 1924), whose clarity of form and accuracy of detail were sometimes misleadingly associated with Photorealism.

The openly traditional goals of such painters of the human figure lent increasing weight in the 1970s to those who questioned the pre-eminence still accorded the avant-garde for its own sake. For the Paris-based Israeli artist Avigdor Arikha (born 1929), for example, truth of expression had to reside in the particularities of working directly from the motif or from the human figure, as had been the case for artists from Velázquez through to Degas and Vuillard. Why, indeed, should such directness be deemed to have run its course simply because it failed to correspond to Modernism's insistence on the invention of new forms? Even in his

Avigdor Arikha
August 1982

paintings of empty interiors Arikha was intent on conveying, through the quivering presence of each brush-stroke, a palpably physical sensation of stillness and the comforting warmth of light. For the London-based American R. B. Kitaj (born 1932), who in the 1960s had unwittingly influenced the course of Pop art, such pre-Modernist traditions of life drawing had also become the most rigorous standard of excellence. His most ambitious paintings, however, combined Modernist principles of juxtaposition derived from Surrealism and collage with a concept of

R. B. Kitaj
The Autumn of Central Paris (After Walter Benjamin) 1972–73

Georg Baselitz
Waldarbeiter 1968

allegory rooted in Renaissance and Symbolist art, with images chosen for their layering of meaning through re-use, as in the art historical discipline of iconology. Often misguidedly accused of eclecticism, Kitaj in fact made a powerful case for the availability to modern artists of the entire fund of historical styles and images. Kitaj's work presaged the development of many younger artists not just in his commitment to representation but to passionate convictions about particular themes and to a freewheeling synthesis of separate elements filtered through one artist's sensibility and related to a coherent subject matter.

In Germany as early as the 1960s a number of artists such as Georg Baselitz (born 1938) and A. R. Penck (born 1939), both originally from East Germany, had sought to fragment and overturn conventions of painting in search of a vitality and violence which had specific precedents in turn-of-the-century Expressionism. In his early work Baselitz favoured

images of overt sexual provocation, animality, mutilation and mental illness; he often expressed a sense of fragmentation and alienation by means of dismembered and apparently hastily reassembled interpenetrating sections, disrupting the coherence of both the image and the space in which it was pictured. By the end of the 1960s he had made actual a demand which he had voiced as early as 1963 to 'Stand the topsy-turvy world on its head': while still favouring traditional subjects of human figures, animals and natural forms, he both painted and exhibited them upside down, thus insisting on the reality of the picture itself as its own justification. Penck took a rather different course, notably in his reliance on an elemental language of hieroglyphic-like simplicity, but through the impetuousness of his technique and often wilfully crude symbolic forms similarly insisted on the primitive impulses lying just below the veneer of civilization in contemporary society. For many German artists of a generation too young to have experienced World War II, such as Jörg Immendorff (born 1945), Rainer Fetting (born 1949) and Helmut Middendorf (born 1953), the traumatic crisis in national identity occasioned by the Nazi period stimulated a direct return to specifically German traditions of Expressionist subversion. For Anselm Kiefer (born 1945) the purging of this recent past necessitated a direct confrontation with Fascism, for example in a series of paintings of scorched or burning fields which he presented as metaphors for the destruction of the Jews at the service of the Aryan ideal; in several of these canvases he made reference to Richard Wagner, Hitler's favourite composer, and specifically to the opera *Die Meistersinger von Nürnberg*, with its additional historical overtones of pre-war Nazi rallies and the post-war trials of war criminals. Kiefer's canvases are often aggressively physical, with the images painted over black-and-white photographs or supplemented by the incorporation of actual straw in a one-to-one identification with a dessicated field; this was not just a device to make

A. R. Penck
Der Beginn der Löwenjagd 1982

the subject more literally palpable, but a means of suggesting organic cycles of life and death and the possibility of regeneration.

Avant-garde developments during the 1960s were characterized by almost puritanical restrictions against allegedly extraneous subject matter and traditional forms, and it was thus with an air of self-conscious defiance that many artists in the following decade embraced such taboos. Indeed the very notion of a self-perpetuating avant-garde began to be called into question. Michael Sandle (born 1936), an English sculptor based in Canada from 1970 to 1973 and subsequently in Germany, had described his work as early as 1964 as 'an attempt to find symbols for that which I fear, or hold in awe . . . "ghosts", Death, War, dissolution . . . to invest my work with "magic" . . .' To these ends he deliberately turned his back on the innovations made by other sculptors and looked instead to pre-Modernist forms of monumental sculpture, notably in his first large-scale work in bronze, *A Twentieth Century Memorial* (1971–78). This represents a skeletal Mickey Mouse manning a machine gun, an image by which he decried the futility of modern institutionalized violence and what he judged to be the lightweight nature of contemporary culture. His subsequent bronzes, many of which combined references to World War II with devices derived from traditional funerary sculpture, were often provocatively traditional in a specifically Victorian sense. Together with the work of other artists loosely referred to as Post-Modernists, who sought to counter Modernism's linear progression and quest for new forms with an eclectic and synthetic approach to the entire history of styles, Sandle's sculptures helped make a case for the continuing power embedded in seemingly old forms and timeless themes.

A deeply ingrained sense of tradition, phrased in a personal and often intimate tone of voice, characterized the work of a number of Italian painters who became a strong presence in the early 1980s, such as Francesco Clemente (born 1952), Sandro Chia (born 1946), Enzo Cucchi

Michael Sandle
A Twentieth Century Memorial 1971–78

Anselm Kiefer
Die Meistersinger 1982

(born 1950) and Mimmo Paladino (born 1948). Promoted under various labels, including the Transavanguardia and New Image painting, they made frequent reference to their place in Modernist traditions – for example in Chia's case by allusions to an earlier Italian movement, Futurism – while stressing their inherent subjectivity and their elevation of the imagination over intellect. Among Clemente's most affecting works were small-scale, lusciously coloured and sensual pastel drawings conceived as emblematic representations of the human body. Like many of the New Image painters, however, he made a point of working in a large variety of styles and media as if bound to express the restlessness of his visual life and to define his complex relationships to conflicting traditions originating in different cultures and periods. Through such thinking a series of overtly Expressionist oil paintings such as *The Fourteen Stations* (1982), in which he reinterpreted a symbolically laden Christian theme by means of his own recurring image, could co-exist with large-scale gouaches on paper in which he transformed his appreciation of Indian miniatures into a poignantly awkward archaic style, as if he were reinventing conventions of representation. For other Italian artists such as Cucchi, as for Beuys in Germany, the emphasis lay largely in defining the role of the artist as visionary; in Cucchi's case images with ritualistic overtones are often conveyed in sombre and emotive colours and with an impassioned brushwork indicative of an all-consuming energy. As he explained in a brief text in 1979, 'One can establish profound things in the material components of the work. They say it is useless to reason with

Francesco Clemente
Interior Landscape 1980

Enzo Cucchi
A Painting of Precious Fires
1983

the head. Then we'll reason with the elbow (again), but only when we quicken our "rhythm" step.' Logic and material fact were no longer such attractive propositions to many artists, perhaps specifically because of the sway that these characteristics had held throughout much of the 1960s and 1970s. Peter Phillips (born 1939), for example, who from 1960 had

Peter Phillips
Anvil of the Heart 1986

seemed one of the most rigorous and defiantly materialistic Pop painters in Britain, turned in the late 1970s to a mysterious dream-like imagery in paintings of extreme refinement and delicacy. He continued to base his pictures on collages of photographic images culled from magazines but presented them now as fragments of obscure origin rather than as immediately recognizable images. Familiar in their texture but naggingly unidentifiable in form, such motifs appeal to the spectator's memory and to sensations of touch as a means of short-circuiting a self-consciously cerebral response.

A number of artists in the 1980s have addressed themselves to the virtual impossibility of originality given the sheer weight of innovation presented in the many guises of Modernism for nearly a century. Rather than wage what might seem to be a losing battle, artists such as the

Sigmar Polke
The Copyist 1982

David Salle
My Head 1984

Germans Sigmar Polke (born 1941) and the Czechoslovakian-born Jiři Georg Dokoupil (born 1954), the American David Salle (born 1952) and the Japanese Shinro Ohtake (born 1955) have chosen to embrace as many different styles and methods of working as possible, either from picture to picture or even in a profusion of seemingly contradictory idioms within a single canvas. Motivated to a large measure by the detachment towards style demonstrated in the 1960s in Pop art, and even earlier by the assertion of the Dadaist Francis Picabia that styles should be changed with the same frequency as one's shirt, such forms of representation could best be apprehended as conceptual acts. In such works intentions are often left deliberately ambiguous. Is Polke's presumed self-image as a copyist an emblem of despair and cynicism, for example, or one of exhilaration at the prospect of devouring and making one's own something which is already in existence? Should we assume from Salle's *My Head* that he is mocking the obtuseness or congestion of his imagination or celebrating the wealth of images teeming within it? For Ohtake as a young Japanese artist the predicament has specific cultural connotations in the hunger to assimilate and paraphrase every conceivable variety of contemporary Western art so as to restate it in his own terms.

One of the words most often cited by young artists in the 1980s was *appropriation*. This could entail the emulation by New York painters such as Jean-Michel Basquiat (1960–88) and Keith Haring (1958–90) of the urgent street culture represented by the graffiti scrawled on walls or subway trains, or acts of such Duchampian simplicity as the presentation

Shinro Ohtake
Family Tree 1986–88

Jeff Koons
Rabbit 1986

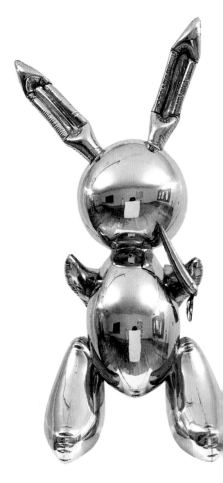

by the American Jeff Koons (born 1955) of a sculpture cast in stainless
steel from a bargain-shop Easter rabbit. In a similar spirit another
American, Sherrie Levine (born 1947), had earlier displayed as her own
work framed photographic reproductions of famous modern paintings.
She wrote in 1981: 'The world is filled to suffocating. Man has placed his
token on every stone. Every word, every image, is leased and mortgaged.
. . . Succeeding the painter, the plagiarist no longer bears within him
passions, humours, feelings, impressions, but rather this immense
encyclopaedia from which he draws.' For another American, Julian
Schnabel (born 1951), the answer lay not in acquiescence but in an often
violent assault on his chosen images and materials alike; in his best-known
works, painted on a jagged surface of broken crockery, he seemed intent
on literally destroying all conventions by a sheer act of will. As in the art
of earlier Modernists, there is a sense that everything is possible and that
art can be made out of whatever materials, images and subjects are most
readily to hand, yet the optimism with which such methods had
previously been associated seems unavoidably weighted now with the

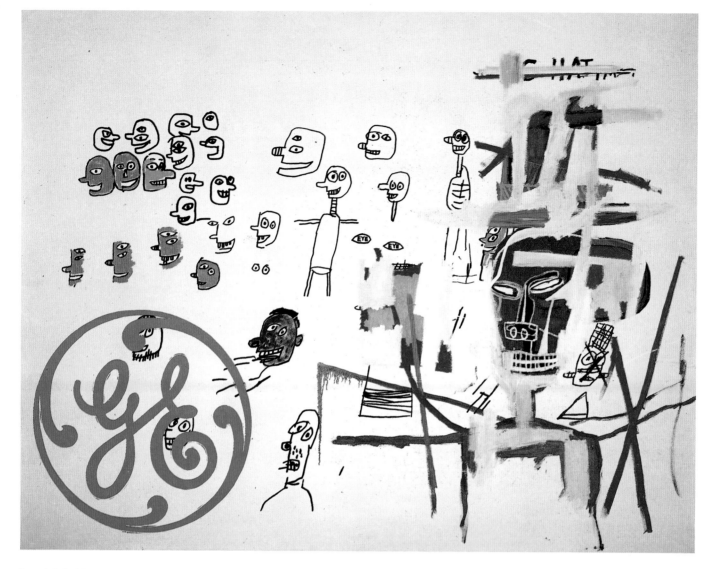

Jean-Michel Basquiat/Andy Warhol
Collaboration 1984

Sherrie Levine
Untitled (Lead Checks 6) 1987

Julian Schnabel
The Death of Fashion 1978

demands of career, competition and ego. Others, however, have suggested ways in which apparently unconstrained appropriation can serve to create a dialogue between different levels of experience and society. For example the English painter Colin Self (born 1941), best known for his intense and unsettling Pop art drawings of the 1960s, has demonstrated in collage paintings a readiness to make his own not just styles but actual artefacts produced by others as a way of exploring our common humanity. In '*Let's have it here and charge admission . . .*' (1988) he has appended mass-produced plastic toys (including a figure of the comic strip character Bugs Bunny) to an amateur Tachist painting of the type produced in evening classes; the casual, almost throwaway quality of this act belies, however, Self's deeply held convictions about what he calls 'people's art' as a form of artistic expression worthy of our respect.

Colin Self
Let's have it Here and Charge Admission . . .
1988

Against such currents of stylistic manipulation during the 1980s, other painters have sought to use their work as a vehicle for human psychology. The American Eric Fischl (born 1948) has specialized in narratives of the seamier side of suburban life, in which larger-than-life and often naked human figures are encountered in intimate and sexually charged situations that turn us uncomfortably into voyeurs. Although the images are clearly derived from photographs, our attention is deflected from their probable source to their materialization as succulent paint and then to the significance of their gestures and inter-relationships in the drama of an otherwise unexplained moment. Although similar subject matter had

Eric Fischl
The Old Man's Boat and the Old Man's Dog
1982

been explored by the French painter Balthus (born 1908) since the 1930s
in his erotic presentation of young women in claustrophobic interiors, or
in the English painter David Hockney's (born 1937) large double
portraits of the late 1960s, which were subtly expressive of isolation and
mutual dependence, the possibilities for other painters were far from
exhausted. Paula Rego (born 1935), a Portuguese-born artist resident in

Paula Rego
The Maids 1987

England, began in the mid-1980s to make specific reference to childhood memories resurrected almost in the manner of theatrical tableaux by means of a persuasively volumetric treatment of objects in space; however innocent the actions of the figures might at first appear, a disturbing sense remains of sado-masochistic power and dependence. In many of Hockney's paintings of the 1980s the human figure is no longer directly represented; by means, however, of pictorial devices such as multiple viewpoints and reverse perspective, interior spaces are organized so that we as spectators have taken centre stage in an overt acknowledgment of our presence and of our role in completing the picture.

Abstraction and representation, terms which seemed to define irreconcilable positions at the start of the 1960s, no longer hold much meaning in the work of many artists. The English painter Howard Hodgkin (born 1932), for instance, has relied largely on a severe vocabulary of simple brushmarks and basic geometric forms, but his layering of the surface with coloured patterns has a specific function in each case in reconstituting the memory of a person or group of people in a particular location, often an interior space. In that sense his work, while it uses a language resembling abstraction, remains an intimate art of human behaviour and emotion. For the German painter Gerhard Richter (born 1932), by contrast, a dependence on the photograph as a mediator since his Pop work of the 1960s has served to draw attention to the

David Hockney
Large Interior, Los Angeles 1988

Opposite:

Howard Hodgkin
Dinner at Smith Square c. 1978–79

Gerhard Richter
Sulphur 1985

Bill Woodrow
Twin-Tub with Beaver 1984

identity of every image both as an abstraction and as a representation. His landscapes represent not so much a specific place as their photographic source, and in that sense remain conceptual acts; conversely his 'abstract' paintings, possessed of illusions of photographic variations of focus in their contrasts between crisp delineation and smudginess, read as representations of brush-strokes rather than simply as studies in form.

Such interplays between reality and illusion, between the work of art as a thing in itself and as a sign for another level of experience, were central to much art of the 1980s. It was to such ends that a number of British sculptors, including Tony Cragg (born 1949) and Bill Woodrow (born 1948), used as their basic material found objects, sometimes altered but presented without disguise. A work by Cragg such as *Plastic Palette II* (1985), formed as the title indicates not from paint but from individual shards of cheap plastic, may at first appear to be a caustic comment about a now outmoded concept of what it means to be an artist. As an emblem of his own definition of creativity, however, it is as lucid as it is sincere: for what he presents to us here, in a mood of celebration, are his raw materials transformed into art, all the more to be cherished because they had been abandoned as useless by others. Woodrow's inventive

fabrication of metaphoric images from discarded consumer items, their original identity still clearly visible, likewise presents the artist's duty as one of salvaging and making new, as is explicitly the case with *Twin-tub with Beaver* (1981).

Almost every movement and art form initiated since the early 1960s continues to exist as a defensible proposition as we approach the last decade of the century. Styles have appeared to succeed each other like passing fashions, with conflicting impulses and alternative traditions defended with equal vehemence and conviction. No single way of working can be said any longer to dominate, as had been the case earlier in the century. Unnerving as it may be to feel the ground constantly shifting under our feet, it can safely be said that not since the advent of Modernism at the end of the nineteenth century have artists been faced with such an openness and wealth of possibilities.

Tony Cragg
Plastic Palette II 1985

Chronologies and Select Bibliographies

1 Impressionism

Chronology

1863 Salon des Refusés includes works by Manet, Cézanne, Jongkind, Whistler, Pissarro. Delacroix dies.
1864 Monet, Renoir, Cézanne, Sisley and Bazille work as a group at Chailly.
1865 Manet exhibits his *Olympia*, which is the target of violent criticism.
1867 Paris World Fair has sections devoted to works by Manet and Courbet. Zola writes about Manet's works.
1869 Manet exhibits *Déjeuner sur l'herbe* at Salon.
1870 Outbreak of Franco-Prussian War. Bazille killed. Monet and Pissarro come to England.
1872 Durand-Ruel exhibits Impressionist paintings in London.
1873 Second Salon des Refusés.
1874 15 April–15 May. First Impressionist exhibition at Nadar's, 35 boulevard des Capucines, with 30 participants.
1875 A group of Impressionists organize an auction sale at Hôtel Drouot; average price 144 francs.
1876 Second Impressionist exhibition, 11 rue le Peletier, with eighteen participants, who begin to meet together at the Café de la Nouvelle-Athènes.
1878 Paris World Fair; Duret publishes *Les Impressionnistes*.
1879 Fourth Impressionist exhibition, 28 avenue de l'Opéra, with fifteen participants. Manet exhibits the *Execution of Maximilian* in New York.
1880 Fifth Impressionist exhibition, 10 rue des Pyramides, with eighteen participants.
1881 Sixth Impressionist exhibition, 35 boulevard des Capucines, with thirteen participants.
1882 Durand-Ruel organizes seventh Impressionist exhibition, and arranges showings of their work in London, Berlin and Rotterdam. Important exhibition of Japanese prints at the gallery of Georges Petit.
1883 Death of Manet.
1884 Eighth and last Impressionist exhibition at 1 rue Lafitte, with seventeen participants. Zola publishes *L'Oeuvre*, based on his relationship with Cézanne, and Van Gogh arrives in Paris. Durand-Ruel holds exhibition of Impressionists in New York.
1889 Monet and Rodin exhibit at Georges Petit's.
1890 Death of Van Gogh.
1891 Death of Seurat.
1892 Pissarro holds retrospective exhibition at Durand-Ruel's.

Select Bibliography

A. Boime, *The Academy and French Painting in the Nineteenth Century* (London, 1971); T. J. Clark, *The Painting of Modern Life* (New York and London, 1985); Raymond Cogniat, *Au Temps des impressionnistes* (Paris, 1950; Eng. trans. New York, 1951); Bernard Denvir, *The Impressionists at First Hand* (London and New York, 1987); M. Easton, *Artists and Writers in Paris; 1803–1867* (London, 1964); *The Encyclopaedia of World Art*, entry on Impressionism (New York, 1968); U. Finke (ed.), *French Nineteenth-Century Painting and Literature* (Manchester, 1972); William Gaunt, *The Impressionists* (London and New York, 1972); Robert L. Herbert, *Impressionism: Art, Leisure and Parisian Society* (London and New Haven, 1988); Jean Leymarie, *L'Impressionnisme* (Geneva and Eng. trans., 1955); Melissa McQuillan, *Impressionist Portraits* (London and Boston, 1986); Linda Nochlin, *Realism* (London and New York, 1971); Phoebe Pool, *Impressionism* (London and New York, 1967); John Rewald, *The History of Impressionism* (New York, fourth edition 1973); Robert Rosenblum and H. W. Janson,

Art of the Nineteenth Century (New York and London, 1984); A. Scharf, *Art and Photography* (London, 1968); Lionello Venturi, *Les Archives de l'impressionnisme* (Paris, 1939, 2 vols).

2 Symbolism and Art Nouveau

Chronology

1848–50 England: Pre-Raphaelite Brotherhood formed. Rossetti paints *Ecce Ancilla Domini*.
1874 France: First Impressionist exhibition.
1876 France: Moreau exhibits *Salome*.
1879 France: Redon's lithographs first published.
1881 France: Puvis exhibits *The Poor Fisherman*.
1883 England: Arts and Crafts Exhibition Society formed.
1884 France: Huysmans publishes *A rebours*.
1886 France: Gauguin's first visit to Brittany.
1888 France: Gaugin paints *Vision after the Sermon*. Nabis founded.
1889 France: Gallé exhibits vases in Paris World Exhibition. Gauguin sees exhibit about French colonies in the South Seas. Norway: Munch paints *The Scream*.
1891 France: Gauguin leaves for Tahiti.
1892 France: Salon de la Rose + Croix formed.
1893 USA: Tiffany begins to design vases. Holland: Toorop paints *The Three Brides*.
1894 England: Beardsley illustrates *The Yellow Book*.
1895 Germany: First publication of *Pan*.
1896 Germany: First publication of *Die Jugend*.
1897 Austria: Vienna Secession formed. France: Last exhibition of Salon de la Rose + Croix.
1898 France: Moreau and Puvis die.
1903 Marquesas Islands: Gauguin dies.
1904 Scotland: Willow Tea Rooms designed by Mackintosh.
1916 France: Redon dies.

Select Bibliography

Symbolism: Robert Delevoy, *Symbolists and Symbolism* (trans. Barbara Bray, Elizabeth Wrightson, Bernard C. Swift, New York, 1978); *French Symbolist Painters* (Arts Council of Great Britain, London, 1972); J. K. Huysmans, *A rebours* (Eng. trans. *Against Nature*, Harmondsworth and New York, 1958); Wladyslawa Jaworska, *Gauguin and the Pont-Aven School* (London and Greenwich, Conn., 1972); Philippe Jullian, *Dreamers of Decadence* (London and New York, 1971); Philippe Jullian, *The Symbolists* (London and New York, 1974); Edward Lucie-Smith, *Symbolist Art* (London and New York, 1972); H. R. Rookmaaker, *Synthetist Art Theories* (Amsterdam, 1959); Belinda Thomson, *Gauguin* (London and New York, 1987).
Art Nouveau: Renato Barilli, *Art Nouveau* (London and New York, 1969); Gillian Naylor, *The Arts and Crafts Movement* (London, 1971); Maurice Rheims, *The Age of Art Nouveau* (London and New York, 1966); Robert Schmutzler, *Art Nouveau* (London and New York, 1962).

3 Fauvism and Expressionism

Chronology

1888 Brussels: Ensor exhibits *Entry of Christ into Brussels*.
1891 Munich: Kandinsky arrives from Russia.
1892 Berlin: Munch's pictures create scandal at group exhibition.
1899 Paris: Matisse meets Derain and others at Académie Carrière.
1902 Berlin: Secession movement founded.
1903 Munich: Important exhibition of French and Belgian Post-Impressionists.
1904 Paris: Matisse holds his first one-man show.
1905 Paris: First Group showing of Fauves at the Salon d'Automne. Dresden: Die Brücke founded, and holds first group exhibition; first Van Gogh exhibition there.
1906 Paris: Fauves exhibit as a group at Salon des Indépendants.

1907 Paris: Matisse opens an art school. Retrospective exhibition of Cézanne. Berlin: Wilhelm Worringer publishes *Abstraction and Empathy*.
1908 Paris: Fauves begin to break up as a group.
1909 Berlin: Neue Künstlervereinigung founded. Munich: Similar group founded.
1911 Dresden: Last of Die Brücke group leave for Berlin. Munich: Der Blaue Reiter group founded, *Almanach* published. Berlin: the word 'Expressionist' accepted in catalogue of 21st exhibition of the Berlin Secession.
1912 Berlin: First 'Expressionist' exhibition at Sturm-Galerie. Der Blaue Reiter holds its last exhibition. Munich: End of Neue Künstlervereinigung.
1913 Munich: Virtual dissolution of Der Blaue Reiter.

Select Bibliography

Fauvism: Georges Duthuit, *The Fauvist Painters* (New York, 1950); John Elderfield, *The Wild Beasts* (New York, 1976); *Le Fauvisme français et les débuts de l'Expressionnisme allemand* (Musée National d'Art Moderne, Paris, 1966); Jean Leymarie, *Fauvism, a Biographical and Critical Study* (London and New York, 1959); Ellen C. Oppler, *Fauvism Reexamined* (New York, 1976); John Rewald (introduction), *Les Fauves* (New York, 1952); Sarah Whitfield, *Fauvism* (London and New York, 1989).
Expressionism: Lothar Günther Buchheim, *The Graphic Art of German Expressionism* (New York, 1960); Wolf-Dieter Dube, *The Expressionists* (London and New York, 1972); L.D. Ettlinger, 'German Expressionism and Primitive Art', *Burlington Magazine* (London, April 1968); Barry Herbert, *German Expressionism* (London, 1983); Charles Kessler, 'Sun-worship and Anxiety; Nature-nakedness and Nihilism in German Expressionist Painting', *Magazine of Art* (Paris and New York, Nov. 1952); Émile Langui, *Expressionism in Belgium* (Brussels, 1971); Bernard S. Myers, *The German Expressionists* (New York, 1955, and as *Expressionism*, London, 1955); Michel Ragon, *L'Expressionnisme* (Lausanne, 1966); Robert Rosenblum, *Modern Painting and the Northern Romantic Tradition* (London and New York, 1975); Wieland Schmied, *Neue Sachlichkeit and German Realism of the Twenties* (London, 1979); Peter Selz, *German Expressionist Painting* (Berkeley, 1957); Denis Sharp, *Modern Architecture and Expressionism* (London, 1966); Frank Whitford, *Expressionist Portraits* (London, 1987); John Willett, *Expressionism* (London and New York, 1970); John Willett, *The New Sobriety* (London, 1979); John Willett, *The Weimar Years* (London and New York, 1987).

4 Cubism, Futurism and Constructivism

Chronology

1904 Picasso settles at the Bateau Lavoir, meets Salmon.
1905 Picasso meets Apollinaire. Fauves exhibit at the Salon d'Automne.
1905/06 Picasso meets Gertrude and Leo Stein. Matisse exhibits *Le Bonheur de Vivre*, bought by Leo Stein.
1906/07 Winter, Picasso begins *Les Demoiselles d'Avignon*.
1907 Braque sells all six Fauve canvases he exhibits at the Salon des Indépendants. Kahnweiler signs a contract for his entire production. Apollinaire takes Braque to Picasso's studio. Braque begins *Nude* in response to the *Demoiselles*.
1908 November, Braque exhibits new landscapes at Kahnweiler's, and Louis Vauxcelles writes of his 'cubes'.
1909 On 20 February, 'Foundation and First Manifesto of Futurism', by F. T. Marinetti, published in French on the front page of *Le Figaro*. Picasso spends summer at Horta de Ebro in Catalonia; Braque spends the summer at La Roche-Guyon. Returning to Paris in autumn they find their work is becoming increasingly similar.
1910 Artists influenced by Picasso and Braque exhibit

Cubist works at Salon d'Automne. On 11 February, 'Manifesto of Futurist Painters'; on 11 April, 'Technical Manifesto of Futurist Painting'. Futurist evenings in Italy.

1911 Cubist rooms at the Salon des Indépendants and the Salon d'Automne establish Cubism as a major influence. Picasso and Braque do not exhibit. Juan Gris paints his first Cubist works. The Futurist Boccioni and Carrà visit Paris, and Severini introduces them to the Cubist painters, including Picasso. Mondrian arrives in Paris.

1912 Gleizes and Metzinger publish 'Du Cubisme'.

1913 Apollinaire publishes *Les Peintres cubistes*. Marcel Duchamp's *Nude Descending a Staircase*. In Moscow, Larionov and Goncharova publish Rayonnist and Futurist manifesto. Tatlin visits Berlin and Paris; seeks to become Picasso's apprentice.

1914 Marinetti lectures in Moscow and Petrograd. Mondrian returns to Amsterdam.

1915 Malevich and Tatlin exhibit in Petrograd.

1916 Boccioni dies.

1917/18 Russia: after the initial revolutionary chaos, the arts are organized by the Department of Fine Arts (IZO). In 1918, Malevich exhibits his *White on White* canvases. Rodchenko exhibits *Black on Black* canvases. Kandinsky appointed member of art *kollegia* in IZO. Death of Apollinaire, 9 November.

1919 IZO gives Tatlin commission to design *Monument to the Third International*. Rodchenko is made co-director of Industrial Art Faculty in Moscow. Malevich usurps Chagall's position as head of School of Art in Vitebsk.

1919 Gropius appointed director of the Bauhaus, Weimar.

1920 Kandinsky presents his programme for the Institute of Artistic Culture in IZO in Moscow, but it is rejected by the Constructivists. Gabo and Pevsner: Realist manifesto.

1921 Kandinsky leaves Russia for the Bauhaus. '5 × 5 = 25', an exhibition of Constructivist works by Rodchenko, Vesnin, Exter, Popova and Stepanova. IZO liquidated.

Select Bibliography

Cubism: *Apollinaire on Art; Essays and Reviews 1902–1918* (London and New York, 1972); Douglas Cooper, *The Cubist Epoch* (London, 1970); Pierre Daix, *Cubists and Cubism* (London, 1983); Edward F. Fry, *Cubism* (London and New York, 1966); John Golding, *Cubism: A History and an Analysis 1907–1914* (London, revised edition 1988); Robert L. Herbert (ed.), *Modern Artists on Art*, includes Gleizes and Metzinger, *On Cubism* (New York, 1964); Robert Rosenblum, *Cubism and Twentieth-Century Art* (New York, 1961); Gertrude Stein, *Autobiography of Alice B. Toklas* (New York, 1933).
Futurism: Umbro Apollonio (ed.), *Futurist Manifestos* (London and New York, 1973); Pontus Hulten (ed.), *Futurism and Futurisms* (London, 1987); Joshua C. Taylor, *Futurism* (New York, 1961); Caroline Tisdall and Angelo Bozzolla, *Futurism* (London and New York, 1978).
Constructivism: John E. Bowlt (ed.), *Russian Art of the Avant-Garde* (London and New York, revised edition 1989); David Elliott, *New Worlds* (London and New York, 1986); Camilla Gray, *The Russian Experiment in Art 1863–1922* (London and New York, revised by Marian Burleigh-Motley, 1986); Sophie Lissitzky-Küppers, *El Lissitzky* (London and New York, 1968); Christina Lodder, *Russian Constructivism* (New Haven and London, 1983); Angelica Rudenstine (ed.), *Russian Avant-Garde Art: The George Costakis Collection* (New York and London, 1981).
De Stijl: H. L. C. Jaffé, *De Stijl, 1917–1931* (New York, 1982).

5 Dada and Surrealism

Chronology

1913 Duchamp renounces painting, makes first readymade.

1915 Picabia and Duchamp arrive in New York, Picabia executes series of machine drawings; Duchamp begins the *Large Glass* and meets Man Ray.

1916 Cabaret Voltaire opens in Zurich on 5 February, and in April its participants adopt the name 'Dada'.

1917 Publication of first issues of *Dada* in Zurich. Picabia publishes nos. 1–4 of *391* in Barcelona. Duchamp sends *Fountain* to the Independents in New York; Man Ray and Duchamp edit *The Blind Man* and *Rongwrong*. Première of Apollinaire's 'Surrealism drama' *Les Mamelles de Tirésias* in Paris. Galerie Dada in Zurich.

1918 Breton, Eluard, Soupault, Aragon see *Dada*. Tzara's *Manifeste Dada 1918* published in *Dada*, 3. Club Dada in Berlin; Hausmann and others start using photomontage.

1919 *Littérature*, edited by Breton, Aragon, Soupault, appears in Paris, publishes Lautréamont, and serializes *Les Champs magnétiques*. Jacques Vaché commits suicide. Ernst and Baargeld found 'Dada conspiracy of the Rhineland' in Cologne. Schwitters makes first *Merz* works.

1920 Tzara arrives in Paris. Dada tour in Germany by Huelsenbeck, Hausmann and Baader. In Berlin *Dada Almanach*; 'Dada Fair'. Dada exhibition in Cologne.

1921 Publication of *New York Dada*, edited by Duchamp and Man Ray. Exhibition of Ernst in Paris; Dada stages 'trial of Barrès', loses Picabia's support.

1923 Duchamp leaves *Large Glass*. Masson makes first automatic drawings. Miró paints *Tilled Field*.

1924 Breton publishes first *Manifeste du Surréalisme*.

1925 'Exposition, La Peinture Surréaliste' at Galerie Pierre.

1926 Galerie Surréaliste opens with Man Ray exhibition. Arp settles in Paris. Publication of Ernst's *frottages Histoire naturelle*.

1927 Masson makes first sand paintings.

1928 Breton publishes *Nadja* and *Le Surréalisme et la peinture*. Dali makes *Un Chien andalou* with Buñuel.

1929 Breton publishes *Second Manifeste du Surréalisme*, purging dissidents and calling for political action.

1930 Buñuel and Dali make *L'Age d'or*.

1932 Breton publishes *Les Vases communicants*. Group exhibition of Surrealists at Julien Levy Gallery in New York.

1933 Victor Brauner joins Surrealists.

1934 Dali visits America. Dominguez joins Surrealists.

1936 Exhibition 'Fantastic Art, Dada, Surrealism' at the Museum of Modern Art in New York. First exhibition of Surrealist objects in Paris. Exhibition in London. Dali censored for support of Fascism.

1937 Breton opens Galerie Gradiva. Matta joins Surrealists.

1938 Breton meets Trotsky, and they write manifesto *Pour un art révolutionnaire indépendant*. Eluard and Ernst break with Surrealism. Wilfredo Lam and Hans Bellmer meet the Surrealists.

1940 Many Surrealists, including Breton, Masson, Lam and Ernst, meet in Marseilles *en route* for New York.

1942 'First Papers of Surrealism' exhibition in New York.

1944 Breton meets Gorky.

1947 'Exposition Internationale du Surréalisme' at Galerie Maeght: last major group exhibition.

1966 Breton's death effectively ends movement.

Select Bibliography

Dawn Ades, *Dada and Surrealism Reviewed* (London, 1978); William Rubin, *Dada and Surrealist Art* (London and New York, 1969).
Dada: Jean (Hans) Arp, *On My Way* (New York, 1948); Marià Lluisa Borras, *Picabia* (London, 1985); Marcel Duchamp, *Salt Seller* (eds Michel Sanouillet and Elmer Peterson, New York, 1973); John Golding, *Duchamp: The Bride . . .* (London, 1972, and New York, 1973); Anne d'Harnoncourt and Kynaston McShine (eds), *Marcel Duchamp* (New York, 1973, and London, 1974); Robert Motherwell, *Dada Painters and Poets* (New York,

1951); Hans Richter, *Dada: Art and Anti-Art* (London and New York, 1965); Michel Sanouillet, *Dada à Paris* (Paris, 1965); Michel Sanouillet (ed.), *391* (Paris, 1965).
Surrealism: Dawn Ades, *Salvador Dali* (London and New York, 1982); Sarane Alexandrian, *Surrealist Art* (London and New York, 1978); André Breton, *Surrealism and Painting* (New York, 1972); André Breton, *Surrealist Manifestos* (Ann Arbor, 1970); André Breton, *What is Surrealism?* (London, 1936); Suzi Gablik, *Magritte* (London and New York, revised edition, 1985); David Gascoyne, *A Short Survey of Surrealism* (London, 1935); J. H. Matthews, *An Introduction to Surrealism* (Pennsylvania, 1965); Maurice Nadeau, *The History of Surrealism* (London, 1968); Roland Penrose, *Miró* (London and New York, revised edition, 1985); John Russell, *Max Ernst* (London and New York, 1967).

6 Abstract Expressionism

Chronology

1933 Washington: Public Works of Art Project gives employment to American artists. New York: Mark Rothko has his first one-man show.

1934 New York: Hans Hofmann opens his school of art.

1935 Washington: The Federal Art Project extends the principles of the PWAP. New York: Adolph Gottlieb and Rothko help found The Ten, a group wishing to combine 'a social consciousness with an abstract, expressionistic heritage'.

1936 Paris: Wols arrives in France.

1937 New York: Joseph Albers founds American Abstract Artists.

1940 Fall of France. Leading Surrealists and other artists emigrate to New York, including Dali, Léger, Masson, Matta, Mondrian, Tanguy and Zadkine.

1941 New York: Gottlieb begins his *Pictograph* series. Breton, Chagall, Ernst and Lipchitz arrive.

1941–42 New York: Gottlieb, Motherwell, Pollock and Rothko experiment with automatism.

1942 Paris: Dubuffet resumes full-time paintings after many years. Fautrier paints his *Hostages* series. New York: De Kooning experiments with automatism.

1943 New York: Gorky achieves his mature style with the *Garden of Sochi* series. San Francisco: Clyfford Still resumes painting after an interval caused by the war and has his first one-man show.

1944 New York: Baziotes shows at the Art of This Century Gallery; Hofmann innovates a 'drip' technique of painting. Paris: Dubuffet has his first exhibition.

1946 New York: Hofmann begins his 'push and pull' abstractions. Paris: Hartung takes French citizenship.

1947 New York: Pollock begins his 'drip' paintings. De Kooning paints his black and white abstractions in commercial paints. Still exhibits his first colour-field abstractions. About this time, Rothko adopts his mature style, in which soft rectangles hover in space. Paris: Georges Mathieu stages *L'Imaginaire*, an exhibition of Lyrical Abstraction.

1948 New York: Gorky kills himself. Barnett Newman enters his colour-field manner. Baziotes, Motherwell, Newman and Rothko are among the founders of The Subjects of the Artist, which led to the later Club meetings of the Abstract Expressionists. Paris: the Cobra Group is formed.

1949 New York: Motherwell begins his *Elegies to the Spanish Republic*.

1950 USA: About this time, Franz Kline, James Brooks, Philip Guston and Bradley Walker Tomlin abandon figuration for an Abstract Expressionist manner. De Kooning begins his *Women* series. Paris: Pollock has his first European one-man show.

1951 New York: Frankenthaler is introduced to Pollock's work. Gottlieb abandons his *Pictographs* for the *Imaginary Landscapes*.

1952 USA: Morris Louis sees Pollock's 'drip' paintings and learns about staining from Frankenthaler.

1953 New York: Pollock abandons his drip technique. Spain: Antonio Tàpies begins his *matière* paintings.

1955 New York: De Kooning returns to abstraction.
1956 USA: Pollock dies in a car crash. Paris: Dubuffet adapts his new collage style.
1957 New York: Gottlieb begins his *Bursts* series.
1960 New York: De Kooning's *Women* series is resumed.
1962 New York: Kline dies.
1970 New York: Rothko kills himself; Newman dies.

Select Bibliography

Abstract Art Since 1945 (Brussels, 1970, and London and New York, 1971); Dore Ashton, *The Life and Times of the New York School* (New York and Bath, 1972); Michael Auping, *Abstract Expressionism* (New York and London, 1987); *Catalogue des travaux de Jean Dubuffet* (Lausanne, 1966); Jean Dubuffet, *Ecrits de Jean Dubuffet* (Paris, 1967); John Elderfield, *Morris Louis* (New York, 1986); E. Frank, *Jackson Pollock* (New York, 1983); Clement Greenberg, *Art and Culture* (Boston, 1961, and London, 1973); Georges Mathieu, *Au-delà du Tachisme* (Paris, 1963); *The New York School, The First Generation* (Los Angeles, 1965); Bernice Rose, *Jackson Pollock* (New York, 1980); Irving Sandler, *Abstract Expressionism, The Triumph of American Painting* (New York and London, 1970); Wolfgang Schulze: *Vols* (Paris, 1958); Diane Waldman, *Willem de Kooning* (New York and London, 1988); Diane Waldman, *Mark Rothko 1903–1970* (New York and London, 1978).

7 Pop

Chronology

1947 London: Eduardo Paolozzi starts to make collages using images from magazines and advertisements.
1949 London: Francis Bacon begins to use photographic sources.
1952 London: Independents' Group (IG) formed at Institute of Contemporary Art.
1953 London: exhibition 'Parallel of Art and Life' organized by Paolozzi, Nigel Henderson (a photographer) and Alison and Peter Smithson.
1954–55 London: IG reconvened by Alloway and McHale specifically to discuss popular culture.
1955 New York: Robert Rauschenberg makes first combine painting, Jasper Johns produces first flag and target paintings. London: Richard Hamilton's exhibition of paintings at the Hanover Gallery is much discussed at the IG in relation to use of popular imagery. Richard Hamilton organizes exhibition 'Man, Machine and Motion'.
1956 London: exhibition 'This is Tomorrow' at Whitechapel Gallery. Contributors include Hamilton, Paolozzi and the IG members. Emergence of key pop themes: Marilyn Monroe, cinema ads, packaging.
1957 London: Richard Smith shows painting *Blue Yonder* at 'Young Contemporaries', combining large-scale abstraction with popular figurative references.
1958 London: Hamilton starts work on *She*. Paris: Yves Klein makes first *Anthropometries*. Christo makes first wrapped objects.
1959 New York: Claes Oldenburg's exhibition 'The Street' at Judson Gallery. London: David Hockney, Derek Boshier, Peter Phillips, R. B. Kitaj at Royal College of Art. Paris: Arman produces his first assemblages.
1960 New York: Andy Warhol makes first comic strip painting, *Dick Tracy*. Tom Wesselmann exhibits his first *Great American Nudes* at the Tanager Gallery. James Rosenquist develops his Pop style. London: Allen Jones and Patrick Caulfield at Royal College of Art. Paris: César makes first *Compressions*. Milan: Critic Pierre Restany publishes first manifesto of New Realism.
1961 New York: Roy Lichtenstein independently paints his first works based on comic strips (Mickey Mouse, Donald Duck) and advertisements. Claes

Oldenburg opens his 'Store' on East 2nd Street. California: Pop art begins to develop on the West Coast. London: the Royal College group emerges at the 'Young Contemporaries' exhibition; Kitaj, Blake and Hockney are prizewinners at the John Moores Liverpool exhibition. Paris: Second manifesto of New Realism published.
1962 USA: Andy Warhol paints Marilyn Monroe and Campell's soup cans, and has his first show at the Jeans Gallery in Los Angeles. Ed Ruscha produces his first book of photographs, *Twenty-six Gasoline Stations*. In September–November Pop art in the USA is fully established with G. R. Swenson's interviews with Lichtenstein, Warhol, Wesselmann, Rosenquist and others, published in *Art News*, and with two exhibitions, 'The New Painting of Common Objects' at the Pasadena Art Museum and 'New Realists' at Sidney Janis in New York. London: BBC-TV film 'Pop goes the Easel' with Boshier, Phillips, Blake and Pauline Boty. Pop art is now a firmly established and fully identified movement. Europe: New Realism develops on a French–Italian axis.
1963 Düsseldorf: German artists Gerhard Richter and Conrad Lueg organize a 'Demonstration of Capitalist Realism'.

Select Bibliography

Lawrence Alloway, *American Pop Art* (New York, 1974); Lawrence Alloway, *Roy Lichtenstein* (New York, 1983); Mario Amaya, *Pop as Art* (London and New York, 1965); Michael Compton, *Pop Art* (London and New York, 1970); Michael Crichton, *Jasper Johns* (London, 1977); *Figurative Art Since 1945*, essays by Lawrence Alloway (London and New York, 1971); Christopher Finch, *Pop Art* (New York, 1968); R. H. Francis, *Jasper Johns* (New York, 1984); Henry Geldzahler, *Pop Art, 1955–70* (Sydney, 1985); Lucy R. Lippard (ed.), *Pop Art* (London and New York, 1967; includes essay by Lawrence Alloway); Kynaston McShine (ed.), *Andy Warhol* (New York and London, 1989); Norman Rosenthal, *Robert Rauschenberg* (New York, 1984); John Russell and Suzi Gablik, *Pop Art Redefined* (London and New York, 1969).

8 Pluralism since 1960

Chronology

1960 Formation of the Groupe de Recherche d'Art Visuel.
1961 Joseph Beuys begins teaching at Düsseldorfer Kunstakademie. Publication of Clement Greenberg's *Art and Culture*.
1962 'Geometric Abstraction in America', Whitney Museum, New York.
1963 'Toward a New Abstraction', Jewish Museum, New York.
1964 'Post-Painterly Abstraction', Los Angeles County Museum of Art. 'Nouvelles Tendances', Musée des Arts Décoratifs, Paris.
1965 'The Responsive Eye', Museum of Modern Art, New York. Publication of 'Minimal Art' by Richard Wollheim in *Arts Magazine* and of 'A B C Art' by Barbara Rose in *Art in America*.
1966 'Primary Structures', Jewish Museum, New York. 'Systematic Abstraction', Guggenheim Museum, New York.
1967 'Light-Motion-Space', Walker Art Centre, Minneapolis. 'Arte Povera', Galleria la Bertesca, Genoa. 'Sculpture of the Sixties', Los Angeles County Museum of Art.
1968 'Minimal Art', Gemeentemuseum, The Hague. 'Earthworks', Dwan Gallery, New York. 'Realism Now', Vassar College Art Museum, Poughkeepsie.
1969 'Anti-Illusion: Procedures/Materials', Whitney Museum, New York. 'When Attitudes Become Form', Kuntshalle, Berne, Museum Haus Lange, Krefeld, and

ICA, London. 'Ecologic Art', John Gibson Gallery, New York. 'Conceptual Art', Städtisches Museum, Leverkusen. Publication of 'Art After Philosophy' by Joseph Kosuth in *Studio International* and of first issue of *Art-Language*. 'New York Painting and Sculpture: 1940–1970', Metropolitan Museum of Art, New York.
1970 'Conceptual Art and Conceptual Aspects', New York Cultural Center. 'Conceptual art, arte povera, land art', Galleria Civica d'Arte Moderna, Turin. 'Information', Museum of Modern Art, New York.
1971 'Art and Technology', Los Angeles County Museum of Art.
1972 'The New Art', Hayward Gallery, London. 'Sharp-Focus Realism', Sidney Janis Gallery, New York.
1973 'Photo-Realism', Serpentine Gallery, London.
1975 'Bodyworks', Museum of Contemporary Art, Chicago.
1976 'The Human Clay' (selected by R. B. Kitaj), Hayward Gallery, London.
1977 Opening of Centre Pompidou, Paris.
1980 'Heftige Malerei', Haus am Waldsee, Berlin. 'Aperto '80', Venice Biennale. '7 junge Künstler aus Italien', Kunsthalle, Basel. 'Nuova Immagine', Milan Triennale.
1981 'A New Spirit in Painting', Royal Academy of Arts, London. 'Westkunst', Museen der Stadt, Cologne. 'Objects and Sculpture', Arnolfini, Bristol, and ICA, London.
1982 'Avanguardia–Transavanguardia', Rome. 'Transavanguardia', Galleria Civicà, Modena. 'Zeitgeist', Martin-Gropius-Bau, Berlin. 'Englische Plastik Heute', Kunstmuseum, Lucerne.
1983 'The New Art', Tate Gallery, London.
1984 'An International Survey of Recent Painting and Sculpture', Museum of Modern Art, New York. 'The Hard-Won Image', Tate Gallery, London.
1985 'Kunst in der Bundesrepublik Deutschland 1945–1985', Nationalgalerie, Berlin.
1987 'New York Art Now', Saatchi Collection, London. 'Berlinart 1961–1987', Museum of Modern Art, New York.

Select Bibliography

Art of Our Time: The Saatchi Collection (4 vols, London, 1984, and New York, 1985); Gregory Battcock (ed.), *The New Art* (New York, 1966); Gregory Battcock (ed.), *Minimal Art* (New York, 1968); Gregory Battcock (ed.), *Idea Art* (New York, 1973); Gregory Battcock (ed.), *Super Realism* (New York, 1975); Guy Brett, *Kinetic Art* (London, 1968); Germano Celant, *Arte Povera* (London and New York, 1969); Henry Geldzahler, *American Painting in the Twentieth Century* (New York, 1965); Henry Geldzahler, *New York Painting and Sculpture: 1940–1970* (New York and London, 1969); Tony Godfrey, *The New Image in Painting* (Oxford, 1986); RoseLee Goldberg, *Performance Art* (London and New York, revised and enlarged edition, 1988); Clement Greenberg, *Art and Culture* (Boston, 1961); Klaus Honnef, *Contemporary Art* (Cologne, 1988); Ellen H. Johnson, *Modern Art and the Object* (New York, 1976); Max Kozloff, *Renderings* (New York and London, 1970); Rosalind E. Krauss, *The Originality of the Avant-Garde and other Modernist Myths* (Cambridge, Mass., 1985); Udo Kultermann, *The New Painting* (revised edition, Boulder, CO, 1976); Lucy Lippard, *Changing: Essays in Art Criticism* (New York, 1971); Edward Lucie-Smith, *Movements in Art Since 1945* (London and New York, 2nd revised edition, 1984); Ursula Meyer (ed.), *Conceptual Art* (New York, 1972); Achille Bonito Oliva, *La Transavantgarde italienne* (Milan, 1980); Frank Popper, *The Origins and Development of Kinetic Art* (Greenwich, Conn., and London, 1968); Frank Popper, *Art: Action and Participation* (London and New York, 1975); Irving Sandler, *American Art of the 1960s* (New York, 1989).

List of Illustrations

Dimensions in centimetres and inches, height before width

Illustration Credits

Index